WOMEN POTTERS
Transforming Traditions

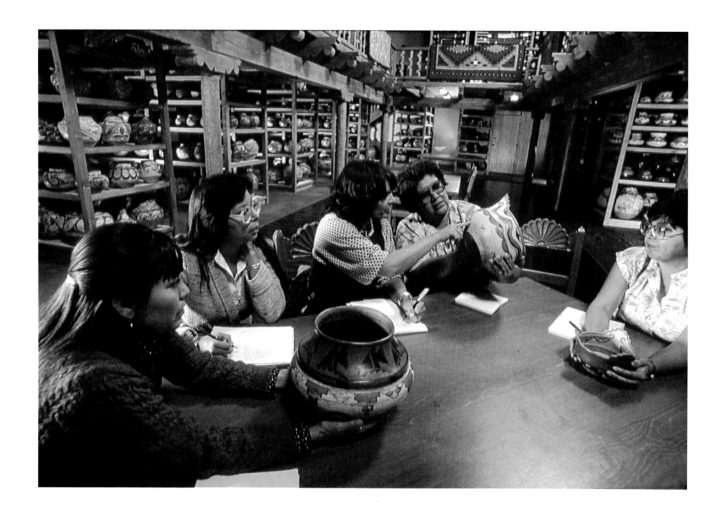

I am in awe of this clay that fills me with passion
And wonder.
This earth
I have become a part of,
That also I have grown out of.

Nora Naranjo-Morse from the poem 'When the Clay Calls'
Taken from Mud Woman: Poems from the Clay (University of Arizona Press, 1992)

WOMEN POTTERS

~

Transforming Traditions

Moira Vincentelli

A&C Black • London

First published in Great Britain 2003
A & C Black Publishers
37 Soho Square
London W1D 3QZ
www.acblack.com

ISBN 0-7136-51857

A CIP catalogue record for this book is available
from the British Library and the US Library of Congress.

Front cover: Roxanne Swentzell, 'Pueblo Figurines for Sale'. Photo by A. Doty. Courtesy of the Larsen collection.
Back cover: Inaq Rab'iah, Lombok, shapes a form with a stone and wooden paddle. Photo by Jean McKinnon.
Frontispiece: Pueblo potters examining old pottery in the School of American Research, Santa Fe, New Mexico.

Cover design: Dorothy Moir
Design: Penny and Tony Mills

Printed and bound in Singapore by Tien Wah Press.

A & C Black uses paper produced with elemental chlorine-free pulp,
harvested from managed sustainable sources.

CONTENTS

ACKNOWLEDGEMENTS

A book is like an iceberg; the final publication is the part that shows but beneath lies the supporting structure – the people and the institutions who allow it to come about.

In the first place I must thank the many potters who so kindly gave up their time to answer questions and demonstrate their work, especially Jabu Nala, Nesta Nala, Thembi and Zanele Nala, Fee Halsted Berning, Aselina Mbatha, Mary-Ann Orr and the potters of Endlovini Mission, Sara Evian, Marlene Roden, Cecil Baugh, Norma Harack, Concepcion Aquilar, Enedina Chavez Ruiz, Gloria Garcia Chavez, Juan Lopez, Anna Maria Juarez Lopez, Alberta, Alejandra and Macrina Mateos, Cecilia Jose Crus, Rachel Sahmie, Nancy Youngblood, Norah Naranjo-Morse, Ingrida Zagata, Sofronia Theodoro, Christina Andreou, Rodothea Andreou, Madame Hennad of Ouadhias.

Scholars, museum curators and experts who shared their knowledge and contacts or looked out photographs: Richard Carlton, Marie-Eugenie Poli Mordiconi, Jane Perryman, Natalie Torbet, Joe Molinaro, Eric Mindler, Marcus Winter, Robert Markens, Sabina Teuteberg, Kim Sacks, Sue Greenberg, Gertrude Litto, Chris Kinsey, Lynne Bebb, Patricia Fay, Mollie Mullin, Jean McKinnon, Gwenllian Ashley, Jonathan Batkin, Jan and Carmen Bially, Stan Jenkins, Sarah Posey, Shelagh Weir, Michael Cooke, Hugh Cheape, George Bankes, Nigel Wood, Laurence Kruckman, Leedom Lefferts, Louise Cort, Jerry Brody, Rena Swenzell, Patricia Capone, Brian Schaffer, Roderick Ebanks, Juliet Armstrong, Corinne Mahné, Mthembeni Zulu, Meri Wells, Patricia May and Josie Walter.

Friends and students who helped with translation, photographs and information are Inga Millars, Agnieska Depta, Alejandra Eguiarte, Simon Hudson, Mercedes Mills, Maria Eugenia Martinez, Iskra Holstein, David and Pat Williams and Helga Gaboa.

A very special thanks to my friends and colleagues in particular Jo Dahn who has discussed ideas throughout and read drafts at the end, Joan Anthony Jones whose patience and sharp eye is ever an asset and Elizabeth McDermott, Kathy Talbot, Jeff Jones, Janet Bujra and Laurel Brake who have all been supportive in different ways.

The team at A&C Black are always enthusiastic and helpful. Linda Lambert steered it all through and Michelle Tiernan has worked tirelessly on the production. Thanks are also due for helpful comments from the copy editor, to Shao-Chi Huang for the illustrations, Tony and Penny Mills for the design, Rob Burns for the maps, and Drusilla Calvert for the index.

I would also like to acknowledge the support of the University of Wales, Aberystwyth who awarded me two travel grants and a period of study leave which allowed the research to develop.

Finally to my family, especially my son Alessandro who has always taken an interest in the work and, above all, to my husband, Adriano who has accompanied me on many of the study trips as driver, companion and negotiator and without whose passion for photography this book could not have come to fruition.

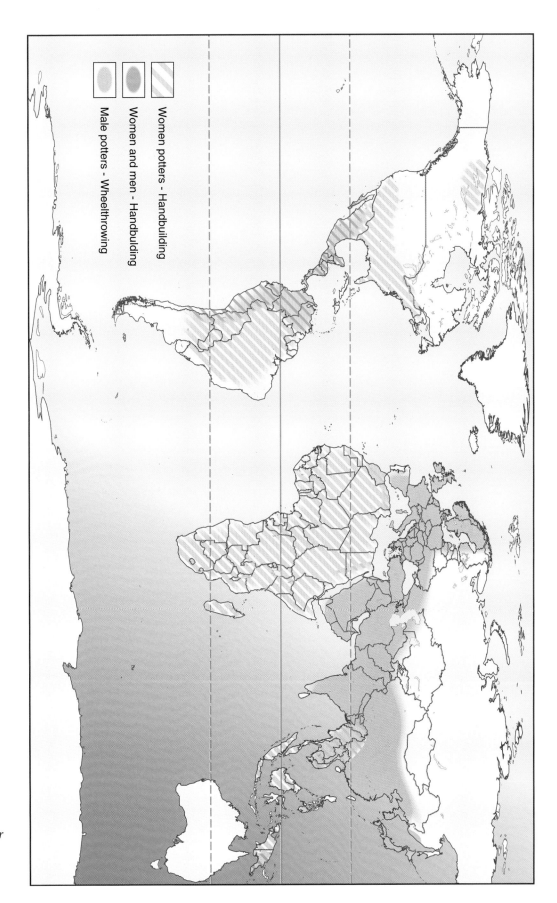

Map of the world
showing the broad
relationships of gender
and technique in
traditional pottery
circa AD1600

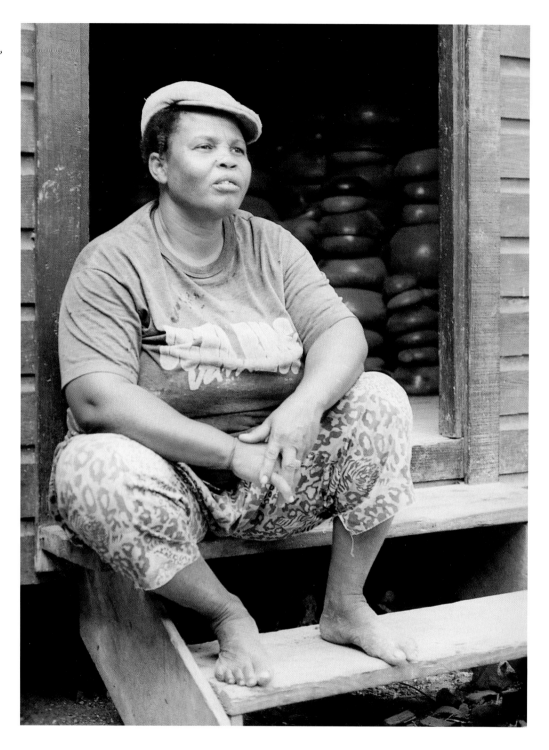

Marlene 'Munchie' Roden of Spanish Town, Jamaica, sitting on the steps of her storeroom.
Photo A. Vincentelli, 1999

INTRODUCTION

I HAVE been thinking about women and ceramics for over 25 years. It was a revelation to me, when first I discovered it, that many people believed women to have been the first potters. It was intriguing to find that women still represented a huge percentage of the world's potters; in four out of five traditional societies, pottery is a female task. But why did I not know this?

Knowledge is never innocent or disinterested; it is always grounded in an individual or particular world view. My perceptions of the world of ceramics were based on my Western experience, educated in art history and, briefly, archaeology, in a British university in the 1960s. Quite literally, the ceramics that women made 'did not come into the picture'. Fine Art reigned supreme, the applied and decorative arts were rarely discussed, women artists were ignored, and non-Western art was mentioned only in the context of Gauguin or Picasso.

Writing and study of ceramics are divided into many different camps whose

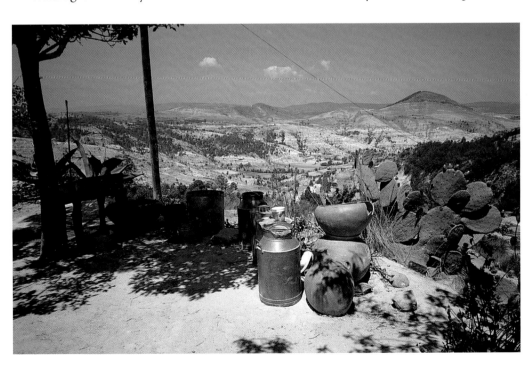

The outdoor kitchen of the potter Cecilia José Cruz at Vista Hermosa, Mexico, 2001.

A. Vincentelli

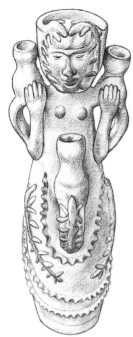

Anthropomorphic pot of a woman/vessel from Famagusta, Cyprus. Cyprus Folk Art Museum, Nicosia: drawing by Shao-Chi Huang

practitioners include archaeologists, ethno-archaeologists, anthropologists, collectors, dealers, auctioneers, art and design historians, museum curators, potters, ceramic artists, and teachers of ceramics. They represent different spheres of influence with limited cross-overs. Like the air in a soap bubble, knowledge is trapped by transparent walls – visible but locked in its own space.

Interest in the field of ceramics is understandably directed towards objects that demonstrate beauty, skill or high value so that, where a society has produced elite or highly specialised wares, the more mundane examples are overlooked. In terms of books, publications and museum displays, it is the fine crafts that are reproduced and used to identify a society. Plain pots along with mounds of shards will be consigned to the back store in the museum. Cooking pots – plain or decorated – may be of interest if the only pottery is cooking pots but, if there is something more elegant or elevated, that will tend to be the focus of attention.

The pottery that women make is easily taken for granted – humble cooking pots and simple water jars are everyday household equipment, not works of art. Value, however, is not intrinsic to objects but assigned to them by people. In his essay 'On Collecting Art and Culture' (1988), James Clifford shows how objects can move between different categories – a green glass Coca-Cola bottle can become a rarity as a collector's item and a 'classic' example of design; or a large number may be amassed to set into the mud walls of a house in Africa as a decorative motif. Recent work on the symbolic value of material culture suggests the way that everyday objects can be endowed with meaning and value for owners and users: the pot that is broken when somebody dies, the pot that has always stood in the corner of the room from which no water ever tasted sweeter, the cooking pot buried with its owner, the figurine by the hearth, the souvenir of a holiday in Turkey, or a gift from a grandmother's dresser. Pottery made by women may not be elevated in the art stakes but it scores high if we take into account other values.

Pots, as Nigel Barley has observed 'are good to think'. Making pottery is a miraculous process full of metaphorical potential – wresting clay from the ground, shaping it, subjecting it to the ordeal of fire to transform it into something permanent. It may be useful and beautiful, pleasing to the eye and to the touch, but it is also meaningful. Creation stories frequently draw on potting imagery to illustrate the beginning of human life, when gods and goddesses shape mud into human form. Making pots is perceived as analogous to giving birth; the vessel is a metaphor for the body or the womb; pots are metaphorical children – they have to be treated with love and care; clay itself is part of the earth and has to be respected; the earth must even be placated for 'taking its flesh'. The symbolic relationship of woman and vessel is a powerfully recurring symbol throughout history, as illustrated in many images.

In this book I have tried to create an overview and offer comparative material that can be built on in more detailed studies in the future. Most writing about traditional potters is by people who are specialists in a particular area of the world. Writers often suggest that something is unique when a similar technique, practice or belief is to be found elsewhere. Much of my study relies on other people's investigations and observations; my own fieldwork is based on short visits to selected places rather than extended research in any one area. Each of the main chapters deals with a continent or major part of the world and normally starts from the archaeological evidence before

Water Carrier, Fiji,
postcard, circa 1900,
based on a photograph
with hand colouring by
J. W. Waters, Suva, Fiji.
Pitt Rivers Museum,
University of Oxford
B45A.50

considering selected geographical examples. The central focus is on women but it has often been necessary to discuss the issue in relation to the way gender roles are negotiated. Certain patterns emerge and nearly all arrangements find parallel examples elsewhere, dictated by similar social changes or exigencies. In each chapter there is a consideration of recent changes and evidence of the way traditional potters are responding to new challenges and opportunities. These can be evaluated in different ways. Some may believe it is better for the old traditions to disappear rather than to change into a hybrid or even debased commodity. I do not feel this way. The idea that the old traditions are unchanging is often false. I may not like all the new work that I see but I am excited by its possibilities. New young artists, sculptors, potters and entrepreneurs will always emerge. Writing of Colombia, Ronald Duncan suggests with some concern that, 'More than pots, craftspeople are selling ethnicity and cultural memory' (2000:14). But does it matter? Despised 'airport art' can become tomorrow's gallery art. The stimulus of tourism is often seen as a negative one where the maker is merely pandering to a market, but the product is a negotiated deal between maker and buyer and is a means of communication; while it can indeed depress the quality, it can also improve it. As suggested by Dean Arnold, it may not be so different from the potters and ceramic artists who catered for the elite markets of the ancient world of the Maya. Cultural values are not fixed but negotiated and, as Pierre Bourdieu has argued, taste is always grounded in social experience and the possession of what he called 'cultural capital' based on background and education. The assessment of any individual piece of ceramics against the yardstick of art is only one criterion. It may have many other qualities or attributes through which it is given value.

Developments in Ceramic Technology

The earliest ceramics must have arisen from the use of unbaked clay and the realisation that the material became hard and permanent if subjected to fire. The earliest use of baked clay was for small figurines and amulets and some of the most ancient pottery suggests a symbolic rather than a utilitarian use.[1] The technology, however, really began to transform society when it was used to make containers.

Ceramics have traditionally been associated with sedentary cultures and agricultural societies but the two did not necessarily develop at the same time, as was once

[1] K. Vitelli (1999) suggests that some early Greek pottery was for ritual use and was perhaps made by female shamans.

thought. The technology is not exclusive to sedentary societies and some nomadic peoples make pottery. Handbuilding and open firing have no need of fixtures such as workshops and kilns and require only a suitable source of clay and firing material. The development of ceramics, however, complements that of crop cultivation and animal husbandry. Pottery is an ideal container for the storage of grain, protecting it from pests and damp; it is also portable, unlike a storage pit. Ceramic vessels can be used to boil root vegetables, pulses and meat, so making them soft and palatable in soups and stews. Cooking in ceramics allows children to be weaned earlier and old people to survive longer as there are soft and digestible foods available. The society gains as women have a more flexible lifestyle and older people can continue to make a contribution through their labour and life experience.

Scholars in archaeology and anthropology have constructed models for the development of ceramic production which are based on an evolutionary pattern progressing through various levels, from part-time to full-time. The earliest stage is household production, whereby potters work occasionally, usually according to season, to make pottery for their own household; an intermediate stage is the village industry where producers may still work part-time and seasonally, but for barter or commercial exchange; full-time activity is normally linked with specialist workshops which, in their expanded form, culminate in factory production. Ethnographic studies suggest that women potters are associated with the early stages of these evolutionary models, are increasingly marginalised or even absent in workshop production, but are brought into the workforce again as cheap labour in factories. Models inevitably simplify; they do not address all the variables or explain every case but they can be useful guidelines.

In non-ranked egalitarian societies there is relatively equal access to resources; production is related directly to human needs and there is no advantage in producing 'surplus' goods. As a society becomes more stratified or develops a more elaborate ritual expression, there is a need to make objects that will signify status through display or gift giving, or to create goods that can be exchanged for these. Things can either be produced in greater quantity in a more standardised way, or certain artefacts can be made in a more elaborate way, requiring increased time and skill and thus rendering them more individual or special. Pottery can become a focal point for the creation of high status goods, although that role may be allocated to other materials such as stone, metal or textiles.

In every society there is some level of specialisation based, in the first place, on age, secondly, on gender, and thirdly, on particular individuals undertaking certain tasks. A spiritual leader or shaman may be exempted from productive tasks in order to carry out special duties while in more complex societies, powerful families have special privileges that require other people to produce for them. Women are more likely to specialise in tasks which allow them to maintain childrearing – so they tend to do whatever can be fitted around their primary responsibilities which typically include food preparation, vegetable growing, textile production and pottery. Under these conditions women often produce pots for their own needs and those of their family or community. All women will learn how to make pottery and it will only be produced in sufficient quantities for immediate needs. A higher level of specialisation occurs when a community becomes recognised for its pottery and will then produce extra to exchange for other goods. It is often a seasonal activity; even specialists may only work

when the weather conditions are propitious or when the demands of agriculture allow. Such potters would be classed as part-time specialists.

As a society requires more diverse goods, people begin to specialise and increase their expertise. There will be growing pressure to speed up and standardise production, to improve quality or make the work visually appealing in order to compete in the market, or create objects accepted as prestigious by an elite. Villages become well-known for an individual product, or parts of a town will specialise in a particular vessel form, as can be still seen in Mexico. Where there is no official control, as in a guild system, this social code helps to regulate the supply of goods and allows everyone to survive. Women, because of their gender-assigned domestic duties, are much less likely to be released to become specialised workers. If the activity remains within the household they continue to be involved at some level, whether as potters or as helpers in clay preparation, decorating or finishing. In general, household production, especially in recent times, is associated with utilitarian pottery. However, within certain forms of less commercial household production, pottery can become a symbolic and personal activity where women have the option of applying time-consuming finishes or elaborate decoration. The work is deeply embedded in their psychological and social identity. This can be seen, for example, in Kabylie in Algeria or among the

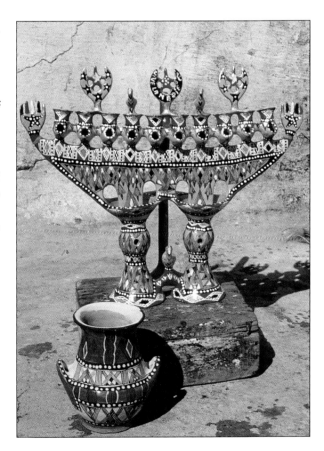

Candelabra from Ouadhias, Kabylie, 1982. This elaborate piece designed for use at a wedding ceremony and said to be for the potter's own use, was decorated with coloured and metallic enamel paints. It shows traditional and modern symbols such as 'The Hand of Fatima', the stars and crescent of the Algerian flag with 'Vive La Mariée' – 'Long Live the Bride' in the centre. In the foreground there is a traditionally painted pot.
Photo M.Vincentelli

Shipibo-Conibo in Peru, where the complex decorative systems are potentially full of personal meaning for the potters. Thus it would not always be right to assume that elaboration denotes full-time specialists, it may equally imply a special symbolic significance.[2]

One of the questions that has been little discussed is why women worldwide have been so reluctant to take up throwing on a potter's wheel and, even where a version of the wheel is available, will tend to use it for coiling rather than throwing, as in Eastern Europe. I have argued elsewhere that among women studio potters in the early 20th century, taking up throwing involved crossing both a class and a gender code. Throwing was an artisan activity for men. It became

[2]For a discussion of this aspect in relation to weaving, see Cynthia Cone's study of two contemporary Mayan craftswomen where the lengthy and elaborate process involved in women's weaving had social and sacred significance while women's pottery was merely a marketable product.

obvious during my research that even now it is very hard to persuade traditional women potters to take up the wheel and abandon handbuilding. Teaching wheel-throwing to men and women who have no previous pottery skills is far easier than persuading people to change their method of working.

I also maintain that the Western studio potter's veneration of the wheel has often been unhelpful in development projects where the wider context of social meanings involved in the use of different technologies is not always understood. Furthermore, the undoubted speed of the potter's wheel is not necessarily an advantage if the time or cost of clay preparation is taken into account. Handbuilding accommodates more variable types of clay as well as less refined clay bodies.

Similarly, the advantages of kiln over open or pit firing are often exaggerated. Most simple kilns are designed to fire with wood, whereas bonfires burn for a short period with many different fuels, including some that do not deplete the world of precious natural resources. Very little research has been undertaken on the differences, and comparisons are made within too narrow a focus. A simple kiln does not necessarily fire at a temperature much higher than a bonfire. The problem is that the only people who are experienced in open firing are traditional potters, who do not write books or teach in colleges. In Bourdieu's terms they do not possess the cultural capital to influence systems of knowledge. Their knowledge is limited to their own experience and particular conditions. Archaeologists, ethnographers and the odd studio potter who have experimented with the technique cannot hope to have the same kind of expertise.

It is very easy to assume that household production of ceramics has always been undertaken by women and, although there are exceptions, the ethnographic record provides strong supporting evidence for this. But is it correct to suppose that conditions in the past were the same? Historically, what we know now is a world where almost everywhere specialist pottery has emerged at some level. With the exception of large parts of Africa, in every continent men have been producing pottery on the wheel for many centuries and in some cases millennia. Both high value and high volume ceramics are produced in large-scale enterprises with predominantly male workers. Traditional potters today work in ways not dissimilar to those of the past, but where wheel technology is known men rarely continue to build by hand, leaving that activity to women. In earlier times it is possible that men may also have made pots with low technology systems, if there was no alternative. In the modern world male handbuilders are unusual: there are a few examples where they produce small-scale domestic pottery such as at Botel Tobago south of Taiwan; in a number of places men continue to make the very largest jars whilst in others they make 'special' objects including ceremonial pots or pipes that only men use. Where both men and women are potters they often use quite disparate making methods. One example is the male Hausa potters of Northern Nigeria who employ a beating technique, while most women potters in Nigeria use a coiling or pulling-up system.

There are very few cases of women potters enjoying a high status but, for the most part, the same is true for male potters. Pottery is often seen as dirty and polluting and in some parts of the world this is reflected in the way such workers are viewed. In India, among certain groups, they belong to the lowest class – the Untouchables – however, where the potter's wheel plays a significant role in wedding ritual, the potters themselves hold a special place in the social system. Often a distinct caste in the

sub-Saharan region of Africa, blacksmiths and potters are sometimes considered to have dangerous knowledge and magical powers. In some areas they are kept at a distance and it is common for them to intermarry. Large bonfires and kilns produce heavy black smoke so it is quite understandable that such polluting activity is carried out on the edges of towns and may bring potters a negative image unless the whole town specialises in the work. Pottery is rarely lucrative but in the past it probably produced a fair income in relative terms. It is in the modern world that women's pottery has such low value and has to compete with mass-produced goods. W. Longacre (1999) calculates that for a potter in the Philippines, the annual income is comparable to that of a school teacher but the social status is lower. Daughters of potters aspire to be teachers or nurses as these are modern professions which carry with them the badge of education and middle-class status. In many parts of the world women do not have that choice. Limited, even non-existent, schooling and lack of equal opportunities mean that the system is stacked against them. Daughters of potters often suggest that, if they had the opportunity, they would prefer a different occupation from their mother.

Do women potters gain status through their craft? There is evidence that they have the advantage of a source of income which may make them more prosperous than, for example, those in the next village where women do not make pots. The skill may even raise a woman's stakes in the marriage market – as in 19th-century Denmark. It may bring them into contact with the outside world when they market their pots and, in some cases, this may open unexpected doors. The interest shown in their expertise by outsiders – tourists, anthropologists and fellow potters from the Western World – may give them a sense of their own worth. In any craft-producing village certain individuals will emerge as particularly able, and that is likely to bring personal satisfaction and even status. Very occasionally, women potters have a role as a priestess or leader in a women's secret society where their specialist skills can be used. The Nigerian potter Abatan is a well-documented example. Where particular named individuals have become famous they will be able to command higher prices for their work and they may have opportunities to demonstrate or exhibit abroad; there are clear advantages and enhanced status for them, but even that is not without its price. This can be seen from a number of studies, especially amongst Native American potters of the south west USA, Mexico or South Africa. It is difficult if you live within a tight village community where everyone has a relatively equal position and income, to be the one who begins to rise above the rest.[3] Success does not automatically carry with it universal approval.

The starting point of this book is what I have chosen to designate as 'women's traditions' in ceramics, to use the broad term for fired clay. A woman's ceramic tradition is one where the production of pottery (usually unglazed earthenware) is identified as part of the female role, either because all women know how to make pottery or because making it is an exclusively female activity. Thus, in certain societies, working with clay becomes a 'naturalised' activity linked to female identity. However such roles are not dictated by nature but by culture and are the result of choices that particular groups have made. In considering how ceramic traditions change and adapt this book also reflects on a wide range of different gender roles in relation to ceramic practice.

[3]See Cone (1995) for an excellent discussion of this phenomenon.

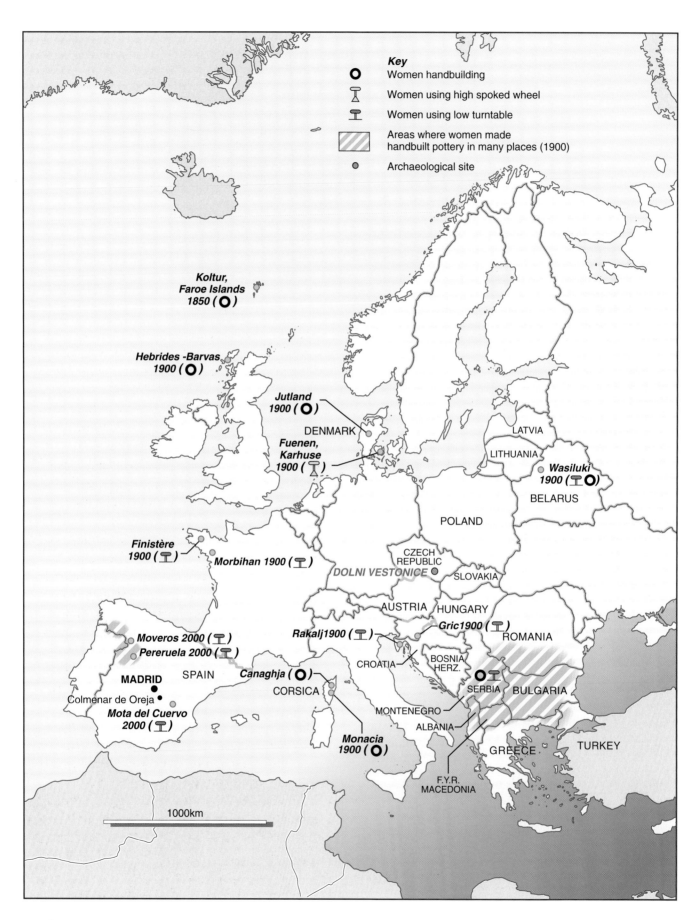

Key

⭕ Women handbuilding

⏳ Women using high spoked wheel

⏱ Women using low turntable

▨ Areas where women made handbuilt pottery in many places (1900)

● Archaeological site

Koltur,
Faroe Islands
1850 (⭕)

Hebrides -Barvas
1900 (⭕)

Jutland
1900 (⭕)

DENMARK

Fuenen,
Karhuse
1900 (⏳)

LATVIA

LITHUANIA

Wasiluki
1900 (⏱ ⭕)

BELARUS

POLAND

Finistère
1900 (⏱)

Morbihan 1900 (⏱)

CZECH
REPUBLIC

DOLNI VESTONICE

SLOVAKIA

AUSTRIA HUNGARY

Moveros 2000 (⏱)

Pereruela 2000 (⏱)

Rakalj 1900 (⏱)

Gric 1900 (⏱)

ROMANIA

MADRID

SPAIN

Canaghja (⭕)

CORSICA

CROATIA

BOSNIA
HERZ.

SERBIA

BULGARIA

Colmenar de Oreja

Mota del Cuervo
2000 (⏱)

MONTENEGRO

ALBANIA

Monacia
1900 (⭕)

GREECE

TURKEY

F.Y.R.
MACEDONIA

1000km

WOMEN'S POTTERY TRADITIONS IN EUROPE

Few people are aware that women's ceramic traditions still exist in Europe and, where they are recorded and discussed, tend to be considered in isolation as strange survivals of 'primitive' pottery, or anomalies with no particular significance. Women's pottery in Europe has remarkable similarities to traditions elsewhere in the world – pot making will be a designated female activity and, if men are involved at all, it will be in the transport of materials, or in marketing, or perhaps in the firing. The pottery is normally handbuilt using coils, although the pot is sometimes constructed on a tournette or low, revolving disc or turntable. Rarely will it have sufficient turning momentum to allow true throwing to take place. Firing is carried out in an open bonfire, a pit fire or a simple updraught kiln. The pots are fired once and are almost never glazed, although various forms of finish and decoration are applied.

These traditions have survived in Europe for 2000 years in spite of the widespread use of wheel and kiln technology and furthermore have run parallel to industrial ceramic production since the 18th century. There are specific functional or economic reasons why this kind of pottery has continued to play a role: sometimes such pottery is valued for its properties for cooking on an open fire (Spain, Cyprus, Corsica, Denmark, Tenerife, Anatolia), for baking bread (the Balkans), for water cooling (Spain, Cyprus, Kosovo), for its properties in medicinal use (Barvas ware from the Hebrides, Scotland), for its quaintness to tourists (Denmark, Hebrides) or for its ritual use (Denmark, Czech Republic). Sometimes this pottery may even imitate industrial forms (Denmark, Hebrides, the Canaries).

It may be significant that these traditions have survived on the edges of the continent and in places far from the heartland of industrial Europe. It is hard to resist the notion that they are continuous survivors of Iron Age pottery but we should be wary of any simplistic conclusions. There are records of women's traditions in Cyprus, Bulgaria, Yugoslavia, Croatia, Russia, the Czech Republic, Poland, Belarus, Denmark, the Faroe Islands, the Hebrides in Scotland, Brittany, the Pyrenees, Western Spain and Portugal, Corsica and the Canaries. Many have survived well into the 20th century, some to the present day. In Europe men are rarely documented as handbuilders. There are two major exceptions: firstly the very large storage jars used for wine or oil, which would be impossible to throw on a wheel (Colmenar de Oreja in Spain, Cyprus), and

OPPOSITE PAGE
Europe: countries and places mentioned in the text

17

secondly, there are certain villages where men handbuild using a hand-turned wheel (Belarus, former Yugoslavia, Greek Islands, Southern Spain).

This chapter will lead us on a tour around Europe, starting in the far north west, to consider some of the better documented examples of European women's pottery. In some of these places pottery is still made and in most was still in production at the end of the 19th century. The reports on these different places date from the 19th century to the present but, in the modern world, things change quickly and the situation of pottery production observed in 1980 may be very different 20 years later. For example, by the end of the 20th century, the war in former Yugoslavia had hugely disrupted any remaining pottery production recorded by Filipovic in 1951. However, it is worth noting that in his much more recent studies of the Western Balkans, Richard Carlton (1998) found that there were places where old skills were being revived in response to the loss of modern amenities in war zones.

Barvas ware of the Scottish Hebrides

In 1863 Dr (later Sir) Arthur Mitchell was travelling around the western islands of the Scottish Hebrides in his capacity as Deputy Commissioner in Lunacy. He was a keen student of ethnography and material culture and was amazed to discover in the village of Barvas a type of pottery still being made that closely resembled that of the Neolithic period.[1] Known locally as 'crogans' or 'craggans' the typical vessel was a round-bottomed container with a narrow neck which was used to hold milk, butter or other food. The mouth of the pot could be covered by a piece of leather tied with a thong. Mitchell was able to observe a pot being made. His description is graphic, if tantalisingly limited:

> The clay she used underwent no careful preparation. She chose the best she could get, and picked out of it the larger stones, leaving the sand and the finer gravel which it contained. With her hands alone she gave to the clay its desired shape. She had no aid from anything of the nature of a potter's wheel. In making the smaller Craggans, with narrow necks, she used a stick with a curve on it to give form to the inside. All that her fingers could reach was done with them. Having shaped the Craggan, she let it stand for a day to dry, then took it to the fire in the centre of the floor of her hut, filled it with burning peats, and built burning peats all round it. When sufficiently baked, she withdrew it from the fire, emptied the ashes out, and then poured slowly into it and over it about a pint of milk, in order to make it less porous.

(Mitchell, 1880, pp. 28–9)

Barvas craggans from Arthur Mitchell, The Past in the Present – What is Civilisation? *1880*

It is likely that, before that time, larger vessels were also made for boiling, cooking and as

[1] Arthur Mitchell's travelling companion in the Hebrides was Captain Frederick Thomas who was working on a survey of the islands around the north and west of Scotland and was an antiquarian (Cheape, 1993, p. 114).

milk churns.[2] Crogans seem to have a particular association with milk products and the residue in the bottom may have meant that milk was constantly slightly soured. It is also recorded that certain crogans had a curative purpose and that milk was drawn freshly from the cow into a crogan, boiled and given to consumptives. (Cheape, 1993, p. 125)

One of the reasons why this pottery was made and continued to be made in the treeless islands of the Outer Hebrides was the lack of available wood. In most of the mainland of Scotland wooden utensils were used for eating and for many domestic purposes until the 19th century when industrially-produced ceramics became readily available. Older traditions of handbuilt ceramics may have existed earlier on the mainland but were not able to compete with wooden utensils and the development of manufactured pottery in lowland Scotland after the 18th century.

In England handmade pottery co-existed for a considerable period alongside wheel-thrown wares but usually in different regions. By the early 13th century most pottery was wheel-thrown and kiln-fired. Ireland seems to have had very little pottery after the Neolithic period up to the 17th century, at which time early Delftware potteries began

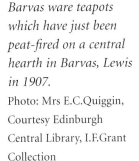

Barvas ware teapots which have just been peat-fired on a central hearth in Barvas, Lewis in 1907.
Photo: Mrs E.C.Quiggin, Courtesy Edinburgh Central Library, I.F.Grant Collection

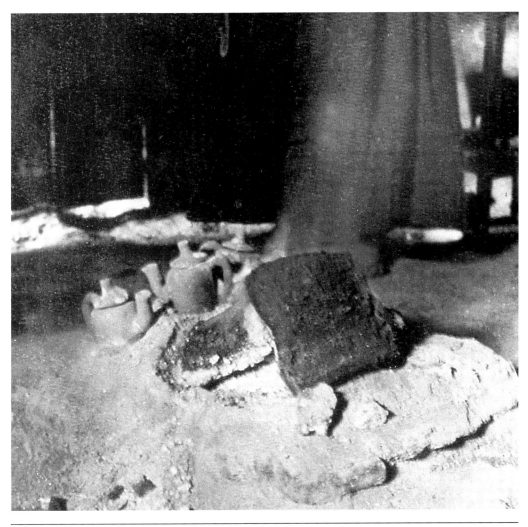

[2] The earliest account from Martin's Description of the Western Islands of Scotland (1695) talks of vessels made of fine red clay 'for boiling meat and others for preserving their ale, for which they are much better than barrels of wood' (quoted by Cheape, 1988, p.16).

to be established. There is archaeological evidence that in the Hebrides crogan pottery co-existed with imported wares for several centuries and was in continuous production at least as far back as the 16th century (Cheape, 1993, p. 114).

One of the strangest characteristics of these Hebridean pots is the development of forms such as teapots, jugs, sugar bowls and even animal models. It is hard to imagine that a teapot and teacup of such low-fired coarse pottery would really be practical, especially when alternatives were available, but tea drinking was not widespread in the Hebrides even at the end of the 19th century. Barvas ware, as it was known, was advertised in the Edinburgh and London press in the 1890s and it seems likely, therefore, that these teasets were made for the curio market as a quaint phenomenon, comparable to the novelties produced by Pueblo potters in the southwest of the USA in the same period. A rare early photograph from 1907 testifies to a potter firing in a small peat fire in the centre of a room. The photograph shows that three teapots have been fired while in the background a dresser appears to hold some glazed pottery (Cheape, 1993, p. 118).

In the years following the publication of Mitchell's book, *The Past in the Present – What is Civilisation?* in 1880, and through its mention in L. Jewitt, *The Ceramic Art of Great Britain*, 'Barvas ware' attracted a certain interest and museums and visitors sought it out, but by the 1930s it had all but disappeared.

Barvas ware tea-set c.1900. National Museums of Scotland, by courtesy of Mrs Thelma Aitken, Lanark

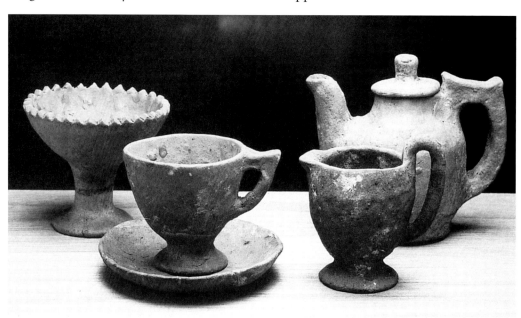

Black Pottery of Denmark

Denmark has one of the best recorded female pottery traditions thanks to the strong commitment to the documentation of folk customs in Scandinavian countries. Women were still practising potters reliant largely on a tourist/collectors market in the 1930s and, in a sense, this has not been entirely extinguished as the technique continues to be demonstrated by women at the Historical and Archaeological Research Centre at Lejre near Copenhagen.

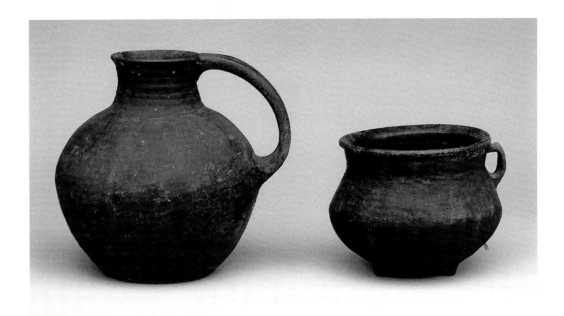

Danish black pottery or *Jydepotter* had its apogee in the 18th and the first half of the 19th century, a time when the Danish economy was relatively depressed. The industry established itself in the moorland areas of Jutland where it supplemented a meagre agricultural income and was further supported by a cottage industry of sock knitting. Pottery and knitted goods were exported overland and by sea, often by middlemen who had to be specially licensed. Toll books show that in 1808, over 900,000 pots were exported from Hjerting on the west coast, representing a considerable economic value. The pottery was traded in Denmark and through Northern Europe including Norway, Sweden and Germany and as far afield as Vienna (Steensberg, 1939, p. 144). In 1838 it was estimated that there were about 450 potters, with each woman producing 2000–3000 pots in the season which ran from spring to autumn. Not only was a knowledge of potting said to increase a woman's chances of a good marriage as the economic worth of this skill was recognised, but it also came to be seen as a desirable attribute of a good housewife (Lynggaard, 1972, p.135). A wide range of pots was made including many shapes and sizes of cooking pot, jugs, coffee pots, sweet dumpling pots with six hollows, bed warmers, distilling pots for the (illegal) distilling of schnapps and a food carrying pot with handle and lid, known as a birthing pot. This was more of a ceremonial vessel as it was used to bring food to a mother after the birth of a baby.[3] The industry began to decline after the 1850s as better incomes could be had from the expanding agricultural economy, especially the dairy industry. The domestic oven eventually superseded open-fire cooking and demand for black pottery declined. The pottery then took on new more decorative forms and was bought as gifts and for domestic display as much as for use. It is a familiar pattern in the development of all forms of folk pottery.

[3] A similar kind of lidded food-carrying pot with a handle over the top was made in former Czechoslovakia. It was called a 'corner pot' because women were brought food in it after confinement as they lay isolated in a corner (Hasalová and Vajdis, 1974, p. 119). Special pots used for food after childbirth are also part of the repertoire of Hungarian folk pottery.

19th-century illustration showing Danish women potters at work. The image seems to suggest that the women are overseen by the man standing at the back. (after Jensen 1924)

OPPOSITE PAGE
Two Danish potters of Karhuse using a wheel to make coiled pots. The woman at the back is preparing the coils. (after Jensen 1924)

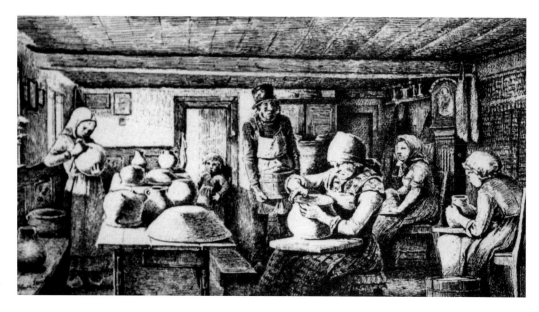

Danish black pottery employed an unusual system of handbuilding from the rim down and it was also smoked and fired in distinct ways. The clay was collected and left to mature over the winter. It was then brought into the house as balls of clay and worked with the feet, with lumps and stones picked out, after which micaceous sand was added. A final working was done by hand. The woman sat on a chair wearing a rough apron with a pot board on her lap and a box of clay and water by her side. The clay was formed into a tall cone which was hollowed out by pushing down first with the fingers, then the hand, and shaped. The rim was made by adding coils and then moulding with a piece of wet cloth held between the fingers. The pot was allowed to dry out at this stage for a few hours or even a day and then the lower part was formed. This time the pot was balanced directly on the canvas apron on the lap and the body was beaten out with the fingers of the right hand, the left hand acting as a support for the outer wall. For larger vessels a special beater stone could be used. Simple tools were employed including bent spoons, knives for smoothing and a much prized flint stone for polishing.[4] In the past a bent stick was used for this, which appears to be very similar to the bent stick used by the Hebridean potter.[5] The final stages of the pot consisted of smoothing down with wet slip, and polishing with the flint stone to give the characteristic shiny swirls that decorate the surface. As the market for functional wares declined, the pots became more ornamental and were sometimes decorated with flower patterns, emulating designs on industrial ceramics of the period.

There was, however, another forming technique used by women at Karhuse on the island of Fuenen. Here the potters used a simple wheel combined with coiling where very thick coils were wound on to the pot. They also used a kiln. This is a particularly

[4] The polishing stone is frequently cited as the most important tool to women potters and it is prized in many parts of the world. Polishing stones were sometimes left in the will (Szabadfalvi, 1986, p. 9).

[5] The limited description of the forming method of Barvas ware makes it hard to compare techniques precisely but it seems as though the pots were largely made by shaping and beating out and scraping. Coiling is never mentioned and within the Jypdepotter tradition is very minimal. Steensberg shows a number of the tools used. (Steensberg, 1939, pp. 124–5).

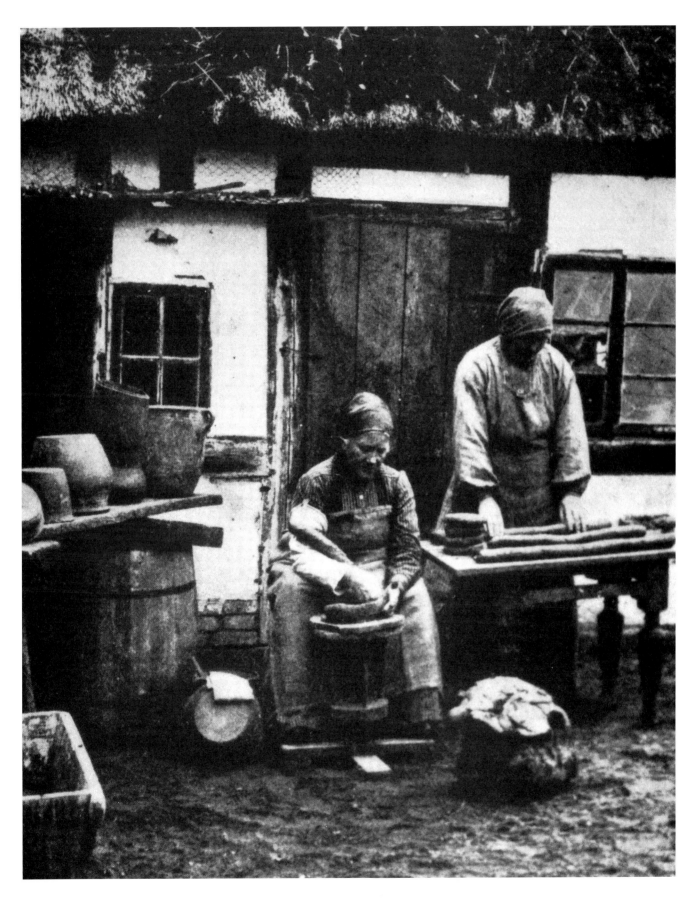

interesting example of a transitional situation where women were using more specialised technology such as the wheel and kiln whilst retaining a handbuilding method. It bears comparison with the way women work in the Spanish village of Moveros where in the final stages the pots are actually thrown. The wheel used in Fuenen is similar to that used widely in Eastern Europe.

The most distinctive feature of black pottery production was the smoking stage which required a special construction much like a kiln. It consisted of a pit dug out of the ground where slow burning heather peat was left to smoulder underneath a rack on which the pots were placed. Above ground, the construction had low walls and a sloping roof covered over with turf. The pots were left to be smoked in this enclosed waterproof capsule for about four days. They emerged a brown colour and were then carried immediately to the firing area without allowing them to cool down and reabsorb moisture. The firing was a pit firing in a low depression. The pots were laid one inside the other on á layer of peat, covered over with straw or hay, then a final layer of peat. The aim was to keep the camp from bursting into flame and windy or rainy weather was avoided if possible. Sometimes pots were placed inside iron pans. It was important to create a good reducing atmosphere with oxygen excluded, to achieve the desirable black colouring. According to tests the temperature remained quite low, between 500°–600°C (846°F–1026°F), with a firing time variously reported of between two and seven hours.[6] The smoked surface helped to make these unglazed pots watertight but, for a more complete seal, the pots were boiled in milk (Steensberg, 1940, p. 150). This creates an important parallel to the Hebrides.

It seems likely that there is a connection between the black pottery of Denmark and Hebridean crogans through the Norse incursions around the northern and western isles. In the other direction, looking south and east in Europe, there is evidence of an extended tradition of 'black' pottery dating back to the Middle Ages in Poland, Czech Republic, Slovakia, Hungary, Romania and Anatolia. The use of simple swirls of shiny black decoration against the matt surface is also to be found on some of these wares (Hasalova and Vajdis, 1974, p. 118). Black pottery is not necessarily a female tradition and in most areas it is made on the wheel and fired in kilns, as in Hungary. There is evidence that pockets of handbuilding remained in particular centres at least until the late 19th century.[7] Black pottery appears to have adapted to new technology and changing gender roles as the economic value of pottery increased and as markets expanded through improved transport and communications. Danish black pottery may be the anomaly in its resistance to both technical and social change in spite of its increased economic importance in the 18th and 19th centuries.

[6] Steensberg, 1940, p. 151 suggests two to four hours, although Lynggaard suggests six to seven hours (Lynggaard, 1972, p. 134).

[7] According to Imre Danko in the village of Magyarhertelend up until 1880 all the women coiled pottery using simple turntables. The pots were fired in bonfires in the yard. See Szabadfalvi, 1986, p. 6.

Eastern Europe

One of the earliest images of a female potter is the much reproduced 15th-century playing card showing a woman sitting at a spoked kickwheel. This cannot be used to prove that women were commonly throwing pots in the mediaeval period, although they may have been. The image in fact shows the potter finishing or decorating with a comb tool. Furthermore, as we have seen in Denmark, such wheels were used to make pottery using the coiling method. In the late 1930s Holubowicz photographed women potters using a similar system in Belarus. He suggested that there was good evidence of an older female tradition of handbuilding, but that around the 11th century, the wheel had been introduced. Gradually men had taken over, especially in the towns where the occupation became a full-time workshop activity with pottery being fired in kilns. At the same time in some villages male potters worked part-time and still used hand-wheels. By the time his research took place, men predominated, although in at least one village, Wasiluki, women made pottery without any form of wheel. Like so much hand-built pottery, the wares were valued for their ability to withstand thermal shock over an open fire. The potters specialised in cooking pots but also made other utilitarian objects such as bee fumers – an object also made by the women potters of Corsica. The pottery was fired in baking ovens and then plunged, whilst still hot, into a mixture of flour and water to produce a dark finish.

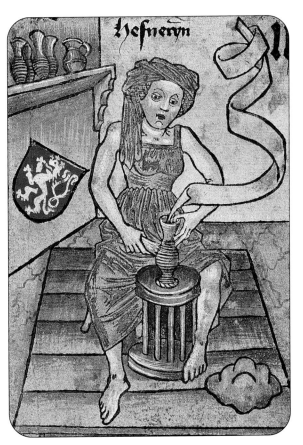

A female potter using a bone tool to create the decorative finish on a pot. The illustration appears on a mid-15th century German playing card. Kunsthistorisches Museum, Vienna

The model that Holubowicz presents appears also to be relevant in Poland where there were still women potters using handbuilding and bonfiring methods in the 19th century (Reinfuss, 1955). In Latvia, between the 14th and 18th centuries, pottery was practised by German and Swedish craftsmen and indigenous people were prevented from working independently. Since the break up of the USSR, many Latvian potters asserted their national identity through revivals of earlier pottery traditions including black pottery and folk decorative motifs.[8] It is probable that the spoked wheel, used as much for handbuilding as throwing, spread out from central Europe, north to Denmark, south towards the Balkans and eastwards towards Russia. The new technology

[8] I am grateful to Ingrida Zagata for this information.

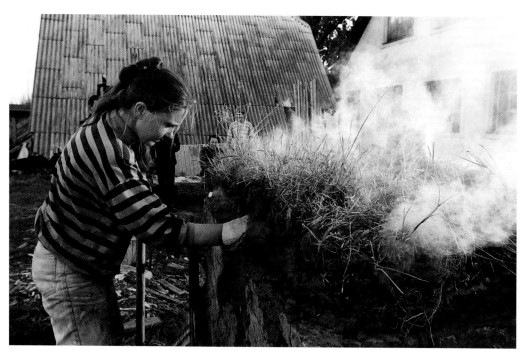

Above *Smoke-fired bottle by Ingrida Zagata, Latvia.*

Right *Ingrida Zagata, Latvia, creates a modern form of traditional black-fired pottery.*

usually signalled a gender change, with men becoming the main potters, although the women's tradition seems to have been maintained in certain villages. There is no evidence that women ever used the wheel for throwing.

Women's pottery in the Balkans

The pattern of ceramic production in the Balkans is highly complex, reflecting, but in no sense neatly corresponding to, the ethnic origins of the makers. Three traditions are usually acknowledged: handbuilding, handbuilding and throwing using a hand-wheel, and throwing on a foot wheel. In much of Bulgaria, Serbia and Macedonia a female tradition of domestic handbuilding survived into the late twentieth century in rural areas whilst in the towns, and further north from Slovenia to Romania, male potters predominated using wheel and kiln technology. In Croatia, Bosnia and Herzegovina, hand-wheels are often used in conjunction with coiling and bonfiring. In some villages such as Gric in Slovenia and Rakalj in Croatia, at least until recently, women made pots using a hand-wheel. In other places the potters are men, although women are often actively involved in these small-scale domestic enterprises. Widows and unmarried daughters may carry on a business out of economic need. Richard Carlton's (1998, 2002) description of the techniques of a male Bosnian potter bear a remarkable resemblance to handbuilding in other parts of north and eastern Europe. These include grinding calcite as temper, handbuilding using a low hand-wheel, pre-heating the pots in a smoke house also used for smoking meat, bonfiring and plunging the pots while still hot into a bath of floury water to darken them and to seal the surface.

The relationship between pottery and gender roles was considered by Filipovic whose research in the Balkans was carried out in the 1930s. He suggested that:

> In those parts where the manufacture of pans is still general and is considered a woman's job, men do not participate in that work for it would be beneath their dignity to perform a female function. At the same time, the production of pans is not a degrading work for women, moreover it is their duty. (Filipovic, 1951, p. 166)

Such a statement exemplifies the way pottery became a sign of wifely duty and feminine worth when it was seen as an explicitly female activity. As pottery became a more specialised task, making pots at a domestic level was an indication of poverty and was increasingly relegated to the least prestigious members of society. In some areas of Eastern Europe it was taken over by gypsies, a particularly marginalised group.

The Balkans is rich in archaeological ceramic remains which have been evocatively, if controversially, discussed by Gimbutas (1989) who linked the material to ancient female-centred religion. Filipovic was able to observe a mixture of the functional and ritual or magical beliefs that appeared to characterise women's pottery traditions in the area. Similar practices are, however, much better documented outside of Europe. The fact that such beliefs were maintained well into the 20th century and were strongly associated with female rather than male potters lends weight to the supposition that female traditions are older and have been preserved, rather than being new trends that have developed subsequently.

The characteristic ceramic form made by the women Filipovic studied was a wide circular pan (40–60 cm/16–24 in.) with a shallow wall or rim 7.5 cm (3 in.) high. The base and walls were 4 cm (1.5 in.) thick. The pans were used for cooking on the open fire and were especially valued for baking bread but could also be used for meat, fish, parching oats, drying salt or keeping silk worms.[9] In some areas the pans were pierced with a hole in the middle which allowed a stick or poker to be inserted as a lifting device. Cones and pyramids for balancing the pans over the fire, or as loom weights or yarn spools were also widely made and in some areas spindle whorls, flat disks (*pitulicarka*) used as griddle baking covers and even statuettes were produced. Unbaked clay ovens were also made by women in Serbia, Macedonia, Bulgaria, Greece, Cyprus and western Turkey.

All these objects have strong domestic associations and most were linked by their association with the hearth. Such a connection has also been noted in the archaeological accounts of Çatal Hüjük in Turkey where statuettes were found in the hearth area. Among the Mijaks, the clay cones were dubbed 'old men' or ancestors which, it was suggested, was associated with an earlier tradition where ancestor statuettes were kept in the hearth (Filipovic, 1951, p. 170). There was also a close link between pans and statuettes in one area of Macedonia where:

> The women make them [statuettes] simultaneously with the pans and use the same clay for it. These figurines perform the function of magical protection of the pans. (Filipovic, 1951, p. 164).

Clay objects were endowed with magical powers and clay, a material wrested from the

[9] Similar clay pans with a ridged base made from a micaceous clay were made in Grande Kabylie in Algeria. They are different from the other pottery with no painted decoration and are valued throughout the area for their excellent breadmaking properties.

earth, had to be treated with respect. Although there were many variations from one area to another, certain taboos prevailed. The digging of clay was undertaken at set times of day or on particular days of the week. Offerings might be made and singing and dancing were part of the ritual. There were purity taboos associated with clay – it could not be worked by menstruating women, pregnant women or women who had been in contact with a dead person for up to a year after the death. Fasting was considered appropriate at times of potmaking and strangers watching the process were unwelcome. The pan was protected by rubbing with basil, garlic or by placing a feather in it.

Pans were normally made by women, although in some areas male potters who produced other kinds of pottery began to supply the market with pans as well (Filipovic, 1951, p. 151). Women often worked collectively, kneading the clay with their feet, or even going round to each others' houses to prepare the pots. In other places individual women carried out all the processes for themselves. The more commercial the activity the more likely were men to become involved, first in collecting and preparing clay or marketing, then in the actual manufacture.

Filipovic's attention to the beliefs and customs associated with pan-making in the Balkans is unusual in reports of European women's pottery. It is, however, very much paralleled in discussions of women's pottery in other parts of the world, especially in Africa and amongst Native American potters.

Cyprus

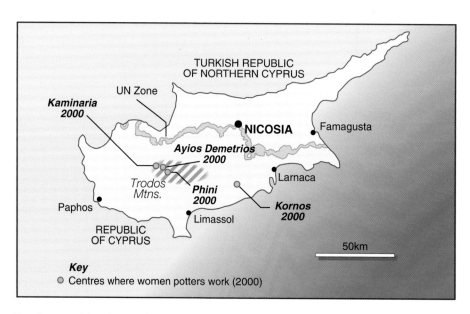

In Cyprus[10] in the 19th century, both men and women were involved in production, but there were distinct gender roles and couples often worked together, with the men undertaking the collection of the clay and fuel and, sometimes, the firing of the kiln.

[10] My information on Cyprus is largely based on a personal visit in 1983. I am grateful to Simon Hudson who gave me additional material following his study visit in 1988.

The very largest pots, huge wine storage jars measuring 1.5 m (5 ft) in diameter, were made by itinerant male potters.[11] These are no longer produced, although many can still be seen, often signed and dated by the potters. Women made all the other forms of vessel, including large roasting pots several feet high. For most pieces, women employ a small tournette or bat balanced on a pivot to allow the pot to swing round as they work. They sit on the ground or on a low seat in front of the tournette, starting the pot off by pressing down into a tall cone of clay, then building up by adding large fat coils of soft clay which are smoothed into the body as the work progresses. The pottery is wood fired in circular, stonebuilt, updraught kilns open at the top, there is a firehole at the base with a grid of clay to separate the pots from the fire. During the firing, which lasts six or seven hours, the entrances at the side and the top are closed over with broken potsherds or bark.

Women were still making pots in the 1980s in the villages of Phini, Kaminaria and Ayios Demetrios in the Trodos mountains. These villages did not have a substantial

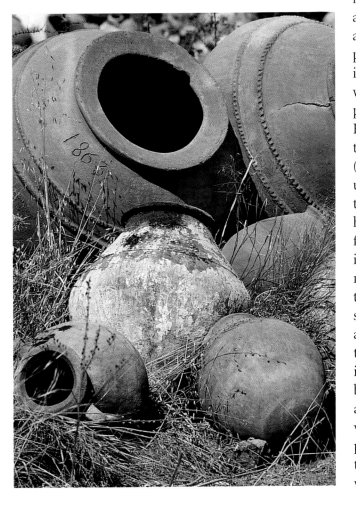

Large pots showing signature and ninteenth-century date, Cyprus

number of visitors, although at Phini there was a tiny folk museum. They produced a range of wares including tall roasting jars, water pots and cooking pots.[12] One potter (from Kaminaria) calculated that to make a pot around 60 cm (2 ft) high she took ten minutes to make the lower half, ten minutes for the upper half and five to ten minutes for smoothing and polishing. As the clay did not cost money, this potter preferred to make large rather than small pots which were fiddly and therefore took more time. Large pots were made in stages, being supported by strings or ribbons of rags around the belly of the pot; vine leaves around the rims prevented them drying out too fast before the next stage was added. The women's

[11] For the system of itinerant potters see G. London, 1989, and for the large jars see R. Hampe and A. Winter, 1965: 4pp. 4–17 and pp. 36–41.

[12] According to Gloria London (1986) two older men had recently learned pot making to work with their wives. But there was little evidence that young women were taking up the craft.

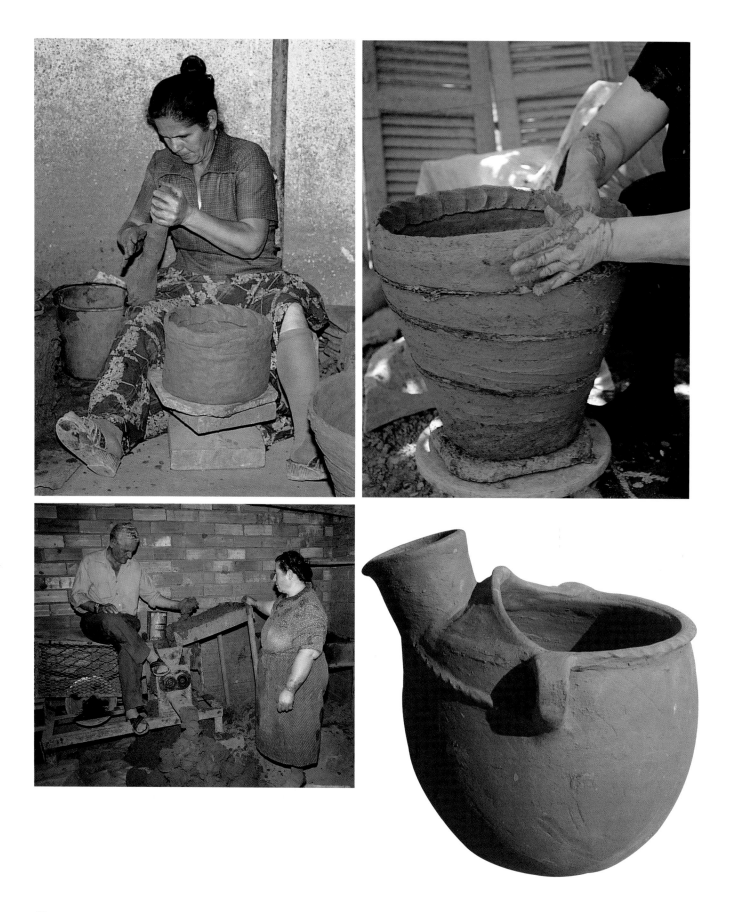

Right *Pitcher and ashtray with birds, Kornos, Cyprus*

OPPOSITE PAGE
Above Left *Coiling a pot at Kornos, Cyprus.*

Above right *Cyprus, coiling using strings to hold the sides*

Below left *The recently acquired electric pugmill was operated by the male administrator but only women made pottery. Kornos, Cyprus, 1983.*

Below right *Goat milking pot, Cyprus*

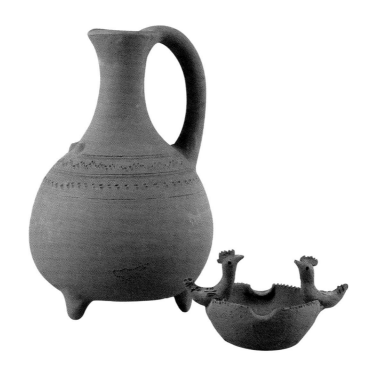

pots, like the men's pots, were built in batches so that, for example, the bases were all done on one day, the upper parts the day after.

The best known pottery village is Kornos which is situated not far from the motorway to Nicosia. The village has a history of pottery making going back more than 300 years. In 1954 a pottery cooperative was established to support the activity and maintain employment in the village.[13] The venture prospered and by 1983 there were at least seven women potters who worked there and one male administrator. The construction techniques had not changed but, when I visited, an electric pugmill had recently been installed to speed up clay preparation. Following the predictable gender division of labour, the new technology was supervised by the administrator who also oversaw the kiln firing with the help of a part-time male employee. Although cooking pots and other functional wares were made, the emphasis in this pottery was on small decorative objects which were marketed to tourists, many of whom arrived in bus parties, especially at weekends. The pottery functioned mainly in the summer and the potters earned enough in the season to keep them through the winter.

The decorated wares were distinguished by unusual multiple forms, pierced designs and bird and flower modelling. Such work had been in existence since at least the 1950s but probably dated back earlier and developed with the stimulus to diversify and produce small scale marketable products.[14] It is interesting to compare some of these designs with archaeological ceramics from Cyprus and indeed some inspiration may have come from that source.

[13] It was claimed by one informant in 1983 that all women over 40 in the village knew how to make pots.

[14] It was difficult to establish for how long the decorated wares had been made. There is little evidence of it in the photographs from the 1960s in Hampe and Winter. However a woman in Kaminaria said that such wares had been made 'in her grandmother's time'. Another potter could remember small gifts and toys of clay and 'tourist' pots '30 years ago'.

Corsica

One of the most unusual forms of pottery made by women was in Corsica where asbestos was mixed with the clay. The pottery villages were in the north east corner of the island which was also the main centre of asbestos working.[15] The mineral was mined in Corsica from earliest times although it is not clear for what purpose; there is evidence that it was used in ceramics as early as the Iron Age (Mezzadri, 1985). In 1838 the Director of the Royal Sèvres Manufactory asked for a report on the use of asbestos in ceramic production and was clearly interested in its potential for large-scale production. In his account his correspondent in Corsica, a school inspector in Ajaccio, offered a rare description of pottery techniques used on the island. He concluded that it was common practice to add asbestos in at very least the village of Canaghja, in the province of Campile. He described two systems of firing, one a typical bonfire system using chestnut wood, the other, the asbestos pottery, which was fired in bread ovens. In sending two examples of the pottery he was apologetic, recognising its inferiority to examples of ancient Celtic origin or pottery from the Americas and described such pottery as being

Corsican woman of Campile peddling pottery (after Galetti 1863). She is selling pots for roasting chestnuts, an important food and cash crop in this period in Corsica.
Musée Regional d'Anthropologie de la Corse, Corti.

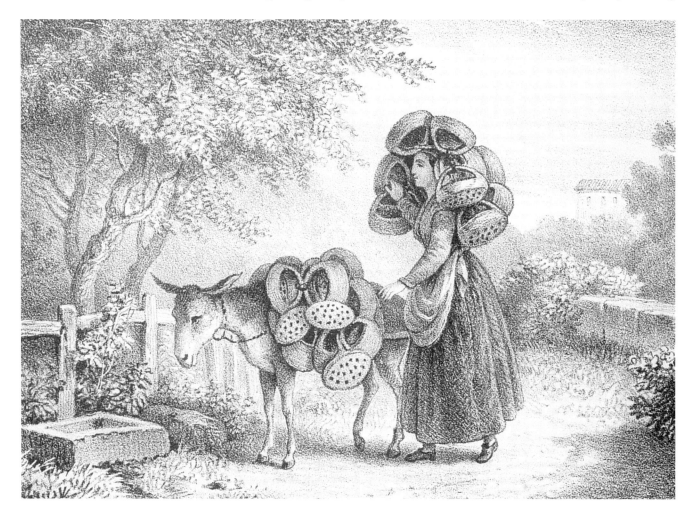

15 Asbestos was used widely in the 20th century for its insulating properties until the health risks were recognised. The Corsican mines were the only source in France and were an important economic resource between the 1920s and 1965 when they were closed down.

32

Clay brazier, clay with asbestos, Corsica.
Collection Musee Regional d'Anthropologie de la Corse, Corti

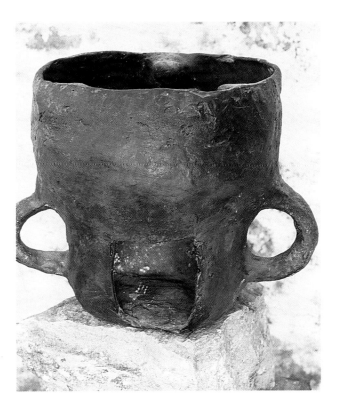

used by the poor, as anyone of means bought 'faience or even porcelain'.

Apart from an idealised 19th-century engraving of a woman pottery seller, there appear to be no photographs and only limited first-hand descriptions of this pottery tradition which survived well into the first half of the 20th century. One of the main informants was, unusually, a man of Monacia who had begun to help his mother as a potter from around the age of ten but after a war injury never returned to the work. The other was the last remaining potter of Canaghja, aged 87 in the 1950s, who confirmed the use of the bread oven for firing pottery. The pots appear to have been placed directly into the flames with 20 to 25 pieces in the oven; the oven was left open while they burned for two to three hours (Chiva and Olajo, 1959). At Farinole, the oven mouth was closed over with a piece of cork. At Monacia the pots were fired in a bonfire with the pots set on layers of wood and covered over with wood chips. In this case the whole was left to burn for a day, cooling down through the night and opened the next morning, a technique which has parallels with charcoal production.

Asbestos appears to be used as a temper or filler. It opens out the clay body to make it more workable and resistant to thermal shock, both in the firing and in open-flame cooking. It was also believed to make the pottery more resistant to breakage. At Canaghja three-quarters of clay was mixed with one quarter of asbestos, while in Monacia two different clays were used, one a white clay which contained asbestos as a natural constituent. Corsican potters produced a range of containers nearly all of which were associated with cooking or heating. Forms included stewpots with handles like baskets, single and double-handled cooking pots, pierced basket forms for coffee roasting and chestnut roasting, brasiers, bedwarmers and bee fumers. Liquid containers were not made and water was carried in wooden buckets.

All the records describe Corsican pottery as made and marketed by women although men seem to have participated at times in the collection of clay and the open firing, as opposed to the oven firing. Potters sometimes travelled around making pottery to order and then returning two weeks later when it was dried and ready to fire. The one example of a male potter seems to be the exception and he came from a family where his mother, grandmother and all his aunts were potters. Men mainly worked in fishing, small-scale agriculture and the cultivation of chestnuts, a staple product of the Corsican economy.

The Canaries

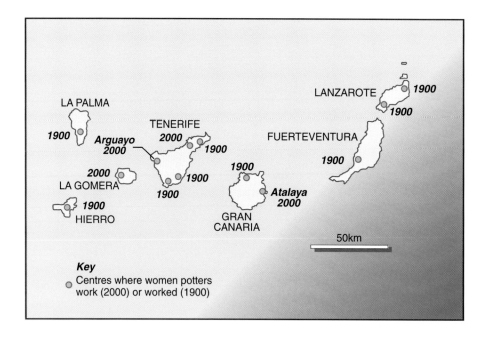

Off the north coast of Africa in the Atlantic lie the Canary Islands, where Guanche peoples from North Africa settled. This ancient culture with its close affinities to Berber traditions has been heavily overlain by European influences.[16] The pottery techniques again demonstrate the persistence of handbuilding, sometimes with the use of a low turntable, and both bonfiring and kiln firing depending on the village. Pottery was primarily a female tradition which died out on some of the islands in the course of the 20th century but was well documented. It is still to be found on Gomera, Tenerife and Gran Canaria. Men have come into pottery work through collecting the clay, firing kilns and marketing, but in the 20th century, as pottery became more commercial, some male potters have become better known. Decoration, where it exists, involves the application of a red slip made more shiny with the addition of oil, paraffin or, in the past, urine, and by polishing with a selection of much prized pebbles.[17] On the other hand, the *bernegal*, or water storage jug, was often given a characteristic incised wavy pattern around the widest part.

At Arguayo on Tenerife four women still work together, including a mother and daughter. They make a range of wares, selling cooking pots to local people and other forms to tourists. Miniatures were traditionally made to give to children at Epiphany but they are now sold to tourists all year round.[18]

[16] The Canary Islands were annexed to Spain by the late 15th century and through trading links developed close contact with South America. From the late 19th century there was a strong British influence.

[17] 'Pebbles with the right qualities for this purpose are highly prized and the potters at Acentejo, Tenerife, use stones that have been handed down over two centuries. In Atalaya, Gran Canaria, the most sought-after stones come from a beach at Arguineguin, over 35 km (22 miles) away in the south of the island' (Eddy, 1989, p. 16).

[18] Personal communication from Jo Dahn.

Water filter system in Arguayo, Tenerife. Photo Jo Dahn

Spain: Moveros and Pereruela and Mota del Cuervo

The rich traditions of Spanish pottery are largely dominated by male potters, although they often work with other family members. Typically they produce maiolica, slipware and unglazed, wheel-thrown earthenware. Again we find that in a few villages where potting is a female activity, the techniques are quite distinct and have more in common with other female traditions than with the male pottery production in nearby villages. A number of villages in Spain and Portugal still follow women's traditions, including Mota del Cuerva to the south of Madrid, but the most documented are in north west Spain, close to the Portuguese border. In the mid-1970s the villages of Moveros and Pereruela each had about half a dozen women potters, and ten years later their work was continuing.[19] The potters used rough metal kidneys and worked either sitting or kneeling on a cushion or sacking on the ground, in front of a low wheel or turntable. This was constructed on a stone base with a steel spike supporting a wooden cross framework with upright batons on which a 60 cm (2 ft) wide wooden wheelhead was fixed. The pot was formed from the base which was punched out of a lump of clay and then the walls were built up from thick coils of clay. In the final stages there was just enough momentum in the wheel to create the centrifugal force for the sides to be pulled up as in conventional throwing. Thus, the final pieces can look as if they were thrown. As in Cyprus, the widest parts of larger vessels were supported by strips of rag tied around the pots as they dried. Brushwood was used to fire the simple updraught kilns, open at the top and sealed with broken sherds. Firing lasted from six to ten hours. At Moveros there was no separate firebox and the wood was pushed in around the first layer of pots while in Pereruela the kiln had an internal clay floor to separate the fire from the pots. Similar kilns can be found in Cyprus, in Crete and the Canaries.

The range of wares produced included water jars, cooking pots and flat roasting pans but at Pereruela they also specialised in large coil-built bread ovens. These domed forms with a front opening were around 90 cm (3 ft)

Sculpture of a woman potter in the main square of Mota del Cuerva, erected 1986.
Photo Meri Wells

A LA CANTARERA 1986

[19] Other villages include four villages in the province of Orense, Mota del Cuervo in Cuenca and centres in Asturias and Portugal. (Köpke, 1974)

In Mota del Cuerva the skills pass down through the female line. Dolores Canego finishes a large coiled jar by turning on the wheel while her granddaughter looks on.
Photo Meri Wells

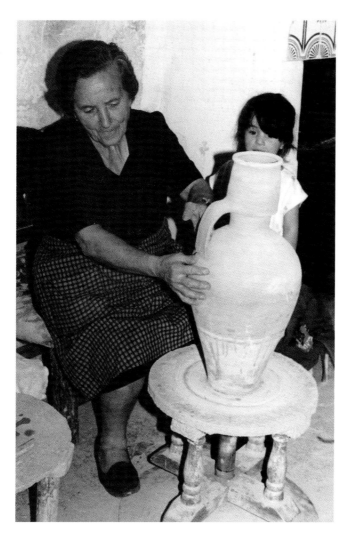

high by 1.2 m (4 ft) wide and had to be dried out carefully over many days. All the wares were marketed locally and sometimes further afield. Not surprisingly, by the 1970s, little miniature domed ovens were beginning to be made to cater for a growing tourist market.

Pereruela Bread ovens drying in the sun.
Photo Meri Wells

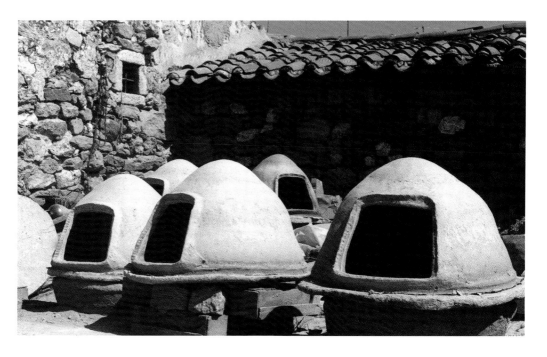

Paulina Mosquera of Moveros kneels at her low wheel to begin her work.

Photo Meri Wells

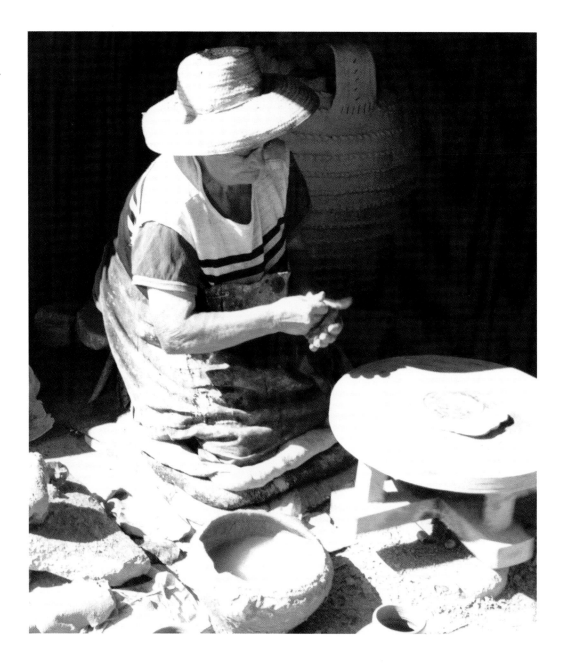

Brittany

Wheel and kiln technology has predominated in France for 2000 years. However, in parts of Brittany handbuilding was still practised in some places. In the villages of St Jean-la-Poterie near Rieux and Malansac in Morbihan, women made domestic pottery while men coiled large jars known as pones or charniers.[20] Further west in Finistère on

[20] By the 20th century women potters of St Jean-la-Poterie appear to have used a complicated wheel which was turned by hand using a stick. The older lead-glazed ware died out by the 1940s but a highly decorated painted ware issued from a later workshop, continuing in production until a fire in the early 1990s.

the north-west tip of Brittany, potters still worked with a low wheel similar to that in Spain. A photograph in Franchet (1911) shows a woman and a man working at such a low wheel.

Conclusion

What are the main points to draw from this tour around Europe? Firstly it is clear that there is a strong correlation between certain ceramic technologies and women's making traditions. There was only one example of a village where women had begun to use a potter's wheel that revolved fast and freely enough to throw pots; on the other hand the evidence from Cyprus, Brittany and especially Spain, suggests a transitional stage where women use a low tournette or hand-wheel system. While in Central and Eastern Europe and Karhuse in Denmark women used a higher spoked wheel but still formed the vessel using a coiling system. There is much to support the idea that when the wheel comes into use for throwing using centrifugal force to pull up the walls, pottery becomes a full-time activity with male workers. Women's traditions seem almost universally to be based on once-fired terracotta and rarely incorporate glaze technology (although there was some lead-glazing in the Spanish examples). Much more typical of women's traditions is the emphasis on polishing, as in Denmark, and in reduction firing to give a blackened surface which also acts as an additional seal on the surface. This is to be found in many other parts of the world. Women's traditions in Europe are associated with particular villages where many women make pottery and barter or sell it in local markets. Women work from the home, in the kitchen or the yard, and rarely have a specialised workshop. There was little evidence of every woman in a village making pottery merely for their own use, except perhaps in the Balkans, although that may have been the case in some places in earlier times. Typically women's pottery industries are seasonal and seem to have evolved out of the necessity to supplement the meagre income from agriculture. They might be classed as a household industry (Peacock, 1982, p. 17). As other sources of income have become available, so fewer women have chosen to carry on. New materials and mass-produced goods inevitably cut out the need for much of this pottery but other opportunities have arisen in particular tourism, which can be a lucrative market to which some potters have responded.

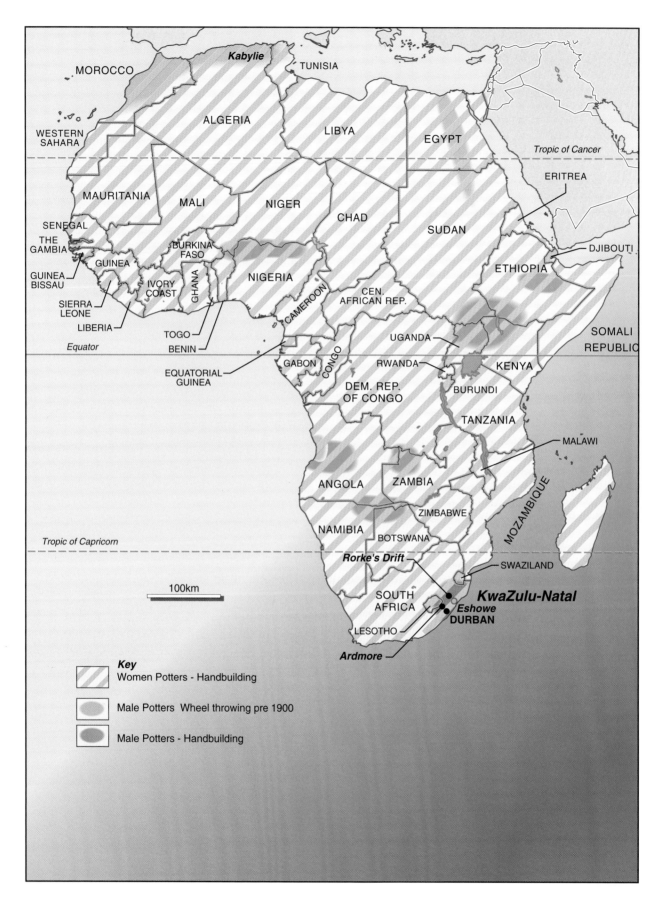

MOROCCO

Kabylie

TUNISIA

WESTERN
SAHARA

ALGERIA

LIBYA

EGYPT

Tropic of Cancer

ERITREA

MAURITANIA

MALI

NIGER

CHAD

SUDAN

DJIBOUTI

SENEGAL

THE
GAMBIA

BURKINA
FASO

ETHIOPIA

GUINEA

NIGERIA

GUINEA
BISSAU

IVORY
COAST

GHANA

CEN.
AFRICAN REP.

SIERRA
LEONE

SOMALI
REPUBLIC

LIBERIA

TOGO

CAMEROON

UGANDA

KENYA

Equator

BENIN

GABON

CONGO

RWANDA

EQUATORIAL
GUINEA

DEM. REP.
OF CONGO

BURUNDI

TANZANIA

MALAWI

ANGOLA

ZAMBIA

MOZAMBIQUE

ZIMBABWE

NAMIBIA

BOTSWANA

Tropic of Capricorn

Rorke's Drift

SWAZILAND

100km

KwaZulu-Natal

SOUTH
AFRICA

Eshowe
DURBAN

LESOTHO

Ardmore

Key

Women Potters - Handbuilding

Male Potters Wheel throwing pre 1900

Male Potters - Handbuilding

WOMEN POTTERS AND GENDER ROLES IN AFRICA

Changing perceptions of African ceramics

WITH FEW exceptions, women are still the main pottery producers on the African continent. Even in North Africa and Egypt, where wheel-thrown pottery has a very long history, women's handbuilding traditions have not been extinguished. In sub-Saharan Africa there are particular groups where men are the designated potters usually working with a distinct technique (anvil) or form (figures, pipes) but they are the exception that proves the rule.[1]

In 1695 Grevenbroeck gathered information from early Dutch contacts in Southern Africa and recorded:

> The women also make earthenware vessels quite skilfully out of moistened clay. They dig up the clay and carry it home, where it is cut up into portions the size of a walnut. These are placed on a skin and sprinkled with a little water from time to time to prevent them getting too dry. They are then kneaded into little cylinders, like bottles, each an ell long.[2] The first step is to mould the clay into a circle to form the bottom of the pot; then by further modelling they make a deep or wide vessel as suits their fancy and the law of proportion. This is polished and smoothed inside and out with a red colouring matter rather like minium (cinnabar, red lead). The pot is then left for a day or two in the same house in which it was made, well covered with a skin or mat, lest it gets too much air or wind, and so dry too quickly and fall into cracks. Finally the pot is stuffed with dry cowdung, provided with handles and placed on a bright fire. After baking it is ready for various uses.(Grevenbroeck (1695) in J.F.Schofield, 1948, p. 59)

In this early description of women potters in Africa, the Dutch writer recorded the procedure with some care and interest, indeed respect. By the 19th century, however,

OPPOSITE PAGE
Africa: countries and places mentioned in the text

[1] De Critis found that of 215 ethnographic accounts, 86% assigned pottery to female occupation. See Gosselain 1992, p. 563; also Herbert 1993, pp. 203–6 and Stössel, 1984, pp. 66–67.

[2] A unit of measurement of 1.15 m (45 in.).

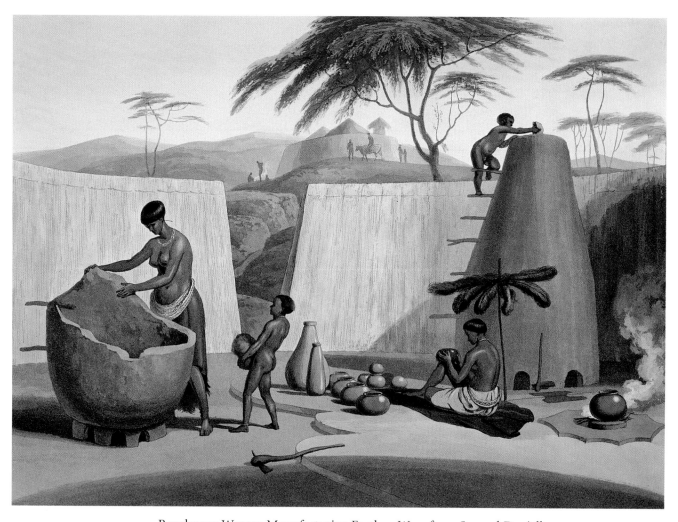

Booshuana Women Manufacturing Earthen Ware from Samuel Daniell
African Scenery and Animals, 1804, plate 23
The Trustees of the National Library of Scotland

The caption that accompanies the image states
'Although these people have made some progress in civilization, yet they retain that common fea-
ture of a savage state which condemns the weaker sex to perform the severest labour and the
greatest drudgery. The woman in the print is employed in the construction of one of the large
earthen vessels in which they deposit grain. They are made of tempered clay, dried in the sun
and washed over with a solution, red ochre, so as to appear to have been baked with fire. These
vessels are six or seven feet high, and hold from two to three hundred gallons…The different
pots, of a smaller description are intended for holding water or milk, and also for boiling their
meat. In their choice of animal food they are not very nice. They eat even the flesh of the wolf
and the hyena, but prefer that of different kinds of antelopes.

when accounts of African potters were more numerous, the tone is likely to emphasise the 'primitive' qualities:

> In the Tunisian country, even in the suburbs of Tunis, people use hand-made pottery. This pottery is red-faced, rude, and primitively ornamented. Most frequently the potter – who is a woman – traces on the paste of the fresh clay some lines with her finger dipped in henna.
>
> (Myres, 1903, pp. 47 & 86)

And, as late as 1960, Margaret Trowell, a sympathetic colonialist art educator could write:

> While in metal work, wood carving, cloth making and printing the African craftsman has developed very considerable skills, and exercises his ingenuity in working out methods of casting, constructing looms, printing and dyeing cloth and so on, yet with few exceptions his achievement in the craft of pottery has never reached an outstanding level. The preparation of clay is very perfunctory, nothing is known of an indigenous wheel beyond a simple turn-table, no kiln is used for firing, and the use of vitreous glaze is not attempted. Nor has the African aspired to build any great variety of shapes for his pottery, or to put it to many different uses.
>
> (Trowell, 1960, p. 59)

A cursory glance at any library on ceramics or any general study of world pottery reveals that African ceramics do not hold a high place in the history of the subject. They may be of interest to archaeologists and anthropologists, but, outside their own context, they have rarely been valued as aesthetic objects. In sub-Saharan Africa pottery was, and still is, made by handbuilding and open-firing technology; it did not have to compete with wheel-thrown ceramic production until very late. The pottery is functional, and part and parcel of the activities of daily life. Sometimes ceramics are made primarily as decorative or prestige objects, but it is also common for everyday ceramic objects to be endowed with ritual or symbolic significance in particular circumstances.

The study of African ceramics since the mid-20th century, while still being mainly undertaken by scholars of anthropology, has become much more sensitive to the objects in their own right. The Museum of Mankind's publication *The Potter's Art in Africa* (Fagg and Picton 1970) reveals by its very title a different value system. Occasional articles on individuals such as the female cult leader and potter, Abatan (Thompson 1969) and the acclaim inspired by the Nigerian potter, Ladi Kwali's tours in Europe and the USA, are all symptomatic of some recognition. Other milestones include Sylvia Leith Ross' *Nigerian Pottery*, based on the collection at Jos Museum, Stössel *Afrikanische Keramik*, 1984 and Nigel Barley's *Smashing Pots, Feats of Clay in Africa* (1994) which accompanied the Museum of Mankind's exhibition of the same name. In the USA, the work of the Center for African Art has produced important exhibitions and publications. The journal *African Arts* published a special issue on African ceramics in 1989 and by the end of the century the same publication was increasingly covering contemporary art including ceramics. Recent scholarship has examined

ceramics within the wider social context, not merely as an art form and an end in itself, but in a more holistic way that takes into account the social and symbolic potential of clay. Such scholarship questions the Eurocentric notion of 'art' and 'craft' which colonises meaning and over-values certain objects whilst devaluing others.

Potters and gender in Africa

Women potters are to be found in all parts of Africa but few, if any, of their making traditions are untouched by the industrial world. Some indeed exist quite successfully alongside it. In 1865 Barbara Bodichon wrote enthusiastically about Kabyle pottery and lamented that:

> The exquisite water jars…will be without doubt replaced in a few years by ugly jugs, or tin cans, or wooden buckets and yokes: and the oil jar and the rest of their beautiful forms, will give way before hideous and cheap French earthenware.

Such fears are commonplace in writing about women's pottery but somehow it usually survives. Potters are still working in Kabylie in the 21st century. The introduction of electricity may render terracotta unsuitable for cooking or piped water may obviate the need for water storage jars but there are still many places in the world where such modern amenities are not available. Thus there is no reason to think that all these traditions are dying; some are, but many are responding to change and evolving new strategies in response to new situations and shifting markets.

The introduction of workshop practices using wheels and kilns nearly always involves a shift in the gender balance amongst makers. Men take up pottery, indeed are invited to take up pottery, as a viable economic activity. Wheel-thrown pottery has been known for many centuries in North Africa and in the late 17th century the Portuguese introduced wheels and kilns in Angola and trained men as potters.[3] Since the mid 20th century many such workshops have been set up and some have included women, as at Abuja in Nigeria or Rorke's Drift in KwaZulu-Natal. These projects produce a form of African studio pottery selling to people looking for something that will bridge the gap between indigenous culture and Western taste. Perhaps this is just the process that has always gone on. It is surely worth noting that both Ladi Kwali at Abuja and Dinah Molefe at Rorke's Drift continued to use the female handbuilding techniques in workshops that were predominantly producing wheel-thrown work.

[3] There are also certain areas of Africa where it appears that, among certain groups, men have long been potters using low technology techniques of handbuilding and open firing. Pockets of male potters are found in the Southern Saharan region from the Sudan west to Nigeria and in Central Africa: Uganda, Democratic Republic of Congo (Zaire), Zambia, Angola and Namibia especially in the border regions where these countries meet. In all these places women also make pottery and are usually the main potters. It is rare to find men and women making pots together and there are almost always distinctions in technique or in the pots or objects produced.

North Africa

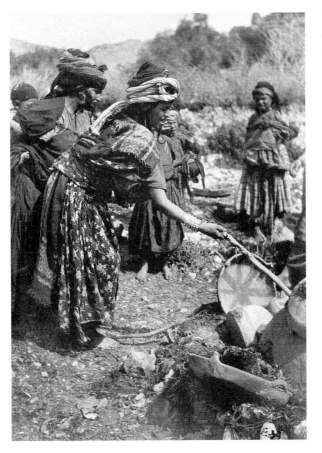

North Africa has two ceramic traditions which run in parallel: they are distinguished by gender, technology and ethnic identity. In the male tradition, pots are produced in workshops, thrown on the wheel and fired in kilns.[4] Unglazed, or glazed and decorated in blues, greens and yellows, they reveal their links with the Islamic traditions which extend from India in the east through North Africa and into Spain. The female tradition, still found in a broad swathe in the mountainous regions behind the coastal zone in Morocco, through Algeria, Tunisia and Libya, is associated with Berber culture which preserves a distinct linguistic and social identity.[5] Their pottery is coil-built, burnished and often richly decorated with geometric designs in white, black and red using coloured earths. It is fired in group bonfires or sometimes in small bonfires in the potter's courtyard. Traditionally, most women made pottery for their own consumption but the practice became increasingly specialised in certain villages and by the late 20th century was made by individual potters on a more commercial basis. Previously it was thought a dishonour to sell pottery except for widows who were recognised as the family breadwinner. In contrast with the simplicity of the thrown form, the handbuilding technique appears to encourage a greater freedom and makes it easy to create complex shapes with handles, spouts and lugs and multi-pieced pots such as double water jars or food servers with bowls joined together. An enormous variety of forms is produced, including ornamental works of birds and animals. Although pots are individually decorated, particular designs are associated with each village and, along with details of costume and weaving patterns, form important identifying sign systems. Ceramic decoration in Kabylie is also aligned to domestic mural painting, another woman's art, but much less documented and now almost defunct. The designs are often said to embody prophylactic motifs to protect from 'the evil eye'

[4] For two publications which consider this contrast see Balfet, 1981 and Myers, 1984.

[5] The cultural traditions in North Africa are very mixed and overlain by Arab and European influences but Berber languages and culture appear to represent older traditions which have maintained a distinct identity in language, dress and handcraft traditions.

Interior decoration in Ouadhias, Kabylie, Algeria showing wall painting, painted table and pottery used also in the display on a high shelf around the wall.
Photo M. Vincentelli, 1982

OPPOSITE PAGE
Potter from Darfur, Sudan building a pot using a stone anvil to beat out the form in a hollow lined with a woven mat, 1980.
Photo Natalie Tobert

or bring well-being to the household.[6] The pottery is used extensively in domestic display and is arranged on special shelves around the wall. As such it is an important signifier of female identity and domestic prowess. In the last 30 years the availability of coloured enamel gloss paint has offered exciting possibilities for new decoration. The bright colours stand out in dark interiors. To the Western observer, however, such decoration is frequently seen as a travesty of traditional ceramic technique.

How is it that such distinct traditions have survived over many centuries in such close proximity to Arab and European culture? Much of the distinctiveness of Berber culture has been passed on through female cultural traditions particularly weaving, pottery and wall decoration. Berber pottery has long been admired by the outside culture and there is evidence of a collectors market from the beginning of the 20th century and even earlier; Barbara Bodichon, for example, reported on its distinctive forms in the *Art Journal* in 1865. Berber peoples have used their language and cultural artefacts to maintain their identity in the face of otherwise close contacts with European colonisers or the

[6] The question of the meaning of the designs has been discussed by a number of researchers. Balfet, who has written extensively on pottery in North Africa, suggested that as the pottery became more commercial, so 'anecdotal motifs, which can amuse and hold a clientele, appear' (Balfet, 1965, p. 166). Grüner found that potters gave little evidence that there was any symbolic meaning to the design, although she suggested the opposite: that meanings may have become lost with commercialisation (Grüner, 1973, p. 112). See also Devulder (1951) who considers the magical properties of decorative motifs; Bynon (1984) who considers particularly 'the evil eye', and Vincentelli (1989). From his early work on Algeria, Pierre Bourdieu has frequently used his study of the Kabyle house as a microcosmic expression of culture and gender relations (Bourdieu, 1977).

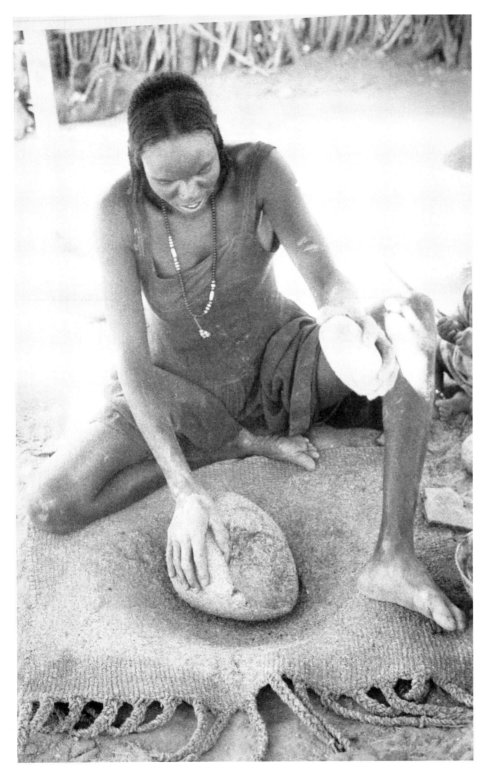

dominant Arab culture. Women, much more isolated than their menfolk from the surrounding cultures, have made a virtue out of necessity and maintained their cultural traditions.[7] Thus their activities have a significant and potentially subversive role in the politics of modern Algeria.

Sudan and the Saharan region

Among many groups in the southern and west Saharan region women potters form part of an artisan class where the men are blacksmiths. This artisan caste is often a group set apart, sometimes despised or said to be of slave origin, but in other places feared or respected. Their 'special' knowledge associates them with secret powers and may account for their frequent practice of intermarriage, thus maintaining the craft skills within the enclosed group (see Barley, 1994, pp. 63–4; Herbert, 1993). In the hierarchy of this culture the blacksmith is the more revered but women potters also hold important powers and they practice a range of other specialised activities including healing, midwifery,

[7] In Kabylie in the early 1980s, while most men spoke either French or Arabic, many women, particularly older women, spoke only Kabyle. In some villages, women were offered little or no schooling and did not read or write, nor did they have access to the new medium of television. Many more men than women had spent years abroad as emigrants. Arabisation policies have created radical changes.

Berber pottery, Kabylie, 1920s. Lamp and double jar, hand-built and decorated with natural pigments before firing. 38cm (15 in.); 26 cm (10 in.)
Collection University of Wales, Aberystwyth

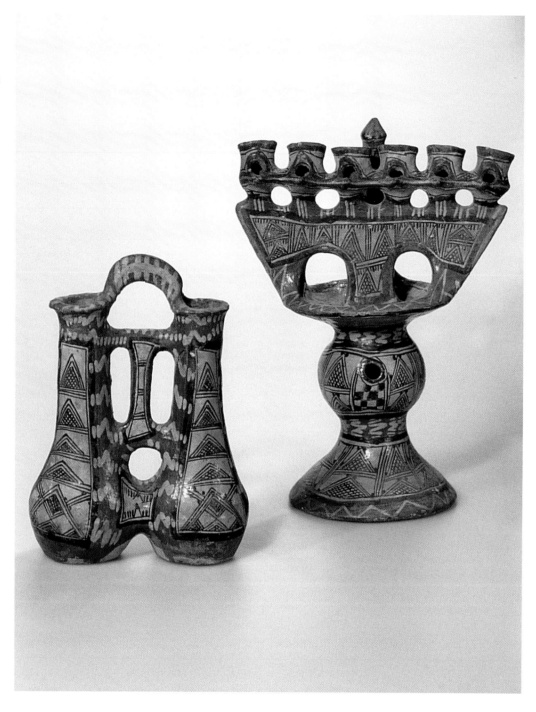

hairdressing and excision.[8] Clay and clay pits are felt to be places with dangerous spirits likely to cause sterility, miscarriage, blindness or even death. It is forbidden to dig clay on certain days of the week, usually Fridays but also, depending on the group, other days. Women may make special greetings, prayers or offerings to the spirits, and there are taboos against menstruating women coming to such a place (Frank, 1998, p.

[8] Excision or female circumcision is still widely practised among this group (see Frank, 1998, p.168).

Potter from Darfur, Sudan in the final stages of beating out the form using a stone anvil, 1980.

Photo Natalie Tobert

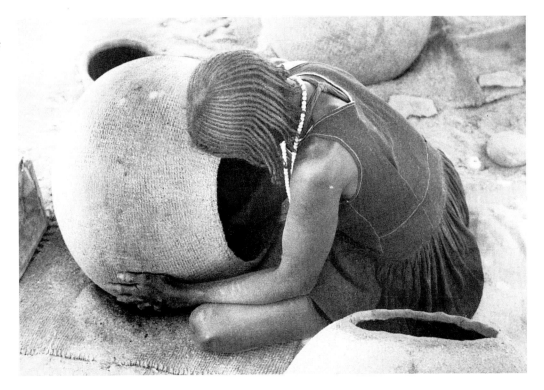

81). Similar beliefs are to be found in many places in Africa and in other parts of the world.[9]

In Northern Darfur in Western Sudan there are two groups of women potters: the Zaghawa and the Berti. Zaghawa men are blacksmiths and the potters, who are migrant workers, often live independently of their men. They work for two to six months during the dry season and set up a temporary camp on the outskirts of villages (the smoke from their fires is not liked by their neighbours). Their migrant status but also the fact that they are women on their own could help to account for the suspicion with which they are regarded. They are women free from the control of men. Other ethnic groups including the Berti also have women potters but they have no association with the blacksmith class; they work on a more modest scale from their own households or that of relatives and are, therefore, more integrated into their communities.

The construction technique for both groups is essentially the same – using a piece of mat in a hollow in the ground and powdered donkey dung as separator, a heavy stone is used to beat out a ball of clay into a rounded shape. The upper part is finished by coiling. There are slight variations in detail; for example, the Zaghawa pots are thicker (8 mm) and unusually employ two different tempers: millet husk for the main body which requires damp strength, and donkey dung for the rim which gives a finer, harder firing body. Berti potters, on the other hand, use only cow dung and make a thinner body (5 mm). The outside of the pot is given a covering of a red (haematite) slip and then burnished to give a smooth finish. Potters usually fire independently in

[9] Claypits are often physically dangerous because potters have to dig under the overlying layers to reach the best clay. There are frequent reports of accidents in claypits.

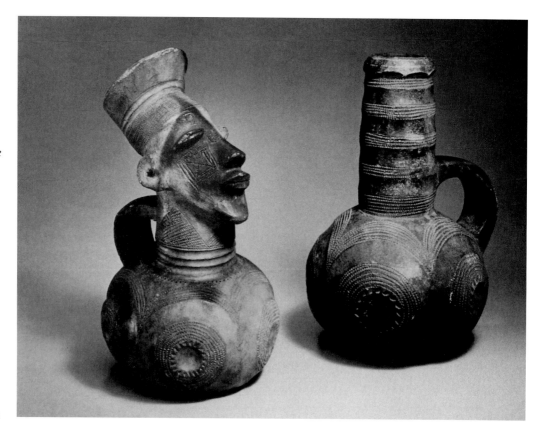

Mangbetu anthropomorphic pot and water jar. The bases are identical and the head was an embellishment of an older traditional form. These sculptural pots based on the fashionable hairstyle of Mangbetu women became very popular and collectable. There is some evidence that the head pots were made jointly with women making the pot and a very few male artists modelling the heads. 21 cm (8.2 in.); 13.5 cm (5.4 in.).
Lang Col. 1910, Neg. 338163, courtesy the Library, American Museum of Natural History

bonfires using dung and straw. All the women potters make a range of vessels in contrast with the greater specialisation of some male traditions in Sudan where potters will make only one or two types of vessel.[10] Although the techniques are similar to those used by many women potters, the social position of the potter as a full-time producer for an urban market is characteristic of male production.

Another version of this process, where men take on specialised ceramic work, may be exemplified in the figurative pots that are characteristic of the Azande and Mangbetu peoples who live in an area around southern Sudan and the northern region of the Democratic Republic of Congo. Traditionally in this area, women made domestic pottery except amongst the Azande where both men and women were potters. This unusual situation amongst the Azande is paralleled in their culture by a flexible attitude towards sexual roles in other matters. In the 19th century, many Azande warriors were unable to amass the wealth to purchase a wife and instead took young boys as 'wives'. These were formal arrangements between families and brought many of the same ties and obligations to in-laws. The boys took on most of the domestic tasks that wives would have performed (Evans-Pritchard, 1970, pp. 1429–31).[11] In the early colonial

[10] For example, a male potter of Kosti, an industrial town in Eastern Sudan, makes large water pots whilst his neighbours make other types of vessel. He builds his pots over convex solid clay moulds, finishes them by coiling and fires them in an open clamp fire. They are driven by lorry to the market and sold by a middleman.

[11] The Azande have strongly institutionalised bisexuality among the ruling class and homosexuality amongst the warrior elite. (Evans-Pritchard, 1970).

period during the late 19th century, representational imagery began to appear in wall painting, carving and pottery, in response to a growing ethnic awareness, even a sense of African identity, caused by the colonial encounter (Schildkrout and Keim, 1990, p. 26). Male potters of the Azande and Mangbetu developed a new kind of pottery which combined a pot with a head. These anthropomorphic forms had a ready appeal to the European eye and were produced in quantity, often as presentation items as much as trade goods. Some of this pottery may even be the product of inter-tribal marriage and joint male and female production where women made the pot while the men specialised in modelling the head (Schildkrout and Keim, 1990, p. 112; Stössel, 1984, pp. 129–30; Barley,1994, p. 144). The most characteristic design which typifies this art is the modelled head based on the highly stylised hairstyle favoured by fashionable Mangbetu women in this courtly society in the early part of the 20th century.

Ceramics in West Africa

Domestic pottery in the area from Mauritania through to the Cameroon is produced by women in one of the longest and richest ceramic traditions on the continent.[12] The connection between smithing and potting is also to be found in some areas among the Mande and the Dogon of Mali, the Senufo (Ivory Coast) and the Mafa and Dowayo (Cameroon). In West Africa pottery has every conceivable use:

> Pots are generally made to serve as containers for the cooking of food and the brewing of beer; for the storage of water, medicine, oil, grain, clothes, jewellery and other valuables, masquerade costumes; for the dyeing of cloth; for the remains of the living at death, for the immaterial spirits of the deceased; for agreements, curses and deceases. Pottery may be made as furniture and tools: for example, seats, door stops, lamps, stands for other pots, floor tiles, mallets used in the manufacture of pots; and pots can also be musical instruments, either percussion aerophones[13] or, with a skin over the neck, drums.
> (Simmonds, 1984, p. 54)

Vessel forms are made in one of three ways, with most potters using one main technique characteristic of their village or ethnic identity. The first is beating out the clay over a convex clay mould, either specially made or an old pot. When the base is sufficiently dry the pot is turned over and placed in a saucer and completed using a coiling technique. The second is forming the pot in a concave mould which usually revolves on the ground. The sides of the wall are built up using a coiling method or by beating with paddle and anvil. The third is a system where the potter punches into a thick tube of clay, the walls are pulled up and outwards and again finished by coiling and smoothing. Firing is normally in bonfires, usually with women firing communally,

[12] In the area of Northern Nigeria among the Hausa and Mossi (Sokoto and Yelwa) there are male potters. They make waterpots in a distinctive technique by tamping out the form in a hollow in the ground.

[13] Wind instruments or flutes

with up to 1,000 pots, sometimes in a slight hollow in the ground, or in the case of some Yoruba potters, with a simple low-walled kiln. The handsome round-bellied water pots and cooking pots give a dramatic effect piled up in the bonfire, laid out in the market place or stacked one above the other in the interior of a woman's house.

The sculptural possibilities of handbuilding in clay are also given full range. Pots can be composite forms with multiple spouts, or sweeping swathes of clay bands, deeply cut and giving dramatic effects in the light, or with shallow relief decoration with carved or millet husk roullettes pushed across the surface. The pot is often highly burnished and can be blackened by smothering with sawdust or leaves at the end of the firing and finished with various vegetal infusions to give a dark shiny surface. Sometimes contrasts of colour are created through the application of coloured slips, dark red or white. Much of the pottery follows traditional village styles but, within that, there is scope for personal expression and, increasingly, women are becoming specialists, working on a regular rather than on an occasional basis. Women usually market their own work or arrange with others to sell on their behalf. Pottery offers women an opportunity to develop business skills and some economic independence. In many parts of West Africa women run small businesses and organise marketing; potters are more likely to be involved in cash exchange and are often better off than non-potters.

The potters make all forms of domestic pottery and also a range of ritual vessels which are associated with older religious practices still widespread in spite of the impact of centuries of Islam and Christianity. Ritual vessels are not necessarily particularly well made or beautifully finished, although it might be argued that normally they have less rigorous use than a domestic pot. It is their strange form that sets them apart. The production of such pottery places women at the centre of important aspects of cultural life. Sometimes this confers special status on the maker. The Yoruba potter, Abatan, was recognised for her skills as a potter but her position in society was really based on her role as a priestess in the cult of Osun and Eyinle. With great ingenuity and invention she made pots that would be inhabited by the spirit. It is rare, however, for potters to officiate over the rites although they may produce most of the pots. It is also important to note that ritual vessels are not always separate from domestic vessels and pots can move between the two roles. When a husband dies a cooking pot becomes a 'widow pot'. It is carried to the edge of the village and ritually broken to signify the end of the marriage when a husband dies.

As elsewhere, pottery is surrounded by customs and taboos. Among the Yoruba, red (connoting blood, menstruation, danger) is never worn at the claypits. A sieve is only made by post-menopausal women as the pot is seen as a metaphor for the womb. Knowledge of pottery is widespread among Yoruba women and some work from home; however they also form group workshops where firing is done and each woman has a shed or *ebu* to store tools and food.

With the spread of Islam and Christianity and the increasing access to manufactured household goods, there is decreased demand for traditional pottery. Women have adapted their skills to produce new forms that cater for the growing urban market for house decoration, flower pots, lamps and objects with figurative forms. In the early 1990s there was a revival of interest in traditional pottery among urban dwellers (Fatunsin, 1992, p. 85). The Nigerian studio potter, Danlami Aliyu has reported over the decades on his observations of the village of Tatiko near Abuja where he was orig-

Eyinle (or Erinle) cult vessel made by the Yoruba potter, Abatan, mid 20th century. Sacred river pebbles and water are kept safe under the figurative lid while the bowl held by the figure is for kola nuts. Height 31 cm (12in.)
Drawing by Shao-Chi Huang after a photograph by Drewal.

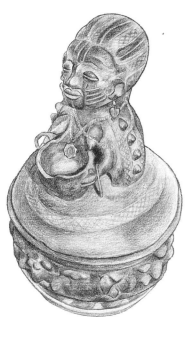

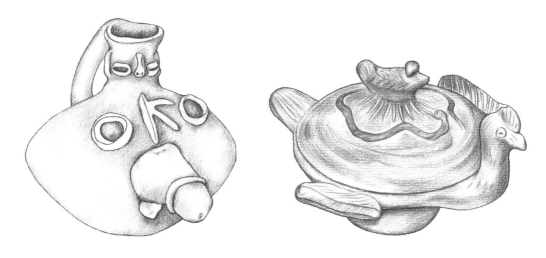

Left Yoruba pot from Abeokuta used in the Sango festival when female worshippers carry pots with various attributes including these phallic images. Height 21cm (8 in.) Drawing by Shao-Chi Huang after Fatunsin

Right Madam Adedoja Bamikole of Abeokuta - decorative lidded pots in the form of birds used to store small personal objects such as jewellery. Height 15cm (6 in.) Col. Fatunsin, Drawing by Shao-Chi Huang

Below Firing pots at Feraba Banta using palm fronds as fuel, The Gambia, 1992. Photo Alessandro Vincentelli

inally trained. In a recent conversation with the author he noted how the village had increasingly gained a reputation for its artisan production and, with better road transport and communications, the potters were busier than ever. On the other hand in the village of Gwari, previously an important centre of traditional pottery, the activity had now disappeared. The administrative centre at Abuja offered more lucrative occupations for the young women of the area.

The Gambia is not noted for its pottery although there are two villages which have long served the needs of the people for cooking and water storage. Water pots are still required although imported, mass-produced cooking pots are readily available in the markets. Pottery production is based on the village of Feraba Banta, about 20 miles (32 km) from the country's biggest market at Serekunda, and at Sotuma Sere, 300 miles (480 km) upstream in an area that takes about seven hours to reach by road from the

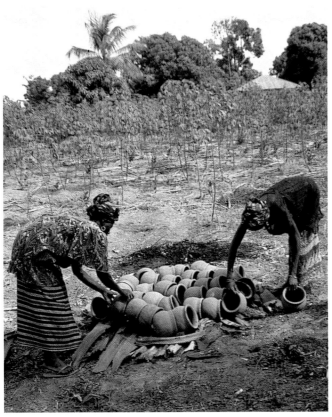

Pots from Feraba Banta awaiting sale at Serekunda, 1992. Photo M. Vincentelli

coast. Neither of these villages is directly affected by frequent visitors in the form of tourists, although both display pots by the side of the road, mainly for sale to local people. At Feraba Banta, where most of the women once knew how to make pots, by the 1990s only a few were still producing. They make the pots by the coiling method and bonfire using palmfronds, grass and sometimes dung. The pots, mainly large cooking pots or water pots, are transported by lorry and sold in the capital town at Serekunda market. Sometimes the potters stay with relations in Serekunda for a few days until they have sold them or leave them for others to sell on their behalf. They appear to have made little or no adaptations to sell to the tourists.

Central and East Africa

Women potters are widespread throughout all this area. They mainly work on a seasonal basis during the dry season, when farming activities are limited, to make pottery which is distributed through a network of village markets. As pottery is a ready source of cash income, men have also taken up potting. Among the Avalogoli, men specialise in large beer pots while women make all the other items. It seems significant that in the numerous photographs of women potters in Kenya they are always to be seen sitting on the ground or standing over their work as they pull up the sides, one image of a man, however, shows him sitting on a chair to bend over his coiled pot. It is not a traditional pose for an African potter.[14]

Techniques are varied but are primarily based on three basic systems: coiling, pulling up the pot in a cylinder and then shaping it with a scraper against the hand, or pulling up but constructing the pot from the rim upwards and filling in the hole in the base as the final step. Pottery is fired in individual or group bonfires as elsewhere in Africa.

Clay working is deeply infused with social meanings. Clay, clay pits and pots have secret powers and must be treated with respect. Ceremonies may be performed when extracting clay for the first time. Miniature pots are modelled and the potter dances round them intoning a ritual song. Thus she pays her respects to the clay that will be the basis of her work and make her a successful potter. Pots are often key objects in marriage ceremonies; they are placed on graves; broken pots are used for cursing; new pots must always be eaten from first by a woman as they might make a man impotent. Menstruating women should not approach the claypits; pregnant women should not make pots; Karanga Shona girls (Zimbabwe) bring to their new house freshly made pots as signs of their virginity.[15] Among the Makonde of Tanzania women make pots as well as pottery face and body masks which are associated with female initiation ceremonies. In the Nkisi

Mbusa pottery originally associated with girl's initiation ceremonies, Bemba, Northern Zambia. On the left are two contemporary pieces showing traditional forms being updated to create contemporary meanings. These are by Paulina Mubanga glazed and fired by Bente Lorenz, both circa 20cm (8 in.) high, 1995. On the right is a more traditional piece.
Drawing by Shao-Chi Huang

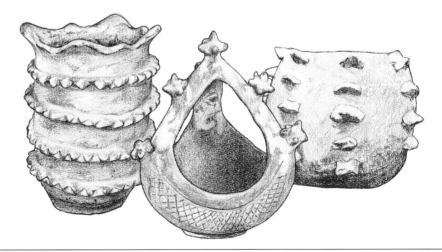

[14] See Barbour and Wandibba, 1989, p. 47. Margaret Trowell reported a very mixed situation in Uganda: 'among some tribes, e.g. the Lango and to a certain extent the Kiga and Hutu, the men of each village will make the pots for their own household. In some tribes the potter is of no importance, whilst among the Ganda the "Royal Potters" who work for the Kabaka have a special title, special privileges'. In some districts where the potters were men there were strong taboos against women approaching the claypits or coming near potters at work (Trowell, 1953, p. 117).

[15] These examples are taken from Barbour and Wandibba, 1989 but see also Barley, 1994, pp. 85–96.

tradition in the southern region of the Democratic Republic of Congo, ceramic vessels are an important form of *Minkisi* which are containers of spiritual powers. They may be made from a variety of materials, may also be figurative and are used in healing and in ceremonies to allay personal or communal disasters.

In Jules-Rosette's study of women potters among the Bemba in Lusaka, Zambia, she noted that, where women potters moved into the towns, their work ceased to have the same ceremonial significance as an expression of female identity. For them the commercial aspect of their work had become more important. (Jules-Rosette, 1977, p. 113).

In some cases beer brewing and potting had become connected in the form of the shebeen queen:

> The shebeen queens generally live alone, and receive several male clients. The outsider might see them as 'prostitutes'. However, they are not viewed in this way by the community and must be distinguished from 'modern' prostitutes or 'call girls'. The shebeen queen organises the weekly parties, and her pottery is sold along with her beer. Her work is valued only in terms of the social context in which it is used.
>
> (Jules-Rosette, 1977, p. 115)

The value of social context is also central to the pottery, wall painting and floor sculpture used in the women's initiation ceremonies of the Mbusa in Zambia. The variously shaped vessels and figures are characterised by a powerful tactile appeal with ridges and bosses designed for maximum visual and emotional impact. Paulina Mubanga and Agnes Buya Yombwe are two Zambian artists who use this tradition in contemporary art works. Encouraged by the Danish potter, Bente Lorenz, who has lived in Zambia for many decades, Mubanga creates highly sculptured vessels in glazed ceramics, inspired by traditional forms and imagery, while Yombwe creates installation pieces combined with performance. Thus we see another way in which African ceramics can be transformed for new situations in the modern world.[16]

South-west Africa

In Angola and Namibia most of the traditional potters are women although there are a few groups where men also make pottery. [17]

During the late 1930s Daisy and Antoinette Powell-Cotton, the daughters of the game hunter, naturalist and collector Major Powell-Cotton, undertook two research trips to Angola to document life and crafts. In hundreds of photographs, on film, and with careful written documentation, they created a valuable archive of material. In the four areas where they found women potters, distinct techniques and systems of working demonstrated how individual villages or kin groups maintained separate traditions over generations.

[16] See Hoover, 2000, pp. 41–53.

[17] This is sometimes attributed to the early introduction of wheel and kiln technology through the Portuguese and later in the German colonial period however the male potters of the Chokwe or Okavango do not employ a technique which suggests any influence of European technology.

At Ochimbundu the potter sat on the ground outside her hut. She coiled the pot in a deep conical basket, first forming a cylinder, then adding the base, smoothing down the walls and finally pushing them out to form the shape using a gourd.

At M'Wila the potter also sat outside her hut working in the sun 'so that the clay may dry quickly' and before she began she made a streak of clay on her forehead. At the end, before splashing the pot with a red liquid made from pounded bark she drank a little and rubbed it on her chest. Apparently arbitrary superstitions, such actions symbolise the linked identity of the potter with her product.

The Wila potter formed her pot in a very unusual way on a stalk of clay resting in a grass ring. Only right at the end of the process was the stalk cut off and the base smoothed over. The notes record that, as she was working, her little daughter sat beside her modelling her own trial pot. The pot was dried for at least three days but, unusually, the decoration was added on the day of the firing by adding strips of clay with cross-hatching to the dampened pot.

At Dombondola and Dombelantu the potters worked in underground caves dug out of the ground and kept covered over when not in use. Working in a dark, cool shady place, the system of building was also quite different. These potters started from a cone of clay which was hollowed out and the walls pulled up or, for a larger pot, from

Angola, Wila potter cutting off the stalk of clay at the base of the pot, 1930s.
Photo Daisy and Antoinette Powell-Cotton. Courtesy Powell-Cotton Museum

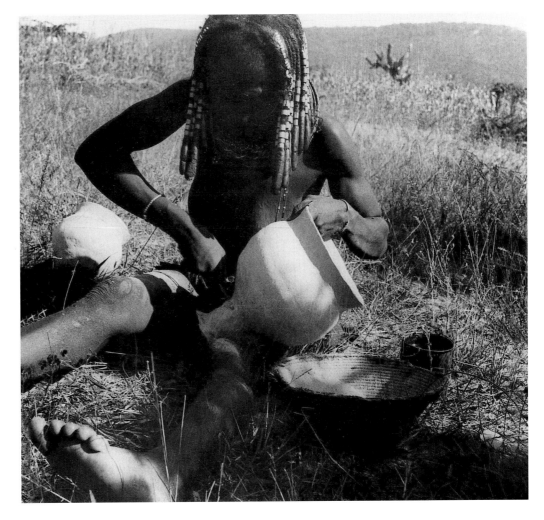

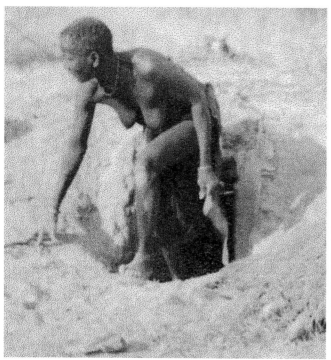
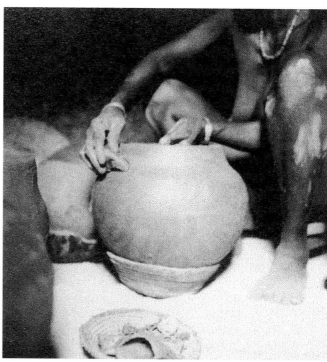

Angola, Dombondola potter emerging form the underground cave where she worked, 1930s
Photo Daisy and Antoinette Powell-Cotton. Courtesy Powell Cotton Museum

a hollow oval built from sections and then upended and shaped. They never used coils. The whole potting cycle was accompanied by specific rites and charms to be spoken at set stages: when the clay was dug, when the potting cave was entered, when the water used to mix the clay required a sprig of a particular plant and was taken into the mouth and spat out. The particular informant was also a medicine woman and had extensive knowledge of plants and leaves and how they might be used for particular maladies. The description of this potter evokes a person who was totally identified with the land, the plants that grow on it and the things she made from it.

All these potters worked seasonally making pottery for their own or local use, for barter or financial exchange. They had specialist skills and knowledge that were passed from mother to daughter and pottery was not a skill that any woman was free to take up.[18]

South Africa

Among most of the peoples of southern Africa, including some nomadic groups, pottery was used and made by women. The Hottentots, for example, made distinctive jars with a pointed base. The Venda are noted for their strong shapes and designs based on simple geometric patterns of contrasting shiny graphite fields against red slip. Studies by Schofield (1948) and Lawton (1967) and recent exhibitions such as *Ubumba* 1998 (Bell and Calder) provide ample documentation of ceramics in this area, suggesting a dynamic rather than static tradition.

[18] I am grateful to Helga Gaboa for drawing my attention to this material and to Malcolm Harman of the Powell-Cotton Museum for allowing me access to it.

As South Africa and KwaZulu-Natal confront the new millennium, the gender change in ceramics is constantly re-enacted. Among the Zulu-speaking people of southern Africa, women are the designated potters. The area is rich in clay so pottery was produced widely, and some areas became noted for their production. Daniel's print (p. 42) from the early 19th century illustrates women making large pots and there is here a sense of clay as the predominant material for three-dimensional forms. In a modern day yard we see metal and plastic alongside clay pots and round houses are now often built in a rectangular form, the better to be able to accommodate commercially-produced furniture. What use is there for low-fired pots in such a transformed society? Young people have no memory of pottery being used for carrying or storing water, or for cooking. The great three-legged iron pot is used in households where there are many mouths to feed at one meal-time and plastic is much lighter to bring back the water from the river. Where running water and electricity have been introduced, refrigeration and new stoves make the old kind of pottery even less likely to be used. But pottery is still in use. It has been retained in association with beer drinking, itself now largely linked with special family occasions and ceremonies. The typical beer drinking pot is a swelling rounded form with a circular opening. It is decorated with engraved designs or with the *amasumpa*, the distinctive wart-like decorations often applied in bands or 'V'-shaped motifs on the sides. Such forms make the pot easier to hold when it is passed round in ceremonial drinking. The other common form is the beer transporting pot which has a high collar to minimise spillage.

Beer pots on sale at Nongoma Market, KwZulu-Natal, 2000.
Photo A. Vincentelli

Pottery on sale at
Umgababa motorway
market near Durban,
KwaZulu-Natal. The
pottery is not given the
smoked and burnished
black finish as the 'out-
sider' market prefers
terracotta-coloured pots
and it requires less work
from the potters, 2000.
Photo A. Vincentelli

These pots are always burnished and smoked after firing to turn them a rich and,
sometimes, highly polished black. Black is seen as a metaphor for coolness and, by
association, for the ancestor spirits who live in cool, dark places.[19]

These two vessel types, in particular the drinking pot, now appear to be the main
traditional forms produced. They can also be found for sale in the tourist market
alongside new ceramic forms catering for 'outsider' tastes. At the monthly rural mar-
ket of Nongoma, far from major population centres, the traditional black pottery is
sold to the local people alongside the huge array of sleeping mats, roots, vegetables,
bark, dyes, secondhand clothes and skins. By contrast, the market at Umgababa is close
to Durban and has been recently re-sited on either side of a motorway, at a filling sta-
tion and café. It sells indigenous crafts directed towards the urban and tourist market:
crochet waistcoats and tablecloths, carved and painted toys, beadwork, baskets and
pottery – large urns, model birds in a range of sizes, and many different vases, mainly
in non-traditional forms, sold as patio and garden ornaments. Furthermore, in this
market, the smoked black finish is rarely found. No time or care has been lavished on
their finishing, the pots are unburnished, terracotta coloured or with a brown polished
stain, but without the initial smoking the colour has no depth. For the tourist there is
no premium on the black finish, it carries no special significance, indeed there is even
the feeling that the black may come off on the hands. Although organised by a hus-
band and wife team, the sellers at this market are primarily women, selling a range of

[19] For a further discussion see *Ubumba*: Bell and Calder (eds), 1998.

goods, although they may also undertake some craft activity themselves, such as bas-ketry or crochet. The pottery is largely brought from the Mtunzini area some 95 miles (150 km) further north near Eshowe. However, when asked, the market sellers were inclined to give the impression that the goods were made locally, presumably to lend the work an additional quality of 'authenticity' and direct purchase. Clay models of 'African' houses worked on the market site seemed to be the exception. This pottery was sold at relatively modest prices and was produced by women drawing on their tra-ditional skills using handbuilding construction techniques.

Endlovini Mission

Making teapots for a special gallery exhibi-tion at Endlovini Mission, KwaZulu-Natal, 2000.

Photo A. Vincentelli

In the area around Eshowe there is an abundance of clay and many women still make pots, of which the round-bellied beer pot is now the main functional form. Mary Ann Orr's project at Endlovini Mission near Mtunzini draws on these traditional skills and supports craft training and production including pottery, textile printing and wood-turning. The most financially viable aspect of the project is pottery and a number of women have proved adept at adjusting their techniques to produce new forms and designs, including lively teapots and handsome black-fired lamp bases commissioned for a hotel. The workers give some of their time each week to community welfare to

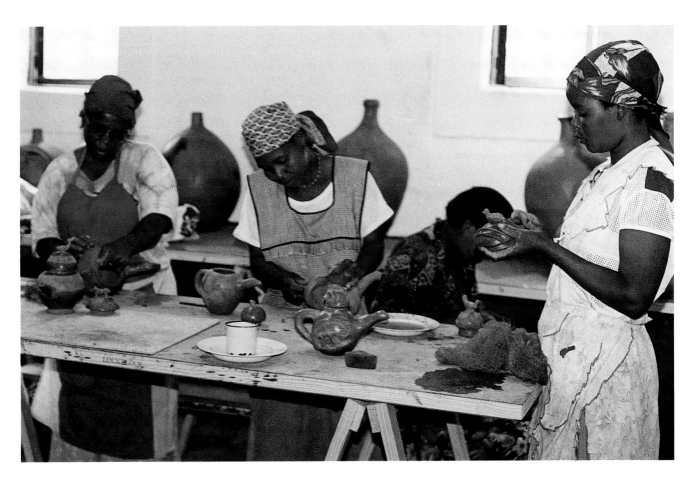

help the sick in an area where AIDS and tuberculosis are rife. The potters also work from home but they are offered improved marketing and advice on design and finish. They are able to obtain more realistic prices for their labour by selling through craft shops and gallery outlets rather than the market.

Rorke's Drift Mission and Arts Centre

The combination of Christian mission and arts and crafts marketing has one of its most notable examples in Rorke's Drift. The mission station, established in 1870, became famous as the site of an heroic action after the defeat of the British army at Isandhlwana during the Boer War. The name also became known in the 20th century for its arts and crafts training centre set up to encourage self-support for people living in isolated rural settings. Established in 1961 with funds from the Swedish Mission, the craft centre and, eventually, the fine art school, produced some of the best known black South African artists in a period when opportunities for black artists were severely limited against the backdrop of Apartheid. Rorke's Drift benefited from skilful Swedish artist/trainers who were able to draw out the talents of their trainees without swamping them with European cultural values. The ceramic workshop was established in 1966 and introduced wheels and kiln-firing, eventually to stoneware temperatures. The heavy kick-wheels were only used by the men while women retained their traditional techniques of handbuilding. The leading women potters in the 1970s and 1980s were of Sotho origins: Dinah Molefe, her daughter Loviniah and their relatives, Ivy and Lephina. Drawing on their native traditions of beer pots and vessels with animal decorations, they developed sculptural vessels incorporating bird and animal imagery in a modern style with matt stoneware glaze. Over two decades the work sold successfully in South Africa and in international exhibitions. However, the muted colours of the stoneware finish now seem quite dated. Since the 1990s the art school has closed, the Swedish funding has been withdrawn, and Rorke's Drift is currently undergoing a re-assessment of its activities (see p.197).

Ardmore Pottery

In a very different way Ardmore Pottery, established by Fée Halsted-Berning in 1985, has created a new kind of pottery that epitomises the hybrid culture of contemporary South Africa. The original seed was sown when Fée Halsted-Berning, who trained in art, and later ceramics, at Pietermaritzburg, began to work with Bonnie Ntshalintshali, the daughter of one of her farm/house workers. Her fertile imagination and sculptural talents quickly revealed themselves and the collaboration resulted in recognition through the Standard Bank Young Artist Award in 1990. Since that time, Ardmore has expanded enormously, with workers at two different workshops, one at the original site and the second at the farm where Halsted-Berning now lives. The project was always conceived as a way of bringing work to women whose menfolk often left for

Above *Young woman decorating a sculptured plate that will fire into strong bright colours. KwaZulu-Natal, 2000.*
Photo A. Vincentelli

Above right *Women decorating pottery in the open air at Ardmore Ceramic Art Studio, KwaZulu-Natal, 2000.*
Photo A. Vincentelli

For an illustration of Bonnie Ntshalinshalis' work see p. 185.

jobs in the cities or mining centres; however a number of young men now also work in the enterprise. Pieces are modelled by one artist and decorated by a second so they are a collaborative product where both artists have relative independence. The maker and decorator are paid equal rates and payment is made when the two stages of the work are complete. The artists rarely have any formal training but learn by example in the workshop. Visual material is made available in the form of old encyclopaedias, illustrated bibles and nature books. The bizarre forms, bright colours and riotous decoration at first seem quite idiosyncratic, but the pieces also display a fine control. Their fresh imaginative quality springs from an artistic confidence that has not been undermined by the conventions of art education.

Nesta Nala and her Family

By far the most lucrative way forward in the pottery business is to direct the work towards the more sophisticated collectors' market. For over 25 years, Nesta Nala has marketed her work through craft outlets such as the Vukani Association, Eshowe and the African Craft Centre in Durban. She lives far away from major towns and presides over an extensive, largely female household, where her mother and four daughters and their children live. They produce a range of fine-walled, delicately decorated black pottery. The Nala family have beautifully refined the traditional beer pot and Nesta Nala has justly gained an international reputation. Her daughter, Jabu has taken the next step. She has moved to Johannesberg, although she still makes the six-hour journey every month to gather her clay from home. Jabu Nala now makes very large pieces, larger than any of the traditional functional pottery. They are gallery art, handsome vessels for the national and international art market. There will surely be opportunities for many more fine potters to emerge in the 21st century (see p. 189).

Nesta Nala firing an individual pot with dried aloe leaves, KwaZulu-Natal, 2000.
Photo A. Vincentelli

Nesta Nala with her pots, KwaZulu-Natal.
Photo A. Vincentelli

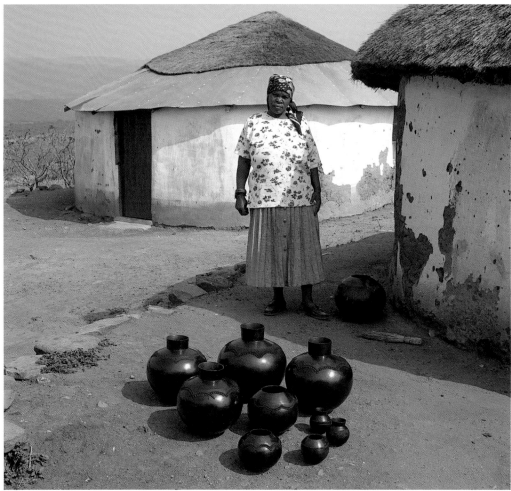

4 generations of the Nala family with Siphiwe and her daughter, Nesta in the middle.
Photo A. Vincentelli

Nesta Nala's daughters work alongside, the older ones producing their own designs while the younger ones help with the burnishing and waxing of the black pottery.
Photo A. Vincentelli

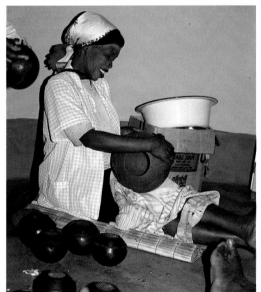

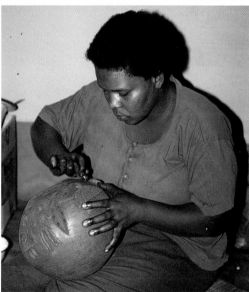

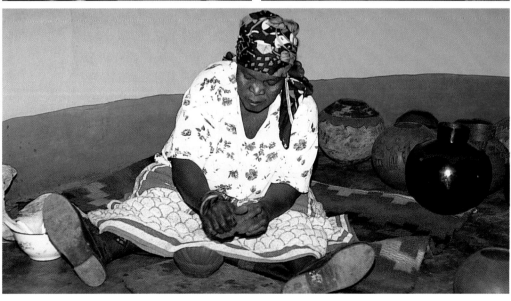

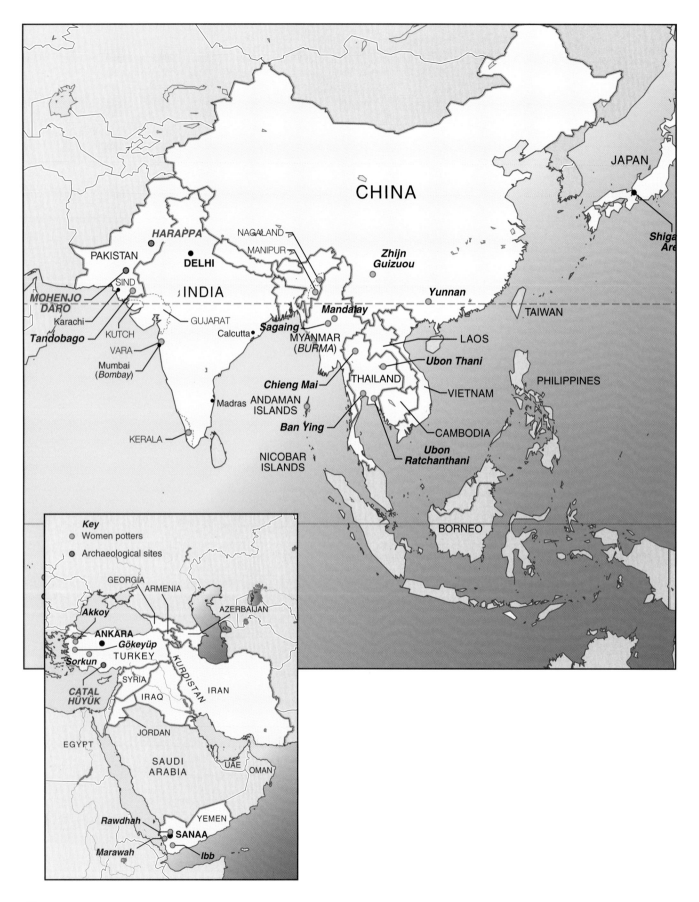

CHINA

JAPAN

*Shiga
Area*

HARAPPA

NAGALAND

MANIPUR

PAKISTAN

*Zhijn
Guizuou*

DELHI

*MOHENJO
DARO*

SIND

INDIA

Yunnan

Karachi

Tandobago

KUTCH

GUJARAT

Mandalay

TAIWAN

Calcutta

Sagaing

VARA

MYANMAR
(*BURMA*)

LAOS

Mumbai
(*Bombay*)

Ubon Thani

Chieng Mai

THAILAND

PHILIPPINES

Madras

VIETNAM

ANDAMAN
ISLANDS

KERALA

Ban Ying

CAMBODIA

NICOBAR
ISLANDS

*Ubon
Ratchanthani*

BORNEO

Key
● Women potters
● Archaeological sites

GEORGIA

ARMENIA

Akkoy

AZERBAIJAN

ANKARA
Gökeyüp

TURKEY

Sorkun

KURDISTAN

SYRIA

IRAN

*CATAL
HÜYÜK*

IRAQ

JORDAN

EGYPT

SAUDI
ARABIA

UAE

OMAN

YEMEN

Rawdhah

SANAA

Marawah

Ibb

WOMEN POTTERS AND GENDER ROLES IN ASIA

Early ceramics

ASIA HAS produced many of the great ceramic traditions of the world and, furthermore, the earliest known pottery: Jomon pottery of Japan has a radiocarbon date of 10,700BC. The principle of firing clay to make it stable and water-resistant was almost certainly discovered in different places at different moments, and although pottery is generally seen as a functional technology, clay figurines often predate vessels by many centuries. Early pottery has been found in various sites in western Asia and the eastern Mediterranean, all dating to around 6000BC. This suggests that the technology was of its time and may have developed in various places rather than spreading out from one centre. Most of these places represent settled agricultural communities as opposed to hunter-gatherer societies. There is no evidence that any of this pottery was fired in kilns. In Anatolia the earliest evidence of baked clay dates to around 6300BC at the major site of Çatal Hüyük where figurines, vessels and clay wall reliefs are remarkable for their strong female associations and their position in a domestic rather than a burial context.

Early literary references from the Near East give hints of female connotations: an association of pottery imagery with birth, of the kiln as metaphor for the womb, and of figures made of clay being placed in the kiln/womb. One of the deities of the city of Kesh was the goddess Dingirmah, sometimes called Nin-bahar or lady potter. She was responsible for pregnancy, childbirth, potters and kilns (Foster, 1991, p. 393). Ishtar, the Babylonian goddess of love and fertility, was said to fashion men out of clay and was sometimes called 'the Potter' (Briffault, 1927, vol3, p. 88).

In Mesopotamia both men and women participated in the crafts and the word for potter has no gender. However, in texts dating from 2066–2010BC pottery is listed among male crafts although women may well have been part of family workshops. Women were also included among temple workers undertaking pottery, weaving, spinning, hairdressing and brewing and other activities, including an elevated position such as priestess or scribe (Seibert, 1974, p. 17; Wright, 1991, p. 202). Biblical references to potters usually suggest the potter as a man who works on a wheel. Since written records were normally made in the large centres of population around courts and administrative capitals where specialist workshops have always tended to develop, it is possible that they reflect limited knowledge of provincial or rural practices.

OPPOSITE PAGE
*Asia: countries and places
mentioned in the text*

In the Islamic world the tradition of unglazed pottery has been overlaid for many centuries by the spread of colourful decorated glazed tiles which first appeared in ninth century AD Baghdad as a development of decorative brick work. The beautiful tiled and faience mosaic interiors that characterise so much of Muslim architecture can be seen from the Taj Mahal in India to the Alhambra in Spain. They represent a highly specialised, professional male ceramic tradition allied to building crafts. With the spread of Islam, gender divisions were accentuated and women were expected to remain within the family home and away from any public work place. In more rural areas women have often enjoyed greater freedom to work within the family business.

Turkey

A distinct gender pattern can be seen in modern day Turkey. Henry Glassie's study of folk crafts considers mainly the kind of highly decorated glazed ceramics which stem from the Islamic tradition. The workshops are run by men although women members of the family may also be employed. By contrast, the study by Güngor Güner undertaken in the 1970s focused on traditional functional pottery. She found that women using handbuilding were the potters in many rural pottery-producing communities, a pattern that had not hitherto been recognised.

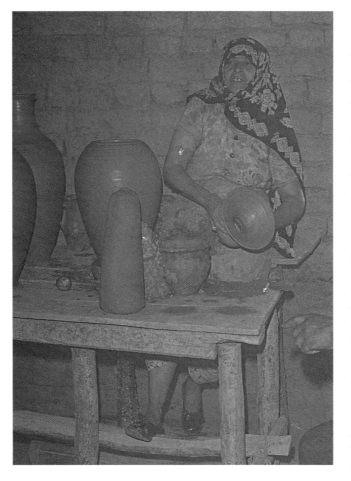

A rare example of a traditional woman potter throwing on the wheel, Akkoy in Western Turkey, 1970s.
Photo Güngor Güner

In some centres there are male potters using wheel and kiln technology but, exceptionally at Akkoy, in Western Turkey south of Canaakale, women throw large vases on a wooden wheel. Much more typical are the numerous images of women handbuilding by coiling on a low turntable, sometimes turning the turntable with the foot. Many centres still fire pottery in open bonfires while others, especially those producing the wheel-thrown wares, employ various versions of single-chamber kiln. None of this pottery has any aspiration to be collectable or artistic but it remains an important source of income and is essential to the lifestyle of the people who purchase it.

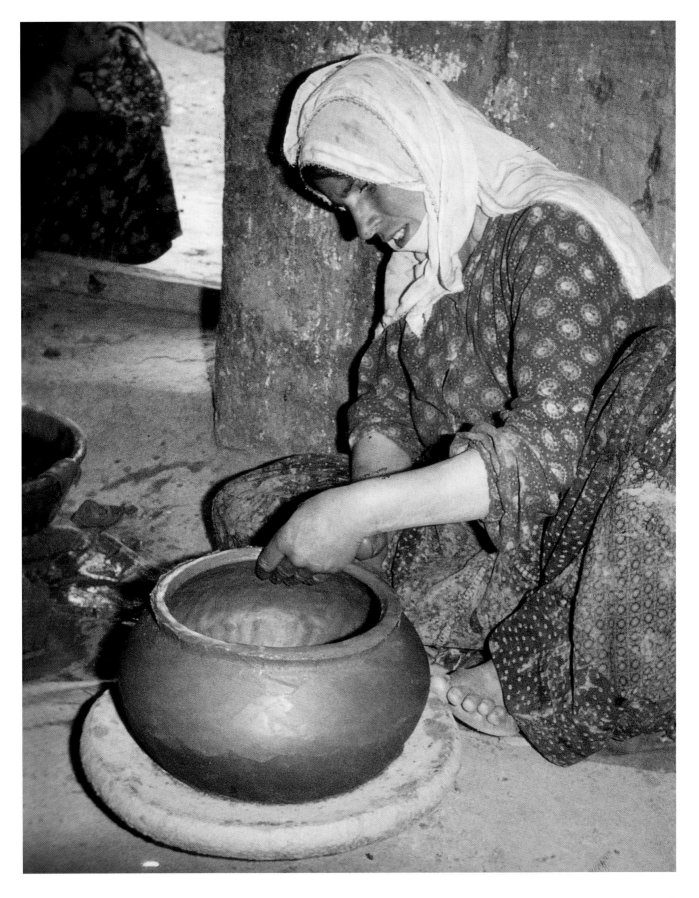

Sorkun cooking pots on sale in Istanbul market, 2002.
Photo M. Vincentelli

Potter at work in Sorkun surrounded by cooking pots drying on individual bats, 1970s.
Photo Güngor Güner

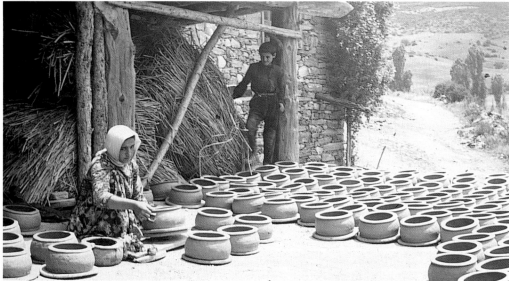

A characteristic pattern is that of Sorkun, Eskisehir in north-west Anatolia, where the village industry is based on household production and most women make pottery alongside domestic duties and agricultural work. The platters and cooking pots are coiled on fired clay bats and allowed to dry out in front of the house, or sometimes on rooftops or balconies. The men of the village work the land but help with the collection of wood and the firing which is done in large bonfires on the hillside. Typically Sorkun cooking pots have a black interior achieved by firing upside down with some sawdust or combustible material inside. Some are also blackened on the outside by smothering the pots with the same materials after they are lifted out of the fire. They are widely marketed in Western Turkey and are still valued for their excellent cooking properties.

The Kurdish peoples still maintained a female pottery tradition in the 20th century. At Bedyal in Iraq (Macfadyen, 1936) and in southern Turkey at the village of Dara (Donmez and Brice, 1953), women made large handbuilt water pots and jars fired in a bonfire.

Yemen

In the Yemen women are active in pottery production but only in a few places is it an exclusively female activity. Several techniques are used: coiling, paddle-and-anvil and wheel-throwing. Firing is either pit-firing or, more usually, using simple open updraught kilns. The limited transport network has meant that pottery is still produced in many places, usually with a potting family supplying the needs of the local area. In the more urban centres there are workshops with male potters where women do not work, as they would be exposed to public gaze. In rural areas however, women frequently work within a family enterprise with men and women undertaking distinct activities; for example at Marrawah men use paddle and anvil techniques while women burnish and decorate the pots. In many other places they make the pots. The

Potter from Mansuriyah, Yemen burnishing a vessel.
Photo Shelagh Weir 1973–4

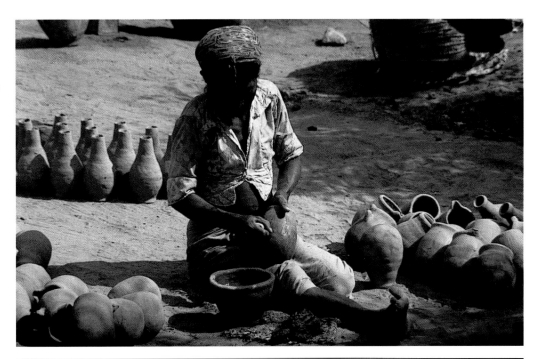

Traditional potters are always on the lookout for new colouring materials. Incense burners from the Yemen decorated with the addition of Quink ink colours.
© British Museum

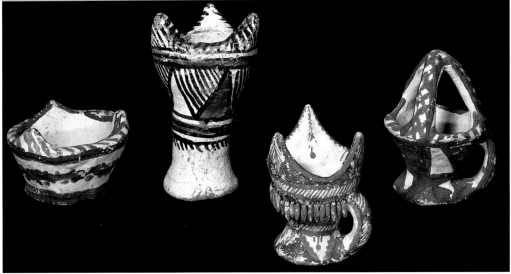

villages of Sarab and Qahzet (near Ibb), visited by Shelagh Weir in the 1970s, appeared to be different, not because of the type of ware or the techniques used, but because of the social relations of the potters. In these inland villages all the potters were women and in the latter, at least, all the women knew how to make pottery. Women used a combination of coiling and paddle-and-anvil techniques to form the wares and fired in rectangular open-topped kilns. These examples could be said to represent a women's tradition as women were the designated potters (Weir, 1975, pp. 66–76).

New markets have developed in response to the influx of tourists. Incense burners are a popular craft item and in one of Sanaa's smart hotels, converted from a traditional multi-storey house, these have been used as lamp bases throughout to maintain the 'authentic' décor.

Pakistan

Although pottery in Pakistan presents itself as a predominantly male tradition, underlying aspects suggest long-standing female potting activity that may date back to much earlier periods. Characteristic of the Arab world, the pit-wheel/foot wheel predominates in Pakistan and is similar to designs found in Palestine, Iran, the Yemen and Egypt, whereas in India the single wheel is almost universal (Evans and Rye, 1971, pp. 116–7; see also Saraswati, 1978, pp. 103). This suggests that they stem from two alternative cultural patterns corresponding broadly to the difference between Muslim and Hindu traditions. Women never use the wheel but are frequently part of the workforce in family businesses.[1]

Two different examples of Pakistani family workshop practice were on show at a 1997 London exhibition where craftwork was also demonstrated. A male artisan from Tandobago threw bowls and plates while his wife, assisted by children, modelled horses and carts and other toys and decorated the wares in the characteristic black and red

Tandobago, Pakistan: the plate is wheel-thrown and made by a male potter while the decoration and modelled forms are the work of his wife assisted by their children.
Horse and carriage 18 cm. (7 in.) wide.
Photo A. Vincentelli

[1] In their major study of pottery in Pakistan, Evans and Rye admit that women's role was difficult to estimate as the researchers could have no contact with the women.

designs. These elaborate patterns of concentric circles, chequers and zig-zags are remarkably close to the geometric designs of ancient Iran or Mohenjo-Daro. A male potter from Hal in Sind Province, where the pottery is celebrated for its bright blue floral glazed decoration, was responsible for wheel-throwing and decoration. This was seen as the distinguishing feature of his work. His wife, however, made handbuilt pottery which was subsequently decorated by her husband. In both cases the women's role tended to be downplayed even though, in the first example, the woman was both modeller and decorator.

India

In most parts of India pottery production is controlled by men although generally they work within a family enterprise where women play an important role. Many pots represent some form of joint production. Pottery is widely used for both domestic and ceremonial purposes. Demand is high and earthenware food containers, being considered easily contaminated, are, in some cases, only used once. The huge significance assigned to the wheel and its mystical position within Hindu religious practices and mythology gives a special status to the male activity within pottery production. In most of India there is a strict taboo against women throwing pots, and in much of northern India this carries over into the further stage of finishing by beating out with paddle and anvil (Saraswati, 1978, p. 29). In other places men throw and women beat out the form; in Kerala, in south-west India, women turn the wheel for the male potters. Women are involved in many of the other procedures: collecting clay, preparing clay, handbuilding including modelling terracottas, coiling and building up in strips especially for making tandoor ovens. Above all they are employed in decorating the

Kutch in North West India: Khetanbai decorating a wall in her sister-in-law's house. The clay and dung mixture is eventually whitewashed and studded with mirrors.
Photo Jane Perryman

Bimla Devi of Himachal Pradesh decorating her husband's pots.
Photo Jane Perryman

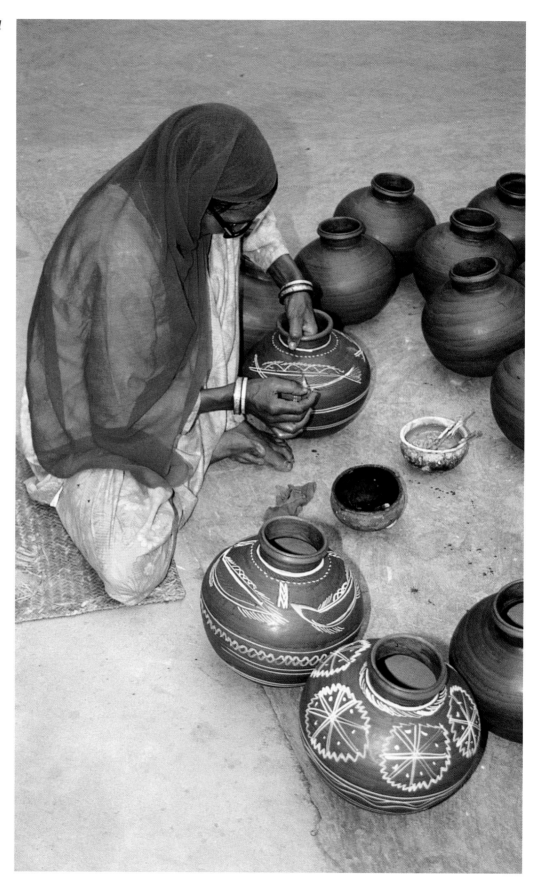

pottery. The relative value assigned to these activities reflects gender hierarchy and reinforces gender difference.[2] The taboo on women making pottery themselves maintains the craft skill in the male line. Women often learn to decorate from their mother-in-law, but even if they learn as children they may only be able to practise if they marry into a potter's family. Although decoration is an important aspect of the meaning and impact of the work, when women decorate men's pots within a family enterprise the activity is not highly valued. This can be contrasted with ritual painting or clay wall decoration which is often a devotional activity and the work more likely to be endowed with personal meaning.

In Himachal Pradesh in northern India clear divisions of labour are upheld. Women decorate pottery. Bimla Devi and her husband, Rhiju Ram work together as part of an extended family of potters in the Kangra Valley. Bimla decorates Rhiju's wheel-thrown and paddled pottery, making each pot slightly different, using white and black slips with abstract or stylised bird and leaf motifs. Pottery does not have a high status but they have achieved recognition and have travelled to various cities and fairs to demonstrate their work. This kind of decoration is strongly reminiscent of the ancient decorative pottery of the Indus Valley[3] and has close affinities with the pottery of Sind in Pakistan and Kutch, the small state between Gujarat in India and Pakistan.

Thus, in many parts of India women are the main decorators of pottery – a phenomenon that might even be categorised as a woman's tradition, although the control of production remains in male hands.

There are, however, some communities where women are the potters. At the town of Vara in Western India, 55 miles (88 km) north of Mumbai (Bombay), there are still ten families who produce pottery. Women work seasonally and make a range of large cooking pots and other domestic wares including unfired clay stoves. The pots are handbuilt using a simple turntable system of a fired clay bat over an inverted iron saucer. In the early stages the potter sits, turning the bat with her foot to keep both hands free for pulling up the walls and building up the shape. The potter completes the form by walking round the vessel, beating the walls out with a wooden paddle and stone anvil. The pots are fired in a rectangular brick-lined pit and the firing is a male task. The men are now mainly employed in agriculture, industry or other trades, as the economic status of pottery has declined. While they have found better-paid occupations, the women have remained making pottery.[4]

In some communities women are also heavily involved in the production of votive offerings. Jane Perryman studied a family of four sisters-in-law who ran a pottery business and employed a man to undertake the thrown work. Although themselves Hindu, their models and *dhabu* or spirit pots were required by tribal peoples who have their own gods and beliefs. In part exchange these people supplied the potters with materials including the buffalo dung for firing.

In Manipur in the far north-east of India, close to Myanmar (previously Burma),

[2] A government report on India states that 'what is important is that tasks assigned to men are considered more prestigious in most communities and regions' (ICSSR, 1975, p. 29 quoted in Miller, 1985, p. 110).

[3] See Mohenjo Daro and the Harappan civilisation.

[4] See Perryman, 2000, pp. 43–51.

Savita, one of four sisters-in-law from Mandvi in Gujurat who work together making terracotta votive models of horses, elephants and other forms.
Photo Jane Perryman

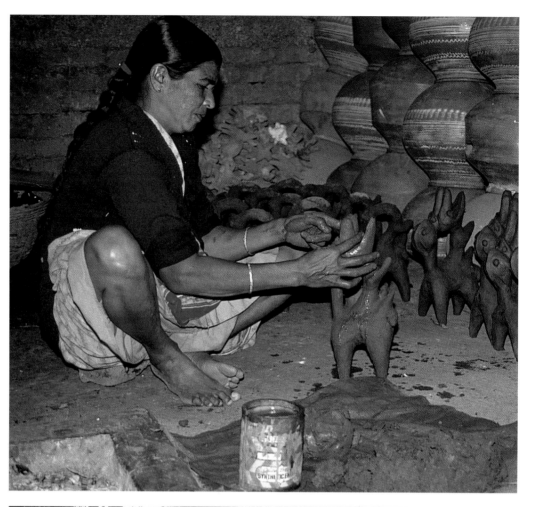

Woman potter of Manipur using a paddle to give a decorative finish to her work, 1937–9
Photo Ursula Betts, Pitt Rivers Museum, University of Oxford 1998.309.922

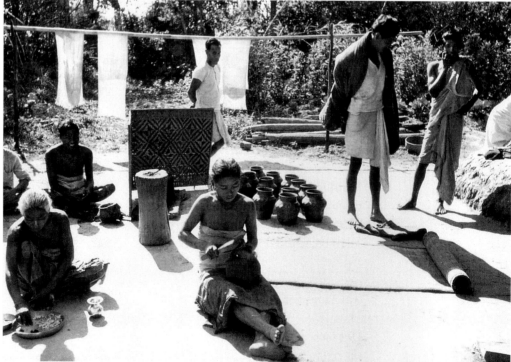

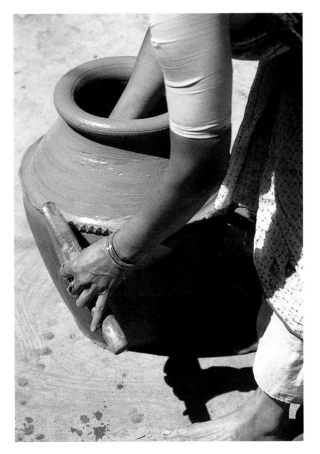

Shoba of Vara in Western India walks round a large jar using a wooden paddle and stone anvil to build up the form.

Photo Jane Perryman

there is a much more distinct women's tradition. Here all the women are potters, not just certain families. The pots are handbuilt using coiling and paddle-and-anvil methods. Just to the north, among the Naga, women are also the main potters and there is a particular taboo against men making cooking pots although they do make clay pipe-bowls. Such an arrangement demonstrates the tendency for men and women to make specific types of objects that themselves have gendered associations. In southern India a women's tradition was recorded in the mid 20th century whereby women of the tribal hill group of Urali Kurumbars in Kerala made cooking pots by beating out the form on a wooden board using a heavy wooden paddle (Aiyappan, 1947).

Thus the picture in India is one of predominantly male-dominated wheel-made pottery with women very active in other aspects of production, especially decoration. The female role is much more in evidence than is the case in Muslim countries to the north and west. As in many other parts of the world there are still places that appear to have either preserved, or developed, an exclusively female practice. The area in the far north east in Manipur and among the Naga peoples has a more defined women's tradition, consistent with much pottery production in Myanmar (previously Burma) and Thailand.

South-east Asia

There is strong evidence that women were the primary potters for many centuries in much of south-east Asia, despite the extensive influence of Chinese ceramic traditions. Chinese pottery and porcelain was imported in large quantities but the potters themselves also migrated and settled, bringing with them their knowledge, skills and working practices. During the 18th century the European market for Chinese export pottery declined and new outlets had to be developed. Blue and white glazed pottery was exported to Myanmar (Burma), Thailand, Malaysia, Singapore, Indonesia and the Philippines and was sufficiently cheap to be used by most classes of people (Rooney, 1987, p. 39). The indigenous tradition in most of south-east Asia is based on the paddle-and-anvil method of forming, with a burnished finish, and this has survived to the

present day in many places. In their extensive studies of south-east Asian potters Lefferts and Cort (forthcoming) have identified six distinctive methods of forming earthenware jars, most but not all, finish the process using a paddle-and-anvil method and some create the initial form by throwing. The pot-making techniques they note do not correspond directly to ethnic or linguistic groups. Pots for cooking and water storage made in the older tradition were never bettered by the new wares and technologies. This pottery is produced either on a seasonal basis by women in agricultural communities, or sometimes in specialist villages where women are still the main potters, although the men do much of the ancillary work such as collecting clay and marketing the wares (Rooney, 1987, pp. 50–1). Wheel-made pottery is produced in larger workshops, mainly in urban centres and, in this case, men are the potters, although in some places women also use the fast wheel. There never seems to have been the same taboo relating to women and the wheel as in India.

Myanmar (Burma) and Thailand

In Myanmar there are many pottery centres producing handbuilt, thrown, glazed and unglazed wares. In certain centres as at Sagaing, south of Mandalay, women are the designated potters, using a paddle system to beat out the form.

There is a strong tradition of women as potters in Thailand. At Ban Kam Ow, Udon Thani, province women work on a part-time and seasonal basis, using the oldest technique of paddle-and-anvil building, and open firing. Given the nature of pottery production it is difficult for one person to work entirely alone without the help of family members and most women rely on the assistance of husbands and family members for transporting clay, loading kilns or marketing. In some places women run pottery businesses and employ others in the work and some have become pottery traders. In Ban Ying, Nakorn Srithamaraj, in Southern Thailand in the early 1980s Mrs Moan was the largest pottery producer of the five left in a village where previously all the women had been potters. She had three kilns, two top-loading but a third was of a new design and loaded from the back. The workshop produced 150–200 pots a day and the work was sold to traders who visited regularly and distributed it in the province. Large unglazed jars made on a turntable were finished off by beating out into a rounded shape (Ho Chui-Mei, 1984).

The technique used for the round-bottomed jars of Ban Tha Hong Lek, Ubon Ratchanthani province, is a distinctive version of the paddle-and-anvil method and is very similar to methods used as far afield as Borneo. The clay, tempered with burnt husks, is rolled into a sausage, turned upright and perforated with a rod and then rolled, like a rolling pin, to widen the opening. The form is then stood on its end on a trunk of wood about waist height and the potter walks around, pulling out the walls using a curved paddle on the inside and a plain paddle on the outside. The rim is shaped at this stage and given a design individual to the potter. The pot is left overnight to dry. The following day the potter gives the piece its final form whilst sitting on the ground. With the pot balanced on her legs she closes the base and beats out the form to its elegant rounded shape, using a paddle and anvil. The pots are kiln fired

using wood and charcoal. Potters at Ban Kam Ow maintain the same building system but use an open-fire which lasts for about one hour.

Many of the larger potteries are based on wheel technology with male potters working in workshops. The men have often learnt their skills in a training school.

In Cambodia, where ceramics can be dated back to the 5th millennium BC, the Khmer empire flourished from the 9th to the early 15 century AD and sustained two ceramic traditions: one was based on wheel-made, kiln-fired and glazed ware employing a Chinese technology although the forms are characteristically Khmer; the other based on a paddle and anvil tradition. The wheel-made tradition disappeared after the fall of Angkor in the early 15th century but the paddle-and-anvil method survives to the present day as a female tradition. Women potters work on a seasonal basis, while their husbands are usually farmers growing rice as a cash crop. They produce functional pottery for cooking and water storage – for which there is still a good market. By contrast, for tableware most people use mass produced china sold by Chinese shopkeepers at an affordable price.

The women collect the clay nearby, sometimes assisted by their menfolk, construct vessels using the paddle and anvil method, and beat out the well-tempered clay to a thin but strong body. The paddles are made of bamboo or wood and are often decorated. The anvil is usually of clay, but wood or stone can be used. The firing, also sometimes carried out by men, is either in an open bonfire or a simple open kiln using wood. Like many women potters world wide, they make pottery alongside their other activities. In one study from the 1980s it was shown that households might produce up to *25* items per day during the season so women were able to make a useful independent income (Mourer in Picton 1984 p. 38).

Japan, Korea and China

Scholars of Jomon pottery, which can be dated back to the 10th century BC have suggested that the work may have been made by women, but the knowledge of wheel and kiln technology and greater mass production indicate a very long tradition of male potters in the Far East. In this area of the world ceramics have enjoyed a social status and recognition as an art form over many centuries. The development of kiln technology, the use of kaolin clay to make fine white porcelain and the knowledge of glaze were all highly specialised techniques that required full-time professional practitioners based in workshops. All these factors mitigate against women being involved in ceramic production other than perhaps in secondary roles. Furthermore, the effectiveness of the marketing and trading of ceramics counteracts the need to produce at a local level. However, it seems likely that in some places women worked in small-scale local production and they would certainly have worked within family businesses. For example, at Shigaraki, one of the great pottery centres of Japan, it was the women's task to break up the clay and knead it ready for use. Husbands and wives frequently worked together throwing on the wheel; the woman acting as the *hideshi* or puller controlling the speed for the different stages of the vessel formation (Cort, 1979, pp. 334–340).[5]

[5] This was a role women also took in industrial production in Britain.

Chinese potters developed ceramic technology at a very early period. Medley (1976, p. 20) states that during the Neolithic period pots were already being fired in simple kilns but that, even after the wheel was widely used, handbuilt pottery continued to be produced during the Bronze Age. The implications are that it did not survive beyond that period. It is quite likely that cooking pots and water pots have hardly been recorded in the face of the highly sophisticated developments of Chinese ceramics which were being exported very great distances to the Middle East, Europe and the rest of southern Asia from the 14th century AD.

Some handmade pottery is still produced in China. There are pottery producing villages in Yunnan province where handbuilding and open firing continues to be used. Among the Dai people potters are women whereas, among the Wa, pottery is a male activity.[6] Black cooking pots are made by women in Zhijn, Guizhou province in southwest China, where the tradition is said to be one thousand years old. The vessels are made over a mould on a turntable. Like so many women's traditions they are fired without kilns. The pieces are placed in clay saggars in an open coal fire and then removed after a short period of about five minutes and smothered in sawdust and rice husks in a reducing atmosphere to turn them black and give them a metallic sheen.[7]

In the East, as in Europe, women have been widely used as decorators in factory production. The employment of women as decorators may go back for many centuries. An inscription on a Vietnamese decorated vase reads 'Painted for pleasure by Chuang a worker of Nan T'se-chou in the eighth year of Ta Ho' [i.e. AD1450]. Roxanna Brown noted that the name character used here in Vietnamese could only be applied to a woman (Brown, 1977, p. 19).

[6] Cheng Zhuhai et al, 1982.

[7] Reported by Gail Rossi in Ceramics Monthly, December 1987, pp. 42–46.

Islands of South-East Asia (see map p. 88)

Throughout the islands of South-East Asia and the Pacific, all the evidence suggests that women have been the main potters, employing various systems of the paddle-and-anvil technique.

The knowledge of pottery probably spread from the mainland: pottery from Chieng Mei in Northern Thailand can be dated back to 6500BC, Sulawesi to 3000BC, the

One of the reliefs on the ancient stupa of Borobudur on the island of Java in Indonesia, built before AD800. The relief shows one of the incarnations of Buddha and reflects the activities of the period. The potters, usually assumed to be women, use a paddle still the main traditional pottery technique.
Photo Jean McKinnon

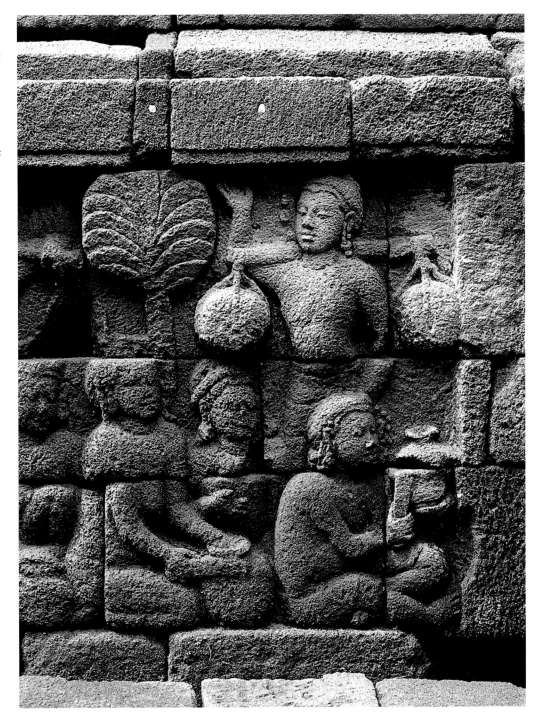

Philippines to 2500BC, and Timor in the south to 2500BC (Ellen and Glover, 1974, p. 371). It is difficult to piece together a clear picture of pottery in South-East Asia and the South Pacific because the evidence is piecemeal and of varying quality. 19th and early 20th century studies are often quite brief or imprecise but indicate the situation before the impact of the global markets of the modern world. Since the mid-20th century, there are a number of more in depth studies such as that of Ellen and Glover in the Molluccas or that led by Sander van der Leeuw in Negros in the Philippines (Van der Leeuw, 1984). Jean McKinnon's book on Lombok pottery is also well informed and beautifully illustrated, documenting an island industry about which there was almost no information in English. All of these texts discuss gender roles at certain points. Solheim and Ellen and Glover are adamant that women are the potters in this area of the world, while more recent studies indicate more male involvement. This almost certainly reflects more recent developments as in Lombok. In many places, pottery is no longer made, as mass-produced cooking pots become available or water pipes are installed. Hence the brief reports and observations of early travellers and observers become an important source of information on issues of gender. These suggest that, with few exceptions, women are traditionally the potters but men have taken up the occupation when the circumstances are appropriate, usually for economic reasons.

Men are found to be the designated potters using low-technology systems of production in a few places such as the southern Andaman Islands, in some places in the Philippines and in Botel Tobago, an island to the south of Taiwan. Here potting is a seasonal activity carried out only by men in the ninth month of the lunar year and there are many taboos to be observed during the process. They make pottery for domestic purposes and for burial urns. Vessels are made using basic moulds, adding patches of clay and then beating out the form with a paddle and anvil. Finally they are bonfired (Kroun in Picton, 1984, p. 286).[8] Hence socially, this male production exhibits many of the characteristics of female systems of ceramic production. It would be difficult to speculate as to why this is without much more detailed information about the history of these people. It is comparable to the way men are sometimes the main potters in some inland villages in Papua New Guinea.

The island of Java in Indonesia maintains a complex mix of ceramic production systems. The older tradition is a predominantly female one based on coiling, slow wheel and paddle-and-anvil technique, although men were working with women at least as early as 1919. Wheel and kiln firing is also widespread – introduced by Europeans, Chinese and Japanese – and in these cases pottery is a male activity.

As you would expect, over the last two centuries the increasing availability of manufactured goods has meant that small-scale potters have diminished and pottery is more likely to be produced in specialist communities often situated in coastal areas. There is evidence that extensive trading between islands was carried out throughout the island communities of South East Asia and Melanesia and that pottery was traded for food or other goods, or carried by traders for their own use. For example, pottery from the Macassans of South Sulawesi has been found on the north coast of Australia (Ellen and Glover, 1974, p. 368).

[8] One potter actually maintained he liked it when the rain and wind came during firing so that the pot turns red, strangely contrasting with most bonfirer's reported fears of the effects of rain and wind.

Chowra Island, Nicobar. 19th century photograph showing a posed group of women potters and three different stages of coiled pottery. Photo E.H.Man, 1886.
Pitt Rivers Museum, University of Oxford
B.30.14b

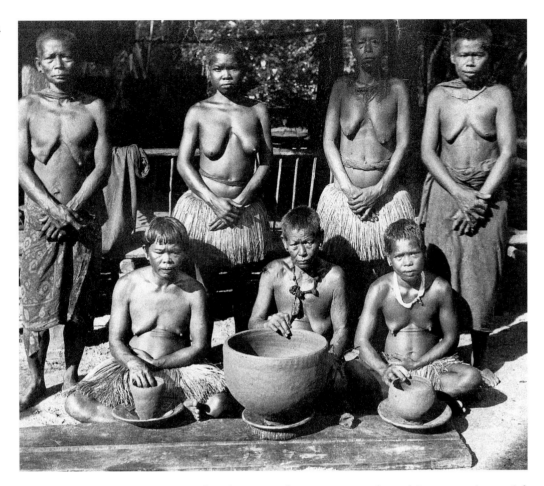

The gender designation and rights to make pottery can be subject to strict social controls. E.H. Man recorded how in the Nicobar Islands it was believed that dire consequences would follow if any Nicobarese other than the women from Chowra Island made pottery, even though the islanders lacked a good local clay source and had to undertake a five-mile sea crossing to find clay (Man, 1894, p. 21).

Similarly, pottery is only made by women on the Moluccas and 'it would be considered a transgression of ritual were men to be shown its secrets; they are normally not even allowed to frequent the place where clay is obtained' (Ellen and Glover, 1974, p. 354). The technique used in the Moluccas is fairly typical. Potters work from home. A lump of clay is placed on an unpivoted turntable, or circle of wood balanced over a piece of tree trunk, with a smoothed upper surface so that the platter can be pushed round. The potter pulls up a rough shape and adds coils. The final shaping is achieved by beating with a paddle against a stone anvil held inside. A red slip is painted over the pot. The firing is a bonfire of bamboo canes with between 24–48 pots firing for 1–2 hours. The potters do not expect major losses in the firing. At the end the pots are often covered with *dammar*, a resin that is applied to the hot pots after they emerge from the firing. It gives a sheen and patches up any cracks.

In a more recent study of pottery in the Kelabit Highlands of central Borneo in the mid-1990s, Sabina Teuteberg found that the practice was almost extinct and all households were using metal pans and plastic containers. For all that, there was general consensus that rice tasted much better when cooked in an earthenware pot, and there

OPPOSITE PAGE
This potter from the Kelabit Highlands in Borneo shapes the form using a thick stick pushed into a lump of clay and then beaten out with a paddle, 1990s. Photo Sabina Teuteberg

were still older women who could demonstrate the process of pottery production with confidence. The original forming process was unusual. A solid cylinder of clay was pierced by a long pointed stick, turned on its side and then rolled with a rolling pin motion. A thicker hollow stick was pushed over the first and the hole widened. The shape was beaten out with a paddle to make a straight-sided vessel and finally finished off by the more conventional paddle-and-anvil method. After a three-week drying period the pots were fired on a high rectangular pile of wood, lit from the base so that the pots resting on the top warmed up gradually and eventually, as the fire burned down, came to rest in the bed of hot embers. Finally, the hot pots were sealed inside and out with a resin extracted from the *agathis kinbaluensis* tree.

On the island of Lombok just to the east of Bali, the Sasak people have been Moslems since the 16th century but have preserved many aspects of their ancient culture. Among these rural farmers and artisans there are 20 pottery villages where most of the women still make pots, often assisted by male members of the family. The industry appears to have increased over the last century as early records of Lombok make no mention of it. As the agricultural economy has declined and many of the people have lost their land, the artisan industry has become more important. Over the last 20 years the potters of Lombok have hugely expanded their repertoire to cater for the demands of new urban and tourist markets. Lombok pottery is now exported to Australia, New Zealand, Europe and the USA.

In spite of this export market, pottery is still a vital part of everyday life in Lombok and is used in ceremonial activities even where other materials have replaced it for everyday use. Pottery is also used to ward off spirits and protect the household. Traditionally the roof cap, sometimes with a sculptural figure, is placed on the highest point of a thatched roof. It is notable that it is men who make these, along with face-mask lamps which have now also become popular tourist purchases.[9] The island is rich in clay which is augmented with river sand or volcanic ash as temper. In some places the clay is mixed with water and the slurry poured off, while in others it is pounded, sieved and then mixed with water. These variations in technique in one small island are also to be found in a range of handbuilding systems which have been handed down from one generation to the next. The large water jars of Adong, Penujak, are built up by a classic coiling method, each coil smoothed down into the body. At certain points the vessel is allowed to rest while it dries out enough to take the next section. In Banyumulek much thicker coils are applied and then pulled up to add about 18 cm (7 in.) to each layer. Finally the walls are scraped down with bamboo blades. On the following day, the walls are burnished by wetting and rubbing over several times with a polishing stone. Smaller cooking pots are beaten out with a paddle-and-anvil system.

Pots are well dried out before they are fired. On the day of the firing they will be pre-heated before the final bonfiring takes place in a hollow layered with ash from previous firings. The main fuel is coconut husks, rice husks and twigs but eventually the fire is covered over with rice straw. The pots are ready when they glow red but in some places a black finish is required and the hot pots are doused with rice bran which flares

[9] It is interesting to compare this with the male sculptural tradition in Papua New Guinea.

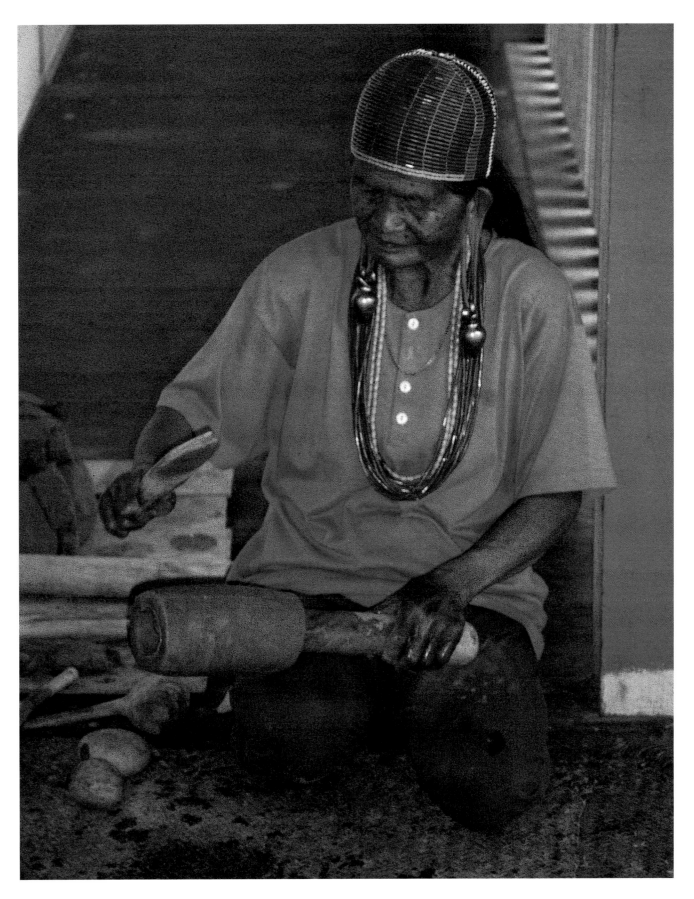

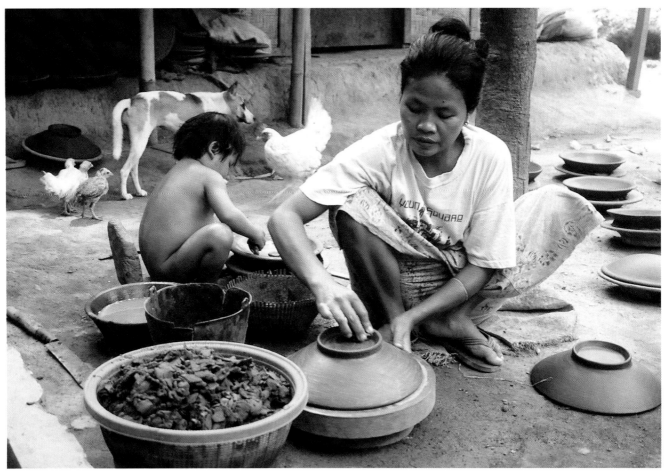

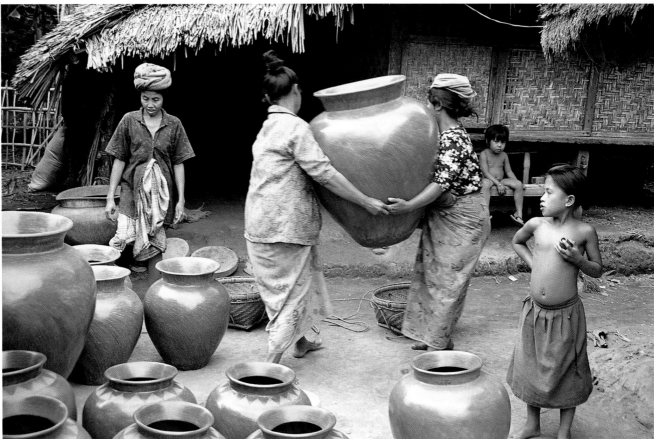

up and carbonises the outside of the pot. Firing sites are often shared and are in constant use. Temperatures range from 750°–900°C (1296°F–1566°F).

It is important to stress that there is nothing 'natural' about gender roles in ceramics: they are socially produced. But this area of the world demonstrates again the characteristic model that women potters predominate where handbuilding methods have prevailed. Men become more involved in general when there is a strong economic incentive, and where new technology and workshop practices rather than home industry are beginning to develop. The association of men with high status, sculptural or ritual forms is also very notable.

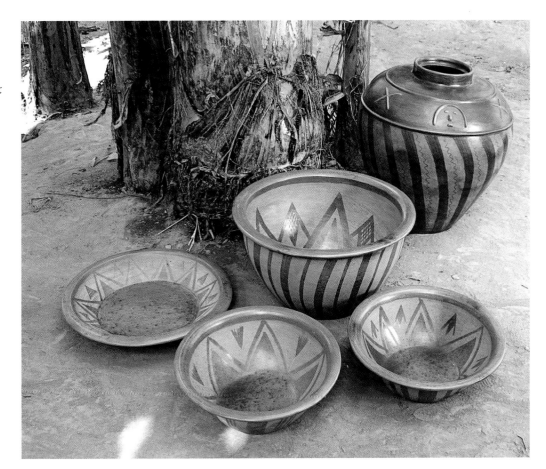

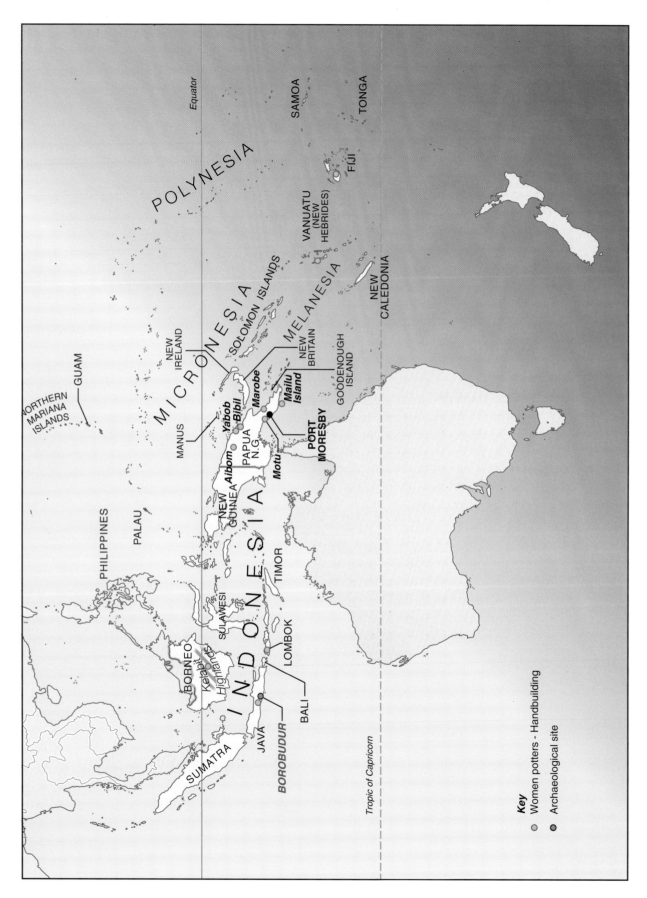

Equator

POLYNESIA

SAMOA

TONGA

FIJI

VANUATU
(NEW
HEBRIDES)

MELANESIA

SOLOMON ISLANDS

NEW
CALEDONIA

MICRONESIA

NEW
IRELAND

GUAM

NEW
BRITAIN

GOODENOUGH
ISLAND

NORTHERN
MARIANA
ISLANDS

Marobe

Mailu
Island

Bibil

Yabob

PORT
MORESBY

MANUS

PAPUA
N.G.

Motu

NEW
GUINEA

Aibom

PHILIPPINES

PALAU

SULAWESI

TIMOR

INDONESIA

Kelabit
Highlands

LOMBOK

BORNEO

BALI

JAVA

BOROBUDUR

SUMATRA

Tropic of Capricorn

Key

Women potters - Handbuilding

Archaeological site

Women Potters and Gender Roles in Oceania

'TARAIVINI Wati of Nailai, Tewa is 57 years old and an expert in something that originated 3,500 years ago – pottery', announced a recent British newspaper article on Fiji. The article went on to describe the potter's handbuilding and bonfiring technique and closed with the hope that future potters would not 'switch to machines'. Fijians are proud of their ceramic heritage. They even used it on special stamps to celebrate the new millennium in 2000.

Fiji 2000, first day cover envelope and stamps linking a contemporary woman potter with ancient Lapita pottery and Fijian scenery.

Of the five continents, Australia and Oceania is unusual in having relatively few ceramics. Historically pottery has only been made in the Pacific islands and, as far as is known, it was never made by the indigenous inhabitants of Australia or New Zealand.[1] For the most part, pottery is made by women.

OPPOSITE PAGE

Indonesia, Papua New Guinea and Oceania: islands and places mentioned in the text

[1] Since the late 20th century there have been some recent developments, most notably the Tiwi Potters of North Australia founded by Eddie Puruntatameri (1948–1995). This family workshop employs ancient aboriginal imagery as decorative motifs on pottery to great effect but there is no connection with a ceramic tradition as such.

Taraivini Wati of Nailai, Fiji, makes handsome relief-decorated vessels. She also works as a demonstrator at Fiji Museum.

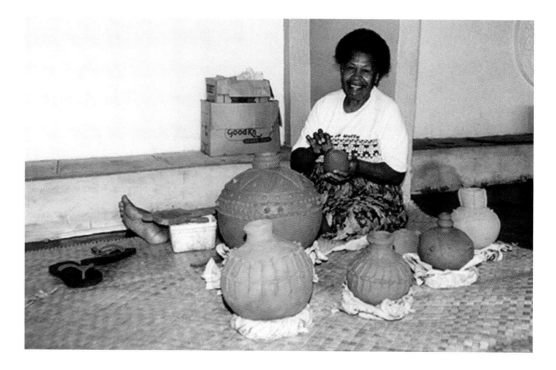

The islands of the Pacific are grouped in three large swathes: Melanesia, running from New Guinea to Fiji; farther east, Micronesia from the Northern Marianas down through Samoa; and Polynesia, the widest spread group which covers the central Pacific including Hawaii. Many of the islands in the central Pacific appear to have been settled by peoples who had no knowledge of pottery or who found no suitable clay. In Micronesia pottery is known in some of the north-westerly islands – in the Marianas, Saipan, Guam and the Palau Islands. Farther south it has been found in the Marquesas, the Cook Islands, Samoa and Tonga; in all but Tonga it had died out by the 18th century, before European contact. There is evidence of pottery production at some time on all the larger islands in Melanesia but by the mid-20th century it was fast disappearing.

The ancient pottery of Melanesia is known as Lapita ware which is used to identify a culture that flourished between 1500–100BC in Melanesia. This pottery, mainly known through fragments rather than full pieces, was made from a fine clay body with impressed relief decoration made using a carved 'dentate' stamp or paddle. It has clear links with pottery in South East Asia.[2] These techniques almost certainly spread from Asia westwards into the Pacific.

The women potters of the Pacific Islands use techniques based on coiling and/or the paddle-and-anvil system probably similar to that used 2,000 years ago by the potters of the Lapita culture. These techniques have been recorded over the centuries of European contact. The pot is formed by coiling or by beating out the shape using wooden paddles and a stone anvil. Relief decoration is applied using decorated or serrated-edged paddles or shells and the pot is finished by sealing with a resin or other plant solution after firing in an open fire. Each island or even village has slightly different techniques, tools or plants used in the final finishing.

[2] Lapita pottery is found in the Bismarck Archipelago through the Solomons and Vanuatu, Fiji to Tonga and Samoa. These peoples cultivated plants and also introduced pigs, dogs and chickens.

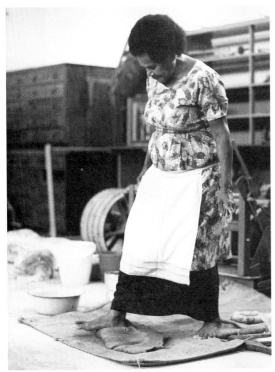

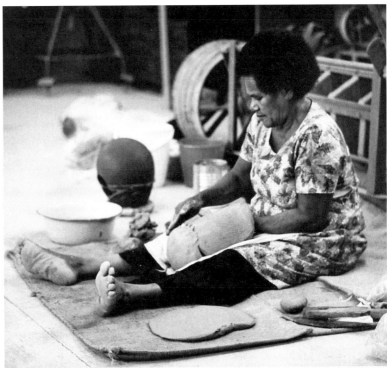

Amele of Sigatoka village, Fiji demonstrating her pot forming technique building up the form with flattened slabs of clay, 1969
Photo Stan Jenkins

Left *Finished cooking pot from Sigatoka, Fiji*
Photo Stan Jenkins

On the Island of Santo (Vanuatu or New Hebrides) the women of the village of Wusi have maintained such a tradition, where they beat out the form and decorate with incised and applied patterns. The pots are finished with a red slip mixed with sea water and fired with coconut-palm fronds and bamboo. Finally they are sealed while still hot with a mixture of arrowroot and sea water.

Ceramic pots were used for cooking, serving food, storing water, food and other goods, for preparing dyes and medicines, and for ceremonial activities. For over a century, metal and plastic have made inroads into the range of ceramic wares still used. In many places pottery has died out but in others, new markets and alternative purposes have developed. As we have seen, in Fiji, pottery has become a symbol of cultural identity, important for both indigenous peoples and the visitor or tourist. On its first day cover envelope, Fiji combines an image of a modern day but 'traditional' woman potter with stamps that show sherds of Lapita pottery signifying cultural heritage, set against beautiful scenic views signalling unspoilt natural beauty. Thus, when interviewed in the 1990s the Fijian potter, Taraivini Wati was proud to claim the she was 'the fifth generation to use the 3,500-year-old methods to make pots'.

Papua New Guinea

The older accounts of Oceanian ceramics mainly record women potters. In New Guinea, however, men are the designated potters in a few places. Often the male potting villages are inland rather than coastal which may account for why they have been so little recorded.[3]

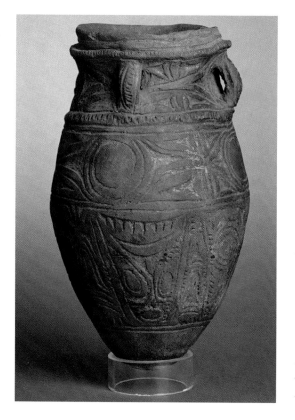

Porpora River Sorcery jar 28cm (11 in.) Papua New Guinea, Art Gallery of New South Wales. Photo Jenni Carter for AGNSW

In the following account I have drawn heavily on Patricia May and Margaret Tuckson's exemplary study of traditional pottery in Papua New Guinea, first published in 1982. In Papua New Guinea, pottery is mainly found along the north-eastern coastal region and the highland areas behind that. In all pottery centres, of which there are many, gender roles are distinct, although they may vary, and most men or most women, depending on the custom, will make pots. Among the peoples of Yabob and Bibil in the coastal area of Madang province, particular villages hold the rights to make pottery; women who marry outside their native village into a non-potting village, even if clay is available, would not make pots, whereas women who marry into potting villages will be expected to learn

[3] There were also some male potters on Bougainville in the Solomon Islands although elsewhere on the same island women make pottery.

Motu mother and daughter, Hanuababa, Papua New Guinea 1921.

Photo Frank Hurley, Nature Focus

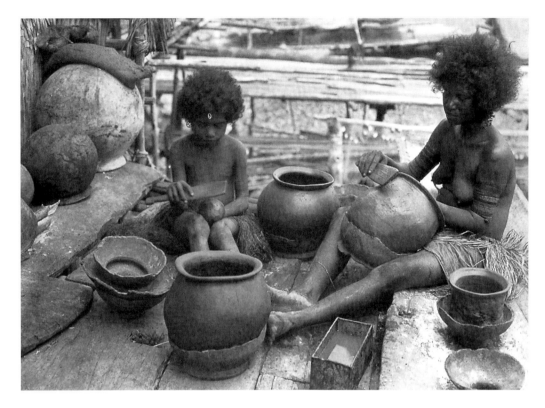

(May and Tuckson, 1982, p. 166). A variety of handbuilding techniques are used, principally spiral coiling and paddle-and-anvil. Most utilitarian pottery is made by women but men may undertake the decoration or make special ceremonial vessels or sculptures. Among the Kaiapit Azera people of Morobe province, men make the pots; however, women have well-defined roles in the process of production. They prepare the clay – an activity subject to considerable social rules and taboos – and they also fire the pots. This is an unusual inversion of gender roles and may indicate more recent introduction of a new technique adopted by men while women have retained significant involvement in the essential processes of production. The potters of the Azera are among the finest in Papua New Guinea and it appears that they have become relatively specialised, with some men being particularly recognised for their skills. Pottery is imbued with a degree of status and prestige and is important in bride-price agreements. Some of the potters travel to non-potting villages to carry out work on commission. By the 1970s younger men were experimenting with new designs and directing their products towards an outsider market including expatriates and tourists. This conforms to the pattern of male involvement when it has economic worth or special status as cult object or sculptural form.

All Papua New Guinea potters use a bonfire method of firing sometimes with a system of preheating the pots by burning grass in the pot or, in one case, putting pots to dry over the remains of a cooking fire which is then rebuilt into a bonfire for pots. In South East Asia and the Pacific, bonfires are often constructed in a rectangular form, unlike the circular form common in other parts of the world. (see p. 94) The firings which last on average about half an hour do not exceed two hours and can be as short as ten minutes. Firing temperatures recorded are remarkably high reaching temperatures of over 900°C (1566°F). They also appear to be very successful as none

*Firing on the beach on
Goodenough Island,
New Guinea, 1911–12*
Photo D. Jenness, Pitt
Rivers Museum, University
of Oxford, C.112.3b

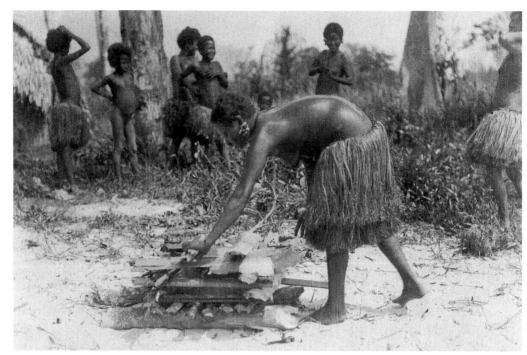

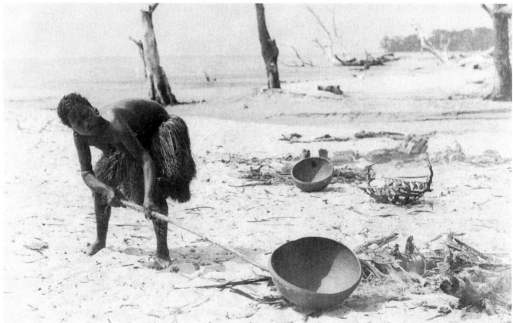

of the fourteen firings observed by May and Tuckson had any breakages, a finding corroborated by other researchers (1982, pp. 46–8).

After firing, a variety of methods are used to seal the pots and make them less porous, such as painting with sago flour solution or rubbing with leaves or putty nut. Pots are usually tested by boiling water or vegetables in them before they are marketed. Traditionally in Papua New Guinea, pottery was extensively traded across coastal waters and to the islands in exchange for food and other commodities. A late 19th-century photograph shows large quantities of pottery made by Motu women of the coastal area near Port Moresby ready for a trading voyage.

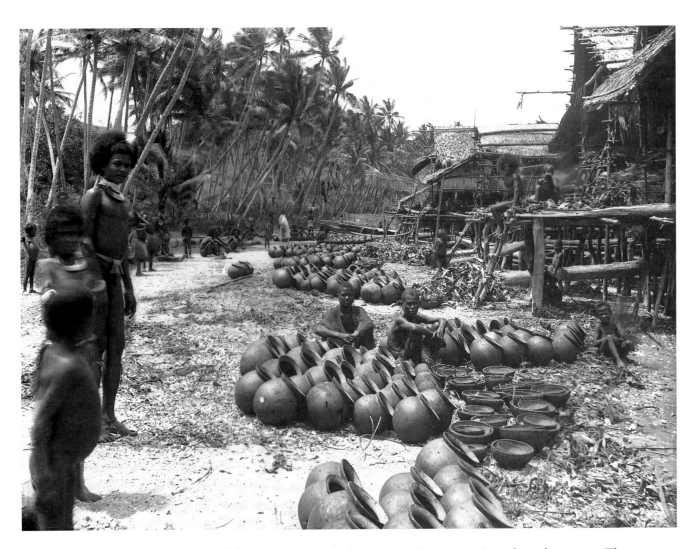

Hundreds of Motu pots on a beach ready for a hiri trading voyage in the late 1800s. Tyrrell Collection. Reproduced courtesy of the Powerhouse Museum, Sydney. Photo Charles Kerry

One of the most unusual places to make pottery is on board a canoe. The women potters of Mailu Island in Central Province, Papua New Guinea, undertake several trading expeditions during the year. They take the clay with them, make pots during the day on the journey and fire them on the beach in the evening when they arrive at their destination (May and Tuckson, 1984, p. 57).

Of all the Papua New Guinea pottery, the sculptural vessels of some Sepik traditions are the most spectacular. The region is noted for its cult activities, in which clay and clay objects play their part, and there are many taboos associated with gathering and working clay. The pottery is unusual for this part of the world, as it is entirely based on spiral coiling and does not use the paddle-and-anvil technique. It is, however, the sculptural finish that is notable. The designs bear a strong relationship to wood carving and in appearance and technique have affinities with the ancient Jomon pottery of Japan. Gender roles vary but it is significant that in this region male pottery activity is quite common. In general men hold the rights to make ceremonial or cult pottery while women continue to make utilitarian pots. Among the Aibom, women traditionally make vessels, gable decorations and hearths and men add the sculptural detailing and painted finishes. By the late 20th century these divisions were more flexible and some women have taken up the sculptural forms. Judy Sawi is noted for her dynamic sculptural sago pots.

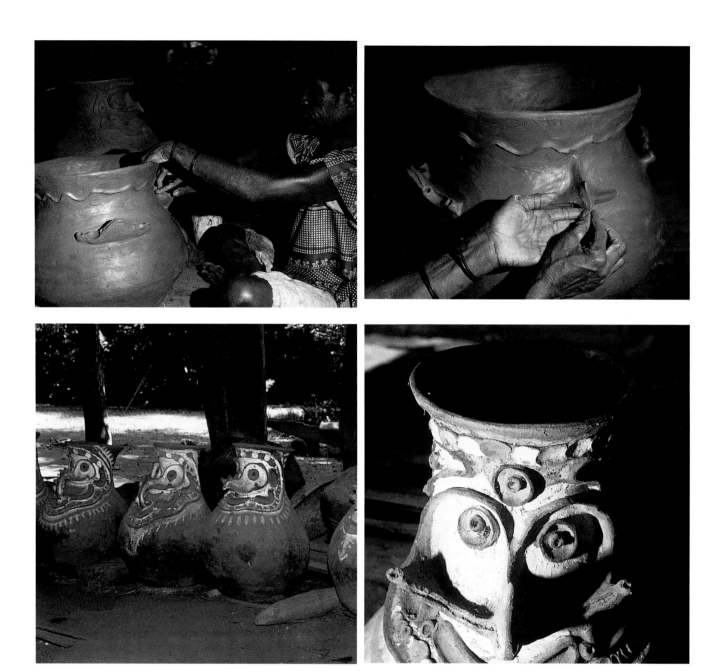

Top left *Esther Meat finishing the decoration on a sago jar, 1984, Aibom, Papua New Guinea*
Top Right *Esther Meat modelling the face, 1984 Aibom, Papua New Guinea*
Above Left *Sago jars by Judy Sawi, 1984, Aibom, Papua New Guinea*
Above Right *Sago jar detail, 1984*
Photos Margaret Tuckson

As in many parts of the world, development projects have been undertaken in Papua New Guinea which alter the balance of gender relationships and techniques used. A training centre in the pottery area of Yabob of Madang province was set up in 1967, kilns were constructed, kick wheels brought in and the men given training in their use. The enterprise faltered after the project leader left. The women, however, continued to work in their traditional way with some slight modifications to the forms and sometimes the use of kiln firing (May and Tuckson, 1982, p. 167). Development projects that ignore the gendered nature of activities do so at their

Solomon Islands – Photo shows a ceremonial pot-breaking, circa 1930.
Photo Beatrice Blackwood Pitt Rivers Museum, University of Oxford C.115.7

peril. These issues are discussed in more detail in the final chapter.

Pottery in Papua New Guinea is an important social signifier. Pottery tools are valued and the anvil or beating stone is often preserved carefully long after a woman has stopped making pots. Pots are a basic unit of wealth and villages that do not make pottery will hoard pots which are also frequently used as a bride-price in marriage agreements. Furthermore, everyday ceramic objects can be endowed with significant social meanings. Pots may be smashed when someone dies or a widow may wear a piece of pot from which her husband's food was cooked. A photograph of the Solomon Islands taken in the 1920s, records a ceremonial visit of Kurtachi women to Tabut 'to break pots to show displeasure at the action of a mission teacher who had destroyed a woman's hood and said they should not wear them'. Although perhaps a rather staged image, a broken pot sits in the foreground while the two women on the left are wearing hoods, presumably to demonstrate their defiance.

In the 21st century, the future of pottery in the Pacific region is assured in spite of the radical changes that have taken place over the last 100 years. Pottery is adapting increasingly to a global market where it becomes a cultural signifier and a marker of identity of village, region or state. For many women and men it brings in an important cash income and generates a sense of pride in a valued cultural heritage.

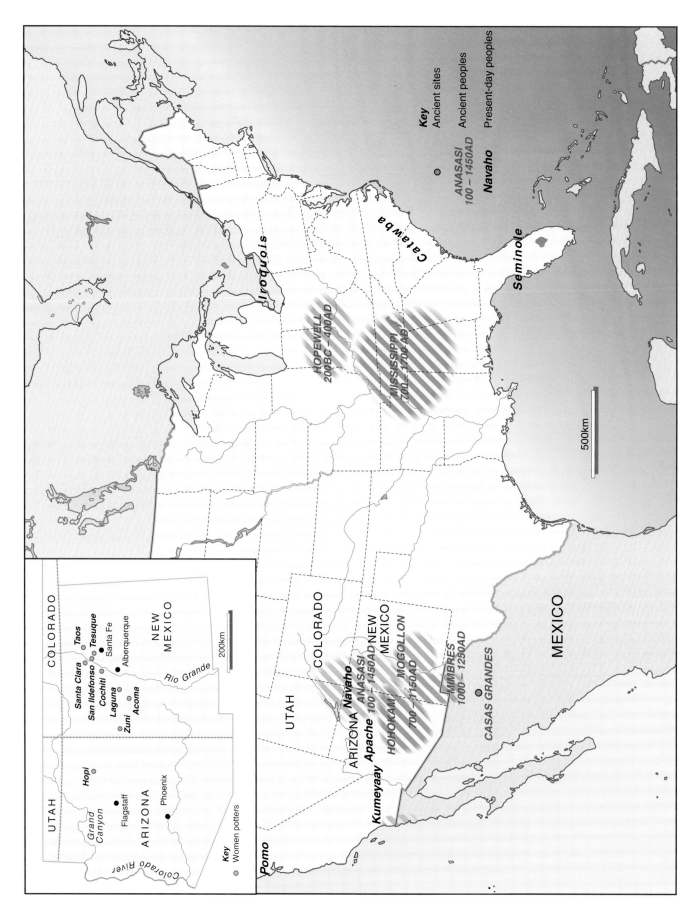

Women Potters and Gender Roles in the Native American Tradition

Then the spirit took the old man and the old woman to the other side of the mountain. A big hole was there. 'Go over there and dig out that clay,' the spirit told the two old people. 'I will show you how to make pots and bowls with it. You will live by this means.' Then the spirit called the woman over to him and touched both her hands with his, instructing her, 'Now work the clay from your own knowledge and with your own understanding.' (Niethammer, 1977, pp. 193–4)

THIS Apache tale characterising clay working as a woman's skill is typical of stories from many different Native American groups. This female tradition has resisted extinction, almost incredibly, within the wider context of the most advanced industrial society in the world. Through a complex process of survival and revival, Native American crafts of all kinds can be found prospering in most areas of the United States and Canada. Pomo baskets, Navaho rugs or Inuit carving have evolved and adapted to new circumstances. Native American ceramics have been no different.

This chapter will consider women potters and gender issues in the long history of Native American ceramics; firstly in the period where archaeological excavations are the main source of evidence, secondly in the historic period after European settlement, and finally in the period of revival from the early 20th century. The main focus will be on Pueblo pottery in the Southwest, with some examples from other areas.

Pre-history in North America

The earliest pottery in North America from sites in the south-east of the United States has been dated to around 2800BC. This is earlier than in Mesoamerica (1600BC) but much later than in South America (5671BC). Pottery was probably introduced into North America in various ways – from the North over the Bering Strait, across the sea from the Caribbean Islands and from the south from Mesoamerica. It has even been suggested, on the basis of the similarity with the Ertbolle culture in Scandinavia, that peoples could have come across the Atlantic via Iceland and Greenland.

In the broad band from the Great Lakes in the north to the Mississippi Basin in the

OPPOSITE PAGE
North America: peoples and places mentioned in the text

Figurine showing a woman potter at work (Indiana) – Middle Mississippi Valley (AD 700–1700) 18 cm (7in.)

Drawing Shao-Chi Huang

south much of the early utilitarian pottery was quite plain, or finished by giving a textured surface with a cord-wrapped or stamped paddle, or by pressing a textile against the surface. After 200BC two major cultures flourished in this zone, the Hopewellian culture (200BC–AD400) and the Mississippi culture (AD700–AD1700). They constructed elaborate grave mounds for important individuals, both women and men, and participated in an extensive trade in exotic goods of copper, mica, carved stone and wood. Ceramic artists of the Hopewellian culture modelled figurines showing women and men in apparently everyday activities and made finely decorated burial vessels. The Mississippi culture developed an even greater range of ceramics including head effigy jars, stirrup jars, animal and human forms and double jars – a variety of techniques and forms which indicates a connection with potters from Mesoamerica. The mythology, occasional images of women with pots and early historical records all testify that among the indigenous populations of North America pottery was a female craft, as it continued to be well into the 20th century.

Women Potters and gender debates in pre-historic ceramics in the Southwest

The Pueblo peoples of the Southwest have preserved ancient traditions that are probably the best-documented women's ceramic tradition in the world. Over the last 100 years the skills and techniques of the Pueblo potters have been carefully studied, the archaeological past has been pieced together, and the pottery has been developed and economically exploited by both Anglos[1] and Native Americans. In most of the Western world in the last 100 years there has been a gender change in ceramic production – potters are no longer, by definition, men. With the development of studio pottery in the early 20th century, women gained access to the profession at a point where traditional small-scale pottery businesses were dying out. The Native American tradition saw a parallel but opposite process. By the second half of the century both men and women made and decorated pots, although women still predominated and family ties remained a strong infrastructure supporting the craft. Many male potters are the sons or grandsons of women potters and are proud to identify themselves with the female matriarchs.

The Hohokam, Mogollon and the Anasazi were the precursors of present day peoples in the Southwest. These cultures were at their high point in the period from AD700 until

[1] Anglos is a term used to designate white Americans and people of European descent as opposed to those of Hispanic or Native American (Indian) descent.

Mimbres polychrome bowl with bat motif (circa 1050-1150 AD) 10.8cm (10.25 in.) Collection Frederick R. Weisman Art Museum at the University of Minnesota, Minneapolis. Transfer, Department of Anthropology, University of Minnesota

about AD1150, after which they appear to have abandoned many of the settlements and towns that had developed. Whether through drought, disease, warfare, or over-exploitation of the resources, it seems the land could no longer support the population.

The Hohokam people, who created village centres with platform mounds and ball courts[2] and systems of irrigation for their fields, had probably migrated from Mesoamerica. They made paddle-and-anvil vessels, some plain and others decorated with abstract and figurative forms. Early Mogollon ceramics were simple shapes built from fine coils used to create a decorative ribbed effect and later these peoples developed the very fine-bodied, painted ceramics known as Mimbres. Classic Mimbres bowls are characterised by thin walls covered in white slip with a black or dark brown design on the inside of the bowl. The outside is often left plain. Many Mimbres pots are associated with burials in the floors of houses and have a 'kill' hole in the base, usually interpreted as symbolically allowing the breath to escape. The intriguing abstractions of the decoration and the tantalising 'naïve' realism of the figurative designs are incomparable and had an immediate appeal to 20th century artists with an interest in 'primitive' and child art. These elegant wares came to light in large numbers in archaeological excavations the early 20th century and were immediately sought

[2] Ball courts are a characteristic structure associated with Central American and Caribbean cultures. These rectangular plazas with steep sides were used to play ritual ball games.

Mimbres bowl showing a woman going about her daily life.
Maxwell Museum of Anthropology, University of New Mexico, Mimbres Archive, owner Roy Evans

after by collectors. Sadly, it was not long before many Mimbres sites were looted and hence their value for serious archaeological investigation was lost.

There has been a vigorous debate about the gender of the Mimbres potters. Women certainly produced pottery and the evidence of a burial where a female skeleton is found with potter's tools seems compelling. The creative range of this work – every one with a different design – suggests many producers and a very high level of skill in potting, decorating and firing. The apparently illustrative designs and the clever stylised abstractions brought them into the realm of 'art' which, when they first became known, made it hard to accept that they could have been designed by 'simple' women potters. The possibility that some of this pottery or its decoration was made by specialists, some of whom were men, has to be considered.

The figurative designs are found mainly at mortuary sites, while the geometric painted pottery is found in abundance; hence it is likely that a few specialised artists may have produced the figurative designs, while each household produced the everyday pottery. The strong association of figurative designs with burials could suggest that they were specially commissioned for the burial, or had a special relationship with the dead person. The latter seems more probable as some of the pots show wear.

The subject matter of the works might also offer us clues. The pottery shows animals and humans, sometimes cleverly stylised and mirrored to create a design. The human scenes often show mythical figures (or people dressed up as them), hunting, fishing, and women (identified by their string aprons) with baskets or pots. In general there are more men represented than women. There are a number of works that show birth scenes and some show erotic imagery such as a man with a giant penis[3], or copulation, in at least one case between men. Such subjects seem less likely to be depicted by women, but this judgement is based on modern day Western norms that might be totally inappropriate to another society. In many Native American societies, including the Pueblo, the 'nadle' or man-woman was a recognised type. He/she could and did transcend the craft gender norms. It is entirely possible that they could have produced such imagery. In a number of Native American societies it is the practice of shamans to commission a specific object such as a mask or a piece of pottery with special designs.[4] Powerful design principles that relate to the overall shape of the vessel are characteristic of most Pueblo pottery but these are often transcended in special ceremonial ware where the imagery takes precedence over the design. That might be said to be a feature of some Mimbres figurative designs where the figures do not relate to the surface space. More often, however, the figures are carefully composed in the space.

No other Southwestern group produced such figurative imagery although some incorporated animal and natural forms into their compositions. Abstract and geometric designs predominated.

[3] Swenzell relates this image to a modern Pueblo (Tewa) derogatory expression wakusoyo – a person with a penis that is too big, that is a person who has an inflated idea of their own importance (Brody & Swenzell, 1996, p. 35).

[4] Strict rules governed the production of sacred designs. At Acoma women potters had to be asked to make certain (ceremonial) designs by the medicine man (Dillingham, 1992, p. 10). See also the potters of the Amazon or the production of masks amongst the sub-Arctic peoples.

Mimbres bowl with feather design (circa AD 1000-1150) 17.9cm (7 in.). Collection Frederick R. Weisman Art Museum at the University of Minnesota, Minneapolis. Transfer, Department of Anthropology, University of Minnesota

The third of these ancient societies, the Anasazi, is seen as the closest ancestor of modern Pueblo peoples. The culture, which was at its height in a slightly later period from AD1100–1450, constructed elaborate adobe, brick and stone dwellings sheltered in spectacular settings under overhanging cliffs. The pottery found in both domestic and grave sites is characterised by all over angular geometric patterns on bowls and mugs with handles. Within a set stylistic vocabulary each design is individual but, more significantly, the technology and the type of pigments vary. Such variability indicates that the pottery was produced by many different people. This is typical of household production where many, or most, women produced pottery according to their needs.

Pueblo Pottery in the Historic Period

The Historic Period in the Southwest begins in the 16th century when the Spanish first came into the region. New Mexico was originally under Spanish and later Mexican administration, but in 1846 it was annexed to the United States. The hispanic influence remains a vital component of New Mexican culture.

An early record by a Portuguese visitor, Hernan Gallegos, in 1581, bears witness to the skills of the Pueblo potters in the 16th century:

The women busy themselves only in the preparation of food, and in making and painting their pottery and [griddles, on] which they prepare their bread. These vessels

are so excellent and delicate that the process of manufacture is worth watching; for they equal, and even surpass, the pottery made in Portugal. (Hammond and Rey, 1966, p. 85 quoted in Batkin 1987, p. 15)

The excellence of Pueblo pottery obviated the need for the Spanish to bring in their own potters so there was never the competition from wheel-thrown wares that grew up quickly elsewhere in the Americas. The Spanish found about 60 Pueblos of which fewer than two dozen remain today: in the West on the Colorado Plateau are Hopi, Zuni, Acoma and Laguna and along the Rio Grande River north of Albuquerque and west of Santa Fe are San Ildefonso, Santa Clara and Taos. All these peoples are descend ants of the Anasazi and Mogollon cultures but they spoke a variety of languages[5] and developed increasingly differentiated pottery styles which became distinctive cultural markers in the 19th century. This was further accentuated in the 20th century under the influence of Anglo museum curators, dealers and collectors. For example, the Indian Fair at Santa Fe with its system of prizes judged largely by these same influential people, discouraged inter-Pueblo stylistic borrowings on the grounds of purity and authenticity.

In the early 19th century larger storage jars with indents for carrying became com-

Curio Dealer Moses Aaron Gold with Tesuque pottery, circa 1880.
Photo Ben Whittick, Museum of New Mexico, Photo Archives neg. 86857

[5] There are four main lingusistic divisions: Tanoan (which includes Tewa, Tiwa and Towa), Keresan, Zuni and Hopi.

mon and new forms such as dough bowls for preparing wheat bread appeared, but in many of the Pueblos pottery production was in decline by the 1880s. The Santa Fe Trail was opened up in 1821, bringing influxes of outsiders and goods, and in 1880 the railroad reached Santa Fe. Pueblo pottery underwent an evolution in the 19th century, parallel to traditional folk potteries in many parts of the world. As the functional requirements for pottery decreased or were overtaken by industrial production of metal and ceramics, potters turned to new markets. There was now an expanding mass market for giftware, mementos, curios, collectables and, increasingly, high art. Pueblo women responded quickly to these new demands, encouraged by Anglo traders, anthropologists and museum curators. Certain pueblos moved over to supplying the needs of the Anglo incomers and visitors. Figurative forms had existed in earlier times but in Cochiti and Tesuque these became the main pottery produced, much stimulated by the Santa Fe traders, Aaron and Jake Gold. A description of a trading post in 1881 which sold Indian goods including pottery, basketware, and Navaho blankets stated that 'a great deal of the pottery was obscene but kept concealed from the ladies visiting the place' (Batkin, 1987, p. 28); some irony if 'ladies' made the pottery! Cochiti has since become distinguished for its figurative ceramics known as 'Storytellers' which are a new form of collectable with good 'Indian' credentials (see Chapter Ten).[6]

Pueblo women make their pottery in broadly similar ways with minor variations between villages. The clay is collected, usually within a few miles of the village, and mixed with temper which may be ground pot sherds, sand or crushed rock. The pots are modelled by hand and all the larger ones are coiled using a circular mould. The coils are carefully bonded in and, when the right height has been reached, the potter shapes the form by scraping and pressing from the inside against her hand on the outside. The pot is smoothed down and, when dried, is covered with a layer or layers of slip (liquid clay) which may be of a different colour. It is then polished carefully to give a smooth and shiny finish. Burnishing has become one of the most admired skills of Pueblo women and in the 20th century has been taken to unprecedented levels of shine at Santa Clara and San Ildefonso.

Traditionally, decoration is applied with a yucca brush which is still widely used. The end is chewed to split the fibres and give the desired width. The flexible form can help to produce long straight lines and even paint application, which in the case of black paint is either of vegetable (from the guaco plant) or of mineral origin. The designs can be applied freehand but are often blocked out by nail indents, charcoal or pencil. Normally each woman or family fires alone in a bonfire system, occasionally with a wall built around the fire to exclude the wind. In the 20th century many variations developed and potters began to use metal grills and sheets of metal to cover the fire, maintain the temperature, and protect the pottery in the firing. Fuels could be manure, wood or coal (Hopi). For the black pots the metal cover is removed and the pots are smothered in dry manure to exclude the oxygen and create a reducing atmosphere in which the fire must smoulder but not burst into flame. The mode of firing is another means of designating 'authenticity'. Nowadays some potters use electric kilns although there is a great stigma attached to the use of such technology implying that it is not

[6] Changes in taste have given new value to some of these figurative works which often depict the Anglo in a humorous way. For a very sympathetic account of Cochiti traditions see Babcock (1986).

proper 'Indian' pottery. Many potters and dealers view it as a form of cheating. A further development of modern technology involves applying a blow-torch to a blackened pot. The carbon is burnt off and the red clay is revealed giving a two-toned pot.

Pottery is strongly identified as a woman's craft and this is further underpinned by the female associations of clay, sometimes known as Clay Mother or Mother Earth. There are numerous accounts of the respect in which clay is held and female metaphors abound, including the idea that pots are like children, an idea also expressed by some male potters.[7] In certain pueblos prayers are said at the collection of clay (Zuni), while making the pot (San Ildefonso, Hopi) or before the risky process of firing:

> I have to be alone… alone with the clay… to listen slavishly to its commands, to feel the rhythm, the pulse, the life of it.
>
> Oh yes, I pray. One must be alone with the Creator – the Supreme Being – to capture the feeling of oneness. One with the clay. One with the creator. One with every living thing, including the grains of sand. (Hopi potter Polingaysi Qoyawayma, quoted in Niethammer, 1977, p. 196)

One of the most famous accounts of the gathering of clay is that of Matilda Coxe Stevenson who described the Zuni potter We'wha:

> On one occasion Mr Stevenson and the writer accompanied We'wha to Corn Mountain to obtain clay. On passing a stone heap she picked up a small stone in her left hand, and spitting on it, carried the hand around her head and threw the stone over one shoulder upon the stone heap in order that her strength might not go from her when carrying the heavy load down the mesa. She then visited the shrine at the base of the mother rock. When she drew near to the clay bed she indicated to Mr Stevenson that he must remain behind, as men never approached the spot. Proceeding a short distance the party reached a point where We'wha requested the writer to remain perfectly quiet and not talk, saying: 'Should we talk, my pottery would crack in the baking, and unless I pray constantly the clay will not appear to me.' She applied the hoe vigorously to the hard soil, all the while murmuring prayers to Mother Earth.
> (Batkin, 1987, p. 20)

In the 1920s Ruth Bunzel made an extensive investigation of Pueblo creativity and design. She considered that Zuni art was more symbolic in 1925 than it had been 75 years earlier and argued that symbolic meaning was secondary to aesthetic concerns. Fixed symbolism was evidence of stagnation and decline. She gave many examples of women who felt that designs came to them in dreams and considered that, even at Hopi and Acoma where there was little symbolism, each pot was 'an individual and significant creation'. With the recent re-evaluation of Native American 'spirituality' and its close relationship with the natural world, Native American potters are more likely to enunciate such values. They are now acceptable, even enlightened, rather than 'primitive' as they might have been thought in the past. Some, of course, would argue

[7] 'We make a prayer when we take clay and when we use it. The pots are spirits. The clay is sacred. You can eat it raw and you go back to it when you die.' Dolores Lewis (quoted in Peterson, 1997, p. 76)

*Pueblo potter from
Acoma firing, circa
1925.*
Photo Beatrice Blackwood,
Pitt Rivers Museum,
University of Oxford C1-
12-9-0

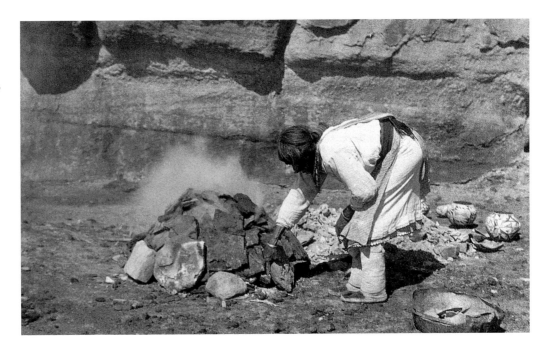

that they are a useful aid to marketing Native American goods. While this is undoubtedly true there does seem to be a genuine revival of older values and beliefs.[8]

There is no evidence that Pueblo men made pots before the 20th century, or even before 1940. When Pueblo communities were in decline and men needed to find cash income, crafts, particularly pottery, became a viable option. Men seem to have been able to move into decorating pots most easily. Sacred wall paintings in the *kiva* (communal area) [9] were executed by men, so it was probably a small step to take up painting on pottery. A visitor to Laguna in 1855 recorded visiting the house of the *cacique* or shaman. 'The cacique himself was painting a new *tinaja* (earthen pot) which he was covering with numerous rude figures in black and red' (Batkin, 1987, p. 20).

Furthermore, it was a common practice in the 19th century for archaeologists and researchers to offer informants drawing materials to illustrate ceremonies or activities, a useful device where there was a language barrier. A number of Native American artists emerged from this practice, including Julian Martinez, the husband of the most famous of all the great matriarchs, Maria Martinez. She could name at least 15 men who decorated pottery at San Ildefonso before 1940 and some as early as 1890, no doubt encouraged by the economic benefits of pottery which were notable in that Pueblo.

Another exception to the female potter is the role of the man-women or transvestite, a recognised phenomenon in many Native American societies, and sometimes associated with shamanism or with special ceremonies[10]. It was characteristic of such

[8] Native Americans have been understandably reticent about speaking about sacred matters, rituals and beliefs and still today certain things are kept hidden from the uninitiated. Different Pueblos have different attitudes to these matters.

[9] Underground religious meeting house, mainly used by men.

[10] Some writers use the term berdache, a word which comes from Spanish and French and refers to a passive homosexual partner (Williams, 1986, p. 9). The berdache tradition is widespread but not universal among Native American cultures and is usually a respected role.

*We' Wha, Zuni potter
and weaver, circa 1888,*
Museum of New Mexico,
Photo Archives neg. 29921

people that they dressed as women and took on female roles. The first reference to this is from 1823 when Jose Amujerado is designated a potter in a census in that year. (*amujerados* means effeminate or transvestite). But the most famous is We'wha (c.1849–1896), mentioned above, at Zuni who was a talented potter, weaver (a male craft in Zuni) and a respected leader of the Zuni community. A much reproduced

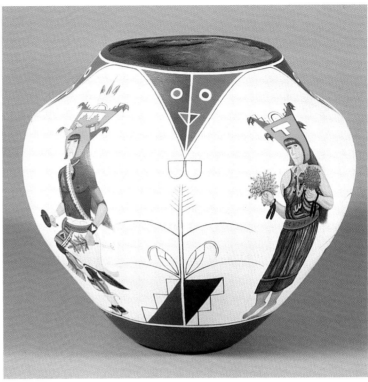

Above left Pueblo potters adapted forms and decoration for the new markets. Marianita Roybal of San Ildefonso. Jug with Spanish inscription, 1881. School of American Research, Cat.no. IAF.2011

Above right Sophia and Raphael Medina, Zia Jar decorated with modern designs and commercial colours, 1970s. School of American Research, Cat. No.1979-10

photograph shows him posing for the camera while on a six month visit to Washington in 1886. He stayed with the anthropologists James and Matilda Coxe Stevenson where he acted as an emissary on behalf of the Zuni, meeting dignitaries including President Cleveland and also recording his knowledge.[11]

In the late 19th century the ideals of the Arts and Crafts Movement swept across the Atlantic and educated Americans were drawn into its ideology. Pueblo pottery was no longer a 'primitive' and redundant skill but a craft to be treasured, nurtured and directed. The history of 20th-century Pueblo ceramics is one of close involvement with Anglo philanthropists and traders, usually benign, but at times heavy-handed. Native Americans have attempted to seize the benefits yet still maintain control over their own destiny. Such tensions remain to this day; Pueblo potters situate themselves along the continuum that stretches from those who still choose to sell to known people or even barter their work, to those who try to work in a very traditional style, to those who have trained in Indian or non-Indian art schools – and develop new Indian styles and eventually non-Indian styles. There are potters of Pueblo origin whose work is really more aligned to American studio pottery or ceramic art. Still others who cater for a highly developed collectors market, keep computer records and offer a certificate of authenticity with every pot sold. Pueblo pottery can also be looked at as a parallel branch of Western studio pottery showing in subtle ways the influence of changing modernist tastes and styles: Art Nouveau (examples from San Ildefonso), Art Deco in

[11] After her husband's death Matilda Coxe Stevenson took over his work and published 'The Zuni Indians: Their Mythology, Esoteric Fraternities and Ceremonies', in the Twenty-third Annual report of the Bureau of American Ethnology 1901–2 published in 1904. For further discussion of We'wha see Batkin, 1987, pp. 21–2; Batkin's essay in Houlihan, 1987, p. 79; Roscoe 1988.

the black pottery of Julian Martinez, 1950s and 1960s poster paint – sometimes in psychedelic colours (Jemez)[12], abstract art and Op Art of the 1960s and 1970s (Acoma), social comment 1980s (Nora Naranjo-Morse), ethnic revival (Cochiti storytellers, Joseph Lonewolf), and postmodern irony (Diego Romero). There are also potters of non-Indian origin who work in Indian styles. Although it is still a strongly female-dominated craft there are now many successful male potters, usually from well-known potting families.

It is not the place of this book to examine Pueblo styles; these have been well documented in numerous popular and scholarly publications. Gender issues have rarely been specifically interrogated. The economic benefits of pottery have been one of the mainstays of Pueblo existence since the early 20th century; San Ildefonso, where there was a strong market for pottery, was one of the richest Pueblos. Some Pueblos are matrilineal and others patrilineal but either way the power of the council lies in male hands, although it is fair to say that women have had a clear role. Precisely at the time when their society was moving into the industrial age, a point where women often lost out and became confined and restricted by polarised ideologies of male/public life and female/domestic life, women who made pots were able to avoid that demotion. They had access to both economic and social power. The status and economic benefits of pottery accrued more to women, indeed in some cases, to particular women. The process of rising above the group, however was not without its negative consequences and it sometimes gave rise to jealousies and conflict. Much of the writing on Pueblo pottery has been of a celebratory nature although a few writers have looked more critically at the social implications[13].

As we have seen the way that men became involved is unusual (in world terms) because it was not through new technology but through decoration. In the last 50 years, however, some men have become potters, not just decorators, and have perhaps been more free than women to experiment with new techniques and styles while maintaining their Native American credentials.

Pueblo potters have almost universally resisted the wheel although in recent years, as previously noted, a number have begun to use modern technology such as an electric kiln or a blowtorch. The definition of the product however remains instrinsically linked to handbuilding and, what are in many of the potters' minds, 'female' techniques of potting. In the Native American traditions this is grounded in ancient beliefs and respect for Mother Earth or Grandmother Clay. Handbuilding and the long hours of burnishing create a tactile closeness with the clay that many potters value. Bonfiring in its various forms is also a very direct form of firing; the fire is manipulated constantly, the pots pulled out while still hot or smothered in dung to achieve reduction and a black finish and then lifted out individually before the final polishing.

[12] This has since gone out of fashion. One older woman stated that her daughter had explained to her that this style was 'not good' and she had returned to earth colours.

[13] See, for example, Edwin L. Wade, 'Straddling the Cultural Fence, the Conflict of Ethnic Artists within Pueblo Societies', 1986; pp. 243–54 and Barbara Babcock, 'Marketing Maria', 1995.

Matriarchal lineages

Although there are now both men and women working as potters, the great families of potters have matriarchs at their head, with the skills being passed on from mothers to daughters, daughters-in-law, nieces and granddaughters. Potters sometimes relate that they talk to their (deceased) grandmother as they work. Many publications stress these lineages and the work is often seen as a familial business, although most potters identify their work individually.

Of the great matriarchs Maria Martinez (1887–1980) is undoubtedly the most celebrated although, unusually, she worked all her life with her husband, sons or daughter-in-law (she had no daughter). She learned pottery from her aunt at a time when the craft was waning at San Ildefonso and, with her marriage to Julian Martinez in 1904, she teamed up with an ideal partner. Their honeymoon was spent as demonstrators at the St. Louis World Fair which was the first of many such events that she participated in throughout her long life. Julian had already gained some recognition for his painting skills, and at a certain point they were invited to live at the Museum of New Mexico, mainly to demonstrate Indian crafts. During this period they were encouraged to experiment, in order to reproduce the black pottery that was found at archaeological sites. It was, howev-

Maria Martinez with a black on black plate with Mimbres feather design, 1950.
Photo Tyler Dingee, Museum of New Mexico, Archives neg. 73452

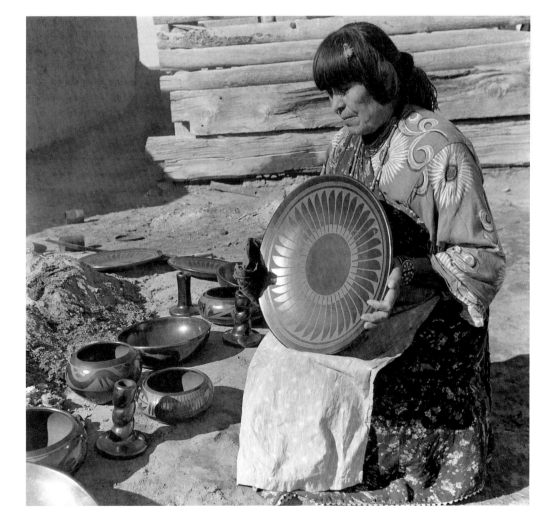

er, their new matt on shiny, black-on-black technique, developed around 1919, that was to ensure their pre-eminence, especially when decorated with Julian's elegant designs – such as the Mimbres feather or the *Avanyu* (water serpent) – inspired by ancient pottery motifs. The designs also corresponded to the fashionable styling of Art Deco. As a couple they were in close contact with leading figures in New Mexican society, including such influential taste-makers as Edgar Lee Hewett and Kenneth Chapman. Ruth Bunzel, one of the early scholars of Pueblo pottery, described Julian as 'a skilful painter and a man of considerable originality and sensitiveness to problems of design, he was a discriminating student and a receptive one...' Julian's role has been somewhat eclipsed, in part because he died (in 1943) so long before his wife. He suffered from alcoholism for many years although he recovered and, towards the end of his life, even became the Governor of the Pueblo. The emphasis on the female line has tended to confirm his secondary role.

Rather like pop stars, their fame overtook them and transformed their lives and those of the people of San Ildefonso. The village became more prosperous than most of the other Pueblos and the Martinez more prosperous than their neighbours. They trained many of the young girls in pottery crafts and it is well known that Maria would sign other people's work because it would then attract a higher price.

Maria Martinez became a world famous potter. She visited the White House on four occasions, was photographed with the great studio potters Bernard Leach and Shoji Hamada who sought her out when they visited North America together, won innumerable medals and prizes and was awarded honorary degrees. She became a living symbol of Pueblo culture and a revered ancestor figure for younger Pueblo potters.[14]

The other great matriarchal figure of the early period is Nampeyo (c. 1860-1942). Although she lived in the Hopi region, she was from the Tewa village of Hano where mainly plain pottery was made. During the last two decades of the 19th century there was a great upsurge of scholarly interest in the 'disappearing Indian' and museums were avidly acquiring examples of material culture including pottery (Kramer, 1996, p. 29). This collecting mania encouraged potters to revive old designs. At least as early as 1892 Nampeyo began to develop a new style based on ancient Sikyatki ware. She was further inspired after 1895 by the archaeological excavations directed by J. Walter Fewkes. Her work was immediately taken up by the traders at Keams Canyon Trading Post who in the early years sometimes passed it off as ancient pottery. Eventually her work became identified as 'Hopi pottery' more than any other. She was frequently invited to do demonstrations and received commissions from museums in the USA and Europe. Her image was used in publicity material for the railroad and her work was sold through the Fred Harvey Stores, with branches from New Mexico to California. She worked closely with other family members especially her daughters Annie and Fanny, and as she never signed pots it is often difficult to authenticate them.[15] Her success stimulated not just pottery among the Hopi but other crafts as

[14] There have been many books about Maria Martinez including two biographies (Alice Marriott, 1948 and Spivey, 1979). Susan Peterson wrote the first major book on her life and work in 1977. See also Peterson, 1997. For a more questioning discussion of her position see Babcock, 1995 and Vincentelli, 2000.

[15] For a discussion of some of the misunderstandings associated with Nampeyo's life, including the influential role of her brother Tom Polacca and her husband Lesso (whose role as a decorator is now generally questioned), see Kramer, 1996.

Nampeyo of Hano Jar.
Museum of Indian Arts
and Culture/ Laboratory of
Anthropology 12079

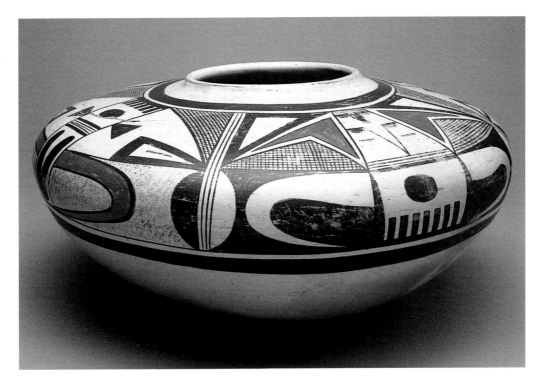

well, including basketry, Kachina doll carving and silver work. At least 40 members of her family work or have worked as potters.

As with Maria Martinez, the ramifications of Nampeyo's success were not without consequence. There were jealousies and resentments over the social inequalities created by the new prosperity and the increasing influence of the dominant Anglo culture. Hopis continue to have a guarded attitude to outsiders. In her study of pottery decoration and factions at Hopi, made after 1979, Wyckoff (1990) argues that ceramic decoration is an active component in the maintenance of difference in world views between 'Progressives', who have dealings with the Anglo-American world, and 'Traditionalists', who try to main-

Nampeyo poses with a
one of her decorated
pots at the entrance to a
kiva or underground
meeting room. Circa
1918.
Pitt Rivers Museum,
University of Oxford BB-
B3-216

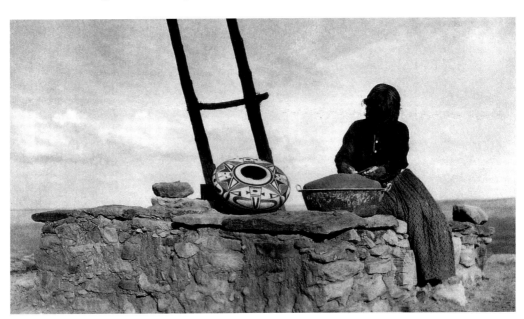

Rachel Sahmie, the great-great-great grand-daughter of Nampeyo demonstrates decorating with a yucca brush using paints she makes from rock material and boiled spinach plant. Boston 1999.

Photo M. Vincentelli

tain traditional religion and values and only make pottery for Indian consumption. Even the language they use for different designs changes; for the commercial market English is used while those for domestic consumption are identified in Hopi.

At Acoma the great potting families were founded by Lucy M. Lewis (c.1890–1992) and Marie Chino, who were especially noted for black-on-white geometric patterns and Mimbres revival designs. The sources of the fine white clay typical of Acoma pottery are still kept very secret and the temper is finely ground sherds. The recycling of old pots is seen as a way of incorporating something of the ancestral past. 19th century Acoma pottery was heavily influenced by the Spanish traditions of floral and bird patterns but Lucy Lewis began to look at pieces of ancient Chaco Canyon pottery, with its geometric decoration, and used that as inspiration. Unlike Maria Martinez and Nampeyo she had little contact with the Anglo milieu of World Fairs, museums or even tourists, and only began to show work in competitions after 1950. The latter part of the 20th century saw a huge expansion in production at Acoma. In 1910 there were 62 potters, all women, identified in the census; in 1991 there were 345, of whom around 35 were men, many working with their wives.[16] Catering for the collector's market has also meant that the potters produce wares which demonstrate the virtuosity of the maker. The walls are made so thinly that the piece could only be used as a decorative object – an *objet d'art* – or else the illusionistic surface pattern is incredibly intricate. The Acoma potters now often use electric kilns because it is so hard to achieve the unblemished surface perfection and whiteness in the traditional fires. It is all too easy to fake the look of traditional wares – even the unevenness of handbuilding. A considerable industry has built up around shops which sell slipcast pottery decorated in both traditional and modern styles using commercial paints and even combining these with decals or transfers. Potters sometimes work together decorating the 'greenware' in workshops connected to the commercial outlets. Just as the early tourist items, such as Cochiti figures, have been reinstated in the canon of Pueblo pottery, some of these souvenirs which are today's kitsch may be tomorrow's collectable. Not surprisingly, there are considerable tensions between the potters over production methods.

[16] These figures are taken from the appendix in Rick Dillingham's excellent study of Acoma and Laguna Pottery. In his final chapter he writes with insight and circumspection about the relationship between Anglo and Pueblo cultures.

Lucy Lewis Jar with black on white geometric decoration
Museum of Indian Arts and Culture/ Laboratory of Anthropology 49555

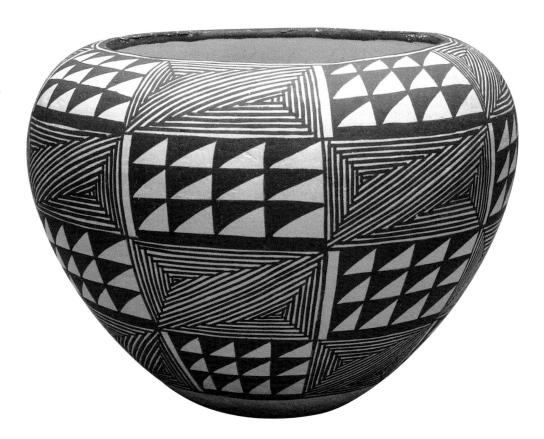

At Cochiti Helen Cordero (1915–1944) developed the 'Storyteller' tradition which has become the basis of a flourishing market, discussed more fully in Chapter Ten. At Santo Domingo the matriarch was Santana Melchior (who died in 1978) while Serafina Tafoya and her daughter Margaret developed the carved black pottery of Santa Clara in the 1920s. There are five generations of potters in this family, including Joseph Lonewolf and his daughter Rosemary. They are still noted for carving clay but work in miniature forms using figurative imagery based on popular legends. In the Naranjo family, also of Santa Clara, a number of the younger generation have moved into figurative ceramic sculpture.[17] (See Chapter 10.)

Pueblo women nurtured their pottery skills with great success through the 20th century, adapting to new markets and opportunities. Any comparison of modern with older pieces demonstrates the way they have become more refined: the walls thinner, the lines smoother, and the surface shinier. Until the early part of the 20th century, many other Native American groups had made pottery, but mainly utilitarian wares for cooking and water storage. As these basic functions were overtaken by modern conveniences the production declined rapidly. Plain cookware was difficult to sell – even as an 'Indian' tourist novelty, and it is the decorated and highly refined pottery that has catered for a collectors market.

[17] Nora Naranjo Morse, Roxanne Swetzell and Jody Folwell, all part of the same family, have worked in various contemporary modes (see Peterson, 1997).

Hand-painted photograph of a Kumeyaay potter, Wass Hilmawa, 1928.
San Diego Museum of Man, Photo Frederick Rogers

Native American Potters in California

Women of the Californian native groups are noted for their superb basketry which was used for storage and carrying and was so fine it could hold liquids. This may partly explain why they took up pottery relatively late, around 1450AD. They used two techniques: they coiled pottery in a similar way to Pueblo groups, and they worked with a paddle-and anvil system. This technique was used in much of the eastern USA in prehistoric times and continued to be employed by Native American groups in Canada, the eastern USA and in North-west Mexico. If the paddle was not used for decorating but merely for smoothing, the technique is difficult to distinguish on the outside of the pots, but on the inside the slight circular dents from the anvil can usually be felt.

One of these Californian groups, the Kumeyaay[18], a branch of the Yuman, were seasonal hunter-gatherers who also undertook a little agriculture and fishing, moving to regular campsites at different times of the year. The culture was largely fragmented by the latter half of the 19th century, surviving to an extent on reservations. Unusually for nomadic people they made pottery, which was an important aspect of female culture.[19] Women were very particular about their sources of clay and often travelled long distances to deposits they knew. As the knowledge was handed down from mother to daughter these were likely to be from the area where a woman had been raised rather than her husband's territory. Clay was also traded as a valued commodity.

Pots were begun from a flat pancake of clay spread over a basket as a mould or another pot or even the potter's knee. When the piece was paddled to an appropriate degree and slightly dried, it was removed from the mould and finished by coiling and further beating out with paddle and anvil. The paddle was a square or oblong piece of wood while the anvil could be a rounded stone, a mushroom shaped clay form or even a shell or basket. The rim was trimmed with a piece of string or agave fibre but the potters might also use their mouths to trim the edge. The firing, which took place in a hollowed-out pit on the sheltered side of a hill, was fuelled with oak bark, yucca or mesquite and, by the 20th century, cattle dung.

Apart from a range of vessels including multi-spouted and double jars, bowls and parching plates, the Kumeyaay also made pipes, rattles, figurines and miniature vessels. These figurines and miniatures may have been toys or may have had some ceremonial function for the dead. Mainly the surfaces were left plain but some had graffiti-like decorations.

[18] The information in this section is drawn from Gena R.Van Camp Kumeyaay Pottery, Paddle and Anvil Techniques of Southern California. 1979

[19] Other nomadic hunter gathers who had pottery include the Anadamanese and Vedda of SE Asia, the Ingalik and Baffin Island peoples and many groups in South America (see Murdock, 1973).

Eastern USA

In most of the Eastern USA, native American pottery is less significant in the Historic Period; no doubt there was a ready availability of alternative pottery or containers. An Iroquois pot from around 1550 shows a refined technique and elegant form which demonstrates the survival of knowledge from the pre-Historic Period, but the Indian women of the Eastern Seaboard developed basketry, beadwork and quillwork rather than pottery. In the South, however, the Cherokee and the Catawba continued to make mainly plain or burnished cooking pots. In the South-East there was a level of intermarriage between the different cultures – black, Native American and Anglo which brought about new visual art forms, such as the patchwork quilt of the Seminole and also created some cultural interchange in pottery.[20] Catawba women of North and South Carolina were noted for their pottery and produced cookware, decorated pipes and double spouted 'wedding vases'. They pre-fired the pots in a domestic oven before laying them on the embers and then piling more fuel on top with a final covering of pine chips. The reduction effect created a dark brown lustrous finish.

Navaho Pottery

Pottery was never a significant Navaho craft although small amounts had been produced for domestic or ceremonial use. In the 18th and 19th centuries, Navahos often used Pueblo pots, and in the 20th century they were able to purchase mass-produced utensils. Navahos were tightly controlled in their use of traditional symbols and imagery so there was limited scope for developing more distinctive ceramics. However, the huge commercial success of Pueblo potters, the opening of new roads and the burgeoning of the tourist industry, especially around the Grand Canyon, stimulated the demand for modestly priced crafts after the mid-20th century. Ceramics, beadwork and even sand painting began to be produced for the new market although textiles and silver have always been the most valued crafts. The pottery produced by Navaho women seems almost deliberately 'primitive', with simple shapes decorated with appliquéd motifs, sometimes of animals such as frogs or lizards. The work is finished in a distinctive way with hot pitch from pinon trees, which gives it a warm dark brown colour. Most of the potters are part of the Lok'aa'dine'e Clan, an extended matriarchal family. Alice Cling (born 1946–) is the best known of the traditional potters, noted for work of an elegant shape and highly polished finish. However, some women of Navaho descent, such as Christine McHorse or Lucy McKelvey, have developed a contemporary ceramic practice nourished by their roots in Navaho culture (see Peterson, 1997).

[20] See Chapter 7.

*Iroquois Pot c. 1550
found by the Sacandaga
River.*
Courtesy of the New York
State Museum, Albany New
York

Conclusion

In historic times Native American women have been central to ceramic work and the evidence suggests that they always were. Certain conditions, however, allowed men to enter into the activity: in the decoration of ceremonial or burial wares; in the case of the *berdache* and, above all, with the economic incentive that grew in the 20th century. The late introduction of wheel and kiln technology, the relative separation of colonial and Native American societies, and the high quality of Pueblo ceramics ensured the tradition's survival. The enduring symbol of Native American crafts has been the woman with the pot – a signifier of the benign 'other', an image produced for the consumption of the dominant (Anglo) culture but in turn re-endorsed by Native Americans themselves. It is an image of unchanging tradition that belies the transforming reality of Pueblo life. The 20th century saw a flourishing of ceramic art, embracing the traditional values of social stability and fine craftwork while at the same time responding to the changing visual tastes of the Anglo consumer, from Art Deco through to Op art and Post Modernism.

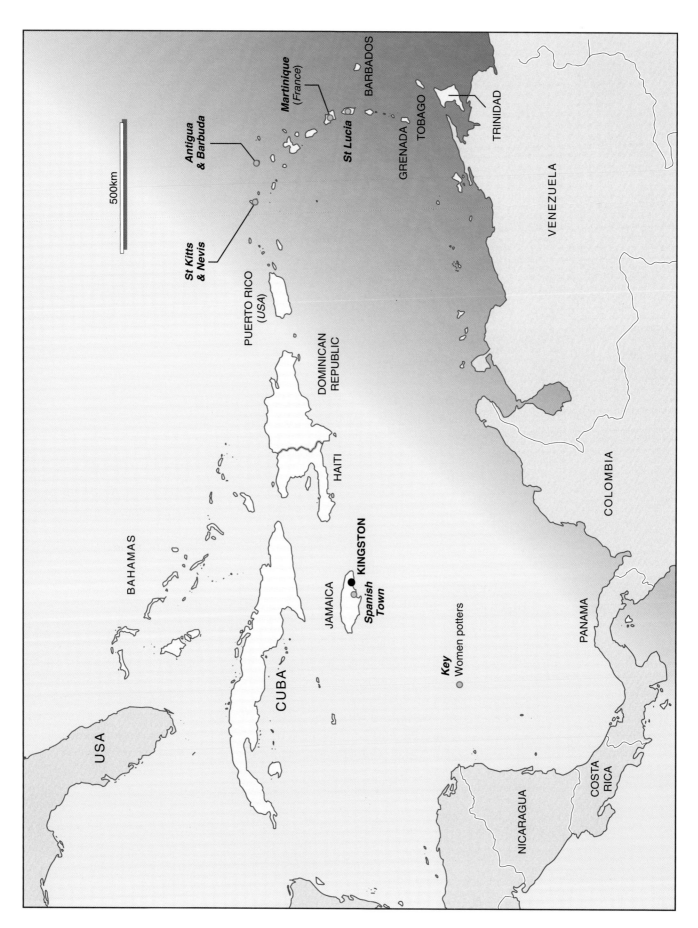

500km

Martinique
(France)

BARBADOS

Antigua
& Barbuda

St Lucia

GRENADA

TOBAGO

St Kitts
& Nevis

TRINIDAD

VENEZUELA

PUERTO RICO
(USA)

DOMINICAN
REPUBLIC

COLOMBIA

HAITI

BAHAMAS

KINGSTON

Spanish
Town

JAMAICA

CUBA

USA

PANAMA

Key
Women potters

NICARAGUA

COSTA
RICA

WOMEN POTTERS AND GENDER ROLES AMONGST CARIBBEAN AND AFRICAN-AMERICAN PEOPLES

The first inhabitants of the Caribbean

THE EARLIEST inhabitants of the islands of the Caribbean came from Central America around 4000BC, while other waves of settlement moved across from South America through the chain of the Lesser Antilles. Among these were the people identified as the Arawaks and now known as the Saladoid (and later Ostionoid) who began to settle after 500BC. They were agriculturalists whose cultural traditions included the ball court[1] and the production of fine craftwork in basketry, feathers, stone and ceramics. They made plain domestic pottery as well as more elaborate modelled ceramic objects with painted or engraved decoration. These peoples were the ancestors of the later cultures, known as the Taíno and the Igneri who settled in all the larger islands including Puerto Rico, Hispaniola, Jamaica, Cuba and the Bahamas. Although for a period their ceramics declined, after AD900 the Taíno developed elegant ceramic forms for both utilitarian and ceremonial purposes.

Taíno culture flourished between AD1200 and AD1500 and was recorded by early colonisers by the mid-16th century but was very quickly extinguished through conquest and disease. The Taíno lived by fishing, hunting and agricultural work and enjoyed a rich ritual life led by a privileged group of chiefs, artists and shamans. Their cosmology was dominated by *zemis*: gods who were embodied in small three-cornered images made of stone, wood, bone, cotton and clay. These were used both in household contexts and by *caciques* or chiefs. It was a matrilineal society and some women held considerable power as *caciques*, or as their close relations. A female chieftain presented Columbus' son with gifts (Bercht et al (ed.s), 1997, pp. 65–66). Women were also participants in the ball games and were producers of some of the range of

[1] A game played with a rubber ball in a large rectangular space. Participants were not allowed to use their hands or feet. The game was a central focus of cultural life for many Native American groups in South and Central America and in the Caribbean.

fine craft work including the carved seats or *duhos,* symbols of power and authority.[2]

It is well-documented that pottery was a female craft. The pottery is distinguished by its refinement and flowing sculptural forms, sometimes with incised designs which suggest a ritual significance. Vessels often have an ovoid profile with modelled lugs marking the widest parts.

Taino vessel from the Museum of Jamaica. Circa AD1400, 31 cm (12 in).

Photo A. Vincentelli

Colonial period

Although the indigenous cultures were so quickly destroyed after European contact (often within a generation), vestiges of their languages and cultural forms were preserved in the island cultures of the succeeding centuries. The craft skills and traditions, however, largely disappeared. The early introduction of slaves from Africa, led to intermarriage between indigenous peoples, Europeans and Africans, giving rise to a complex mix of traditions.

Early Europeans would have had access to imported domestic utensils but the women of African origin were able to reactivate their ceramic skills where they could find clay. In the new society all high status ceramics would have been imported, but handbuilt pottery was preserved through domestic use, presumably made by women of African descent. In the 18th century Hans Sloane recorded that 'all Negro houses' have a Pot of Earth'.[3] Excavations at the Old King's House, Spanish Town, Jamaica have shown a range of handbuilt pottery jars and bowls alongside imported European ceramics. The locally made pottery would have been used in the kitchens and servants quarters of even the grandest houses (Matthewson, 1972, p. 55). Apart from adaptations such as flat bottoms and handles, the forms and decorative touches suggest African pottery. A few examples of thrown and glazed pots indicate there may also have been some local workshops.

This kind of industry would have developed to serve the parallel economy of the slaves. The plantation owners encouraged slaves to grow their own food and even develop artisan crafts that could occupy them when they were not needed for work in the fields. As the workload was seasonal it helped if they could be more self-sufficient and not entirely dependent on the plantation owner. Slaves usually did not work on Sundays and sometimes not on Saturday afternoons. In Jamaica – despite the fact that slaves were not supposed to barter or make money – an alternative market grew up creating extended networks of economic support that were ripe for expansion after emancipation (Mintz and Hall, 1960). Pottery was just one of the products that benefited from this system.

[2] It is unusual for women to work in wood but there are early European accounts that some duhos were made and owned by women (Bercht et al (ed.s), 1997, p. 46).

[3] Hans Sloane toured Jamaica in the early 18th century and recorded, 'The Negro houses are at a distance from their Masters, and are small, oblong thatch'd Huts, in which they have all their Moveables or Goods, which are generally a mat to Lie on, a Pot of Earth to boil their Victuals in, either Yams, Plantains or Potatoes, with a little salt mackerel, and a Calabash or two for Cups and Spoons' (Sloane, 1707, p. xlvii, quoted in Heath, 1991, p. 33).

In general, the craft skills of the slaves were considered of little value although blacksmithing in the Caribbean seems to have drawn usefully on the skills of African artisans. Pottery workshops were set up from as early as the 17th century, apparently to supply the specialised needs of the new slave economy – namely, the sugar industry. In Barbados the original potters were brought from Bristol, one of the main ceramic centres in the 17th century and an early slave-trading port. There were estates on Barbados, Trinidad and St Lucia which employed specialised male potters to make sugar pots[4] (Higman, 1984, p. 172), although they were also produced in Bristol for export. European plantation owners would have been unlikely to think of training slave women even if they did know they could make pottery.

Barbados

By the early 19th century a thriving cottage industry of pottery production had developed in Barbados. Individual men with their own wheel and kiln were supported by family members; they made 'goglets' (long-necked vessels for storing water), 'monkeys' (a kettle shape for storing water) [5] and 'cornarees' (for storing food). The pots were marketed by the womenfolk who travelled long distances on foot to sell their wares. The archive records indicate that these 19th century potters were black which suggests that the plantation potteries were probably originally worked by specially trained male slaves. The industry waned rapidly between the 1930s and the 1960s.[6]

Other Islands

In Barbados the existence of wheel and kiln technology in pottery production had probably long superseded the female tradition of making. Elsewhere in the Caribbean it was different. In all cases it appears to be the African tradition, rather than the earlier indigenous tradition that survived, albeit modified by European forms. In the late 20th century there were small groups of women potters in Newcastle pottery, Nevis, in St.Anne, Martinique, in Spanish Town , Jamaica and Sea View Farm, Antigua. The largest pottery community, however, is in Choiseul, St Lucia where up to 60 women make and sell a range of goods including coalpots (charcoal braziers), cooking pots, flower pots, kettles, (popularly known as 'monkey' pots), basins and figurines[7].

[4] These were conical jars perforated at the bottom to allow the molasses to drip out leaving the sugar. This was exported in its dry form (clayed sugar or Muscovado sugar) while the molasses was separately exported in hogs heads.

[5] Monkey pots were also a well-known form in Southern Carolina and there too were made by black male potters who had been trained in the workshops where they learned to throw and use kilns. See below note 13.

[6] For further information see articles by J.S. Handler 1963 and 1964.

[7] For these figures I am grateful to Patricia Fay who has worked extensively on potters in the Caribbean.

Julie Hector, Antigua selling miniature versions of traditional forms.
Photo David and Pat Williams

In 2000 the publicity leaflet for the Pottery Shop at Redcliffe Quay, St John's, Antigua, advertises 'a fine selection of hand made pieces from the small but growing community of potters on the island'. Underneath the display of glazed decorative pottery Julie Hector shows scaled down versions of traditional Antiguan pottery directed at the tourist market. There are now only about five potters at Seaview Farm, the pottery village of Antigua, but in 1962 there were 20, all women. Typical forms of ware produced here are 'coal pots' – 'monkey' pots, bowls and plates. The potters use a wooden board as a base and pull up the sides and shape the form, paring down the surface with a calabash and smoothing with a rag to finish. The piece is then covered with a red slip and bonfired using wood and layers of grass.

Nevis

Nevis[8] by the 1980s was an all black community whose economy was based on plantations of cotton, tobacco and bananas but they still looked to Britain as the mother country. A female pottery tradition had survived into the 20th century and had found a patron and promoter in Maude Cross, the headmistress of the Anglican school. She recognised the potential of craft work to support the island economy. In the 1980s potters from North America had also acted as advisors.

By 1986 there were still about 12 women working, although previously the number had been far higher. One of the important forms they made were 90 cm (3 ft) high water coolers, but by the mid-1980s they mostly made smaller pieces. They exported some pottery and had been encouraged to expand their repertoire of bowls, cooking pots, coalpots, plates, mugs and kettles to include more decorative work; for the tourist market they made animal models such as cats or pelicans.

[8] For the information on Nevis I am grateful to Lynne Bebb who in 1992 recorded an interview with Chris Kinsey who spent some years on Nevis in the 1980s and worked with the potters. See also Karen Fog Olwig 1990.

Their menfolk were enlisted to collect the clay from the mountains using donkey transport. Temper was not used, but different types of clay would be mixed together to form the paste. The women worked in their yards, sitting astride a narrow bench[9] to manipulate the clay which was pulled up and pressed out between the hands using a piece of rag and a flat stick. The final stage was a careful burnishing with a special pebble; one potter recounted she had used one that had belonged to her great-great-grandmother. Pieces would be left to dry first in a shed and later outside in the shade, then laid on a layer of coconut shells, and covered with banana palm leaves for the firing which held up to 60 pieces at a time. The bonfire was fired in the day, but was allowed to cool overnight and unpacked the following morning. The system was very efficient, with few losses, and the pots emerged a strong red colour, sometimes with smudges which were accepted as part of the surface effect.

Jamaica

The history of pottery in Jamaica is one that reflects many of the issues that have been addressed in the first part of this chapter. There is some evidence that, by the 18th century, wheel-thrown pottery had been introduced in relation to the plantation economy. It does not seem to have gained the same foothold as in Barbados, however, and it was the female African-Caribbean tradition that was the main source of island-produced pottery in the early 20th century. There are two distinct systems of handbuilding in Jamaica: one based on coiling in a ceramic saucer or *keke*; the other pulling up while walking around the pot and normally combined with firing in an open circular kiln. It was women using the latter technique who taught Cecil Baugh (born 1908), the veteran studio potter of Jamaica, when he first wanted to learn the craft. At that time there were many potters working in three different areas in the clay-rich Liganea Plain between Kingston and Spanish Town, a distance of around twelve miles (19 km). These potters, mainly women, supplied the needs of the island.[10]

One potter in particular gained a distinct personal reputation: Ma Lou (Mrs Louisa Jones) (1913–1992). She was brought up in the Wynters Pen area of Spanish Town where there were many potters. Her mother and her aunts were all potters and she began making pottery at the age of eight, having had very little schooling. Her main production was *yabbas*, round-bottomed cooking pots. Although she sometimes supplemented it with other activities, the work brought her a reasonable income until the early 1950s. With the introduction of aluminium cookware and stoves the demand dropped rapidly, and between 1954–7 she gave up potting altogether. She took it up

[9] This bench sounds remarkably similar to the duho, or ceremonial stool, of the Taíno tradition.

[10] Baugh himself is one of the key figures in the history of Jamaican pottery. Having been trained to handbuild as a young man, he later took up throwing, a technique he learned during a year in 1948–9 spent with Bernard Leach at St.Ives. He set up the ceramics department of the Edna Manley College and trained many young Jamaicans as studio potters. He always had a high regard for the indigenous tradition and even demonstrated the traditional 'pulling up' method for a BBC programme during his stay in England.

Above Yabba *made by
Ma Lou, Jamaica.*

Right *Ma Lou's pots for
sale. Marlene Roden's
house near Spanish
Town, 1999.*

Photos A. Vincentelli

again three years later after a 'vision' and managed to keep producing, even training some of her daughters. By 1984 there were only three potters left.

In the latter years of her life Ma Lou's reputation spread, helped by the publication of a number of articles on her work in Jamaican and international ceramic publications, and the increased government support for the crafts.[11]. Accompanied by Cecil Baugh she visited the USA and demonstrated her skills. She became *the* traditional Jamaican potter. Since her death, her daughter 'Munchie' has carried on the work but by the end of the century she was not finding it easy to make a living.

Marlene 'Munchie' Roden

Ma Lou's daughter, Marlene Roden or 'Munchie', as she is always known, lives in the low-lying suburban sprawl that lies on the edge of Spanish Town. The traffic trundles noisily down the rutted road with its houses on either side, until you park opposite a corrugated iron fence which announces in bold graffiti, 'Ma Lou's Pots on Sale', although her mother has been dead for some years. The house is set back from the road with a yard at the front and a grassy area beyond. On the side of the living quarters are two recently constructed sheds paid for with a government grant and filled with pottery.

Munchie digs the clay from her own land and mixes it with a considerable quantity of sand which she also finds locally. She sits on a low stool and, starting from a pancake of clay flattened out in the palm of the hand, she builds the pot on a balanced upturned clay saucer. The sides are pulled up with soft clay squeezed through the hand, pulling up the shape as it turns. A circular metal tool and a piece of gourd are used to hollow out the shape and scrape down the outside. The pot is left to dry, usually for at least 24 hours, then it is smoothed down using a stick and eventually covered in a red haematite

[11] The Jamaican Government set up the Bumper Hall project and Cottage Crafts Ltd.

slip found locally. The final stage is the burnishing, which takes a considerable time. Munchie has a number of polishing stones but her favourite and most treasured one is that which belonged to her mother – a familiar story. Before firing the pottery has to be dried out well which normally takes a few days. The firing takes place in the yard where the pots are placed on a bed of sticks and covered over with pieces of wood and any other combustible material available. Once firing begins, the pots are judged to be ready when they glow red. At the firing that I witnessed this took about 40 minutes, after which the pieces were immediately removed from the fire and dusted down to bring out the sheen on the bright orange-red pots, with occasional black firing marks.

Effective marketing is difficult. There is a small amount of passing local trade but otherwise the work is sold through small tourist outlets such as those in the centre of Kingston. Here the work is presented under the name of Ma Lou as if she were still alive. The name is clearly the sales pitch.

Munchie finds herself in a dilemma. She makes functional wares that are no longer needed for the purpose for which they were designed. Her method of working – the distinctive quality of her work which is potentially marketable – is not clear at the point of sale. You have to know about it, see it demonstrated or have it explained. The shapes of her pots are elegant and generous but the thick walls and the undecorated rustic quality make them hard to sell in the gallery context. Limited capital means that transport is relatively expensive, and more sophisticated marketing is beyond the potter's resources. Without more support it is unlikely that this pottery will survive into the next generation. Interestingly, it was not her young daughter who helped when required but an older son in his early twenties. Somewhat sheepishly he helped with both the polishing and the firing. He was smartly dressed, with clear aspirations to a more elevated lifestyle. The life of the potter held little attractions for this young man.

Although so close to the capital, Spanish Town is now an all black community that is not an easy place for tourists or outsiders to penetrate. The crumbling villas and classical grandeur of the Governor's palace in the central square, only partly restored, are witness to the remnants of a very different time in Jamaican history when colonial values offered much simpler solutions to social arrangements. The fenced-off tourist developments on the north of the island bring few spin-offs to these people and the faltering Jamaican economy is caught in the spiralling trap of debt, poverty and the world drug trade. Such a setting is not one that bodes well for either the traditional or the modern potter.

Cecil Baugh recalled that already in the 1920s there were some men working with the women and, in the latter half of the 20th century, another form of pottery production developed in Jamaica: the increaisngly popular 'flower pots' or planters used in houses, patios and gardens. Around Kingston these are sold by the roadside and, in some cases, from workshops where they are thrown and kiln-fired. However a large proportion of the pots are still made by the fast form of handbuilding where the sides are pulled up (rather than coiled) and then boldly crimped and given simple decoration. They are kiln fired. There are about one hundred potters, many interrelated, who work in the Trenchtown area of Kingston. They are loosely organised by Mrs Pearl Richards. Ebanks (1984) has identified them as 'syncretic', in that they combine two traditions – the female handbuilding system and the male thrown/kiln-fired wares found, for example, in Barbados; however both the walkaround technique and the low-walled kiln may be of African origins. Much of this pottery is produced by Jamaican Rastafarians whose philosophy

Series of images showing Marlene 'Munchie' forming a pot.
Photos A. Vincentelli

OPPOSITE PAGE
Above Left *Smoothing with a paddle*

Above Right *Range of Munchie's pots showing jars, bowls and a 'monkey'. The sprouted vessel with a handle and lid is used as a water cooler.*

Below *Munchie burnishing and Cecil Baugh looking on.*

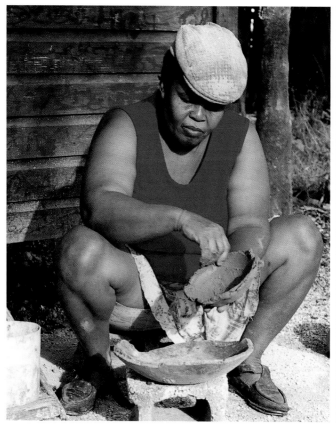

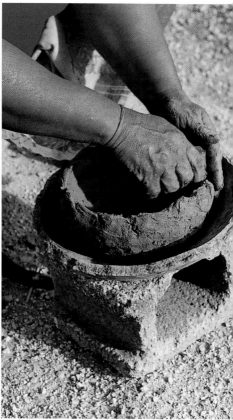

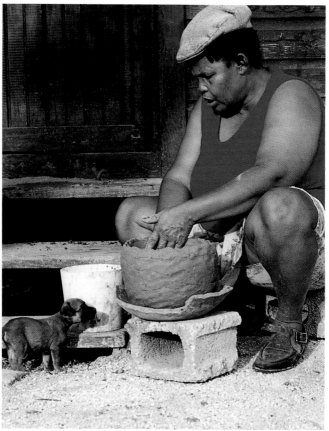

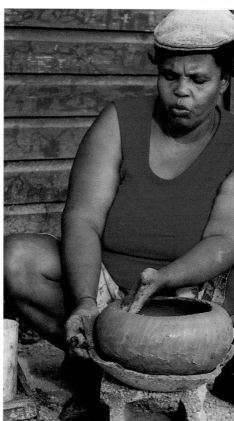

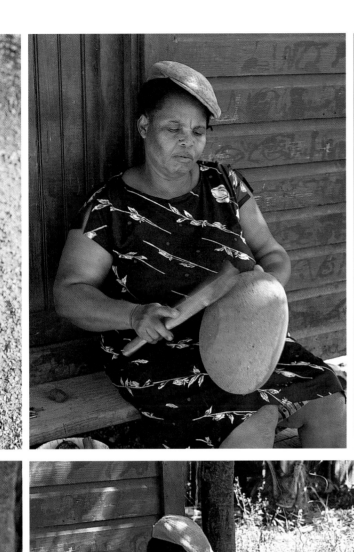

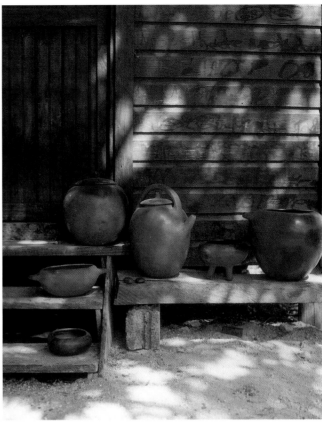

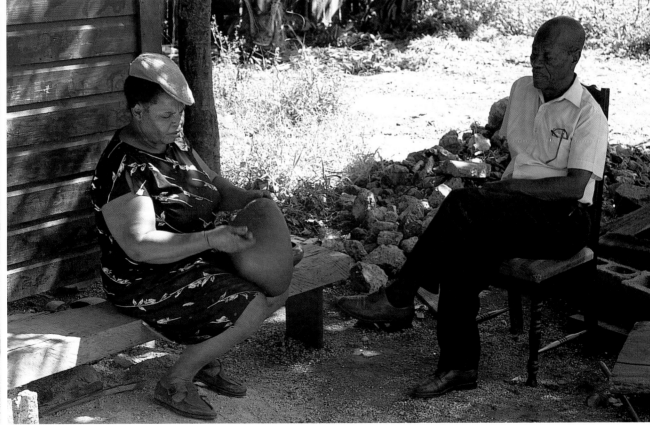

Pots by the roadside in Kingston, Jamaica, 1999.

Photo A. Vincentelli

espouses hand-crafting, low-technology and African traditions. Their choice of hand-building is a political choice. The buoyant market for large planters is not one with which a handbuilder working on her own can easily compete, which is Munchie's predicament.

African-American Pottery

The final part of this chapter examines how women potters brought to North America as slaves may have continued to practice their craft. From the 17th century African slaves were brought into the Eastern parts of North America to work in plantations. They lived in large 'black' communities, with relatively little contact with their masters. As already indicated, it suited the owners well that the slaves were relatively self-sufficient in providing their own food and material needs. Archaeological evidence suggests that slave women in rural areas re-created as much as possible of their old lifestyle and, most significantly, their types of food and ways of eating. Typically they ate from wide serving bowls used for dry foods such as rice, a crop introduced from Africa. Eating in an African style, utensils were not necessary, as people used their fingers to pick up the staple which was then dipped in the sauce or relish made from vegetables and a little fish or meat. Thus characteristic ceramics were large cooking pots for boiling rice, smaller ones, sometimes with a handle, for cooking sauces and vegetables and wide bowls for serving. Known as Colono Ware[12], these ceramics represent up to 70% of the pottery recovered in excavations of slave quarters (Ferguson, 1991, p. 31). Preservation

[12] In the past this has often been assumed to be pottery made by Native Americans.

of the old (African) traditions and crafts would have the potential to comfort in times of cultural loss and would have been an unconscious signifier of resistance to the oppressive, dominating culture. Thus there is good evidence that in the early years of slavery in North America, domestic pottery continued to be made by women, although it is largely undocumented. By the 19th century pottery making had almost died out but in the far south, the intermarriage of Catawba Indians and African-Americans is an example of the way that two women's traditions could come together. It is well-established that itinerant Catawba Indians supplied unglazed cooking pots to households of all types in the 19th century.

Much better known than the women are the black male potters of the Edgefield district of South Carolina, who were trained as 'turners' or throwers in 19th-century workshops producing high-fired stoneware. Planters from Barbados are known to have settled in South Carolina and this may account for further connections between these centres. It has also been noted that among the last groups of slaves to arrive in North America in 1858 were people from the Kikongo, an area in Africa where, unusually, both men and women made pottery[13]. Women also worked in the Edgefield potteries but had subsidiary roles. Among the most intriguing forms produced in these workshops are the unusual face jars and 'monkey' pots (see p. 129) which, it has often been suggested, carry memories of African forms.[14] The practice among some African-Americans of placing around a grave ceramic and glass objects associated with the person is also something that suggests memories of older African practices. Thus we can see how pottery was a vehicle for communicating across time and preserving vestiges of older cultural traditions distantly remembered but deeply imprinted in the memory of people transported across the Atlantic.

Conclusion

Much more research needs to be done in this area of history. It may well be impossible ever to establish the way African, and therefore mainly female traditions of pottery production, were absorbed into the new cultural mix of colonial Caribbean and North American culture. The techniques used by the women potters of the Caribbean Islands are remarkably close, and have either been cross-influenced or derive from an earlier African tradition. The pottery is unlike that of the Arawak/Taíno people. Although there are many different West African techniques, the system of pulling up the walls is quite common. The humble nature of the cooking pot, its simple and relatively undecorated form, and the marginalised social position of its makers, namely slave women, have not encouraged much scholarly consideration. Nevertheless they are an important part of women's history.

[13] One of the last slave cargos to arrive in Georgia landed in 1858. Most of the slaves came from the Kikongo area (Central Africa) and many were settled around the Edgefield District in South Carolina. (See Vlach, 1978, pp. 87–8).

[14] Other sources for these 'face' pots, sometimes known as voodoo pots, is African wood carving but also, possibly, Toby jugs which were themselves known to have inspired African sculpture (Baldwin, 1993, p.81).

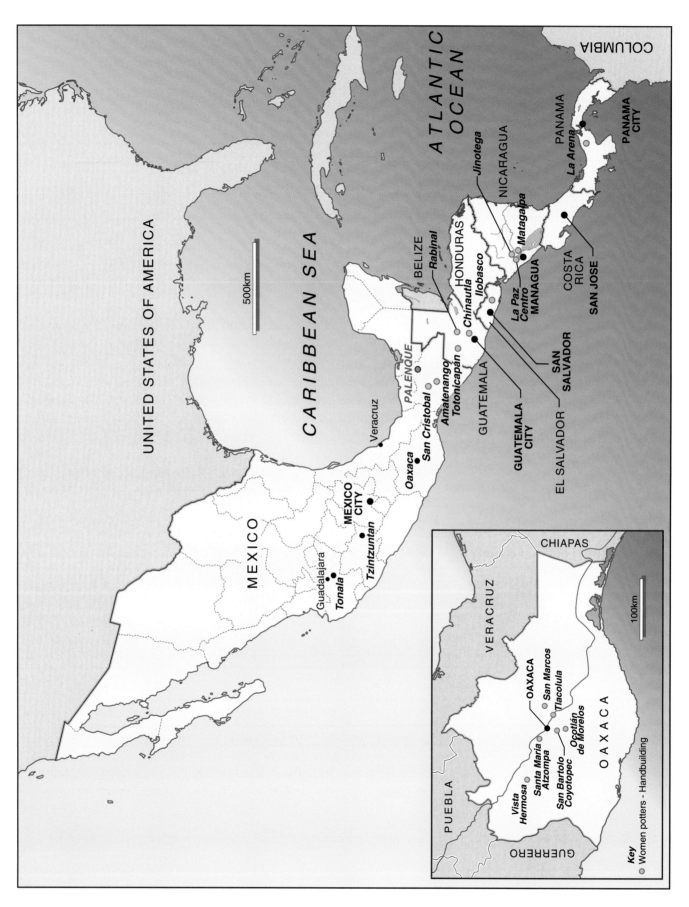

ATLANTIC
OCEAN

COLUMBIA

CARIBBEAN SEA

UNITED STATES OF AMERICA

500km

MEXICO

Guadalajara
Tonala
Tzintzuntan
MEXICO CITY
Veracruz
Oaxaca
San Cristobal
Amatenango
Totonicapan
PALENQUE

BELIZE
Rabinal
HONDURAS
Chinautla
Ilobasco
Jinotega
NICARAGUA
Matagalpa
La Paz
Centro
MANAGUA
PANAMA
La Arena
PANAMA CITY
COSTA RICA
SAN JOSE
EL SALVADOR
SAN SALVADOR
GUATEMALA CITY
GUATEMALA

CHIAPAS

VERACRUZ

PUEBLA

GUERRERO

OAXACA

OAXACA
San Marcos
Tlacolula
Ocotlán de Morelos
Vista Hermosa
Santa Maria Atzompa
San Bartolo Coyotopec

100km

Key
Women potters - Handbuilding

132

WOMEN POTTERS AND GENDER ROLES IN MEXICO AND CENTRAL AMERICA

I N 1770 Archbishop Cortés y Larraz visited Mixco, a small town or pueblo only six miles from Guatemala City, whose main business was pottery production:

> All this work is done by women. They prepare the clay, form pieces without the (potter's) wheel, paint, and fire them without a kiln, and they turn out beautiful, decorated, well-fired vessels. The men have no other participation than to take the vessels to sell, and with this they meet all the household expenses.
>
> (Cortés y Larraz, quoted in Reina, 1978, p. 42)

The pottery industry in Mixco had a defined historical span. In 1951 there were only a few women still making pottery in Mixco and by the mid-1970s there were none. The pueblo was established in 1525 by a group of Pokomam people forced to resettle after the Spanish had destroyed their main political and religious centre. Those who settled there must have found good clay for, by 1648, Thomas Gage, an English Dominican, recorded that pottery was their main activity: 'Those Indians show much wit, and paint them (the pots) with red, white, and several mingled colours, and sell them to Guatemala, and the towns about' (Reina, 1978, p. 42). By the late 20th century the increasing cost and difficulty of collecting fuel, and the proximity to the capital city and its job opportunities for women, were probably among the main reasons for the demise of the industry.

Even so, an indigenous community had managed to survive a major upheaval in the early post-Conquest period, maintaining its language and craft traditions through to the mid-20th century in spite of close contact with Spanish culture. There are many similar examples. Survival into the early 21st century requires constant adaptation.

In Mexico and Central America women are still major producers of ceramics and almost certainly have been so since earliest times. After the Spanish conquest a complex mix of gender roles in ceramic production developed, which may have reflected some aspects of roles in the pre-Conquest period. What evidence do we have of these?

OPPOSITE PAGE
Mexico and Central America: countries and places mentioned in the text

Pre-Columbian ceramics

The ceramics of ancient Mexico and Central America are among the most spectacular of any culture, with a diverse range of forms from simple utilitarian wares through to jars, pedestal vessels, footed bowls, spouted jugs and animal-effigy vessels, as well as an enormous range of figurine and animal sculptures. Most of these wares are finely potted and many are richly decorated.

It is frustrating that there are no images of potters or any descriptions of indigenous pottery from the time when the very specialised ceramics were still being produced. Accounts, like the one already discussed, are from later periods and record women making utilitarian pottery, which was always given recognition for its fine qualities. By contrast, other crafts such as jewellery making, weaving and architecture were recorded and even illustrated in early texts relating to Maya and Aztec cultures. Why are potters never recorded or depicted? The absence suggests that pottery was neither a very visible activity nor a prestigious one. This would support the likelihood that pottery was made predominantly by women and that it was produced in communities away from the major cultural centres.

All the ancient cultures of Central America produced an abundance of pottery; many constructed monumental architectural structures and carved stone. Of these the Mayan civilisation was the most enduring. It flourished in the area roughly corresponding to the present day Yucatan Peninsula (Mexico), Guatemala, El Salvador and Honduras. The Classic Maya period dates from AD300 to AD900; its influence was still strong centuries later but its highpoint was long over by the time of European contact. It was one of the most sophisticated ancient societies with extensive knowledge of astronomy, astrology, building technology, irrigated agriculture and a high level of art and craft skills including papermaking, elaborate painting and hieroglyphic writing. The major Mayan sites were the administrative centres where a rich ceremonial and ritual life was played out against a backdrop of monumental architecture. Buildings included stepped pyramid structures, wide plazas and ball courts – the steep-sided rectangular arenas where the sacred ball game was played. The main population was dispersed, living in small villages and practising slash-and-burn maize agriculture.

Few workshops have been found in the main administrative centres and the writing does not suggest accounts or taxes, thus there is little evidence that they were central points of production or trading. Scribes and painters were among the elite who inhabited these towns but other crafts, including pottery, seem to have been produced in specialist villages. Ordinary pottery found in the ceremonial centres of Tikal and Palenque has been shown to come from places up to 20 km (13 miles) away. Mayan ceramics include large amounts of utilitarian pottery but are most noted for a range of polychrome and monochrome serving vessels, including plates and cylindrical forms which are a vehicle for elaborate painted, and sometimes carved, decoration. Many cylindrical vessels have hieroglyphic texts alongside the illustrative designs. These ceramics must have been decorated by specialist scribes or artists; they would have been presentation items for ceremonial occasions and were probably also commissioned for funerals, to be included in burials.

For handbuilding some Maya potters used a *kabal* – a simple turntable system – but

they also used pressmoulds for figurative forms and applied decoration.[1] Although there is evidence that kilns were used in some places in Central America, for example in the Zapotec capital at Monte Alban, their rarity suggests that most ancient pottery was open-fired or pit-fired. The quality of the firing is excellent and there are few black firing marks. It is possible that saggars or larger ceramic containers were used to protect the wares from direct contact with the flame. Most scholars assume that this pottery was fired only once and it has been suggested that itinerant decorators travelled to the villages. Alternatively, Reents-Budet has suggested that some Mayan pottery was twice-fired, a view that would support the idea of dispersed potters providing the base 'canvas' for elite scribes and decorators. As unfired pots would be difficult to transport it seems more likely that the pottery was fired first, then transported to the main centre, decorated by the specialist artists, and finally refired to stabilise the painted surface. The paints were coloured slips and oxides ranging from reds, blacks, yellows, oranges, maroons and browns through to the white of kaolin.

The hieroglyph for women in the Classic Period was an upturned water jar with a sun sign, suggesting a female association with pottery vessels, water, fertility and the womb (Tate, 1999, p. 86). It is probable that utilitarian pottery was made by women and some men in specialist villages, as it is to this day in many places. But who made the elite pottery? Since potters are never shown but the decorators are, either the pottery was not considered of any consequence or it was made away from the main centre. Whatever the position it seems likely women made some or all of the elite pottery, although the possibility remains that there were small groups of specialist potters in the main centre. Another craft that is not depicted is papermaking, which also provided a base material for the scribes and artists to decorate. This may have been produced by women as a household craft in a similar way to pottery (Tate, 1999, p. 87). What can be shown is that the decorators were men. Mayan scribes and painters, who probably painted designs on pottery as well as paper, are frequently depicted in codices[2] and on ceramics.

These artists were members of the elite group who lived in the cultural centres. This pattern was well-documented in Aztec and even Spanish records and there is good evidence that it was a long-standing system of Central American societies. The hieroglyphic signatures show family names of artists who painted on a variety of media including pottery, stone, stucco and paper. The black outlines were drawn with a yucca brush or one made from animal hairs. Conch shells were used to hold the paint. Much of the elite pottery was decorated in the same way as the paper codices but unfortunately most of the evidence for this is lost as nearly all of these were burned by the Spanish. Scribes were normally men as is attested by many images, however there are shreds of evidence to suggest that they were occasionally women. The word for scribe is *ts'ib* meaning painting, drawing and writing, and there is one known instance of a

[1] For a discussion of the turntable see Foster, 1959; Foster, 1960; Thompson, 1974, p. 77. The *kabal* of Yucatan is similar to the *molde* or *paredor* in Chiapas and Oaxaca in Mexico and has sometimes been seen as a prototype of the potter's wheel. Men and, very occasionally women, turn the base with their feet, but otherwise it is turned by hand and women generally kneel to work.

[2] Manuscript books of ancient Central American cultures are usually made from bark paper and are commonly referred to as codices or in the singular, codex.

*'The Princeton Vase',
Guatemala c 672-830
AD, 21.5 x 16.6 cm (8.5 x
6.5 in.) This Maya
codex-style vase with red,
black and brown on a
cream slip shows a scene
of the underworld with a
God with five young
women. At the base
there is a rabbit-scribe
painting a codex.*
The Art Museum,
Princeton, Photo Justin
Kerr.

woman who has the title *na ts'ib* or 'Lady Scribe' (Reents-Budet, 1995, p. 48). Perhaps a parallel can be drawn with Western art, where women painters are the exception to the general rule. The Maya traced their inheritance through the male and female line equally; women are known to have held significant roles among the elite although the painted images rarely show women except in relation to men and male activities.

When the Spaniards arrived in Mexico the Aztecs were at the height of their power. It is their culture which is best recorded in written and illustrated documents such as the Codex Mendoza and the Florentine Codex. They suggest that women were strongly identified with the domestic arts of weaving and cooking, both important in economic life. Cloth, for example, was used in tribute and in exchange as much as for personal use. As previously discussed, pottery production was never illustrated, which suggests it was not very visible, and probably did not have the same gendered symbolic value – indeed it may not have been an exclusively female activity.

The elite ceramic traditions of the Maya and Aztecs did not survive long after the Spanish. Many skills were lost, although the techniques of moulding, handbuilding and open firing continued to serve the needs of the indigenous peoples. The Spanish and in due course, *mestizo*[3] elites required European-style luxury goods which were imported from Europe and, in the case of ceramics, even from Asia. New technologies were introduced, including the upright loom, the potter's wheel, and kilns, all of which entailed new systems of production. The artisans, sometimes indigenous peoples but more often *mestizo* or *ladino* men, became paid labourers in workshops organised by

[3] Mestizo or Ladino implies a person of mixed Indian/Spanish descent but the technicality of birth is less important than the identity adopted. Significantly, such a person will usually be associated with Spanish-speaking urban, rather than rural, culture.

Spanish-speaking owners. Between the polarities of the two systems of production there are many variations. In Mexico and Central America traditional pottery is usually a community or village specialisation and within that each potter or potting family works relatively independently. Women are nearly always active in the production – often as the main potters but sometimes in communities where men also make pots, and sometimes as decorators of pots made by men. In Mexico most of the major commercial centres have male potters but some regions have strong female traditions. In the state of Oaxaca, many of the more isolated pottery-producing communities have female potters while in the more developed commercial centres near the city men are active alongside women. Further south in Guatemala and Nicaragua the female system remains strong although in major commercial developments, as in San Juan de Oriente in Nicaragua, much of the pottery is wheel-thrown and there are both male and female potters.

After the Spanish arrived, wheel-and-kiln technology was introduced in many places, but the older systems of production survived and were adapted. The reasons for this were the quality of the indigenous ceramics, the relatively effective systems of mass production in the old technology, especially with the use of moulds, and the linguistic and tribal identities of indigenous peoples. Until the end of the 19th century, the high status of European goods meant that locally produced wares were given little value. In Mexico, however, the sentiments behind the Revolution of 1910 encouraged a re-evaluation of indigenous culture and craft traditions, thus stimulating production. The growth of tourism in the second half of the 20th century, especially from the United States, further supported the production of markers of cultural difference, a role that craft objects fulfil admirably. In the latter part of the 20th century, philanthropic organisations such as *Potters for Peace* recognised the economic and social potential of ceramics and encouraged developments such as their water filter project (see Chapter Eleven).

Mexico

The richness of Mexican and Central American ceramic production and its extensive trade networks mean that it is rare to find ceramics produced mainly for personal use, but this is the case among the Lacondón, whose cultural roots are traced back to the Maya. One of the few groups who never adopted Christianity, they now live in seriously depleted numbers in the Chiapas rainforest. Their ceramics are non-specialist household based. Both men and women work in clay – women model figurines, animals and birds while men make the more revered ceremonial goods such as drums and figurative incense burners sometimes called 'godpots'. These pots, modelled and painted to represent the faces of different deities, are used for offerings of food and incense (Sayer, 1990, p. 66). The gender division is significant. Men make the more prestigious ceramics and control the interface with the gods while women make the things of this world.

Among many of the indigenous peoples of Mexico women are, or have been until recently, the potters. In the state of Vera Cruz, Totonac women make a wide range of

ceramic objects including cooking vessels, incense burners in the form of birds and clay beehives which are hung by the side of the door. Among the Tarahumara of Northern Mexico, women make all their domestic pottery and use techniques not unlike those of women in many other parts of the world. The clay is tempered with sand or ground potsherds and sometimes tested by tasting to ensure the proper consistency. A pancake of clay is laid over a cloth in a low bowl which is sprinkled with sand. The sides are built up using a spiral coiling system. When dry the pots are burnished with a stone and fired for an hour and a half in a bonfire.

One much more developed woman-only pottery production transformed itself in the latter part of the 20th century into an important tourist industry. In the Tarascan Indian community of Ocumicho, in the state of Michoacan, women have specialised in figures and figurative scenes for several generations. Men may assist, but it is women who work with the clay. The pieces, which in the past were often mould-made, are now mainly hand modelled, perhaps signifying the importance of the one-off piece to the new markets. They are fired in simple kilns and decorated with enamel or water-based paints. The range of subjects includes animal forms, Christian nativity figures and, most famously, devils – often in comic situations. Small models and figurines have always been used in household shrines and are especially popular around Mexico's great festival of the Day of the Dead on the 1st November. The devils were originally associated with the character of Judas, the betrayer of Christ, but have now lost most of their religious meaning and have become witty or ironic comments on contemporary culture. For the tourist they are the epitome of the Mexican flare for fantasy.

In the same region the women of Cocucho produce more traditional water jars and cooking pots, open firing their pieces individually one after the other. The forms are pulled up, coiled and smoothed out with an *elote* or corncob and then burnished.

The female Tarascan traditions can be contrasted with pottery centres further east in the region at Tzintzuntzan and Santa Fe de la Laguna. In the 16th century these towns were designated for craft production by the Spanish bishop, Vasco de Quiroga, in an idealistic effort to create a harmonious community after the con-

Ceramic figurine of a Devil on an aeroplane, fired clay painted with commercial colours. This type of work is widely sold in Mexico, 1990, 23cm (8.75 in.).
Photo A. Vincentelli

quest of the Tarascans. They have very different systems of production. Two-thirds of the people produce pottery which is formed using double moulds or convex 'mushroom' moulds and fired in simple kilns. Both men and women make pots but certain tasks have a strongly gendered association. Men collect wood and gather the clay but grinding the clay is exclusively a female task. Thus in one region we can see different patterns of production – the rural women potters of Cocucho and Ocumicho speak their indigenous language while the long-standing commercialised production is associated with Spanish speakers.

A similar pattern can be seen in the major ceramic centre of Tonalá, not far from Guadalajara, the capital of Jalisco. The population is identified as indigenous although it has long been Spanish-speaking. Tonalá is noted for its decorated pottery and there are four districts, or *barrios,* and some nearby villages, all of which are recognised for specialities within the production. Around one-third of the population, men, women and children, work in the industry which is mainly based on the production of press-moulded forms with painted slip decoration. There are two main types: the *brunido* or burnished ware and the glazed *petatillo.* The designs are of Spanish origin although by now they might be regarded as typically Mexican.

At Los Pueblos in north-west Mexico pottery is produced in large quantities in domestic workshops using a double-mould system, kiln-firing and glazing. The potters are men with women undertaking ancillary tasks. In a paper presented in 1984 Papousek imagined an archaeological excavation uncovering the village and the assumptions that would be made. He asked rhetorically, ' How has it come about that hand-shaped pottery is produced by the men and not by the women?'[4] It could be argued, however that the pottery production at Los Pueblos has a number of elements that immediately distinguish it from the typical women's tradition of handbuilding: the ware is kiln-fired and glazed, neither commonly associated with women handbuilders; furthermore the handbuilding is based on double moulds where the two halves of the pot are pressed together – essentially a form of mass production, rarely used by traditional women potters.

Mexico – Oaxaca State

Not far from Oaxaca in southern Mexico there are a number of noted communities where pottery is the main occupation: San Bartolo Coytopec, Santa Maria Atzompa and Ocotlán de Morelos. These were relatively well-documented in the last century. Further away from the capital and off the beaten track there are many more small centres of pottery production, nearly all of which are hamlets where women make utilitarian objects. Just 6 miles (9 km) from the modern city lies the ancient Zapotec centre of Monte Alban 500BC–AD700, a hilltop site with magnificent stepped temples, ball courts and stone carvings. It has yielded extensive pottery finds, both utilitarian

[4] The study of the three towns that form Los Pueblos where there were around 900 potters was based on a number of visits made between the 1960s and the 1980s (Papousek, 1984, p. 505).

vessels and figurative forms. When Monte Alban flourished there were people living on many parts of the steep hillside but the village of Atzompa is situated in the valley just below and much of the pottery could have been produced in the surrounding area. Unusually, however, pottery kilns with separate fireboxes have been discovered on the main site. Such a find is important on two counts: firstly it suggests that at least some of the pottery was made in close proximity to the major monumental buildings, and secondly it demonstrates that kilns were an independent development in Central America and not, of necessity, a result of European contact. Despite many differences there is clearly some continuity in the ceramic tradition in the Oaxaca region.

Originally Zapotec, the Oaxaca Valley was later taken over by the Mixtecs and eventually became an Aztec stronghold. The city was re-established by 500 Spanish families in 1526. Colonists used the *encomienda* system which gave them rights to exact tribute from the indigenous peoples who were converted to Christianity, although they often maintained aspects of their earlier beliefs. The new Spanish technologies of the upright loom, the potter's wheel and kilns were introduced in the area and men were employed as waged labourers in Spanish-speaking workshops. Further away from the city village pottery continued to thrive and, to some extent, still does. The huge maze of stalls in the market of Oaxaca are an important outlet for such pottery but there are other weekly village markets at Octolán and Tlacolula where local pottery is sold.

The Zapotec village of San Bartolo Coyotopec is noted for its distinctive black pottery and is discussed in the anthropological literature because of the use of the *molde*, a turn-

Pottery Vendors at Ocotlan market, 2001.
Photo A. Vincentelli

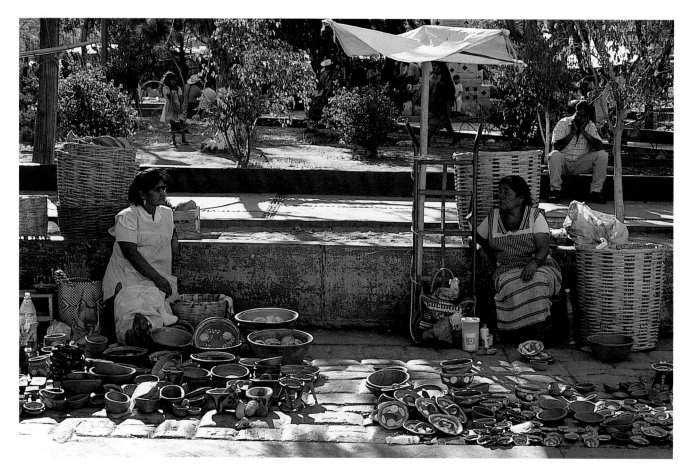

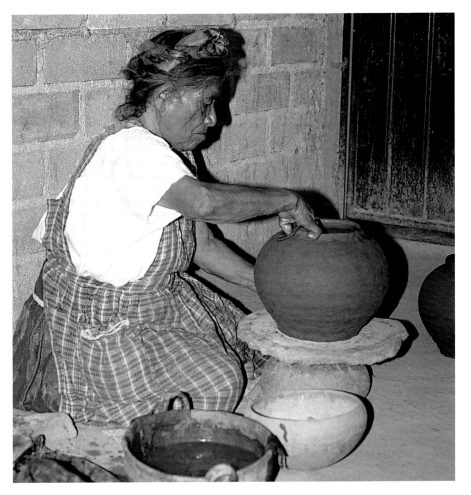

Enedina Chavez Ruiz of Atzompa shaping the neck of a pot on the revolving board. 2001.
Photo A. Vincentelli

ing device based on two concave pivoting saucers which, in the hands of particularly skilled potters, can be used to 'throw' the upper part of the pot. Women kneel at the *molde* while men sit and use their feet to turn. This is similar to many places where the *molde* or *kabal* is used. It is usually attributed to female propriety, although there are some exceptions, and in his work on the Yucatan Thompson did find women who used their feet to turn the *molde* (Thompson, 1974). The *molde* technique was publicised through the demonstrations of Rosa Nieto who already in the 1930s had been singled out as one of the great Mexican potters. In the mid-20th century she pioneered the highly polished black finish which now dominates the production at San Bartolo, but it is not appropriate for utilitarian wares.

An early 16th century Spanish record of this village does not mention the industry, but reduction-fired pottery represents a considerable proportion of the ancient wares found at Monte Alban, so the potters of San Bartolo almost certainly have links back to much earlier traditions. In the mid-20th century the majority of the potters were women but, according to Van de Velde (1939) the industry was 'really in the hands of men' who undertook some potting and saw to most of the ancillary tasks: gathering clay and wood, and overseeing the firing; they also did much of the selling. No doubt Van de Velde's comment was based on his perception of the economic power that men held. The pots were, and still are, fired in a cylindrical pit kiln lined with stones and linked to a firebox – basically a simple kiln built into the ground. They are loaded in from the top and covered over with sherds.[5] Now, in the early 21st century, pottery is a thriving industry in San Bartolo and coach parties arrive throughout the day to bring in tourists who buy large quantities of black pottery. Many more men, including the sons of Rosa Nieto, are now potters. At least 15 members of her family work in the pottery. There is an enormous variety of decorative forms made, many based on moulding with intricate patterns cut into the walls. The process of miniaturization is also marked, with baskets brimful with shiny black pierced miniature jars offered to the eager buyers.

[5] Neither Foster (1959) nor Van de Velde (1939) is clear about how the pots are fired black.

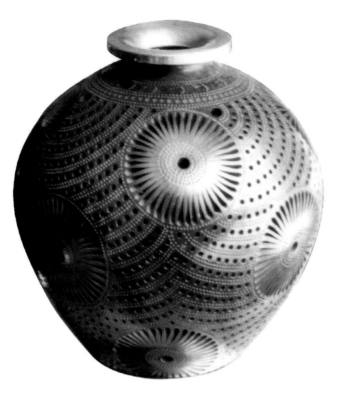

Modern pierced black pottery vase with gold decoration from the Doña Rosa Pottery, San Bartolo, 2001.

Photo A.Vincentelli

Atzompa, also in the region of Oaxaca, was studied by Jean Hendry in the mid-1950s (not published till 1992). The village was unusual in the region as the people had lost their native Zapotec and had been Spanish-speaking for at least a generation. Although most of the pottery was made by women, and in general the activity was viewed as 'women's work', some men were potters and many helped with related tasks such as gathering clay or firing. Farming was the main male occupation. Pottery expertise was passed on from mother to daughter and in a few families from father to son, but when women married they usually conformed to the tradition, or *oficio*, of the family into which they married. Each household tended to specialise in particular forms. Women sold their wares directly in local markets or in the main market at Oaxaca. However, by the 1950s certain individuals had begun to act as middlemen. Making pottery was not a highly valued occupation and it was more prestigious to be a butcher or a farmer; women had fewer career choices and the money women potters earned gained them some authority in the family and the community. In general, however, there was considerable peer pressure not to rise beyond a certain level.

Today Atzompa is a well-developed tourist attraction with a cooperative selling outlet and a number of bars. Each potting family works in its own yard, has a kiln, and may have a small selling area. None are on the scale of the Dona Rosa Pottery at San Bartolo Coyotopec. As in that village women form pots kneeling in front of a revolving *molde*, while men sit before it and turn with their foot. The characteristic ware, known as *loza verde*, is handbuilt, kiln-fired and lead-glazed on the inside in green. It is widely sold in the Oaxaca Valley and much appreciated for cooking although nowadays the lead glaze makes it harder to market further afield. More decorative vases and ornamental forms are glazed all over and in recent years some of the pottery has been brightly decorated with enamel paints. Atzompa represents a hybrid tradition. The glazing in particular, suggests the influence of Spanish techniques although in many other aspects the potters have retained older systems of working and social organisation. Although a few male potters have begun to use the wheel it is not widely used.

In their large yard at one end of Atzompa, Juan and Anna Maria Juarez Lopez work together. Anna Maria makes the pots; Juan fires them and takes the finished pots to Oaxaca market twice a week. Anna Maria's mother was a potter while her father fired and helped with the work. However, in her own generation she has four brothers who

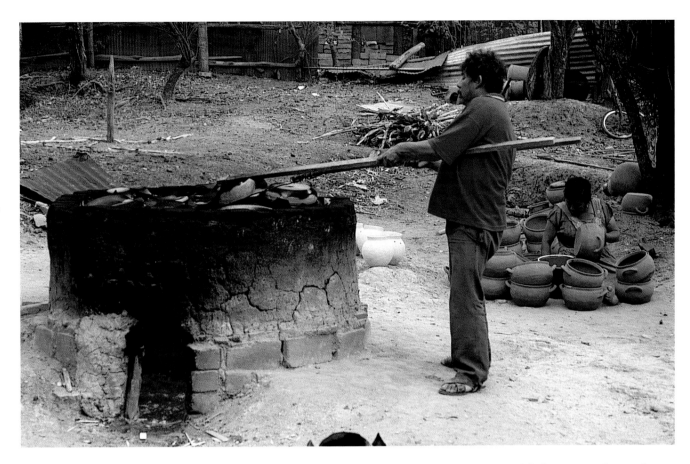

Atzompa Juan Lopez tending the kiln as Anna Maria prepares pots ready for lead glazing, 2001.

Photo A. Vincentelli

have become potters. It seems clear that pottery is a reasonably lucrative alternative to other occupations in this village, especially for families who do not own much land. In the mid-20th century Hendry found that initially it was the men who were more likely to take up new work such as modelling and freehand decoration, as women were nervous about their ability to draw designs. This reticence on the part of women, however, is in complete contrast with the best known individual artists who have emerged at Atzompa, all of whom are women gifted in modelling or sculptural work. Teodora Blanco Nuñez (died 1980) was the first to make a name as an innovator, modelling ceramic forms and figures. Dolores Porras and Angélica Vasquez worked with her and have since become well known in their own right, selling internationally and demonstrating their work in the USA. Both women have risen from early experiences of poverty and economic hardship but Vasquez' story is perhaps indicative of the position in which women can easily find themselves in a male-dominated Mexican society. As a young wife her work was sold by her father-in-law and by mere chance she heard that a piece had won an award and a money prize. Her father-in-law had even signed some of her pieces. When she tried to work independently local traders refused to market her work and for some years she gave up ceramics. An introduction to a gallery owner gave her the right kind of encouragement and her work soon attracted attention. She is now one of the most successful ceramic artists in Atzompa. Living in her house above the town she is able to work in her own way and enjoys the fruits of her acclaim – but Angélica Vazquez can never quite be one of the people any more. She is an international artist.[6]

Far from the main tourist routes many potters still find an outlet for their wares

[6] For a more lengthy discussion of the figurative artists see Wasserspring, 2000.

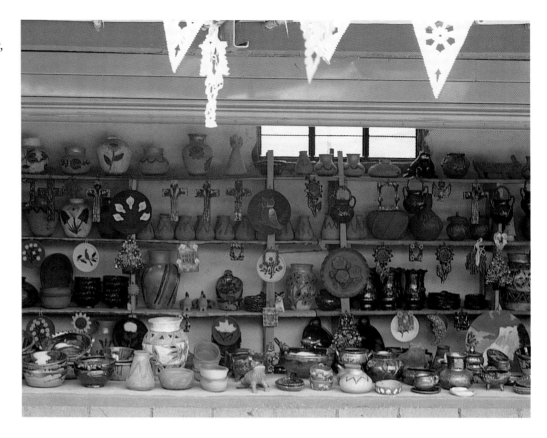

through the network of local markets or through middlemen who sell on to craft shops and galleries in Mexico and the USA. The house of Cecilia Jose Cruz and her husband, Celso, lies some kilometres off the main highway north from Oaxaca. The road winds steeply into the mountains, offering stunning views over the valley. Cecilia Jose Crus is one of about seven women working independently in the little community of Vista Hermosa, Tonaltepec. She makes handsome pitchers and jars distinctively decorated 'Jackson Pollock' style with splattered paint made from boiled oak bark. The decoration is applied as the pots are removed hot from the kiln – a circular open-topped construction with a firebox at the base. At Vista Hermosa these potters of Mixtec ancestry do not use the *molde* or shaped dish for turning the pot but instead balance a cone of clay on a flat thin slice of stone with sand underneath which acts almost like ball-bearings.

East of Oaxaca, beyond the market town of Tlacolula, San Marcos lies on the lower slopes of the hills. Its position off the main routes means it does not see many tourists. A small hostel on the edge of the town is currently not in use. It is a place that preserves the old ways. Pottery is one of the main occupations for women, many of whom still wear traditional aprons and hairstyles. Their first language is Zapotec and not everyone speaks Spanish. In 2001 I visited the Mateos family, one of the most successful potting families in the community; a sign on the high wall at the entrance to their compound announces the activity. Four of the women in the family make pots – the mother, two daughters and a niece. The younger women have all chosen to remain unmarried and one of them, Macrina, indicated that she valued her independence. The men are not involved in pottery work at all. The family has sufficient agricultural land and currently

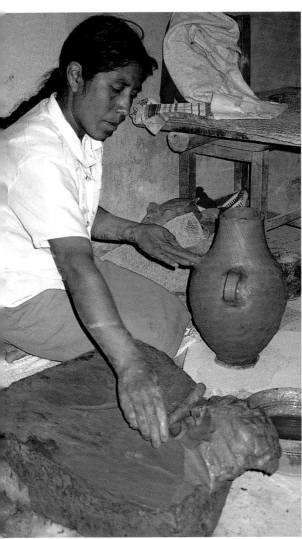

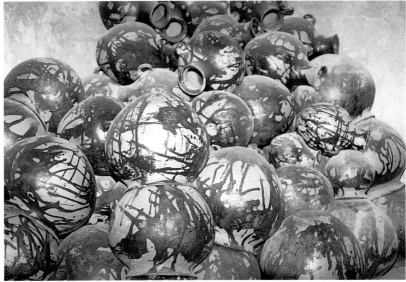

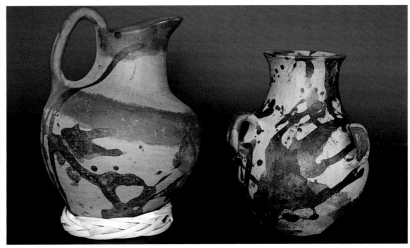

Above left *Cecilia Jose Cruz, Vista Hermosa forming a vessel on a thin slice of stone to allow the pot to revolve, 2001.*

Top right *Cecilia Jose Cruz Vista Hermosa, stacked pots ready for collection, 2001.*

Above right *Cecilia Jose Cruz, Vista Hermosa, jug and jar showing the spattered vegetal paint decoration that makes this work so distinctive, 2001.*

Photos A. Vincentelli

the *maguey* plant earns good money[7]; a team of oxen is housed in one part of the court-yard around which are a number of dwellings and workshops. The potters are doing well and now no longer sell in the local market at Tlacolula but in Oaxaca and through middlemen to the USA. Macrina and Alberta have already had the opportunity to visit the USA as demonstrators. These potters do not use the *molde* but a brick with a hol-low in it into which they sprinkle some sand over which a piece of leather is laid. The form is punched out from a large cone of clay and then balanced in the base and built up as it is turned. Burnishing is important and pieces are polished twice before they are fired in an open bonfire. Firing takes place in the courtyard and lasts about an hour and a half. Old pots are used to build up a 'wall' around the outside of the firing area, 40 to 50 pots are placed mouth downward on a layer of wood. The care-

[7] Maguey is used to make mescal, the alcoholic drink that is widely sold in this area. The fibres of this plant can be woven and are still used in rope making.

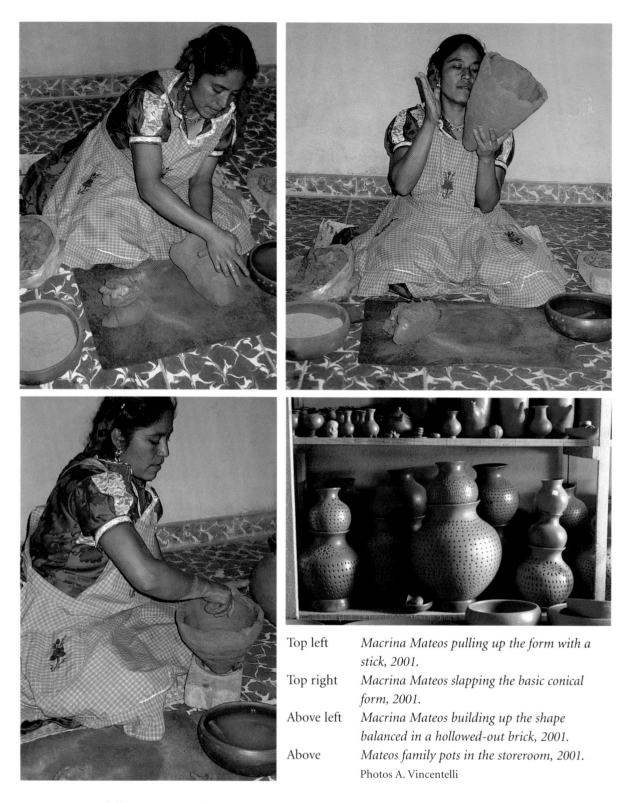

Top left *Macrina Mateos pulling up the form with a stick, 2001.*

Top right *Macrina Mateos slapping the basic conical form, 2001.*

Above left *Macrina Mateos building up the shape balanced in a hollowed-out brick, 2001.*

Above *Mateos family pots in the storeroom, 2001.*

Photos A. Vincentelli

fully constructed mound is covered over with pieces of metal then more wood, bark, and finally grass on top. More fuel is added from time to time throughout the firing and attention is constantly paid to keeping the pots well covered. They calculated that two or three pots broke in the average firing, but none broke in the one I watched.

In the area around Oaxaca we can see a complex mix of pottery traditions and related, but distinct, systems of forming. The potter's wheel has never been adopted, although in Atzompa a few have been introduced. Popular rumour has it that a

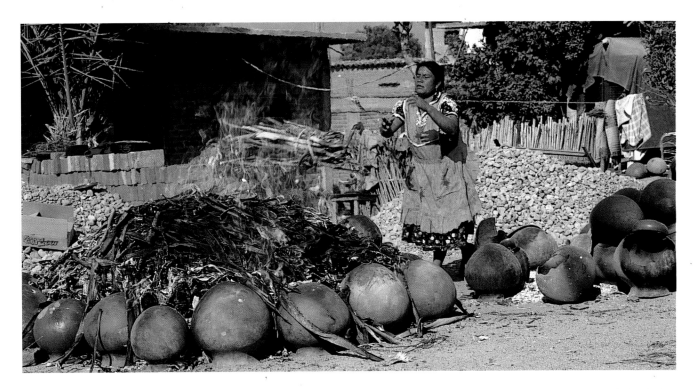

The women of the Mateos family firing pots in their yard. They fire 40-50 pots at a time and have few breakages, 2001.

Photo A.Vincentelli

woman who took up wheel-throwing had suffered three miscarriages. Wheels had also been introduced in San Marcos in the early 1990s but had not been a success. Kiln firing, however, is widespread, and it is difficult to assess to what extent the kilns are a continuance of ancient systems or, as is more likely, developed after Spanish contact. Their form is identical to the open-topped Mediterranean kiln found in Spain, the Canaries and Cyprus. Women do fire using kilns but kiln firing is frequently seen as a male activity if not a male preserve. Of all these pottery centres it seems significant that bonfiring is still used at San Marcos where women undertake all the work.

Mexico – Chiapas

June Nash studied the Tzeltal village of Amatenango del Valle in Chiapas, Southern Mexico over a long period between 1957 and 1987. The area has maintained a strong indigenous identity and the women wear distinctive local costumes with embroidered blouses or *huipiles*. Before the 1960s in this community men had mainly been farmers and women had made pottery, which had been used in a barter system for cotton textiles or staple foods. Men and children marketed the wares in villages and larger markets, sometimes travelling over 60 miles (100 km) and being away for many weeks. The dramatic increase in the economic potential of pottery brought about by the opening of the Pan-American highway changed the relations of production, affecting 'betrothal systems, marital relations and the redistribution of wealth within families' (Nash, 1993, p. 139). Women with pottery skills could command a higher dowry. The expanding tourist market created a demand for new decorative pieces, small models and sculptures. By the 1980s many more households were headed by women and some women were even rejecting marriage in favour of the independence they could sustain through their occupation. Independent women were more likely to be innovators, as their need to respond to the market was more urgent. Low-technology systems pre-

vailed and a scheme to introduce kiln firing foundered. In the past women collected their own clay and the wood for firing, but by the 1980s men were much more involved in all aspects of production, particularly as owners of trucks – a major symbol of wealth and status in the community. Men became involved in the transport of clay and wood and in taking pottery to more distant markets. Some men even began to make pieces, especially the new decorative figures and animals. The changing balance in economic relations between men and women created jealousies and envy. A women's co-operative running in the town in the 1970s had failed acrimoniously and the woman who had headed it was murdered in mysterious circumstances. In part, it seemed to have represented a challenge to the power of family and male authority.

June Nash's study is valuable precisely because it was conducted over a period of rapid expansion in a small community pottery industry. The growing commercial value of pottery production quickly gave incentive for men to become involved in an activity that had previously been a strongly female preserve. The new economic power that women began to acquire created corresponding resentment, and men developed new forms of control through the ownership of trucks or contact with more prestigious marketing outlets not easily available to women.

As we have seen, in many of the major pottery centres in Mexico, women are active in pottery production, but men are also sometimes involved in ancillary activities such as collecting clay and firing materials, firing kilns and frequently controlling the transport and marketing. Many of these centres still have household or family production rather than specialised workshops and it continues to be rare for women to work in group workshops, although they often work together informally with female relations. The techniques of moulds, the use of the *molde* or turntable, and kiln firing, albeit quite simple kilns, seem to be a hybrid production system which accommodates both men and women as significant and relatively equally valued participants in the industry. There are, however, more isolated indigenous communities where making pots is still identified as a female activity. These tend to be places less influenced by Spanish-speaking culture and traditions.

Southern Central America

In the countries of Central America south of Mexico, domestic pottery is still produced by women using traditional methods. Mostly they are full or part-time specialists but in some places women still make pottery on an occasional basis sufficient for their own use. Certain centres have been able to build up good sales in decorative wares directed at the tourist market, as at La Arena near Chitré in Panama; or have created a specialist product such as the *sorpresas* (surprises) of Ilobasco in El Salvador, miniature clay scenes of everyday life set in walnut-size shells. In Nicaragua during the troubled years of the 1980s women's co-operatives were established to help potters develop and market their work more effectively. The most famous pottery centre is San Juan de Oriente where during the 1970s there was a successful transformation of an older tradition. Much of the pottery is wheel-thrown and the artisans, both women and men, now make a wide range of decorative pieces in styles

identified as flora and fauna, 'contemporary' or pre-Columbian. From a long line of women potters, Amanda Guzman of la Paz Centro established her reputation in the 1980s and has been an important teacher and role model for Nicaraguan potters; at Matagalpa and Jinotega an older tradition has been successfully revived and women produce decorative vessels and figurines in highly burnished black pottery.

Central America – Guatemala[8]

Over many decades Ruben Reina studied traditional pottery in Guatemala, a work that was eventually published in 1978. Reina's book offers the most extensive field study of any Central American country and can be used to examine the gendered division of labour in traditional pottery. Traditional potters either belonged to one of the many Indian peoples of Maya descent, each with their own language, or were of mixed descent, spoke Spanish and were identified as *ladino*.

During the 1970s traditional utilitarian pottery in Guatemala was still largely made by women and, of the 25 centres documented, all had women potters, although in three centres – Rabinal, Santa Maria Chiquimula, and San Cristobal Totonicapan – both men and women made pottery.[9] At Rabinal and Santa Maria Chiquimula the method of production was close to a form of mass production, where different men and women had specialist tasks but the whole production was overseen by the senior male in the enterprise. San Cristobal Totonicapan was unusual in a variety of ways: the potters produced a wider range of vessel types than in other centres and men specialised in very large jars; the potters used a turntable system – a fired clay concave basal mould with a pivot on the bottom which rotated on a wood or stone base. The vessel was spun quite fast and produced an effect akin to throwing. These potters also glazed their pottery which, despite its roughness, gave San Cristobal's wares an edge in the market place. The use of glaze suggests an unusual degree of influence from European traditions despite the retention of traditional building techniques.

All women's pottery was handbuilt and mostly open-fired (only three out of 25 had any form of kiln) but within that there were distinct methods which varied from village to village. Most used some form of coiling, and burnished the pots in the final stages, but there were a number of distinct methods for building the form: a concave basal mould, a convex mould where a slab of clay is draped over the form, a flat mould, and a system where the pot is built up by the potter moving around the work pulling up the sides. Reina was able to show that particular systems corresponded to language groups. Men in the family sometimes helped with the gathering or transport of clay or wood but otherwise the pottery production was in female hands.

[8] In this section I have used the past tense as my evidence is drawn from publications pre-dating 1990. However I have no reason to think that much of this activity does not still exist. Reina's study was based on work by Margaret and Charles Arrott from 30 years previously, on earlier studies by Reina himself and later on work in collaboration with Robert Hill.

[9] In Antigua, Jalapa and Totonicapan, pottery was made by men who produced wheel-thrown ware using European techniques introduced in the post-conquest period. They did not form part of the study.

Within their own villages good potters were respected members of the group, with a relatively high status within the society. Potters expressed a feeling of respect for the clay and a sense that they worked in an activity that was in harmony with nature – a sentiment also prevalent in many Native American traditions in the USA.

Among Indian communities the individual was constrained by the needs of the wider group – by social custom or *costumbre*. Men and women had their allotted roles within a system and a structure. In the Pokomam community of Chinautla, men worked their land and were charcoal burners while women were potters selling in local markets to villages where they did not produce their own pottery. The Chinautla woman was proud of her craft skills – 'the ability to make a traditional *tinaja* was a public announcement of being a good Chinautleca.' In the 1950s a widow who had sole responsibility for raising her orphaned grandchildren pioneered a new kind of figurative work that quickly attracted the attention of the urban market. As a result her granddaughter had found it impossible to conclude her marriage arrangements as she was deemed to have departed from the appropriate way. Only when she conformed and began to produce the traditional *tinajas* did she find that the marriage arrangements made headway. Thus intitially it could be difficult to depart from tradition. However with Guatemala City only 10 miles (15 km) away, the economic advantages of producing miniature vessels and figurines for the tourist and urban market eventually won the day. It became more acceptable to make modelled figures and by the end of the 1950s Chinautla became well known for this genre. Innovation became acceptable.

Conclusion

Is it possible to speak of a woman's tradition in pottery in Central America when men are so frequently involved in production? I would argue that it is. It could be said that men choose to become potters while women are born into a potting family. That is one of the major factors determining a woman's tradition. Patriarchal cultures construct man as higher than woman and there is a great deal of evidence to suggest that this pattern has prevailed in this area of the world as elsewhere; indeed, the 'macho' traditions of Latin culture are strong. Even where women are the potters, husbands often have a powerful or controlling role and in some places seem to direct the work of the women in the household. However, for women, pottery skills can be an important female attribute, a symbol of identity and a valuable asset that can generate respect, social standing and economic benefit. Many scholars note that potters, both men and women, bemoan their fate at being practitioners of a low status craft. Foster, when looking at Mexico and India, found that they were happy to abandon it if better opportunities presented themselves. By contrast in the more female-dominated pottery world of Guatemala, Reina reported that potters were in general satisfied with their lot and were held in positive regard within their own community – something that for most people is perhaps the primary factor for a good life. Reina noted the respect the potters had for the clay and the sense they had of working in harmony with nature. This sentiment is one that is prevalent in most Native American traditions. Like Pueblo potters in the USA, Guatemalan Indian potters, mostly women, were likely to conceptualise their pri-

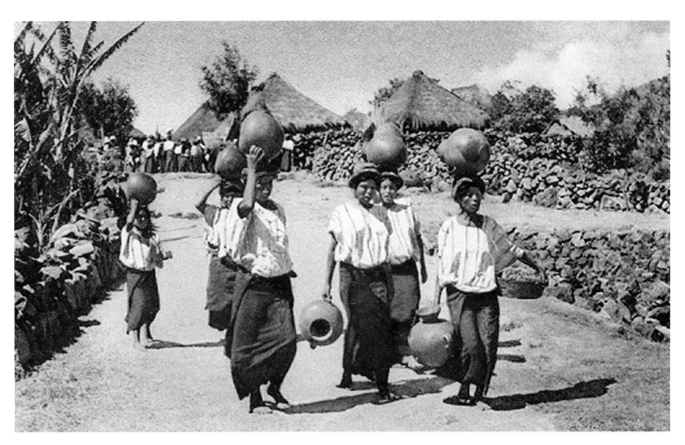

Hand-coloured postcard from the 1930s of Guatemalan women of Tzutujiles of Santiago Atitlán going to fetch water. Photo Adolfo Biener. Postcard.
Fototeca Guatemala/Cirma

mary material, clay, as a person who is owed respect and whose needs have to be understood. The potters saw their *oficio* or ceramic work as embedded in the social fabric and in the community economy. Articles were made for community festivities and ceremonial occasions, regardless of financial reward. *Ladino* potters, often men, were much more free of community pressure, their production was for personal economic gain and was rarely endowed with any strong social significance.

Central America offers no departure from the general rule that women's traditions are characterised by low-technology systems of handbuilding combined with slip painting, burnishing and open firing or, occasionally, simple kiln firing. The mould system, developed in Central and South America to its finest level, is to the Americas what the wheel is in Europe or Asia. The two-part pressmould, a form of mass production, is nearly always associated with specialist full-time workers who are more likely to be men although women often work as helpers in family businesses. Mould technology is not necessarily associated with elaborate clay preparation, investment in specialised equipment, complex kilns or workshop organisation. It does not entail a radical change in the technology or the system of production. Thus, unlike the wheel, the technologies used in Central America, even for highly specialised work or mass production, do not exclude women.

Over the 20th century a number of individual women emerged as innovators, usually because they introduced a new form, or style or technique, but the acclaim they were accorded was sometimes viewed as a disruptive factor within the relatively egalitarian Indian communities. The resentment against the women's collective in San Cristobal, the rumoured jealousies of Rosa Nieto or the marginalisation of Vazquez at Atzompa are all examples. Is it harder for women to rise above the general group than for men? It seems likely. Were there any female stars in ancient times such as the woman scribe that might be the exception to the rule? It is always possible.

151

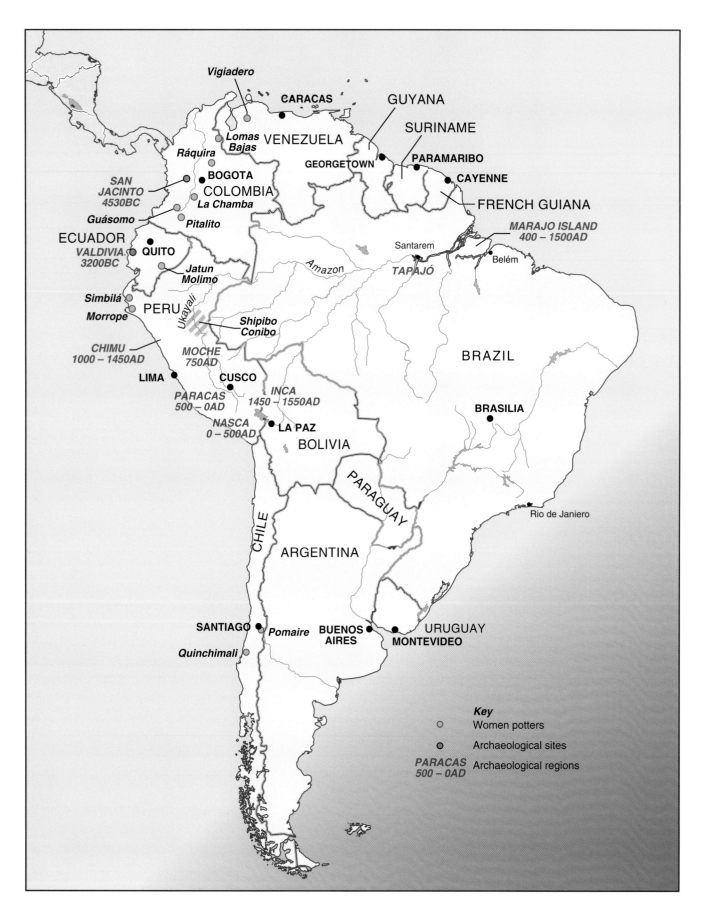

WOMEN POTTERS AND GENDER ROLES IN SOUTH AMERICA

THE HISTORY of ceramics in the Americas differs from that of the other continents in one major way, as elite and specialised ceramics continued to be handbuilt rather than wheel-thrown. For over 2000 years in Europe, North Africa and Asia, wheel-and-kiln technology tended to take over both mass-production and elite markets, leaving handbuilding as the poor relation. In the Americas wheel technology did not arrive until after European contact in the 16th century. Within 50 years it had made a substantial impact in many different centres. In South America, however there was a long tradition of handbuilt elite ceramics. It was the social changes brought about by Spanish contact that spelled the death knell of the indigenous elite ceramic tradition not the technology in itself.

Ancient South America

The earliest ceramics in the Americas are the subject of heated debate among archaeologists and dates are frequently under revision. Ceramic fragments from Taperinha in the Amazon basin in Brazil have been dated to 5671BC with other sites in Colombia (San Jacinto) and Ecuador (Valdivia) dating respectively from around 1000 and 2000 years after that.[1] All the dates for early ceramics in Central or North America are later, which suggests that the technology probably developed in the Amazon area and spread north and south from there. Theories that ceramics were introduced into South America from across the Pacific from Japan, or from North America, or from Africa, can probably be discounted.[2] Europeans introduced new vessel types associated with tableware, usually thrown on a wheel, floral decorated and glazed. The influence of African techniques and forms brought over with the slaves is less easy to distinguish but has survived in pockets.

The early ceramics found in the Lower Amazon are fragments of pottery bowls, sand-

OPPOSITE PAGE
South America: countries, cultures and places mentioned in the text

[1] See Barnett and Hoopes, 1995, p. 210 for a useful map. See also McEwan et al., 2001, pp. 23–24.

[2] For a discussion see essays by A.C. Roosevelt, and John Clark,and Dennis Gosser in Barnett and Hoopes, 1995.

tempered, with simple incised decoration. The people were hunter-gatherers living on a diet based on fish and shellfish and there is no evidence of agriculture (Roosevelt in Barnett and Hoopes, 1995, p. 129). Ceramic figurines are found at Valdivia but in the main the early ceramics in South America seem to take the form of earthenware bowls.

Given the strong female tradition that survives to this day in some cultures, little affected by the modern world, there is good evidence that women made much of the early pottery. The female lore that accompanies these traditions further supports this association.

The ancient Andean societies developed highly specialised craft skills in textiles, ceramics and metalwork (not iron). The area is dominated by the volcanic mountain chain of the Andes, the coastal region is in large part inhospitable, often foggy, subject to El Nino and with huge tracts of desert. On the eastern side, the tropical forests of the Amazonian region form another natural barrier. In spite of these difficulties Andean peoples developed travel networks and systems of exchange for goods. Burials were elaborate and many finely crafted products have survived as grave goods. Particularly unusual is the way that the finely woven textiles have been preserved, thanks to the arid conditions. Between 10,000BC and 1000BC the people of this area developed monumental architecture, stone sculpture, featherwork, metalwork, gourd carving, fine textiles and ceramics.

Ceramics were produced from around 2000BC but flowered in different centres over the centuries: Paracas and Chavin 500BC–AD1; Moche AD50–AD750 and Chimú AD750–AD1400 in the north and Nasca AD1–AD500 and Ica AD750–AD1400 in the south. Finally the Incas dominated the region from Quito in the north to Santiago in the south, a distance of 3400 miles (5,440 km). Inheritors of a long history of fine ceramics, under their influence ceramic forms and production became more standardised over a wide geographical area. The stirrup vessel was a distinctive form used in all these societies. Designed to carry liquid without spilling, it was easily tied to the body or hung up. A huge range of other ceramic objects were produced, including decorated bowls, animal and figure models, pan pipes and double-chambered whistling vessels. The clay bodies were carefully prepared and the vessels had thin walls. The shaping techniques included direct modelling, coiling, paddle-and-anvil and moulding, which was the most characteristic method. Two-part clay moulds were used for more complex forms. This technique allowed for a form of mass production whereby sophisticated sculptural forms could be reproduced in quantity by artisans. In some places *moldes* or rotating stone turntables have been found. All these methods are still used today. The pottery was sometimes decorated with stamps but more often painted with slips and mineral pigments and, in the case of Moche pottery, with highly detailed fineline figurative decoration. Finer pieces were usually burnished. Simple kilns may sometimes have been used but the sparse archaeological evidence for such structures suggests that open fires were the norm. In the finest wares there are few fire clouds and the potters were obviously skilled in their techniques. In some centres, Chimú in particular, blackfired wares were a speciality, proof of their expertise in reduction firing to close off the supply of oxygen.

These fine early ceramics all suggest group production, possibly with different people specialising in modelling the original moulds, making the forms, decorating and firing. They were a form of luxury goods used by a privileged elite. When the power of the elite declined, the market or support for such goods quickly evaporated.

Moche bowl with flaring rim, 34.3 cm (13.5 in.), AD 1-500 detail of fine-line decoration showing women weavers with backstrap looms. Each weaver is shown with a distinctive ceramic vessel and the pattern she is following.

The British Museum

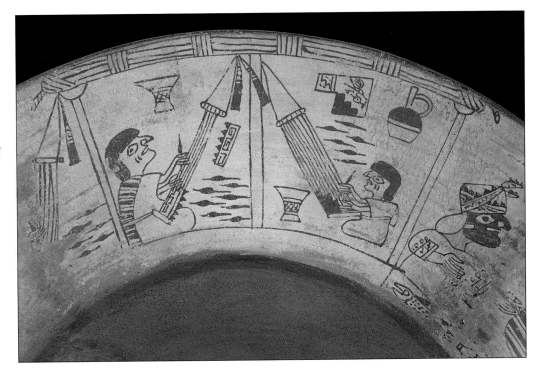

This was the case with the Incas whose tradition was ruptured after the Spanish conquest. The new technology of wheels and glazing was introduced to supply the needs of the Spanish elite. Handbuilding survived as it always does, but in the margins – as a people's art or craft. As we have seen elsewhere the typical gender roles in pottery were repeated. Whoever made pottery in the pre-Conquest period, it was men who were trained up in the new European technology.

But who made ceramics in the ancient South American societies? Archaeologists have shown that pottery has been produced throughout the continent, with the exception of the southernmost tip. Outside the Andean region where the powerful ancient societies flourished, Indian women have been, and to a large extent, still are the producers of domestic pottery. The specialist ceramic artisans of the ancient Americas are much more difficult to identify.

It is puzzling that no record was ever made of potters at work. There is no corresponding image of potters as we find in the Moche fineline bowl that shows women weavers at work, each one identified with her drinking vessel. Ceramics seem to have had an important role in the ritual or symbolic life of the users, although they must also have had a more mundane function. By the time of the Conquest, the older cultures had long disappeared and there are few Spanish records of potters. However it is known that the Inca liked to set up specialised craft communities resettling people from different areas. Just before European contact it was documented that the Inca moved 100 potters from different places to settle them in a centre on the north of Lake Titicaca in order to produce for the state – presumably on a near full-time basis (Donnan, 1992, p. 122). Thus pottery was produced by specialists in outlying villages but the high level of production collapsed very quickly after the arrival of the Spanish. Given that people were being moved as a group it is more likely that whole families moved rather than men only. However most scholars seem to agree that much of the

Moche stirrup-spout vessel with birth scene, AD *1–500.*

B.P.K. Staatlisches Museum fur Volkerkunde, Berlin

ceramics was still produced by part-time artisans but working in specialist villages. Alongside the very fine ceramics, archaeologists also find everyday pottery or cookware, which by comparison does not have the same artistic aspirations or technological sophistication. This indicates a dual tradition with two different kinds of potters, possibly reflecting a gender, class or rural/urban division. In fact, this is found in many parts of South and Central America to this day. Thus, when the elite culture was wiped out the traditions of the general population were hardly affected. It is the case that in the area where these cultures thrived on the western side of South America, pottery production is still today much less gender specific and men use a number of handbuilding techniques.

It seems, therefore that the mixed gender production to be found in Peru is one of very long historical standing that pre-dates European contact. Centuries of production of specialised ceramics alongside domestic wares probably broke down at an early date the older model of women's production. The technologies used and the systems of production, which often remained at village specialisation level did not, however, exclude women entirely from the process. In her extensive study of folk ceramics on the western side of South America, Litto found that it was still common for men and women to work together in many centres, although frequently on different aspects of the work. It was mainly the European technology of wheel and kiln which was associated with full-time male potters (Litto, 1976, pp. 218–20).

The Transforming Tradition

This section considers how women's pottery traditions in different countries of South America have adapted in recent years to new markets and opportunities. The journey will start from Chile in the south and end in Venezuela in the north.

Chile

Handcrafted pottery in Chile has developed from a women's tradition which has now been transformed into more commercial enterprises involving both men and women. Aruacanian Indian women still make pottery for their own use on a seasonal basis and may sell a few pieces, but the main centres of production of handcrafted pottery are in Quinchamali and Pomaire. Quinchamali preserves a female indigenous tradition while Pomaire is typical of *mestizo* production, combining indigenous and European technologies.

Nowadays Pomaire, just a short drive from the capital Santiago, is a boom town for the pottery industry. The abundance and quality of the local clay is well suited for the production of cookware and can be used with minimal additions. The dark brown, burnished, smoke-fired dishes have long been valued for their superior qualities for cooking paella and other Chilean specialities. The pottery is fired in simple open-topped, updraught kilns with a grid base of pierced clay. The main fuel is wood and the reduction is achieved by covering the sherds that close over the pottery with leaves and grass and by throwing cow dung into the kiln. By the 1970s the potters had branched out and were making planters and other decorative and domestic wares. Ceramic stoves were also produced, often for use in apartments as decorative flower containers. New finishes were developed using metallic paints or black polish to achieve a shiny black surface sheen. Handles with links like chains were also very popular.[3] An important marketing factor has been the emphasis on handmade production and Litto (1976) observed that handmade wares commanded a higher price than wheel-thrown. For at least two generations both men and women have been working as potters, although it is mainly men who take up throwing. By the 1970s individual makers were beginning to emerge with distinctive products. Working to commission, Julieta Vera specialised in religious sculptural forms especially nativity groups which she marketed in Italy among other places. Many of the families of the town are involved in the pottery industry but it has now become a centre for other artisan crafts.

BELOW
Left *Julieta Vera,
Pomaire, Chile,
Nativity scene, c. 1974*
Photo Gertrude Litto

Right *Quinchamali,
black burnished figure of
a borracho or drunk
man on horseback,
c. 1974*
Photo Gertrude Litto

[3] Very similar forms can be seen in recent pottery in South Africa.

By contrast, Quinchamali, 350 miles (560 km) south of Santiago, is not a tourist town but had in the mid-1970s about 125 women working with clay. The people are of Mapuche origin and the pottery industry has remained in the hands of women who trace their inheritance back to before the Incas. They work only in the dry season and outside the harvest period. The local market for traditional domestic pottery for cooking and water storage has largely disappeared with the advent of electricity and running water, and the potters now specialise in blackware models and small decorative domestic wares. The pieces are hand-modelled, covered in a fine slip, burnished and engraved, and they are proud of the fact that they use no wheels, kilns or moulds. The work is fired in open bonfires from which it is lifted out when red hot and plunged into a heap of dry cow dung and straw to turn it black. After firing, a white clay is rubbed into the lines.

Paraguay

In Paraguay, women made all the household pottery which was also adapted for the consumption of the Spanish settlers. Indigenous women employed as domestic servants would also make the kitchenware for the household. However, often through the Jesuit missions, the new technology of wheel and kiln was introduced and a dual tradition developed. In Areguá, for example, ceramic production has been transformed into a small industry employing men, while at Itá the work has remained in the hands of women who make large, coiled *cántaros* or water jars. The pottery is fired in a pit on a raft of wood and some of it turned black by smothering the fire with animal dung. Jars with modelled decoration of animals or faces were typical of the older tradition and these have been revived in recent work in the form of applied snakes, lizards and all kinds of figurative forms, including face jars.

Bolivia

In Bolivia many rural communities in the late 20th century still had a system where household pottery was produced seasonally for personal use or possibly for some commercial exchange. Such pottery is produced by women but in all the more commercial centres men are the main potters, often working in family enterprises. Although in many centres the pottery is wheel-made, glazed and kiln-fired, in Cochabamba men coil large globular water jars about 1.5 m (5 ft) high. These are open-fired over a period of six days using animal dung as the fuel. The large size of the work, the extended firing time and the commercial nature of the enterprise appear to be the overriding factors that have allowed pre-Hispanic technology to be retained, but used by men. It may also reflect the influence of Inca systems of production.

Peru

The folk pottery in Peru is mainly produced in specialist villages in the highland area. Men and women work together and many use traditional techniques. Most potters still work seasonally, within a domestic environment with participation from all the family. They combine their activity with agricultural work, spinning and weaving even when a range of wares is being made for the marketplace. Pucará is one of the few places where the kick wheel is used. Moulds, glazing and kiln firing have been introduced and are supported by two government handcraft centres.

The Ayamara people who live around Lake Titicaca make a range of domestic and decorative ceramics. The pottery is coiled, covered in slip, burnished and open-fired. Women are the main traders of pottery among these people but, unusually for this technology, the potters are men and a 19th century record seems to imply that such has been the case for at least a century (Tschopik, 1950, p. 203). In this area the Inca set up specialist villages for different crafts and it seems likely that men would have taken up the work when there was a need for highly specialised production. The powerful heritage of skilled ceramic work that descended through the generations from the period of Inca domination left its legacy, even though the demand for elite ceramics disappeared and the market was mainly for functional wares. Even the impact of the Spanish conquest, which substantially changed Ayamara life with the introduction of cattle, sheep, steel, a new religion and plough agriculture, did not bring about any change in ceramic technology. This was perhaps because the gender pattern already corresponded to the Spanish tradition and the quality of the handbuilt work was very high.

A similar argument might also be made for the potters in the northern coastal area of Peru at Simbilá and Morrope, who use a paddle-and-anvil system. Potting is combined with some agricultural work and is a skill passed on within the family. Men make large basins for preparing *chicha*[4] and *cántaros* for water, while women and older men make smaller pieces. The potter sits on the ground with the pot between the knees using a large flat stone held inside and a bat-like paddle on the outside. Carved paddles are also used to impress decorative patterns on to the wares. The pots are fired in an open fire on a base of wood and then covered over with dung and straw. The firing time of 12 hours is unusually long for open firing. The technique is only found in this region of South America and can be dated back at least 1000 years (Bankes, 1989).

Inca pottery used by one elite was replaced by Spanish forms used by the new elite, but the indigenous technology survived. The mass production of elite ceramics introduced at a very early stage in ancient Andean cultures, meant that women and men worked in handbuilding. This is different from other areas of South America. Although the demand for elite ceramics disappeared in the indigenous population, the gender roles did not revert back to the earlier model of women handbuilders. Handbuilding had proved viable for mass production and the advantages of using the wheel-and-kiln were not so obvious. In most parts of the world men become potters with the introduction of wheel-and-kiln technology; in this case the key factor is the mass production of specialised wares.

[4] Fermented drink usually made from maize.

Brazil and the Amazonian Basin

According to the map of different levels of ceramic production created by Gordon Willey (1949) most of the central area of Brazil produced only very simple pottery. By contrast, very fine pottery was made in the eastern coastal region and in the Amazon Basin. In 1557 Hans Staden was impressed by the work of the Tupinambe women who made pots that 'glowed like hot iron' when fired.[5] He must have observed an open firing or, possibly, the smoking process when the hot pots are plunged into dung. The longest known ceramic tradition in South America is associated with the Amazon Basin where pottery is still made by women using very distinctive techniques and decorated surfaces.[6] The high shine and decorative patterns of the pottery amazed Francisco de Orellana 500 years ago and he mistakenly called it porcelain:

> …of the best there has ever been in the world…glazed and embellished with all colours, and so bright…that they astonish…[7]

As we have seen, the earliest dated ceramics in the Americas are now thought to come from the lower Amazon basin. The conventional notion of the Amazon as a sparsely populated area of semi-nomadic peoples is misleading. There is increasing evidence of large-scale permanent settlements and areas of rich cultivated soils. In the mid-20th century many of the 210 tribal groups of modern Brazil were nearing extinction but the situation has been turned around and they are now back to their numbers of the 19th century. They recognise their unique cultural heritage and are determined to preserve it. Material culture, including ceramics, has an important part to play in the maintenance of a distinctive identity.

Around 2500BC the peoples of the Amazon developed tropical root cropping and, in the same period, a highly distinctive pottery with geometric and animal designs appeared. During the 1950s archaeologists began to unearth large jars, figurines and spectacular sculptured grog-tempered vessels which had been made in the lower Amazon region by peoples of the Tapajo around Santarém, and on Marajo Island. The culture of Marajo Island seems to have flourished in the period AD400–AD1500 and was largely extinct by the time Europeans arrived. Pottery is found in both domestic and burial settings and the most elaborate pieces are funerary urns with combined sculptural and painted designs, many of which represent schematically a crouching female form with emphasis on the eyes and female sexual organs. Such funerary urns may have indicated a symbolic rebirth after death. Other forms include bowls, figurative jars, *tangas* or pubic covers, and rattles, commonly used by shamans in the Amazonian region. The pigments are mainly black, brown and red on a white background but pink, orange and yellow are also found. Some of the decoration may have been applied after the firing and then protected by a resin finish typical of decorated

[5] Quoted in D. Whitten, 1993, p. 309.

[6] A rare instance of male potters was noted by Levi-Strauss among the Urubu, Yupi Indians of the Maranhao (Levi Strauss, 1988, p. 26).

[7] See McEwan et al., 2001, p. 11.

Amazonian pottery today. Undecorated utilitarian pottery is found in greater abundance in domestic contexts. The ceramic finds are witness to a society with a rich ceremonial and ritual life where at the very least the image of women seems to have played an important role.

Santarém pottery is noted for its female figurines and complex sculpted vessels with figurative elements. At the time of the conquest, observers noted the powerful position of some Amazonian women and early accounts of the Tapajó people suggest it was probably a matrilineal society with powerful female oracles (McEwan et al., 2001, p. 139). Given the strong female tradition of pottery in the Amazon region it seems likely that women were the main potters, although men may also have been involved, as the abundance and sophistication of the pottery suggests semi-specialist producers.

The increasing scholarly interest and admiration for the pre-Hispanic ceramics stimulated a revival. During the early 1960s Ines and Raimundo Caradosa began experiments to recreate the forms, particularly of Santarém. By the end of the century many hundreds of people had taken up the craft in a dramatic revival of old traditions.

Many of the peoples of the Amazon migrated westwards over the last millennium but, in spite of distinct cultures and languages, there are some common elements which can be compared with the earlier culture of Marajo Island. Among the various language groups of the Amazon there is a frequently held belief that the patron goddess of pottery taught women the techniques of transforming the raw material of the earth into pottery. She is known by various names such as Mother Earth or Grandmother Clay and is a benefactress; she is also jealous and dangerous. She expects respect and reverence and requires certain acts of recognition or abstinences – for example chastity, silence, or fasting at certain times of working clay. Among some Amazonian peoples it was a female snake who was said to have taught women to make pottery and that it was the patterns on the snake skin that inspired the pottery decoration, a connection that seems entirely plausible given their appearance.

The Amazonian area crosses political boundaries and reaches into Ecuador and Peru where, still today, the most distinctive pottery is to be found among the Shipibo-Conibo of Peru and the Canelos Quichua of Ecuador.

The Canelos Quichua of Ecuador live in the tropical rainforest of the Upper

Below left Santarém Pottery, Tapajo Indian caryatid vessel, 10th-16th century AD 19cm (7.5 in.) Museu de Arqueologia e Etnologia de Universidade de Sao Paulo, Brazil.
Drawing Shao-Chi Huang

Below right Marajoara ceramic tangas or pubic covers worn by women. They have small holes at the points where they were tied on with cords. (Marajoara culture flourished 400–1500 AD)
Drawing Shao-Chi Huang

Amazonian Shuar woman from Yuvientza finishing a coiled pot by forming with her lips.
Photo Joe Molinaro

Amazon.[8] The people speak a dialect of Quechua, the language that spread north with the Inca Empire. Their pottery forms one of their most important cultural expressions. It still has an important everyday role for cooking, serving food and drink, and storage, but it also plays a significant part in the mythical and imaginative life of the community and is made for special festivals and shamanic rituals. In more recent times it has come to have a considerable economic aspect and has been adapted to serve the needs of the wider society of Ecuador and tourists who visit the country.

The women make coiled pottery of two types. One is black ware made from a clay that is valued for its natural inclusions of quartz crystals, sand and grit. No temper is added. After the first firing the pottery is covered with sap by rubbing with taro or sweet potato leaves and then fired in a reducing atmosphere to turn it black or dark brown. Black pottery is used for cooking and serving food.

A polychrome decorated ware is used for storing and serving *aswa*, the staple drink made from fermented manioc, also much used in ceremonials. *Aswa* drink and pottery, both the domain of the female, exhibit significant common characteristics in the way the primary materials are transformed by the actions of women. Both are made from materials wrested from the ground. To make the drink, the roots are pounded then the women take handfuls of the pulp and masticate it for a minute before spitting it into a big bowl to ferment. The saliva helps to stimulate the fermentation. In the case of pottery the clay is formed by the action of their hands and even sometimes their mouth. The rim of the pot is run between the lips to achieve a smooth finish. Thus both processes involve a close identification between body and nature; both loosen the distinction between animal, vegetable and mineral and between the individual and the group.

[8] I am grateful to Joe Molinaro for information on Jatun Molino about which he has made a film of the same name. Jatun Molino: A Pottery Village in the Upper Amazon Basin, 1996

Canelos Quicha:
mucawa *or bowl.*
Photo Joe Molinaro

Apart from vessels, the women of the Upper Amazon make a range of figure and ani-mal forms. Much of the pottery is decorated with geometric and figurative designs forming a visual language that reflects the natural world of river and forest and the spir-it world that interacts with it. Pots are seen as having an individual life and may even be talked to as if they were real people. All the women understand the basic design vocabu-lary but some develop it in a more complex way. The shaman has an important role in many personal and group activities, including healing. Although shamans are always male they are normally partnered by a sister or wife, who is a potter and who works with them to interpret their visions. The forms and designs on ceramics are an important vehi-cle for the embodiment of such visions. The 'yachaj' or 'one who knows', is a designation given to the shaman or his female (potter) counterpart. Their role is to mediate with the spirit world and keep its powers in balance with those of the actual world. 'The designs on their polychrome pottery link cosmic networks to everyday events, the general to the specific, the ancient to the present, the mysterious to the mundane' (Whitten, 1988, p. 24).

There are now extensive ethnic craft markets and all kinds of effigy pots and ani-mal forms are made. Sometimes potters take inspiration from the modern world as they come into contact with new people and experiences. The motorised canoe of the oil man is captured in clay; his power is momentarily harnessed as he is incorporated into the potter's changing world. But the piece is no naturalistic representation and combines form and decoration referring to the mythical powers of turtle and anacon-da and furthermore embraces the Christian symbol of the cross. A piece of quaint contemporary folk art, perhaps, but it is an object that also makes reference to more complex stories of power and control.

Potters now move between the ancient cosmology of their traditional life and the new economic exigencies of the region. A town may suddenly be transformed by the influx of oil workers or road builders, or a potter may find herself being promoted through a

Canelos Quichua: efigy container or Tijon *representing an animal of the rainforest.*
Photo Joe Molinaro

glossy catalogue and exhibition display. However, women's pottery has not had the same explosion of success that the new art form of balsa wood-carving has for men. Although it has its roots in forest crafts, balsa wood-carving with its naturalistic painted forms can never claim to be anything other than an ethnic craft. It has always been a commercial commodity and has little connection with the spiritual life of the community unlike the women's pottery, which carefully straddles ancient traditions and modern realities.

Shipibo Conibo

The Shipibo Conibo live along the banks of the Ukayali River, a tributary of the Amazon that extends southwards on the eastern side of the Andes. They speak a Panoan language and have a well developed social and cultural life in comparison with their neighbours who live in the remote jungle areas far from the river. The population has grown since the mid-20th century and there are now 20,000 people in about 100 villages.

Writing in the early 1970s Donald Lathrap concluded an article on Shipibo tourist art by noting that, in spite of all the centuries of disruption by missionaries, rubber traders and exploitative labour conditions, traditional pottery was still being made alongside tourist wares. One major reason might be the strength of the female network within matrilineal and matrilocal families where the pottery is taught to young girls from an early age. In Shipibo Conibo society it is common for older women to adopt a young girl, often a granddaughter, to train in the female arts. A number of observers have noted that women enjoy the companionability of making pottery and teaching it to daughters, granddaughters or adoptive daughters. Shipibo Conibo pottery was being collected by museums from the late 19th century and appears to have flourished over the last century. The pottery has been given value and recognition; it has become a badge of identity, even an anchor of stability in a changing world.

A Shipibo Conibo compound will consist of a number of thatched roofed houses where women will sit to spin, weave, sew, paint textiles and do beadwork. Married women will have a separate kitchen house and often another hut where they make pottery. A major rite of passage and feasting occasion is associated with the *joni-ati* or celebration of young women reaching maturity. Such a feast may involve one or two years of preparation and require a stock of new pottery to use on the occasion. The feasts, which may go on for several days, are the occasion of ritual sports and wrestling, exchange of gifts and general wild behaviour. For women they are an opportunity to display their creative skills: new work is admired and new trends recognised. The characteristic angular geometric designs now seen on the pottery and to some extent on the textiles, were once also used to decorate many other objects, including houseposts, beams, paddles and their own bodies. Pottery is made in the dry season between May and September. The pots are seen as a background on which to place the decoration, which is considered to embody the artistic and innovative potential of the potter. Artists whose work is technically sound, elaborate and original within the boundaries of the style are given recognition. This might, for example, take the form of crowning by the shaman. Women frequently report that they 'dream' the designs and may fast or take special herbal concoctions to enhance their imagination. A shaman working in a trance may also paint a design on a piece of cloth and ask a woman to use the design on a pot.[9] In the past some women, usually sisters, would work together on large pieces, singing to enhance the harmony in an exercise called 'the meeting of souls'.

The characteristic profile of their bowls and drinking vessels is one that is wider

[9] Shamanic singing is often conceived as a translation of a vision of such designs, accompanied by the burning of fragrant herbs to give a complete synaesthetic experience.

than it is high, with a broad, gently sloping upper part that shows off the design well from above. The lower part often remains plain. One of the most popular forms which appears to have been invented in the mid-20th century is a vessel with a face modelled and painted at the neck. There are no known precedents for this form except in the very distant past, such as the figurative vessels of Marajo, but it seems likely to have been inspired by photographs of archaeological pieces.

Tourist markets have encouraged the invention of new forms, the reduction of complexity in the designs, and the miniaturisation of pieces, making them easier to transport as souvenirs. Where income is the main aim, however, beadwork and other forms of tourist art can undermine the production of pottery, which is time-consuming and involves more risk during production.

Colombia

Colombia is rich in clays of many types, including a fine white kaolin and a dark blackish clay. These were fully exploited by the cultures that preceded the Spanish conquest, to make both utilitarian and ceremonial pottery. Burial urns with figurative sculpture on the lids have been dated to around the 11th century AD and bowls with wax resist figurative and abstract designs from the 12th–15th centuries. Pan pipes, whistles, and large water-filter jars and a great variety of vessel forms have also been found. In the social breakdown among the indigenous population in the two centuries following the Spanish Conquest, many of these earlier traditions were disrupted.

Early colonisers, mainly young men, intermarried with local women, producing a new cultural group of *mestizos* who could negotiate more easily between the two cultures. Already in the 18th century this had become the largest section of the population. Another element in this mix were people of African descent. Spanish culture represented a patriarchal and hierarchical structure in contrast with the indigenous culture which was more broadly egalitarian and where women and men had distinct but equally respected roles. The power and prestige of European culture created new class divisions, further reinforced by divisions between urban and rural lifestyles. The adoption of Spanish language and mores brought social advantages for those who were willing to become acculturated, leaving the indigenous Indian rural communities increasingly marginalised. They continue to be the least privileged group. It cannot be doubted that the marginalisation and relative poverty of such people has been one of the main factors that has preserved the female ceramic tradition.

Women continue to this day to be the main potters in many parts of Colombia.[10] They handbuild using moulds, coiling, or sometimes a simple turntable (*molde*). In some centres, open firing is still to be found but much more frequently in Colombia simple roofed kilns are used. Mostly men undertake this work and in the many places where wheel throwing has been introduced it is always a male occupation.

[10] There are exceptions, however, and at the village of Claros, near Garzón in the Southern Magdalena Valley, men and women have been potters for generations. The pottery is coiled but fired in kilns. (Litto, 1976, pp. 157–159)

With the Spanish Conquest, Spain controlled all trade, and only ceramics imported through Spain could be brought into the country. The strong indigenous ceramic tradition continued to supply the needs of most people for cooking and water storage. The more upmarket aspect of ceramics was catered for by goods imported through the mother country, including Chinese and European porcelain and later Wedgwood creamware, Hispano-Moresque maiolica, glazed jars for the transport of wine, olive oil and gunpowder, and even floor and roof tiles although these were eventually produced locally. Thus the more decorative and symbolic designs of the indigenous tradition began to disappear, although new forms such as candlesticks and jugs were made to cater for new needs. Figurative ceramics such as shamanic models or ritual figurines were adapted into ornamental models of horses and chickens or for religious figures such as nativity scenes. From the 19th century, tableware was either imported or supplied by a factory in Bogota that flourished in the second quarter of the 19th century.[11] It represented an extension of the market for ceramics but did not undermine the need for pottery for cooking and water storage.

Ráquira is the centre of a thriving ceramic industry built on a long indigenous female tradition. Women make handbuilt utilitarian pottery that is still valued for its excellent cooking and water storage properties. Over the last century, however, a major gender change has taken place and men increasingly work in the industry. Pottery offered a viable alternative in an area where agriculture was not very profitable. Men took on new activities in marketing, kiln firing and in making miniature models, most famously the 'caballito' or little horse, which has become a mascot for the town. Open firing is still practised by rural women. Thus increasingly men control the commercial activity and the economic power. This male control is expressed by the 'taboo' that has grown up in Ráquira preventing women approaching kilns when they are being fired or menstruating women coming near them at any time. The danger is said to be to the woman's health and fertility but also to the kiln which she may 'pollute' or contaminate, so that it no longer fires successfully (Duncan, 1998, p. 63). In fact the health of all the population in Ráquira is much plagued by respiratory disease, aggravated by the kilns that use coal and salt and produce noxious fumes. People are now using electric kilns when they can afford them.

Most pottery is still produced within family workshops and women continue to produce domestic pottery but their work is undervalued as the strong patriarchal culture adopted by the predominant *mestizo* population[12] disapproves of women working outside the home. In rural villages women have more freedom and status.

Women preserve the older traditions in their dress and their craft practices, whereas men have long adopted more Western style clothes. Men treat their craft work as a job and work hard for defined periods and then relax – often outside the home in drinking places. Women's work is adapted to other domestic responsibilities and they have less defined leisure time. Their work is therefore more loosely defined as 'work'. Even their pottery is seen as a kind of 'housework', is remunerated less, and is viewed as a supplement to male earnings in pottery or agriculture. Innovation is more acceptable in men than in women although women appear to be innovative in later life. The

[11] John and Robert Peake were English and set up a factory in Bogota which is known to have had seven kilns and a staff of 65. It seems to have functioned between 1830–1866.

[12] In 1750s a census in Raquira showed that 681 (70%) were mestizo, 210 Indian and only 80 Spanish.

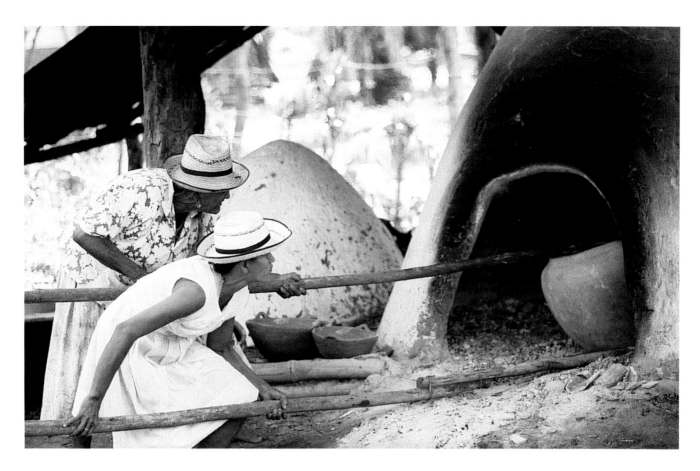

Firing the kiln in La Chamba, Colombia. The smaller pots are placed in large saggars which are pulled out of the flames and smothered in donkey dung to achieve the black finish.

Photo Laurence Kruckman

pottery industry in Ráquira is now huge but the main production is for a particular form of cultural goods for a tourist and gift market.

La Chamba, another major ceramic centre in Colombia, is also founded on a long-standing female pottery tradition but it has taken a very different direction from Raquira. La Chamba is in the Magdalena Valley, a rich agricultural area that provides employment opportunities for men. Pottery production has remained in the hands of women who are involved in all aspects of the fabrication and marketing, although men may help with the work, especially the collection of the clay and the firing. From the early 20th century, women of La Chamba increasingly worked commercially in ceramics. In 1920 over half the households made ceramics; by the 1970s 72% of households and by 1987 92% of households were involved in some way. Their important economic and artisan status gives women some authority and independence in a patriarchal *mestizo* culture, however their income is well below the minimum wage. They are obliged to work long hours and frequently rely on the unpaid labour of children and older men in the family to meet delivery dates.[13] Pottery is mainly sold to middlemen who make 200–400% over what the potter earns (Kruckman, 2001, p. 13).

The pottery is made from a sticky black clay tempered with sand for larger pieces. It is mould made, sometimes with additional coiling, covered in a red slip (*greda*), burnished, and fired in saggars in adobe beehive kilns (an adaptation of the Mediterranean bread oven) whereupon the work turns a bright orange-red colour. Traditionally La Chamba was known for red water storage jars and cooking pots but the market declined as metal cooking pots became available. Now La Chamba pottery

[13] For an extensive discussion of this aspect see Ronald Duncan, 2000.

is turned to a lustrous black by smothering the glowing pots in donkey dung or saw-dust.

During the 1940s a small ceramic school was established and run by a young La Chamba potter, Ana Maria Cabezas, who introduced new forms and techniques: bur-nishing, tableware and 'fine' ceramics such as figurative pieces. By the 1970s a Centro Artesanias de Colombia had been set up which acted as an educational and commu-nity centre. It helped to organise the collection of wares from the surrounding areas, set up displays and distribution and encouraged good quality work but it is now very run down . Most of the women, however, still prefer to sell directly to the middlemen. Pottery from La Chamba has been widely marketed and the work is now sold across the world. Since the 1960s they have specialised in cookware including paella dishes, casseroles and oval tureens. Particularly successful has been a pot for serving *ajiaco*, a food of the colder climates of Colombia not typical of La Chamba. It has become a popular national dish for urban restaurants specialising in Colombian cookery and is typically served in a black La Chamba pot. The cookware can be marketed as dish-washer-proof oven-to-tableware, suitable for cooking over a direct flame, in the oven, or in the microwave. (See Chapter 11). Sadly, the current crisis in Colombia with civil unrest and banditry does not assist the development of global marketing.

There are now also some individual artists, men and women, who have emerged from the tradition. There is higher status and a better return for the labour involved in making one-off pieces and many younger women are beginning to undertake this kind of work. The best known individual artist is, however, a man, Eduardo Sandoval. From a potting family he studied art and design in Bogotá in the early 1980s but returns regularly for clay and to fire his sculptural pieces. He makes still life composi-tions and figurative pieces.

Further south, at Pitalito, is another traditional pottery centre which became famous for its miniature pottery models depicting typical Colombian or South American lifestyles, especially the loaded truck overflowing with people, chickens and

Below left La Chamba potter burnishing.

Below right La Chamba pottery
Photo Laurence Kruckman

In Guásimo in Colombia the women potters are descended from black slaves. This potter from Caloto is spreading a red slip before burnishing and firing in an open bonfire.

Photo Gerturde Litto

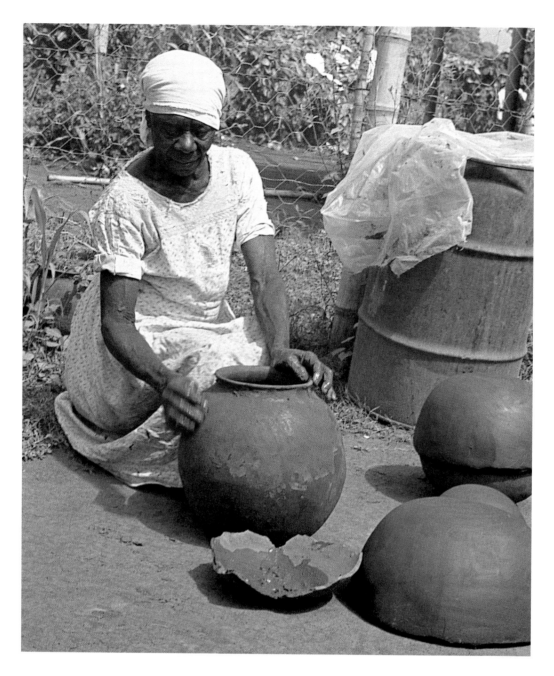

fruit painted brightly in enamel paints. Cecilia Vargas was the first to develop this form but it has been widely copied. The ideal tourist memento, it affectionately characterises Columbian lifestyle while being small and transportable. Now marketed across the world, what started as a small-scale individual business has graduated to a major factory production.

In Guásimo in Colombia the people are descended from black slaves. Many of the women make pottery while the men work mainly in agriculture. As in La Chamba, the pots are formed by draping a flat pancake of clay over an upturned pot as a mould. The pieces are rubbed over with a slip and burnished before being fired in an open fire. Similar work is also produced by another Black community at Boca de Los Sapos. Thus it appears we have communities whose distant origins lie in Africa, who main-

tain pottery as women's work, as they do in Africa, but who use a South American moulding technique.

Venezuela

Venezuela has maintained a strong female tradition of pottery into the late 20th century, but potters tend to work as individual specialists serving a community, rather than whole villages where many families work as potters. Some of the potters use a coiling technique but others apply pads of clay, pulling up the form and finally scraping down. Litto (1976, p. 198) observed that in Vigiadero in the Quibor area all women knew how to make pottery and most still did produce pots every few months to keep up their supply. The pots were decorated with schematic floral designs which were also carried over into mural decoration on house walls.

Inez Rodriguez of Vigiadero holds a pot decorated with branch and flower motifs (ramera). The wall decorations, which use the same style, are also decorated by the women who traditionally all made pottery, 1974.
Photo Gertrude Litto

The village of Lomas Bajas represents one of the most unusual situations where traditional women potters have been using the wheel for some generations, passing the skill on from mother to daughter. Men help with the work, as in so many places, and some men are now taking up throwing. Pottery is kiln fired. Throwing off the hump, the potters specialise in planters and *ollas* which are scraped over and given rounded bottoms so as to disguise the 'look' of wheel throwing and give the appearance of traditional handbuilt pots. A rare example of a wheel-thrown pot imitating an earlier technology, it is also particularly unusual because women have taken up throwing.

Conclusion

In South America we seem to have a general pattern of women as the indigenous potters in most parts, a situation which has prevailed in many places to the present day. In a number of places women's traditions have been transformed into major economic activities, as in Quinchimali and Pomaire in Chile or Raquira in Colombia. In nearly all cases men have become involved in the industry at some level, especially if the pottery is fired in kilns. In his two recent publications on Colombian ceramics, Ronald Duncan has examined the changes in ceramic production with a more critical and sociological eye, identifying the way that the work of both women and children is exploited within a capitalist system for the benefit of the middlemen. The most pure women's pottery traditions seem to have survived in the Amazon Basin with groups of people whose contact with Europeans was fairly minimal until the 20th century. However, some of these peoples have very effectively used their crafts, including ceramics, to establish a highly visible presence in the modern world. The makers have had no problem in adapting the work for new needs and markets. Works which incorporate contemporary imagery bridge the gap between cultures and form a link between tradition and modernity.

Eugenia Nieto of Lomas Bajas, Venezuela throwing off the hump on a wooden wheel. Unusually the village maintained a female traditional with skills passed from mother to daughter in spite of the introduction of wheels and kilns, 1974.
Photo Gertrude Litto

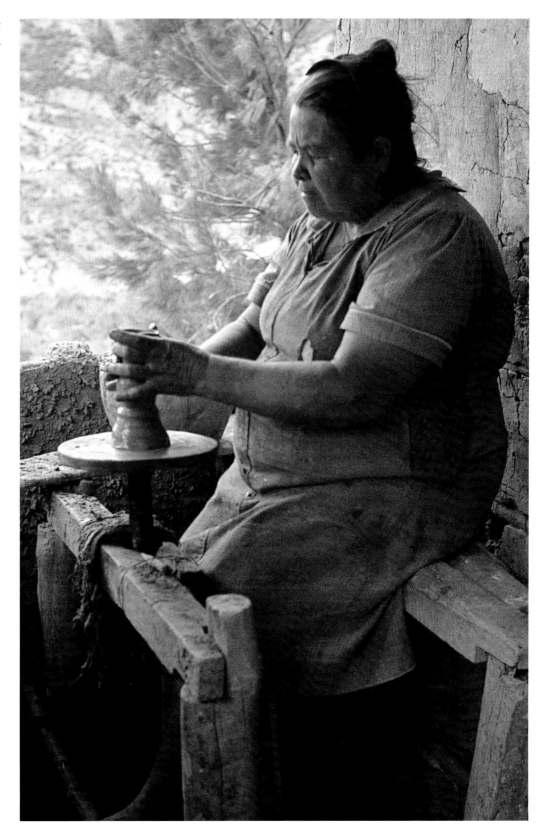

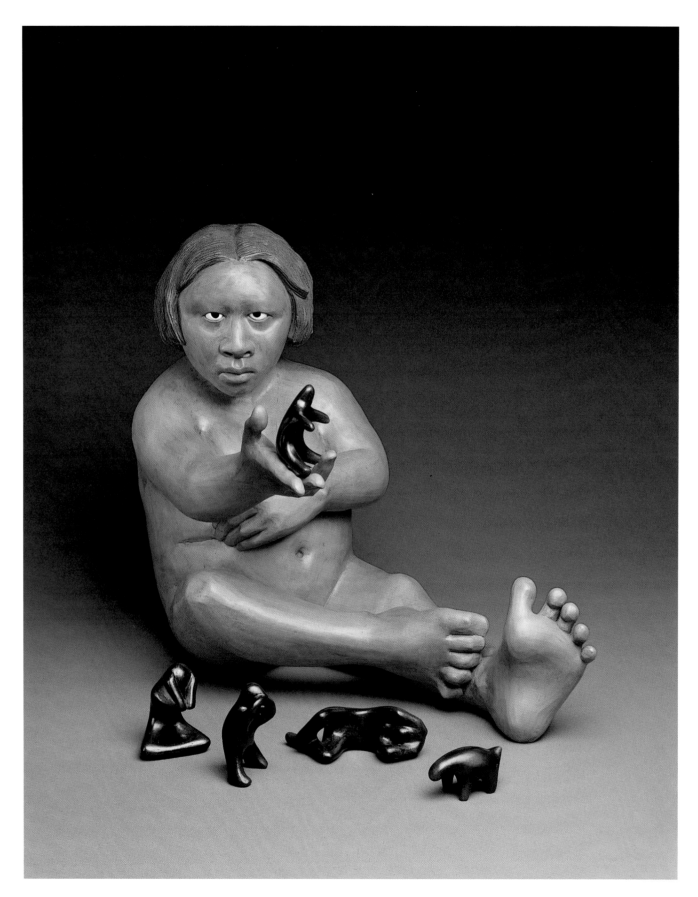

Women's Traditions and the Figure in Fired Clay

I N THE 1930s Beryl de Zoote, dancer and photographer, made a photographic record of folk life in Romania. In one of a series of photographs she recorded a ritual used to bring rain, where women and children modelled a figure in clay, said to represent Caloian, the dead son of the Rain. The figure was buried, given full funeral rites and then dug up, symbolising a resurrection, after which Caloian was thrown into the river. The re-uniting of mother and son allowed the rains to begin.

The ceremony is just one illustration of the ritualistic potential of clay, using simple modelled figures. Clay figurines are the earliest examples of ceramic technology. Finds at Dolni Vestonice in the Czech Republic are dated to 24,000BC, thus predating the earliest known pottery vessels from Japan by 14,000 years (Vandiver, 1989). Stone and wood figurines often co-exist with clay figurines and their interpretations have been much debated. From the ethnographic evidence it is clear that they can have many functions: figurines can be used in burial, fertility and healing rituals to invoke the ancestral spirit world; they can play a part in education and social instruction, and so-called toys or dolls are used in children's games to act out adult roles. As the Romanian example illustrates, each society will have its own particular needs and narratives. In this chapter I want to consider how figurines can be related to women's ceramics generally.

A distinctive form of figurine is found in many parts of the world, dating to the late prehistoric period in tropical South America and Mesoamerica (2nd to 1st millennium BC) and to the Neolithic and Early Bronze age in Europe and Asia (6th to 3rd millennium BC). The figures are predominantly female, usually nude and plump, sometimes with elaborate hair or ornamentation and often appearing to emphasise sexual features such as breasts, buttocks or genitals. Most commonly they are found in association with domestic settings rather than religious contexts. Anna Roosevelt has argued that, although there is no direct connection between these different societies, they have some common characteristics. They were societies with expanding populations, developing crop agriculture and were increasingly sedentary. In such societies, often organised into chiefdoms, men were occupied by warring and defense while women's status was enhanced through property rights to fields and agriculture. Descent was often traced through the female line and, sometimes, to a female 'Goddess'.

The idea of ancient matriarchal societies and 'the great Goddess' was first proposed

*Beryl de Zoote pho-
tographs of a ceremony
to promote rain based
on making a clay model
of Caloian, son of the
Rain, Romania, 1930s.*
Photo Beryl de Zoote,
courtesy Horniman
Museum, London

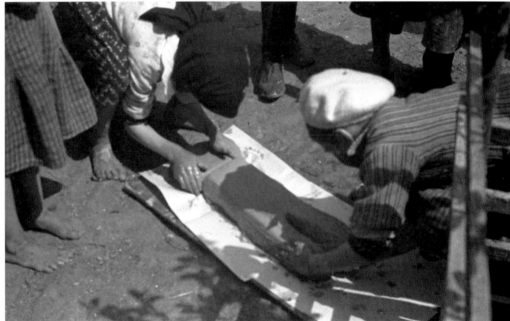

*Beryl de Zoote pho-
tographs of a ceremony
to promote rain based
on making a clay model
of Caloian, son of the
Rain, Romania, 1930s.*
Photo Beryl de Zoote,
courtesy Horniman
Museum, London

in the 19th century by Friedrich Engels and others. In the late 20th century it was most persuasively argued by Marija Gimbutas whose elegantly illustrated books have been so inspirational to radical feminists and to a number of artists. Ultimately, however, her thesis remains speculative. From ethnographic data there are many variations on the use of figurines but it is reasonable to suppose that they were associated with female well-being, reproduction and, by implication, the general good of the society. Hence it is often suggested that they were also used to symbolise regeneration and rebirth for humans and crops, thus aiding agriculture and ensuring the success of the harvest.

Figurines and female imagery are particularly abundant in south-east Europe, the Balkans and Turkey, with the most debated and extensively researched site at Çatal

Çatal Hüyük c. 6000BC Enthroned goddess flanked by felines and giving birth. The figurine was found in a grain bin. 11.8cm (4.5 in.)
Drawing Shao-Chi Huang (after Gimbutas)

Hüyük in Anatolia.[1] The site dates from 6400BC–5400BC and demonstrates an urban settlement pattern in the Neolithic period. It was a town of about 6,000 inhabitants with an economy based on agriculture, animal rearing and trading. It had many household shrines and wall paintings, and some of the earliest textiles and pottery. The site bears no evidence of special buildings or centres, and the dwellings suggest a relatively egalitarian society. The predominance of female imagery and female associated activities, and the lack of evidence of military activity or hunting led James Mellaart, the original excavator, to suggest that the society was one where women had high status. Direct representations of males are few, although the widely used image of animal horns has been interpreted as a male symbol. Women were buried under the main platform of the house and they predominated in the richer burials.

In the Neolithic period in many archaeological sites in south-east Europe, the relationship between pottery, hearths and ovens, figurines, vessels with female form or women holding vessels and wall decoration is very marked. The discussion and interpretation of this material has frequently focused on the relative status of women and the possibility of a female-centred religion. What is not discussed in the literature is the possibility that women – whatever their status – were the makers. This could be a further explanation for the emphasis on the domestic setting and the association of cooking, storage of food and female figurines. Cooking is so widely associated with women that there is no reason to suppose it would have been different in early times, and pottery and house decoration are also strongly linked to the female. Such a link cannot, however, be assumed. According to the archaeological evidence, between the 5th and 3rd millennia BC, this high visibility of women predominates and is associated with the development of grain agriculture. Towards the end of the period the balance changes. Fewer figurines are found and female visibility decreases. Burials no longer take place in the domestic setting but in cemeteries, where the richest graves are now those of men buried with axes, weapons and prestigious metal goods. Such accumulation of goods suggests a more stratified society based on warfare, trading and animal husbandry on a large scale, with greater craft specialisation.[2]

Figurines are also a feature of many archaeological excavations in the Americas, especially Mesoamerica. A similar domestic association emerges from Joyce Marcus' 1998 study of figurines in the Oaxaca area of Mexico which date from the period 1800BC–700BC. Around 1800BC, after many millennia of nomadic life, people began to

[1] The original publications by Mellaart are 1965, 1967 and 1975. See also Barstow 1978 and Hodder 1996.

[2] For a remarkably self-reflexive discussion of this material see Hodder, 1992 and *The Domestication of Europe, 1990.*

settle in village communities, cultivating maize and other crops and breeding dogs for food and for hunting. For about 1000 years the society appears to have had a relatively egalitarian structure in which ordinary people performed the rituals of everyday life. Towards the end of that period a more stratified society developed dominated by Monte Alban, the major defended urban centre which came to the fore around 500BC. Ritual activity was increasingly enacted in temples, probably by male spiritual leaders.

Large numbers of figurines dating from the early settlement period have been found, each one individually modelled and probably fired along with household pottery. They occur in various locations – in houses where they appear to be part of ritual assemblages, in burials – especially female burials – and sometimes under the walls of houses, as if to guard the foundations. They pre-dominantly represent women, often with elaborate hairstyles that may have indicated individual status. Marcus suggests that these grouped displays, sometimes incorporating miniature furniture, were part of household rituals relating to ancestors and the spirits of the departed who watch over the living. They may have been used for divination and for rituals concerning family well-being or fertility, where the figures provided a physical 'body' to which the ancestor spirit could return. Marcus compares these practices with recorded evidence from the time of the Spanish conquest, and with more recent female activities surviving up to the 1930s relating to women and divination. Although we can never hope to fully understand the meaning of these figurines, the historic record of Zapotec women's involvement with divination and ancestors suggests that these practices have deep roots in prehistory.[3]

In a much later period in Mexico (AD1250–AD1560) the Aztecs also made extensive use of

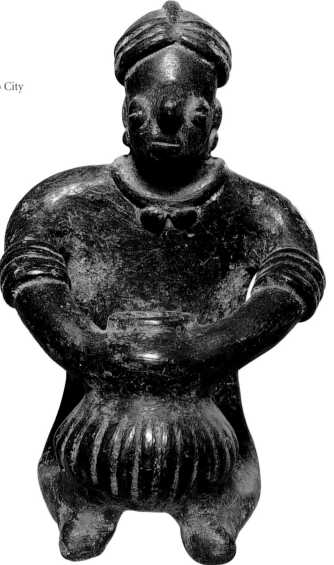

Figurine in black pottery showing a woman with a pot. National Museum of Anthropology, Mexico City

[3] For further discussion of figurines in the archaeological context in Mexico see Lesure (1997) commenting on Chiapas and Guillen (1998), discussing an extensive corpus of figurines dating from around 700BC in Morelos.

figurines – moulded, hollow or solid forms between 10–20 cm (4–8 in.) high. Both the technique and the fact that workshops have been identified suggests that these figurines were produced in specialised centres rather than at a domestic level. However there is good evidence that they were used in the domestic context, as they are rarely found in temples. Early Spanish observers recorded that the Aztecs kept 'idols' on household altars and that these were used in household ceremony at particular times in the ritual calendar. 'Idols' were used to protect children and buried in fields to promote a good harvest. They have also been found in courtyards where there were steam baths associated with women's rituals relating to curing and fertility. A common figurine is that of a bare-breasted female holding a child under each arm.[4]

Writing around 1566 Diego de Landa, the second Bishop of Yucatan, noted that:

[Women] were very devout and pious, and also practised many acts of devotion before their idols, burning incense before them and offering them presents of cotton stuffs, of food and drink, and it was their duty to make the offerings of food and drink. (from Tate, 1999, p. 85)

It is difficult not to see echoes of these practices in the domestic altars of present day Mexicans and the huge popularity of images of saints, devils and nativity scenes. At Ocotlán de Morelos in the state of Oaxaca the four Anguillar sisters follow in the footsteps of their mother, Dona Isaura Alcantara Díaz (1924–1968) who first initiated a

Conception Anguilar of Ocotlán models a devil using a design book to guide her for animal details, 2001.
Photo A.Vincentelli

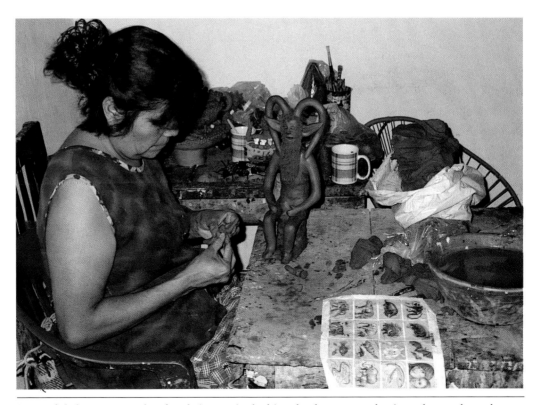

[4] Brumfiel also proposes that female images in the hinterland were more benign, whereas the male-dominated ideology of the Aztec state promoted violent images of women mutilated or beheaded. She argues that this might suggest that the hinterland resisted the dominant militaristic Aztec ideology (Brumfiel, 1996, pp. 155–9).

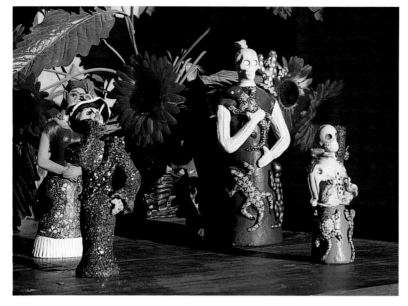

figurative folk art that gained a wider tourist market and attracted the attention of American collectors. They make some near life-size figures but their main work is in smaller figurines and illustrative groups which are brightly painted in commercial colours, sometimes with details picked out in sparkly paint.

Pueblo figures

In the south-west of the USA figurines and effigy vessels appear in the archaeological records at various times although vessels predominate. Figurative pottery is part of ancient Pueblo traditions going back to at least AD300. After the 17th century, Pueblo peoples adopted Roman Catholicism and were discouraged from making 'idols'. Thus in the Historic Period, the existence of such figurative pieces would have been discreet. However, the Pueblo belief that clay artefacts embody their own life spirit is probably very ancient. Small figurines were used in various ways: women who wanted to conceive would make a clay baby and place it on the altar of the church or *kiva*; animal effigies would be similarly treated and then buried in the ground of the corral to make the animals productive (Babcock, 1993, p. 217). The Zuni made figures of owls and at Santa Clara Pueblo they made miniature animals or *animalitos*, but it was at Cochiti and Tesuque that figurative ceramics reappeared significantly.

The Cochiti figures of the 1880s represent an early example of cultural exchange where figurines were produced for sale to a non-Pueblo market. Visitors to the area hugely increased after the railroad reached Santa Fe. The figurines, usually between 40–75 cm (16–30 in.) high, depict characters from Anglo and non-Pueblo culture – probably satirical, or

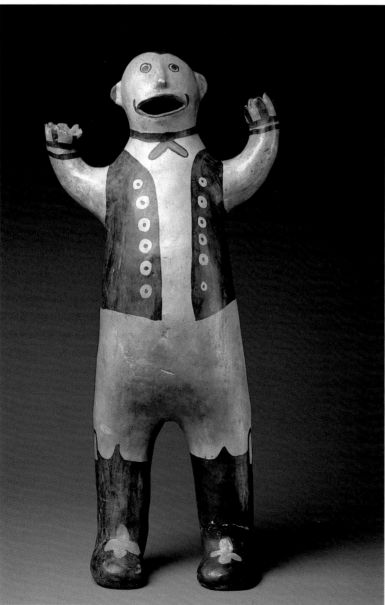

simply as curiosities – they are the new men of the modern world seen through the eyes of Pueblo women potters. Some of the figures reflect the 19th century fascination with freakish aspects of humanity such as conjoined twins. They can also be related to the *koshare* tradition or clown burlesque which was a central aspect of Pueblo culture. The *koshares* perform at dance days, saints days and celebrations, and have power over the weather and fertility, often acting outrageously by mocking and caricaturing the outsider.

The Tesuque figurines were smaller and cruder than those of Cochiti and were sometimes even passed off as ancient. They were marketed as 'rain gods' or idols and exoticised by associating them with Montezuma and the Aztec civilisation.[5] These seated Devil-like figures were sometimes made with genitalia and were probably the source of some of the distaste expressed by contemporary commentators for the 'semi-obscene character of the work' (Holmes, 1889, p. 320).

[5] The association of Montezuma with the Pueblo peoples is spurious, but was a widely held view in the 19th century. The curio dealers often marketed the figures in particular as ancient Aztec pottery (Batkin in Phillips and Steiner, 1999, p. 291).

Both the Cochiti and Tesuque figures were cleverly marketed to a wider American audience as attested by the photographs of such traders as Aaron and Jake Gold. After 1883 the latter renamed his enterprise a 'free museum', catering for those visitors keen to savour local culture. Although obviously associated with the development of tourism in the Southwest, Jonathan Batkin has shown that Indian crafts, including figurines, were promoted through effective advertising and the expansion of mail order. The openly commercial nature of these works and, to an extent, the fraudulent marketing tactics meant that, for many decades, they were despised as 'inauthentic' knick-knacks.

Originally designated as curios, later as Indian craft, the heyday of these figures was between 1880-1920. By 1920 museum officials and advisors were looking for an 'authentic' Pueblo pottery which was identified with functional vessels. The ideals of the Arts and Crafts Movement which still held sway, encouraged 'revivals', but it was always in terms of what the Anglo advisors saw as authentic – that is, as far as possible untainted by outside culture. As we have seen elsewhere, this is frequently a myth based on spurious notions of an unchanging 'ethnographic present', particularly misdirected in relation to Pueblo culture which had constantly been adapting over centuries of contact.

In the 1950s Lange (1959) recorded that most of the pottery at Cochiti was made for tourists and, consequently, was mainly small or 'eccentric' items such as ashtrays in the form of adobe houses, or animal coin banks. Very few women felt sufficiently confident about their skills to make large jars, but he did note some human figures or dolls made by Maria Seferina Arquero who had been working since the 1890s. These were not the satirical male figures of the 1880s but much more stereotyped images depicting women with pots or with children. Popularly known as the 'Singing Mother' or Madonna, these sit comfortably within the ideology of womanhood in that period.

Around 1964 Helen Cordero (1915–1994) transformed this image into 'The Storyteller'. She was commissioned by a folk art collector to make a large 'singing mother' and she remembered her grandfather, Santiago Quintana, who was noted for his gifts of storytelling. He had been an early contact and friend of Adolph Bandelier, one of the late 19th century anthropologists who studied Pueblo Indians; in the 1920s, the anthropologist Ruth Benedict had also collected stories from him. Recounting mythological tales and stories of the ancestors in the oral tradition of storytelling is a way of preserving memories and nurturing a shared identity as Pueblo Indian or Cochiti.

The original Storyteller was a male figure surrounded by children often clambering around

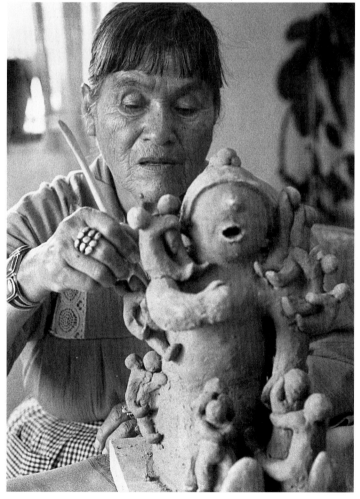

Helen Cordero modelling a story teller figure. 1979
Photo Dudley Smith, Photo Archives, Denver Museum of Nature and Science

him, and there are now many versions of the theme. By the 1990s there were over 200 potters making figurines of this type and the booming market also spawned miniature versions and slipcast models. Helen Cordero became another matriarchal legend of Pueblo pottery. She talked about 'her potteries' in a very personal way, claiming 'They're my little people. I talk to them and they're singing' (Babcock, 1993, p. 215). Such a statement reaffirms the Pueblo belief in clay as a living substance – pots or clay forms are like living beings. Each of her Storytellers was different, each a re-telling of an old story, each celebrating a grandfather's memory. Helen Cordero made a clear distinction between her work and the earlier Cochiti figurative tradition which she associated with 'monos' or fairground figures. Success gave her power and self-confidence bringing with it unexpected control over her life. As she recounted to Babcock, when her husband objected to so many Anglo visitors she had insisted that it was her work and 'he would just have to stand it'.

Today the stories created by makers for the outsider are often represented as a kind of confabulation to help market the goods. They may indeed help to market the goods but they are also an opportunity for the maker or even the seller to re-enact that cultural difference embodied in the work.

Among the younger generation of artists there are a number using the prototype of the figurative form who have extended its range to address new sculptural approaches and a

Norah Naranjo Morse 'Pearlene', 1987, 98cm. (38in.).
Heard Museum, Phoenix, Arizona.
Photo Craig Smith

more self-conscious questioning of Pueblo identity. Nora Naranjo-Morse (Santa Clara) first made her name with satirical images of contemporary characters, such as her brash modern young woman, *Pearlene.* More recently she has turned to monumental abstract sculpture which retains a powerful sense of Pueblo identity. *Our Homes – Our Selves* (1997-8) is an assemblage of 1.8 m (6 ft) tall pole-like clay structures which suggest both Pueblo architecture and human presence.

Her niece, Roxanne Swentzell, creates powerful enigmatic figures which question provocatively the interface between the values of the contemporary world and those of the Pueblo. In *Pueblo Figurines for Sale* (p. 175) a naked female figure holds out small *animalitos* to the viewer. The shiny black of the models uses the finish that is so characteristic of Santa Clara pottery. In the *Clay People* catalogue she accompanies the

Nora Naranjo-Morse 'Our Homes–Our Selves', 1998-9. Seven piece sculpture of fired and painted clay. Tallest piece 200cm (78 in.).
The Minneapolis Institue of Arts. Gift of Sara and David Lieberman.
Photo Addison Doty

piece with the thought that, 'Sometimes I wonder if we have gotten so money-hungry that we forget to be respectful of the things we create. This piece is to remind us artists that our creations are alive in Pueblo belief, and maybe sometimes they don't want to be sold.' We are made to confront that interface between cultures which is constituted in the commercial exploitation of Pueblo pottery. Unlike the comforting and unthreatening images of the Storyteller tradition, here we have an image that conveys something of the darker side of the relationship.

Africa

Figurative clay sculptures are also found in sub-Saharan Africa, although archaeological research to date has been limited. Since the early 20th century it has become clear that there is a long history of figurative clay sculpture in West Africa, whose sophistication indicates a highly complex and probably hierarchical society. The powerful Nok heads and figurative forms which date back to 500BC and the startling realism of Ife sculptures (12th–15th centuries AD) are very different from anything known in historical times. These terracottas are closely allied to the development of metalwork but it is impossible to draw any firm conclusions as to who might have made such sculptures. They were clearly produced by highly specialised artists and artisans.[6] Marla Berns (1990) has noted

a tendency to make a distinction between 'pottery' and 'terracottas': pottery is a utilitarian craft mainly practised by women while terracottas are sculpture or art assumed to be made by men. This underlying assumption runs through much of the literature on this material. The evidence is inconclusive and breaks down when examined more carefully.

There is a widespread production of figurative forms in West Africa, mainly concerned with ancestor commemoration and funeral rites. The fact that they may only need to be produced occasionally gives them a different status from everyday pottery. Roof finials with figures are also common. These more modest sculptural ceramics date from recent times, although the impact of Islam and Christianity have tended to undermine some of the older practices. Gender is often an issue in their production. Although women hugely predominate as potters in West Africa, men are sometimes, and occasionally exclusively, the producers of figurative forms. In some cultures such as the Akan of Southern Ghana, the parallel between figurative work and reproduction has given rise to a taboo on women of childbearing age making figurative sculpture; it is seen as a threat to their fertility. Figures are made only by men and by women who are past childbearing age. In other West African societies women do produce figurative work. At one time, Dakakari women of north-western Nigeria made large, fired sculptures of humans and animals, sometimes 90–120 cm (3–4 ft) high, to commemorate the deceased.[7] Among the Yungur of north-eastern Nigeria, women potters make roof finials and

Seni Camara, Senegal
'Woman with Twins'
terracotta figure 38cm
(15in.).
Courtesy Claude Thorain

Camel and dog, Berber
animal figures from
Kabylie, Algeria.
Ht. 19cm (7.5 in.) and
10cm (4 in.).
Photo Andrew Baldwin

[6] For further discussion see Vincentelli, 2000, pp. 24–7.

[7] In 1969 it was reported that there were only two women left who still did this. (Simmonds in Picton, 1982, p. 66).

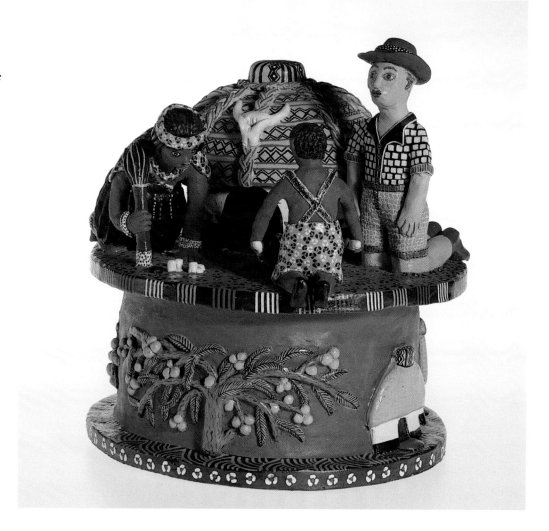

Bonnie Ntashalintshali
'Sangoma reading white
man's fortune', 1993
27.6 (10.7 in.).
Collection South African
Standard Bank

ancestral pots with human features and modelled heads (Marla Berns, 1990) and Yoruba women are also renowned for their figurative ritual pots. As yet there seem to be few producers of figurative pieces to cater for new markets, but one example is the Senegalese potter Seni Camara. Brought up in a village of traditional potters she began to model in clay from an early age and found that there was a market for her sculptures. During the 1980s her reputation grew and she was an exhibitor in the major exhibition in Paris in 1989, *Magiciens de la Terre*. She makes strange fantastical, modelled figures with bulging eyes and noses, sometimes riding a horse or sometimes astride a motorbike.

In countries where there has been a buoyant colonial market, potters have often begun to make figurines for domestic display. Berber women potters in Algeria have been making animal and bird figurines for over a century and in South Africa there is a tradition of small-scale ceramic sculpture, usually associated with particular practitioners who have established a reputation. In KwaZulu-Natal the male artist Hezekile Ntuli (1912–1973) modelled small-scale portrait heads and animal groups, while more recently, Dora Mdlalose has produced figurines that evoke a nostalgic image of Zulu culture. Emerging from the much more politicised milieu of Township Art, Noria Mbasa uses a bold realism in ceramic figures brightly coloured in enamel paints. These artists, whether men or women, do not necessarily arise from a traditional potting background; rather, they draw on the more diverse and hybrid culture of post-colonial South Africa. They all worked in the apartheid period and Mdlalose and

Mbasa, in particular, benefited from the expanding opportunities available since 1990. Bonnie Ntashlintshali (1967–1999) began as an untrained helper working with the artist Fée Halsted-Berning, the founder of Ardmore Ceramic Studio in KwaZulu-Natal. Despite the limited educational opportunities for rural black people in apartheid South Africa, it was clear that she was highly talented. As a young woman, the empowerment offered through her work with Halsted-Berning gave free range to her imagination, fuelled in part by her Catholic upbringing, and expressed in her visionary modelling and painting. In 1990 Halsted-Berning and Ntshalintshali won the Standard Bank Young Artist Award for Visual Art and since then Ardmore has gone on to nurture a number of notable South African ceramic artists. In her sculpture of 'Sangoma Reading White Man's Fortune'[8], the power relations of colonial culture are subtly turned on their heads. Ntshalintshali imagines the farmer to be suffering from sexual problems. His loudly patterned shirt and zipped shorts are wittily observed and contrast with the African context of the Sangoma's traditional dress and round house. The early death of Bonnie Ntashalintshali robbed South Africa of one of its most gifted young sculptors who straddled the divide between folk culture and contemporary art.

Canelos Quichua, figure of the underearth spirit 'Juri-Juri'. The mouth on the front of the head eats animals but there is also a mouth on the back that is said to eat humans.

Photo Joe Molinaro

Conclusion

Long before there were clay vessels women probably made clay figurines and mobilised their symbolic power to create meaning in their lives. Figurines can take the form of a plaything, a teaching tool, a protective amulet, an embodiment of an ancestor, an ornament or a piece of sculpture. Some objects may shift between categories, and distinctions between different classifications are often blurred. In many traditions women have modelled figures alongside the production of domestic pots and often the difference between a pot, an effigy vessel and a figurative sculpture is only a matter of degree. Stimulated by commercial or tourist markets, women have successfully taken up figurative modelling, as can be seen in so many places in Mexico and South America. Moreover, in recent decades women artists have been emerging, whose background is in traditional pottery but who are attracted to the potential of ceramic sculpture as a vehicle for innovative work. The figurine is coming to occupy an increasingly significant place within the female tradition of clay.

[8] Sangoma means wise man or woman, healer or witch doctor.

NEW WAYS AND NEW OPPORTUNITIES

O N EVERY continent there are women potters who find a ready market for their handbuilt low-technology wares. There are still many places where such pottery plays a vital part in people's everyday lives whether for cooking, water and food storage, brewing and fermenting liquids, or dyeing cloth. But in a process that has been ongoing since at the very least the 19th century, these functions are increasingly being met by alternative means: from plastic containers and mass-produced tableware to running water, electric light and bottled gas. As one function disappears, however, women have had to be inventive in finding new outlets for their skills.

In many ancient societies special pots were made to accompany burials as much as for domestic or ceremonial display but in most modern societies it is the latter that takes precedence. One of the most successful ways to develop is to direct the work towards the expanding market for house and garden decoration so characteristic of all urban societies. The pottery has to become more decorative and given distinctive designs to make it competitive. Pottery, which previously expressed a regional or village distinction, becomes increasingly diversified and individual styles or forms emerge. A particular woman 'invents' a new shape or begins to make figurative work and others follow on. Traditional women potters can often adapt their work to cater for the modern collector.

Tourism creates important new markets. In this case the work has to carry a message and say something about its place of origin. Typically tourist objects may illustrate some aspect of 'traditional' life such as the Pueblo Storytellers or Zulu ceremony. If marketed carefully, however, the *technique* of handbuilt pottery can be a selling point and a distinctive marker. The work has to be made 'special' and given 'added value', even perhaps through actual demonstration of the technique. The high shine of the black pottery of San Bartolo in Mexico is a good example of this.

All the chapters in this book have considered particular examples of new initiatives. However, this chapter will consider in more detail some of the other ways that have allowed traditional women's ceramics to continue. It will be divided in three sections: the first part will consider how demonstrations have been used to promote women; the second part will look at development projects and the third part will look at examples where traditional pottery is being marketed across continents. Interwoven in all these initiatives are the global issues of the division between rich and poor in the mod-

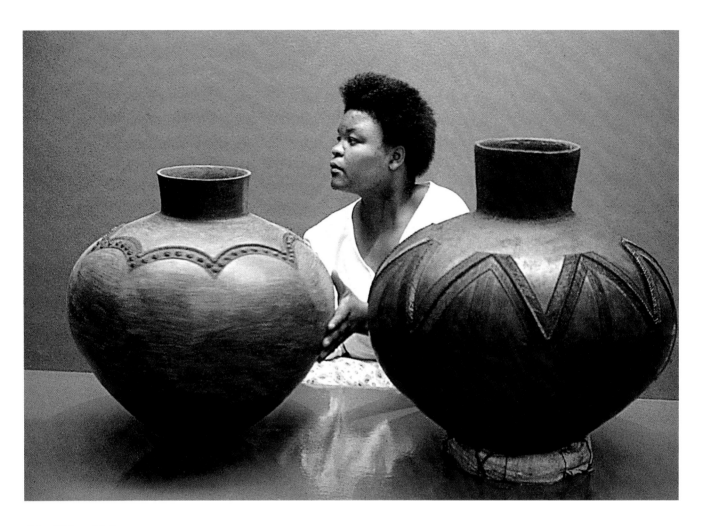

Jabu Nala with her large scale black-fired uphiso vessels.
Photo Kim Sacks

ern world, the exploding nature of cultural tourism, the impact and accessibility of photography, video and computer technology, and the role of the World Wide Web, offering instant knowledge, albeit in 'sound bite' form, and carrying an increasing amount of information about women's pottery.

The survival of ancient technologies in hi-tech societies may be due to strategies self-consciously deployed by potters, entrepreneurs or governments, but in other cases it comes about through chance encounters, happy accidents and fortuitous events. Strewn along the way are many earnest endeavours which failed to deliver – wheels and kilns lying idle, unsold trinkets and cracked pots. I am glad to report that I have met a few prosperous women potters but most, by any standards, are poor. They are, however, often better off than their peers who are not potters. Many love their work, see it as a vocation, and take pride in their achievements.

Demonstrations

Handcrafted objects have frequently been used to distinguish or identify whole cultures or tribal groups, from the Beaker People of archaeological records, to Pueblo villages in the modern world. The object, together with its process of production, acts as a kind of visual language and a marker of difference. From the late 19th century, World Fairs and International Expositions encouraged the presentation of 'exotic' peoples 'exhibiting their everyday lives' for the Western spectator. Dancing, singing and craft skills were key aspects of the entertainment potential of such spectacles.

Fascination with the craft persons' techniques and skills has continued to be an important factor in the marketing of work especially where the craft is deemed to have been superseded by industrial production. The evidence of hand processing is an identifiable difference, and seeing it demonstrated is often part of a leisure time and holiday experience. The signpost announcing 'Pottery' or 'Craft Workshop' is to be found in most parts of rural Britain. The product is given added value by the authenticating process that is in evidence during the visit. Most spectacular perhaps is the thrower working at the wheel. In the 1930s the potters of Upchurch Pottery in Kent regularly attended the Chelsea Flower Show bringing with them the wheel to demonstrate their technique. Wheel throwing, traditionally a male activity, continues to hold a macho charisma and is a central aspect of many potter's events. Who can throw the most, who can throw the biggest? Handbuilding is a less obvious spectacle but in the

San Ildefonso potters demonstrating in front of the Palace of the Governors, Santa Fe, 1912.
Photo Jesse Nusbaum, Museum of New Mexico 147792

promotion of women's ceramic traditions it has also been vital; better still if accompanied by signs of 'otherness' such as exotic costume.

The Pueblo potter Maria Martinez told Richard Spivey, '…when I married in 1904, I went to St Louis World's Fair. We were married in the morning and at three o'clock we went in a train. And there I made little pots' (Spivey, 1979, p. 22). At this event she was part of an exhibit showing Pueblo lifestyle. Thirty years later at the Chicago World's Fair Century of Progress she is said to have stolen the show when she was positioned in front of an industrial ceramic plant. The intention was to show how far things had moved in ceramic production. The ploy may have backfired, but Martinez' role as a signifier of the primitive 'other' was certainly the intention. Edgar Lea Hewitt of the Museum of New Mexico, Santa Fe, was one of the first to recognise the power of demonstration in the museum context. Between 1909–1912 Julian and Maria Martinez lived at the museum, Julian acting as caretaker, with both on hand to demonstrate when necessary. During the summer, courses were run at the museum, with teams of Pueblo women brought in to demonstrate to admiring audiences. These week-long courses were directed at people who wished to learn more about Native American culture, but were also an important impetus in the development of a collectors' market for finely crafted pottery.

Photography also helped to promote the concept of a 'natural' relationship and harmony between potter and product. In the early years, Maria Martinez was often photographed with Julian, and it is more unusual to see images of Julian decorating on his own. Maria is the one who guarantees the essential qualities of the product. She recalled with amazement that one photographer came all the way from Germany, 'to take a picture of my hands. I don't know why he want a picture of [only] my hands' (Spivey, 1979, p. 61). It suggests a form of essentialism – the part stands for the whole: the hands, the potter, the culture. She was the quintessential Pueblo woman. After the mid 20th century, when she had become very famous, she was photographed in many symbolic situations with famous people such as the President of the USA. She also appeared as standing for the great American potter in a much reproduced image with Bernard Leach and Shoji

Maria Martinez and Michael Cardew on the front cover of Ceramic Monthly, *1979.*

Magazine cover showing Rosa Nieto, 1953, displayed at the Doña Rosa pottery, San Bartolo, Mexico.

Hamada in 1952 and later, on the cover of *Ceramic Monthly* with Michael Cardew.

Almost certainly influenced by the success of black pottery in the USA, Rosa Nieto, the Mexican potter, began to gain a reputation for her work. This highly skilled craftswoman had already been singled out in the 1930s by Van de Velde as one of the finest in San Bartolo Coyotopec, a village situated a few kilometres from the elegant regional capital of Oaxaca and noted for its functional black pottery. The original interest in Rosa Nieto was her skillful use of the *molde* and her speed of building a pot with this supposedly 'primitive' device, seen as a possible step, in the evolution of the potter's wheel. She too worked with her husband, Juventino, originally a barber by trade, but as her fame spread people wanted to see her work demonstrated. In the early 1950s, no doubt through her contact with many people from the USA and indirect knowledge of the success of Pueblo pottery, she began to develop highly polished black pottery which had to be fired at a lower temperature to maintain its sheen. The low firing temperature meant the body became more fragile and highly porous. What it gained in beauty it lost in function.

In 1959 the anthropologist and pottery researcher Foster published a rather negative account of his experience of revisiting the pottery after many years:

We were in for a shock, not so much for her work as for the change in the social setting. Four big tourist sedans were parked outside the house which had grown from modest dimension to large size. Rosa had set the tools of her trade against a plain wall carefully orientated for the morning sun, opposite which was a semicircle of thirty wooden chairs. Great quantities of black ware glistened on tables on each side and to the rear, protected by a low roof. When we entered she was finishing a *cántaro*, to the accompaniment of the clicking shutters of a score of tourist's cameras. When I asked permission to photograph she replied, 'of course, but don't forget my tip!' When the vessel was done she rushed to attend to tourist purchases, distracted for fear that someone would slip out without buying. After fifteen minutes another group entered and the pot-making demonstration was repeated. She is now famous, as much a part of the tourist rounds as Monte Alban and Mitla. But she does not smile, and she is feared and disliked by her fellow potters.

(Foster, 1959, p. 60)

Rosa Nieto's son demonstrates for visitors to the pottery, 2001.

Photo A. Vincentelli

Forty years on the enterprise has expanded further. The whole village of San Bartolo appears to be dedicated to the production of shiny black pottery in every conceivable form. The pottery was never used as cookware but was prized for holding liquids. Now, however, most of the production is decorative ware, often incorporating elaborate pierced work or sometimes enamel floral painting over the black. The largest enterprise of all is that of Doña Rosa's, although she herself died 20 years ago. By 2001 at least 15 members of the family maintain the business. In one corner of the extensive car park is a kiln built below ground level. A large open courtyard is surrounded on three sides by showroom displays, while at the front the demonstration area is set up with all the tools alongside examples of old pots. A potter, Rosa's son, describes the process and the history of the pottery and demonstrates the use of the *molde* or turntable. He explains that the traditional pottery was not so highly polished but that Rosa 'invented' the richly burnished finish in the early 1950s and since then many others in the village have copied her. The visitors in Easter week, when I was there, were mainly Mexican and North American, and everybody seemed to be buying large quantities of pottery. The demonstration of the 'traditional' technique guarantees the authenticity of the product, although many of the pieces are now mould-made.

As museums increasingly see their role as communicators to the general public, with a need to bring alive their apparently 'dead' collections, using craft demonstrators is a common occurrence. The Smithsonian Museum has a long history of this practice, usually bringing people to the USA in relation to particular exhibitions or events, but museums round the world, from Fiji to Phoenix, have found it an effective visitor attraction.

Studio potters have always been fascinated by demonstrations of technique and the spectacle such an occasion provides has been popular at their meetings and events. It creates the connection many contemporary makers seek with old and traditional values,

In recent years Nancy Selvage has organised annual ceramic summer schools at Radcliffe Institute, Harvard. Traditional potters are brought in as teachers and demonstrators and the event is accompanied by a strong educational programme of lectures and museum visits. In 1999 the theme was Mimbres Pottery and one of the demonstrators was the Santa Clara Pueblo potter, Nancy Youngblood. Her pieces are formed from very elaborately prepared clay, carefully carved with a distinctive swirling fluted pattern and finished by hours of polishing several layers of slip. The final effect is achieved in the firing: in the first stage it turns a matt pinkish-grey after which, the piece is smothered with fine dung and the reduction process turns it black. After a final polish the piece emerges as a deep shiny black.

Centre right
Nancy Youngblood, assisted by her husband, demonstrates her firing process at Harvard, 1999.

Bottom right
The final piece in its firing basket.
All Photos M Vincentelli

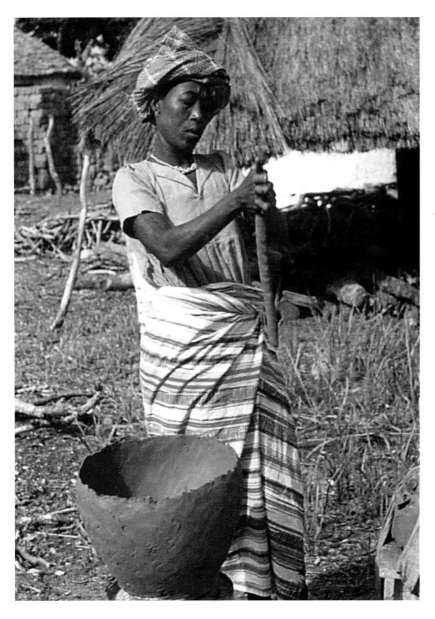

Ladi Kwali making a pot by her traditional method, 1959.
Photo Peter Stichbury

Ladi Kwali glazed stoneware pot with traditional Gwari decorations, made at Abuja pottery circa 1956,
Ceramic Collection
University of Wales,
Aberystwyth

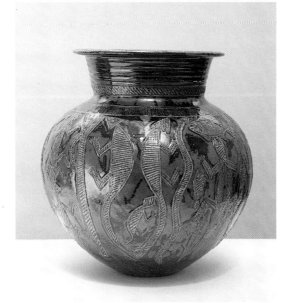

and is a language which enables communication between potters from completely different cultures. In the mid 1960s Susan Peterson raised the funds to create a summer programme of demonstrations of Indian art work to be held at Idyllwild School of Music and the Arts in Southern California. Its success meant that it became an annual event; at first Maria Martinez and younger members of her family were the ceramic demonstrators, later it was Lucy Lewis and potters from Acoma. It was one of the first occasions where Indian artists were teaching their skills as opposed to demonstrating, with new groups of up to 40 students attending each week.

One of the most famous examples of traditional potter-turned-demonstrator was Ladi Kwali who worked with Michael Cardew and was the first traditional Nigerian potter to join the Abuja Training Workshop. She learned to use the wheel and to decorate and glaze in the Western way but she never gave up the techniques she had learnt as a young woman. In the 1950s and 1960s the main market for Abuja pottery was the expatriate population in Nigeria who appreciated the novelty of having such a 'modern' item as studio pottery available on the doorstep. Abuja pottery was a hybrid product, whether it be Michael Cardew's 'Gwari' casseroles or Ladi Kwali's glazed stoneware jars, handbuilt and decorated with traditional Gwari motifs. The partnership had a huge success and was promoted through tours in Europe and the USA, with Cardew lecturing and Ladi Kwali demonstrating her famous technique of 'dancing' round the pot. This system of building is one used in Africa but similar systems are also to be found in Central America.

New forms of cultural tourism offer

opportunities for traditional potters. In the early 1990s a boat trip up the Gambia River included a stop off at Mandinari to visit the 'traditional' potter Marie Thérèse, along with a visit to a 'traditional' house where a local family offered a tour round their compound. The direct sales to tourists would have been a useful source of income. Across the Atlantic in Mexico, using the internet as the only system of marketing, Eric Mindling offers pottery tours in the Oaxaca area which include several days of stopovers to watch traditional potters at work and, indeed, to have the opportunity to learn their techniques.

Demonstrations by women potters from traditional societies are a moment of contact between people who often come from disparate worlds. It may even be an opportunity for traditional potters from diverse cultures to meet and view each others work. At an event in Flagstaff Arizona, Macrina Mateos from San Marcos in Mexico was amazed to see how slowly a fellow demonstrator worked. This Hopi potter would have charged a very high price for her labour, selling to specialist collectors in comparison with a potter whose work is still sold in a Mexican market. It makes a difference. Women potters within the traditional context are usually taken for granted, their skills may be valued but rarely are they well remunerated or given high status. Their pots, when promoted in different ways and backed up by the authenticating process of demonstration, are accorded a new value. Potters gain status, financial independence and a new sense of self worth. As we have seen, they may also become alienated from their peer group and regarded with jealousy or resentment. As demonstrators they are ambassadors, bridging the gap between the modern world and the traditional village. The process at least goes a little way to counteract the imbalance created by the crushing impact of global capitalism and its values.

Development Projects

All over the world there are development projects set up with the best of intentions to help traditional potters survive and gain better returns for their labours. Advisors are often potters trained in the supposedly low-technology systems of wheel throwing and wood-based kiln firing. These technologies dominated the philosophies and ideals of studio potters between 1920-1970. Such potters may also be knowledgeable in clay and glaze preparation, especially in relation to stoneware which, after 1950, was the preferred technique for many studio potters. These technologies are very different from those of open-fired earthenware. One of the pioneers in this tradition, Michael Cardew, was unusually enlightened in his admiration of African pottery and was quick to recognise the futility of trying to replace traditional earthenware. His introduction of stoneware, throwing and large kiln firing in Nigeria produced nothing more than tableware and studio pottery for expatriates and middle-class Nigerians. An interesting and ultimately a highly collectible product – but not a necessity. It did little to change or improve the position of traditional Nigerian potters although the unexpected byproduct was the creation of the world-class potter and star, Ladi Kwali. During the apartheid period in South Africa, the Art and Craft Centre at Rorke's Drift, KwaZulu-Natal, offered art training for black South Africans some of whom became eminent in their field. However, they were creating a hybrid product which sold at a reasonable

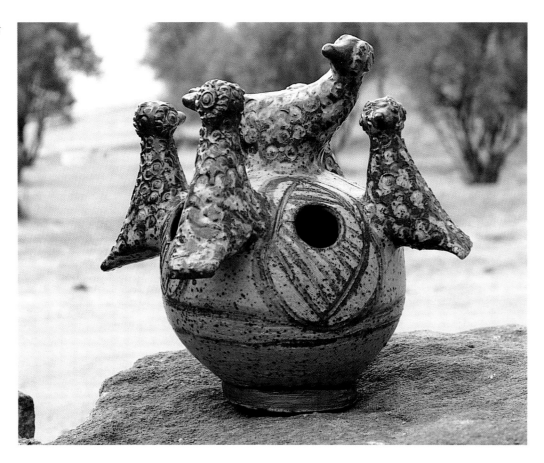

Dinah Molefe handbuilt stoneware vessel with birds made at the Art and Craft Centre at Rorke's Drift in the 1970s.

price mainly to middle-class white South Africans. Scandinavian advisors – mis sionaries and designers – brought a good understanding of contemporary taste and marketing skills. It is interesting that men were taught to throw but the women who made pottery continued (or were encouraged) to use their traditional skills as hand-builders, although they produced glazed stoneware.

On every continent stories abound about the introduction of Western technology – in particular wheels and kilns that proved to be uneconomic or unacceptable. Ceramic magazines carry occasional reports from frustrated potters who are invited out to India for a short project to build a wood-fired kiln, only to find that the locals burn scrap wood and cannot possibly find the amounts needed to fire a large kiln. One writer wanted 'to resurrect pottery in a country where pottery was once a way of life' but lamented the difficulties of obtaining materials for stoneware, ash glazes and fire-bricks. He appeared to see the only way forward as one where it was necessary to introduce Western studio potters' technology rather than start from the skills and tra-ditions that were already there.

In an article published in 1990, Margaret Tuckson examined pottery development projects in Papua New Guinea set up at the request of the Australian government. The initial report by the Danish potter Jorgen Petersen had the laudable intentions of giving existing pottery communities support and education, 'to produce better and stronger quality pots' and improve clay preparation and firing techniques. In some places, as at Bibil and Yabob, the initiative introduced wheels for throwing pots; in another it was kilns; in Yabob potters were encouraged to add three little feet on the round-bottomed

pots so that they would stand on a flat surface; in other places potters were taught to use sieves for clay preparation. By 1984, when Tuckson visited the villages specifically to research the impact of the project, she found it had had little effect. Potters had returned to bonfiring, wheels were little used and when they were, inexpertly. The positive side was that potting still flourished – but it lacked effective marketing. She concluded that:

> …unless the people themselves have asked for help with their pottery, any such project may well be unnecessary. More important than change may be the support for the traditional ware, simply through help with marketing. Maintaining the status of the village potter is not just perpetuating a tradition for its own sake and for that of sentimentalists and researchers but helping the individual potters maintain their self-esteem and their livelihood. Continuity may be better than change.
>
> (Tuckson, 1990, p. 553)

Her report is one that is borne out by my own experience of visiting a pottery project in the Gambia. At Sotuma Sere the thick-walled dark red storage jars and incense burners were laid out by the side of the road and were sold in local markets. There was clearly still a market for their wares. On the edge of the village was a large building with an extensive but empty workshop, the wheels unused. The little sales outlet on the side of the building had tables laden with crudely thrown unglazed earthenware: bowls, incense burners and ashtrays. The pottery looked unfinished with no warm red slip or burnish. Outside there were two small kilns and I was told that the women were afraid to use them and the young man employed to fire them could not make them

Unused kilns at Sotuma Sere, The Gambia, 1992.
Photo M.Vincentelli

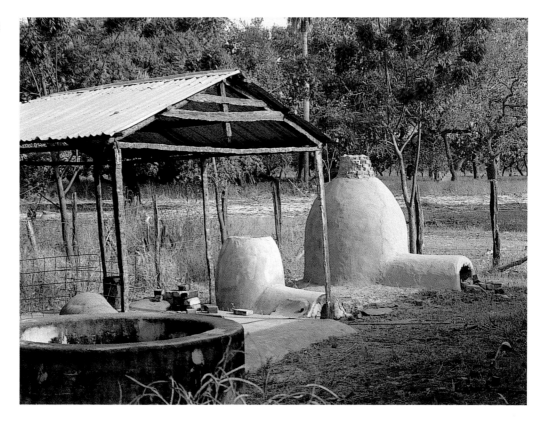

work effectively. A common problem with kiln firing is the need for wood. Bonfires are much more likely to be fired with sustainable materials such as grass, husks or palm fronds which were used in the open firing that I saw in the Gambia.

The Nigerian researcher Antonia Fatunsin also tells a similar tale:

> Government, in its current drive to encourage local industries, has taken a number of measures to introduce modern technology at the local level. In 1990, the Social Welfare Department of the Federal Ministry of Culture and Social Development, Abeokuta, organized a three-day workshop in the use of the potter's wheel for traditional potters in the town. The exercise was a complete failure. The turnout was low and the few who came saw it as a waste of time. The wheel used was small, expensive and not capable of producing the different sizes of pots made by the potters. In addition, the clay was not the type the potters were used to.
>
> (Fatunsin, 1992, p. 81)

Writing of Nigeria in the 1990s she observed that rural people still required water storage in villages where there was no electricity, where they still cooked on open fires and where large clay pots were needed for fermenting cassava and yam.[1] She did recognise, however, that there were positive things that could be done to support potters such as giving them the financial assistance to buy the land where they work rather than having them pay rent.

The development of new potteries where men (and sometimes women) are trained to use wheels and kilns works best where local interest comes from a grass roots level. It is difficult to sustain when the new technology is introduced by an advisor who only visits for a short while. Such situations easily create a culture of dependency. In reality, a local entrepreneur, who in the past may have been a colonial settler, is more likely to create a going concern by setting up a pottery workshop, paying competitive wages and marketing the wares effectively.

Some development projects arise out of a perceived need to change people's lifestyles. These are not primarily about helping potters but may involve pottery projects. Where deforestation is a problem, as in many parts of the developing world, encouraging women to cook on more economical fuel-burning stoves has been an important strategy. Where clay is readily available and potters are already working, ceramic stoves are an ideal outcome. In some areas metal stoves are more viable. An extensive project in the Gambia ran between 1982–1992 and involved training blacksmiths and potters in the production of stoves and even in creating a design for a mud stove that could be owner-built. 761 potters in 36 villages were trained to make ceramic stoves. The project included an extensive education programme and public relations campaign conducted in three languages using posters and local radio. The major beneficiaries were women who carried the burden of cooking and collecting firewood. Furthermore, children often had the task of gathering wood and, in theory, if they spent less time on that they would be able to attend school. By the end of the project

[1] Tuckson noted that glazed pottery or metal turned sago sour and that porous earthenware was still the best material for this traditional Papua New Guinea staple.

it was estimated that between 15–35% of Gambian households were using the improved stoves which, in general, were satisfactory. Unfortunately, the project appeared to have had almost no impact on deforestation which went on apace.[2]

In Central America the USA charitable organisation *Potters for Peace* has been active for over two decades sending advisors largely to Nicaragua to support traditional potters – the large majority women. Their main initiative is the water filter project. The principle is similar to that found all over the Caribbean, South and Central America and, for example, the Canary Islands where water is filtered through one ceramic bowl suspended above another. In the PFP filter, the inner porous ceramic section is impregnated with colloidal silver which disinfects the water and kills bacteria that cause diarrhoea and other water born maladies. The water drips into the outer container which must not be so large that water is allowed to stand unused for long periods. Potters are taught how to make these ceramic filters using clay with a 50% filler, normally sawdust which burns off in the firing, leaving a highly porous receptacle. The beauty of the project is that the filters can be handbuilt or thrown (although the mixture is like throwing sandpaper and rubber gloves are recommended!), and can be fired in a pit fire, open fire or kiln. Potters are also trained to build kilns designed to use firing materials such as rice or coffee husks or sawdust. In 1998 Hurricane Mitch caused large-scale destruction of water supply systems in Central America, highlighting the importance of developing alternative and back-up systems. As with all new technology, the introduction of water filters has to be accompanied by an education programme to ensure people understand how to use and maintain them properly.

There is a good argument for suggesting that it is more viable to build on the skills that are already in the community rather than seek radical change. It is particularly dangerous to make people dependent on technology that they cannot themselves produce, control or maintain. Self-sufficiency is often assumed to be the aim but in fact projects can create dependency when equipment fails or the follow-up expertise is not there.

One of the major changes is that the practice of ceramics often becomes less specifically gender based. It is clear that many projects and development plans barely take this into account and simple ideas about the benefits of certain technologies have been

Advertisement for pottery stoves in The Gambia, early 1990s.
Photo M.Vincentelli

Design for a water filter,
Potters for Peace.

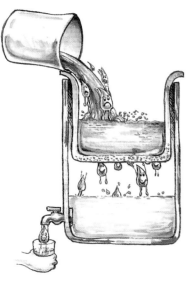

[2] Information from the report of a United Nations Development Project – 'Promotion and Production of Improved Cooking Stoves (Phase 1&2) GAM/85/XO1'.

introduced without any broader understanding of the social structures of the communities into which they are inserted. Development projects that take no account of the relationship between gender and technology are likely to founder.[3] What is certain is that the introduction of workshop practices using wheels and kilns nearly always results in a shift of the female:male ratio of potters. Men are trained in the new skills and are invited to take up pottery as a way of generating a regular income and, initially at least, women continue to work in their own way. The new pottery may command a higher price than the domestic production and needs to be sold to a wider market, in some cases an expatriate market. Thus a disparity arises between the traditional and the project pottery, and so between men's output and women's output.

Global Marketing

It is commonplace to imagine that women potters make work only for their own needs and perhaps for other members of their close circle. This may indeed have been the case in the past but most women potters recorded over the last 100 years have worked, at least in part, for economic benefit, although sometimes on the basis of barter and exchange rather than for cash. A common system is that the price of a pot is equated with the amount of grain it holds. Most potters produce for a regular market on a weekly or monthly basis.

Handbuilt pottery may have ancient roots but that does not mean it is unchanging: women potters have readily adapted their work for new markets and new tastes when necessary, a process that has gained momentum over the last 100 years. In the 18th century, Pueblo potters in New Mexico responded to the needs of the Spanish-speaking community by creating new forms and floral motifs to please European tastes. Their pottery was so good that, unusually, wheel-thrown pottery never really took over. Mexico is another area where women's traditions responded to new demands. In turn the new styles were adopted by the potters themselves and became part of their own cultural vocabulary.

In many people's eyes it is more problematic when potters begin to cater for new markets quite outside their own experience. This work is produced for purely commercial reasons. At its most contentious such products are the despised 'airport' art of the modern world. But we should not be overly hasty to criticise. Some of the finest blue-and-white porcelain was produced for the export market and, as James Clifford has pointed out in his essay 'On Collecting Art and Culture',[4] today's tourist trinkets may become tomorrow's desirable collectibles. Values are fluid. Outside markets are a stimulus to creativity and talented individuals rise to the challenge of new opportunities. When the railroad was opened in 1880 in Santa Fe, Pueblo potters quickly recognised the marketing potential and adapted their works to the tastes of the increasing numbers of visitors. Figurines which had been discouraged by the Catholic Church and had large-

[3] See, for example my discussion of projects in the Gambia in my earlier book Vincentelli 2000, pp. 195–198.

[4] See James Clifford, The Predicament of Culture, 1988, pp. 215–251.

Be a Part of a Living Tradition . . .

Meet the Great Grandaughter of MARIA MARTINEZ

Whose Excellence in the Art of Pottery is Surpassed by Few, and now Featuring Contemporary Watercolor Paintings Using Clay Washes.

BARBARA GONZALES
Fahn-Moo-Whe
of San Ildefonso Pueblo
Booth 511 Indian Market

ly disappeared from the ceramic repertoire by the 18th century, were now revived in witty caricatures of contemporary life or in playful devils, playing on popular stereotypes of Native American cultures.

During the 20th century the development of Pueblo pottery as a fine craft form was largely under the control of the dominant Anglo dealers, curators and philanthropists. One of the major selling points of the year was, and still is, Indian Market held in Santa Fe in mid-August. Prizes were an important part of the proceedings but for many decades they were always judged by Anglos and it was not until the 1980s that Pueblo people began to take more control. In the late 19th century dealers in Pueblo crafts were among the first to market their goods by mail order and they have also been in the forefront of internet marketing. As early as 1990 Rosemary Lonewolf of Santa Clara Pueblo was maintaining careful computer records of every piece she made and its purchaser. New technology allowed her to control her work in new ways. Pueblo potters frequently express a desire to know to whom the work is sold, perhaps a form of resistance to the necessity of working with Anglo dealers. The Internet can appear to offer a direct form of marketing, however, it is dealers who mainly exploit the market (see Dahn, 2003).

Miniaturisation is a common phenomenon as work is adapted for the tourist market. Fijian potters in the 1870s made small models of turtles and canoes while, in the early 20th century, potters at Santa Clara were making miniatures of trains in their characteristic black pottery. The object was a novelty, even suitable as a gift for a child, whilst retaining the (shiny black) essence of Santa Clara Pueblo pottery. In Antigua Julie Hector at Redcliffe Quay makes, among other objects, miniature stoves to sell to visitors. This allows the tourist to 'take home' a replica of a traditional form without the problems of carrying the full-size object. While miniatures use less material they may be time-consuming to make and in some cases it is precisely the intricate and delicate working that gives them a special cachet. Certain Pueblo potters have established their reputation based on the ability to work on a tiny scale. Of these, the Lonewolf family are the most noted. In their case the miniaturisation becomes a virtuoso display of technical skill and is the basis for the high price charged. It is, however, a mistake to assume that the process is always associated with tourism. In Central America there is a long tradition of miniaturisation using objects modelled in clay to create household shrines. Such objects may be used as toys, educational supports, amulets or grave goods and are to be found in many parts of the world.

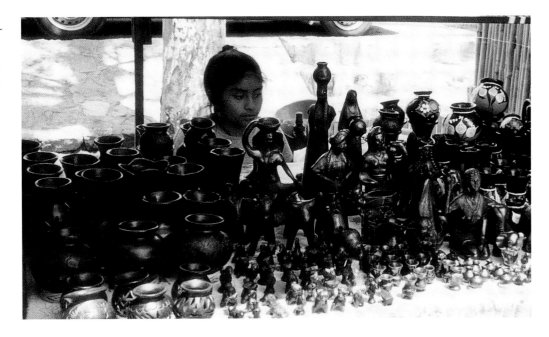

San Bartolo, selling decorative and miniature black pottery at a roadside market stall at San Bartolo, 2001.

Photo A.Vincentelli

Tourism and Global Markets

Tourism encourages diversification in the range of objects produced – candlesticks, ashtrays, incense burners, soap dishes, sauce boats or spoon rests. Museum reproductions are popular in countries such as Mexico where there is an ancient ceramic tradition. Tourism also stimulates the production of some rather unusual hybrid forms. Novelty teapots are highly collectible and always saleable. If made of unglazed, low-fired clay they are hardly functional but, with the symbolic status of tea-drinking as a sign of middle-class refinement, they are frequently reproduced when potters are looking for new forms. In the late 19th century Hebridean women made strange tea

New forms for new markets - teapots and lamps waiting to be bonfired at Endlovini Mission, KwaZulu-Natal.

Photo A. Vincentelli

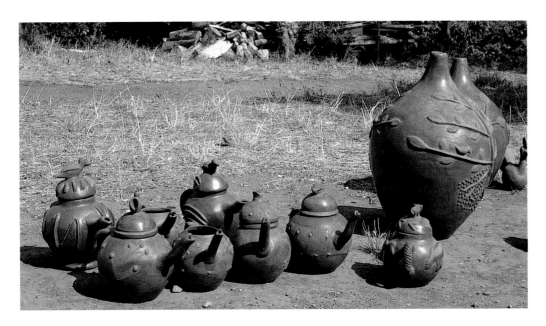

sets imitating factory wares. In 2000 the project at Mtunzini, KwaZulu Natal, led by Mary Ann Orr, was producing novelty teapots with elaborate carved decoration as well as handsome black pottery lamps commissioned by a hotel. The quality of burnished earthenware carried the distinctive look of the local black pottery but the forms were quite new. Indeed I was given to understand that the potters, not used to electric table lamps, found it difficult to conceptualise how they would function. The new shapes, however, were an exciting challenge for the potters and they tackled the work with spirit and imaginative flare.

A step up from the tourist market many women potters have begun to direct their work to the much more lucrative outlets of galleries and dealers where it is marketed in a more exclusive manner. Potters become named individuals with personal styles. Pueblo potters, in particular, have paved the way in this. Santa Fe is a town with a large number of galleries offering Indian arts and crafts alongside paintings and other kinds of contemporary art. The ultimate acknowledgement and confirmation of status for such makers is when the work is exhibited as contemporary art in its own right irrespective of its origins.

The Anguillar sisters of Ocotlan still sell direct to the public from their own studios but their prices are now such that they mainly deal through specialist galleries in Oaxaca, Mexico City, and the USA. In 2001 Conception Anguilar believed that most of her work was selling to North Americans.

In many major cities around the world craft galleries sell traditional women's ceramics in the context of a specialist collectors market. Kim Sacks Gallery in Johannesburg is situated on a prime site alongside some of the major contemporary art galleries in the city. The architectural design is based on Venda architecture but with echoes of Santa Fe adobe. The interior shows mainly contemporary African crafts – pottery, woodwork, textiles, bead and wirework alongside some older pieces. The subtle mixture of traditional and modern carries a powerful message, conferring new values on everyday objects that would once have been taken for granted. She also understands how to encourage traditional potters to develop their work for this new market. In this case often looking for large or 'important' pieces that may even act as loss leaders for the marketing of more modest examples. She has been one of the main

promoters of the black pottery of Nesta Nala and, during the latter part of the 1990s, her daughter Jabu Nala sold through her with great success.

One of the effects of tourism is to diversify the market. Rather than just one type of outlet and buyer these become more various with each requiring a slightly different product. In Kabylie in Algeria in the early 1980s the process of change in a female ceramic tradition was very apparent and styles and forms of decoration emerged corresponding to different tastes among types of consumer. Close contact with European culture had by then been the case for well over a century and it seems likely that the practice of applying a shiny resin to pottery after firing was developed to simulate the effect of glazed European wares. Animal and bird figurines had also been popular since the late 19th century. Much favoured among local people was brightly coloured pottery painted in red, yellow and black gloss, and this could be seen in the decoration of a number of houses I visited; shelves, tables and walls were also sometimes painted with corresponding designs. The tourists – mainly Russian and East European at that time – were more likely to choose versions decorated in the 'traditional' way with natural colours of white, reddish brown and black treated with the shiny resin. There were also

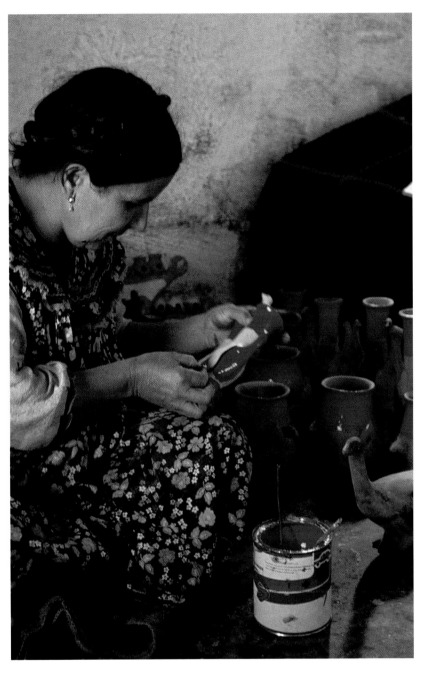

Madame Hennad of Ouadhias decorating pottery with commercial gloss paint.
Algeria, 1982
Photo A. Vincentelli

designs that suggested a more modern look, with simplification and 'streamlining' of the form, lighter but using 'natural' colours and no shiny resin coating. These appealed to middle-class Algerians who disliked the use of gloss enamel paint. Another version of Kabyle pottery was produced in a small factory which employed male workers who used wheels and imported materials to make lemonade sets, ashtrays and coffee pots decorated with a simplified versions of traditional designs and finished with a clear glaze. This was more adapted to the functional needs of modern society and made excellent gifts for Algerians to take when travelling abroad, as they retained a 'traditional' look. Thus in the early 1980s the market was becoming increasingly diversified to accommodate new tastes.

OPPOSITE PAGE
Brochure for Indo Art, 2001.

Lombok

One of the most successful development initiatives of the 1990s was the marketing of crafts including the fine earthenware pottery from Lombok in Indonesia. Originally the Sasak people of the island owned sufficient land to provide for their needs; women made pottery for barter or exchange but social changes have meant that now most people are landless and are increasingly dependent on selling craft work as a commodity. With the help of initiatives such as the Indonesia-New Zealand Lombok Crafts Project, markets have expanded and potters have found new outlets for their work in galleries and craft shops across the world. The Danish firm of Indoart has an extensive catalogue showing both traditional black pottery for cooking and serving food, and also carries a range of modern designs for plates and vases. Some of these even include 'batik' pottery where strong black and white printed cloth is applied to the surface of the pottery and then sealed over so it appears to be an integrated surface finish. Interestingly the designs mainly in black and white are not typical of Indonesian batik although the term 'batik' is emphasised. Pottery is a female activity but characteristic of the new commercial culture their catalogue shows a young man applying the textile coating. The publication presents the firm carefully as an enlightened organisation with a strong environmental policy, and responsible social attitude to its suppliers who have to conform to the firm's rules against child-labour. In return it provides support for health care and even distributes food subsidies.

La Chamba

As most women's pottery is handbuilt and low-fired it makes excellent cookware but it is not best designed to withstand impact. It is relatively heavy, breaks easily and does not travel well. Global mass marketing of handbuilt cookware is not easy but food cooked or served in such wares is appreciated by people the world over. La Chamba in Colombia has produced excellent functional pottery serving the needs of rural people for centuries but in the mid 20th century as the market for their wares began to decline, the potters switched to produce a wider range of forms including tableware designed for the urban market. The women potters became home-based workers selling to middlemen who in turn sold to the urban market. Since the 1990s, despite the very difficult political situation and the prevalence of drug barons and gangsterism, La Chamba pottery commands a successful export market. One of the main importers into Europe is the firm *Scot Columbus* who sell the pottery under the name of 'Tierra Negra'. The soft black sheen and the generous rounded forms give a sense of a handcrafted object while the qualities of the clay make the pottery extremely versatile. The brochures present it as:

> …organic cookware with a natural clay glaze, it is safe to use in the oven and on the hob – gas, electric, Aga or ceramics. It can be used in the grill and in the microwave and can be washed safely in the dishwasher.

INDO ART A/S

cooking. The relevant products bear the codes 60xxx, 300xxx and 4xxxxx. This pottery may also be used when cooking food in the oven, and, with care, on a gas stove.

How to prepare the pottery for food usage

Before using this pottery in the oven, it should be prepared in the following manner:

1) Warm the pottery dish in the oven at a moderate temperature (150-200 degrees) for about 5 minutes.

2) Then grease it using plenty of oil (such as olive oil).

3) Place the pottery in a hot (250 degrees) oven for at least 20 minutes.

When cooking in the oven it is best to soak the pot or dish in water before placing food in it.

After being used to prepare food for a couple of months, the pottery will acquire a patina in the form of a darker colour.

Hand-made kitchen pottery is naturally more fragile than kitchenware made of modern, industrial materials that have been fired at high temperatures, but if you look after it, it will give you many years of use and aesthetic pleasure.

Painted pottery is only for decoration

Pottery products that have been painted or batik-dyed (42xxx, 43xxx and 90xxx) should not be exposed to boiling water or used to prepare food. None of our pottery products should be cleaned in a dish washing machine. The products should preferably be washed by hand and left to dry.

Our Lombok pottery, bearing the product numbers 60xxx, 300xxx and 4xxxxx, may be used with food and will grace any dinner table.

Spring 2001

Pic: 1

42006 42001 42009 42026
42021 42029

SALE Pic: 2

42002 42008 42003 42022
42020 42023

Pic: 3

42122 42018 42015 42121

Pic: 4

42124 42019 42016 42123

SALE Pic: 5

42038 42035

SALE Pic: 6

42039 42040 42036 42037

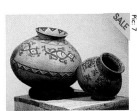

SALE Pic: 7

42151

SALE Pic: 8

42205 42214 42204 42206
42215

SALE Pic: 9

42305 42304 42306

SALE Pic: 10

42404 42405 42406

Pic: 11

43002

Pic: 12

43003 43004

The sales pitch also guarantees a fair trade policy:

> Traditionally the cookware was produced by the women and negotiation on price and design is still controlled by them even though some men now help. As demand has increased they have gained greater economic independence. Advance payments of up to 50% are made on all orders. Prices are increased at least in line with inflation and higher prices are paid for good quality and orders completed on time.

The business has expanded steadily.

One of the difficulties for potters whose business grows from being a strictly local concern to one having a much wider market is that of maintaining quality whilst increasing levels of productivity. Expansion means less flexibility and failure to produce the goods on time may mean that the market is lost. The mediation between the potters and the importer is a delicate matter and is helped enormously by the importers being from a Scottish/Colombian marriage, with family members in Colombia able to make regular visits to the village. The threat of kidnapping of Americans or Europeans has been so high that visiting can be very difficult if not dangerous.

As an academic researcher Ronald Duncan sees the women potters caught in a trap of global capitalism. They feel aggrieved and exploited but are powerless to change their situation. He calculated that:

> A woman's production unit, including herself and children and older relatives, in combination can work twenty hours per day to earn an income equal to the official daily minimum wage for men in commercial agriculture working an eight hour day.
> (Duncan, 2000, p. 6)

Brochure for Tierra Negra by Scott Columbus, 2001.

The difficulty is that functional oven-to-tableware has a fairly clearly defined ceiling price – unlike a piece of art work whose value is much more variable. The relative cost of packing, transport and marketing are proportionately much higher for a low-cost piece than for a high-cost piece. The exigencies of a global market for quality control and standardisation are also much more stringent than for a local market. There is no simple solution but it is to be hoped that the pact between the producer and the consumer on the other side of the world will flower into a greater mutual understanding.

Conclusion

At the beginning of the 21st century the future of women's pottery traditions may seem precarious but all the evidence demonstrates that they will not disappear but will survive one way or another. In our hi-tech world there is still a large percentage of the population who live without running water or electricity. The need for traditional low-fired pottery has not disappeared and its functional qualities still have much to offer. Furthermore, when these are overtaken by modern lifestyles, its decorative or symbolic values become emphasised and it can be adapted to serve new markets and audiences. Tourism and global marketing may be dangerous masters but they also offer exciting opportunities.

Pottery for sale in Ouadhias, Grande Kabylie, 1982
Photo A. Vincentelli

Old and New: comals for cooking traditional Mexican food are stacked up in Tlacolula market alongside miniature pots and model aeroplanes. Traditional potters have to be inventive and alert to new markets.

Photo A.Vincentelli

CONCLUSION

THIS BOOK has been centrally concerned with the role of women in the production of traditional pottery and fired clay figurines. I hope I have been able to demonstrate that women's role in this field has been significant, following certain consistent patterns. Of these the most notable is the continuing resistance to the use of the potter's wheel and the preference for handbuilding and low technology in all its various forms.

A woman's pottery tradition, I have argued, is one where the production of pottery is identified as part of the female role, either because all women from a particular village or cultural group know how to make pottery or because making pots is seen as an exclusively female activity. All societies make gender distinctions, which are expressed through social activities, dress codes and assigned tasks. It might even be said that gender is performed and an association with particular technologies is a manifestation of this. If certain ways of making pottery are learnt at an early age and deeply embedded in the psyche and in personal identity, then they are extremely hard to leave behind even when a new technology is available. There is more at stake than mere expedience.

Our understanding of the world is always shaped by our own social and cultural experience and within Western culture there is no strong correlation of women as potters. Indeed just the opposite: the quintessential 'traditional' potter is a man throwing a pot on a wheel. Many studies of traditional pottery do not address themselves carefully to the observation or classsification of gender roles and the issue is even more murky when we try to investigate the past. Nowadays we have access to vast amounts of information about the world; at the press of a button on a computer we can be in touch with Fiji or Finistère; but information is highly coloured by who is providing it, and why. The everyday cooking pot, for example, made in villages and marketed locally is rarely recorded at any length. It has not been considered of sufficient consequence. At best, women's pottery has tended to be recorded precisely because of its 'primitive' qualities, often seen as an anomalous survival. The look and feel of a burnished or unglazed pot is not something for which Western taste has a refined eye. It is highly significant, however, that following the upsurge of interest in women artists and their wares in the latter decades of the 20th century, there was an expanding interest in techniques such as handbuilding, burnishing and smoke-firing among contemporary ceramists.

One of the marked characteristics of women's traditions is the way that the potter's

have an intimate and tactile relationship with the raw clay and the pottery produced. They may even dig out the clay physically with their hands. In handbuilding the pot is shaped by the hands or simple tools and moved around gently. The most extreme form of bodily contact is the way some women potters actually form the lip of the pot with their mouths (Amazon, Kumeyaay). Almost universal in women's traditions is the emphasis put on the burnishing stage where the pot is usually held in the lap and polished, sometimes for hours. The burnishing pebble is frequently mentioned as the potter's most treasured tool and may be passed on from mother to daughter. Archaeologists often find such pebbles buried in female graves. Bonfiring has a very direct contact between the pottery and the flame. Firing time is usually quite short and the pots are carefully supervised through the process. Bonfiring, in general, does not create the same amount of wasters as kiln firing and is usually done with sustainable fuels. Finally many women's traditions are characterised by elaborate rituals and taboos. Pots are sometimes even personalised metaphorically as children. Such rituals and beliefs are not unknown among male potters, but in general men treat the activity more as a business rather than as an integral part of their lives.

I am not arguing however that there is something essential or natural about this way of working for women. The gender divisions arise from social patterns that have emerged to suit particular needs – most basically that women take on activities that can be combined with domestic and child-rearing responsibilities. As has been discussed, there are places where men are the assigned potters, where they handbuild pots and even fire in open fires, although that is much more unusual.[1]

Although there is a distinct phenomenon which can be found on every continent, different parts of the world have developed different contexts for ceramics.

In Europe and Asia where wheel and kiln technology has been predominant for millennia, women's traditions exist in small pockets. In Europe they are to be found on the fringes of the continent, in many cases in island societies. In Asia they exist in mountain villages as in Turkey and in many parts of SE Asia especially again in island cultures. There is even evidence that, in spite of its ancient and sophisticated ceramic tradition there are still villages in China that preserve a woman's tradition. Africa and the Americas have a very different pattern. Wheel and kiln technology had little impact on sub-Saharan Africa before the mid-twentieth century and here we have an area of the world where nearly all pottery is made by women within the definition of a women's tradition. The indigenous peoples of America also appear to have a long-standing female tradition although it is likely that the elite ceramics of the Andean region and Central America were produced by men as well as women. What is certain is that the introduction of wheel and kiln technology after European contact caused a distinct gender change; thereafter the two traditions run parallel. For Native Americans, especially Pueblo peoples, their female pottery tradition has proved an important signifier of identity and difference, as well as a useful economic resource.

Were women indeed the first potters? We can never know but it seems likely that in many places they were. However, it is also possible that early societies had a more mixed gender designation of potters and it was only as a group evolved and specialist

[1] Examples have been noted in the text in Africa, New Guinea and a few other places in Asia and in South America.

Bong in the fork of a tree, Lombok.
Photo Jean McKinnon

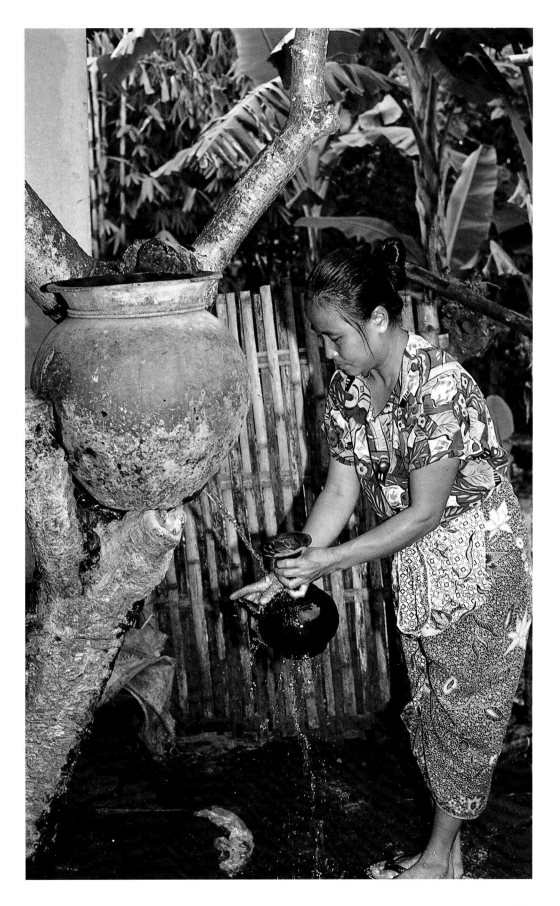

Right *Nesta Nala, KwaZulu-Natal, Black burnished pottery destined for the craft and gallery market. The forms are based on traditional Zulu beer pots, 2000*
Photo A. Vincentelli

OPPOSITE PAGE
Top *Supper cooking at San Marcos, Mexico, 2001.*

Bottom left *Water storage pots in the yard at Maatkas, Kabylie, Algeria, 1982.*

Bottom right *Pots used as planter in Jamaica, 1999.*

All photos A.Vincentelli

roles developed that pottery was one that attached itself comfortably to women's domestic responsibilities. Workshop production which takes place away from the home rarely involves women, whereas workshop production based on the family often takes the form of a male full-time (wheel) potter with his family as co-workers. Decoration, when undertaken by men, is usually the identifying and prestigious aspect of the pottery. If women decorate pottery thrown by men then it is usually seen as a secondary aspect of the work.

Few societies are untouched by the industrial world but still, in the 21st century there is an important place for low-fired pottery. Women's pottery is a survivor. Civilizations rise and fall but in the background the essential qualities of handbuilt vessels are still valued in rural communities across the world. Such pottery often out-lasts the elite ceramics that cater for particular patrons and markets and it may reappear when required. In parts of the Middle East during the Second World War the jerry can became widely available and was used for carrying water but as the cans wore out and new systems of petrol distribution came in, pottery water jars came back into use (Posey, 1994, p. 30). Predictions that traditional pottery will disappear have often proved unfounded although there is no doubt that it may go under only to revive itself in unexpected ways. When given support and recognition it can be transformed into a cultural signifier and a marker of identity so important in the ever-expanding tourist industry.

Probably the most important factor in the survival of women's traditional pottery in the face of overwhelming odds is that many people believe that food tastes better from these pots or that water is sweeter stored in these jars. Long may it be so.

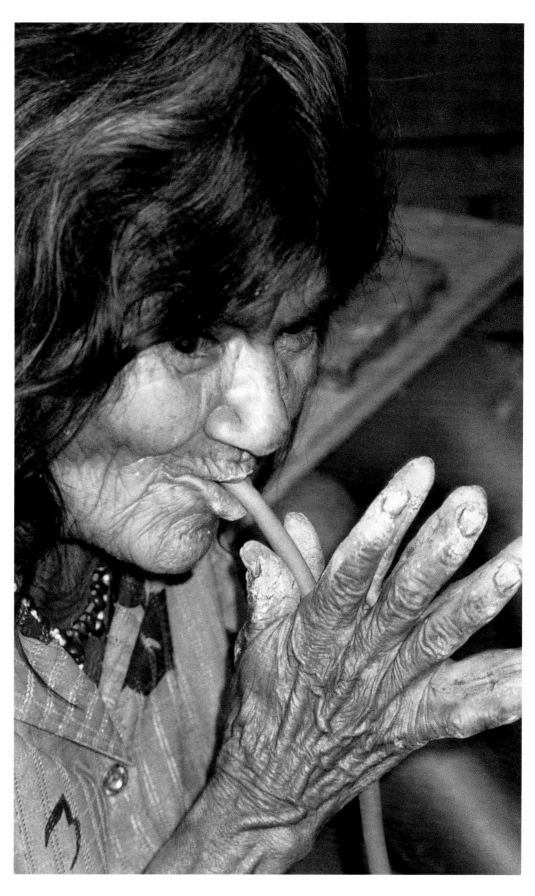

*Potter from Yuvientza,
Ecuador preparing a coil
using her mouth.*
Photo Joe Molinaro

TECHNIQUES AND TOOLS

Quichua potter from Ecuador digging the clay.
Photo Joe Molinaro
Collecting dry clay in Kwanyama, Angola, 1930s.
Photo Daisy and Antoinette Powell-Cotton. Courtesy Powell Cotton Museum

Clay collection and preparation

CLAY IS dug usually within a 5 mile (8 km) radius of the home, often much nearer. Many women dig their own clay and carry it back themselves; however this is an activity where male members of the household are frequently enlisted to help with the digging or the transport. Women rarely pay for clay although sometimes they pay a small fee to the landowner. With the introduction of motor transport it is not unusual for payments to be made to the truck driver. In general, however, the cost

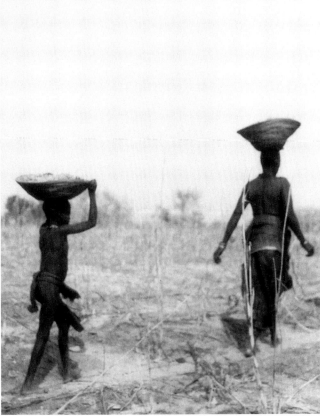

Beating the dry clay into a fine powder, Cyprus, 1983.
Photo A.Vincentelli

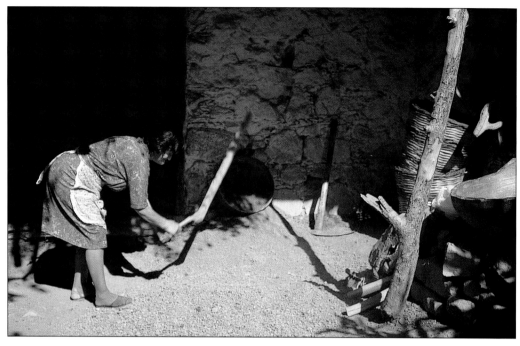

Clay being mixed with sand. Jamaica
Photo A. Vincentelli

of clay is kept to a minimum. Sometimes potters will mix different types of clay to achieve the consistency they require but mostly they use what is available locally.

Clay may be used in a damp state and the stones picked out by hand; more commonly the lumps of dry clay are beaten down and water added. Kneading may be by foot, for larger quantities, or by hand. It is rare for women potters to use a settling tank where the clay is mixed with water and the water allowed to evaporate off to leave a smoother body. This practice can, however, be seen in certain countries, Cyprus, for example.

Tempers or fillers

Most women potters display a clear understanding of the importance of having a body that will withstand thermal shock in the rapidly rising temperature of an open fire. In some cases the clay is suitable in its natural state but more usually it requires the addition of some other material. Different materials used for this purpose include ground pre-fired clay, often known as grog, sand, ground shells, dung, grass or other plant material. More unusual additions include asbestos (Corsica, South Africa).

Forming systems

The simplest forming system for a small pot is that of pressing into a ball of clay in the hand and forming a bowl shape. This is also the basis of most coiled pots, which are formed by sausages of clay rolled between the hands and attached to the pots in rings or spirals and then usually smoothed down.

Equally common is a system of preparing a cone of clay which is then punched down into and the walls pulled up. Coiling is often used to finish the vessel. Most potters will use some basic support for the pot: it might be a saucer or low bowl shape which revolves as the potter works: it might be a thin slice of stone over a gritty surface as at Vista Hermosa near Oaxaca in Mexico.

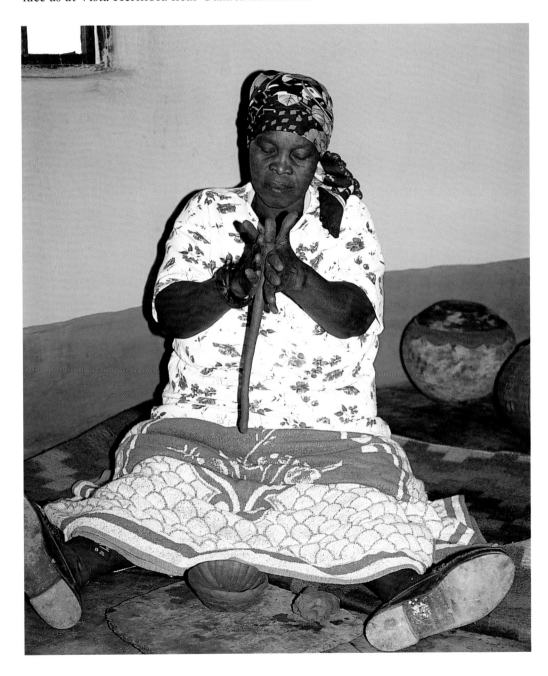

Nesta Nala, KwaZulu-Natal preparing a coil
Photo A. Vincentelli

Different simple wheel systems used by women for forming pots usually by coiling rather than throwing based on certrifugal force.

Drawing Shao-Chi Huang

Tournettes and slow wheels

One step up from the revolving saucer is the tournette or pivoted base of wood, stone or clay, which does not normally allow for throwing using centrifugal energy as it has to be swivelled by the hand or sometimes the foot.

The tall spoked wheel is used by women in Central Europe, Turkey, and South America and is rarely used to throw pots but rather as a support for coiling systems as in Karhuse in Denmark.

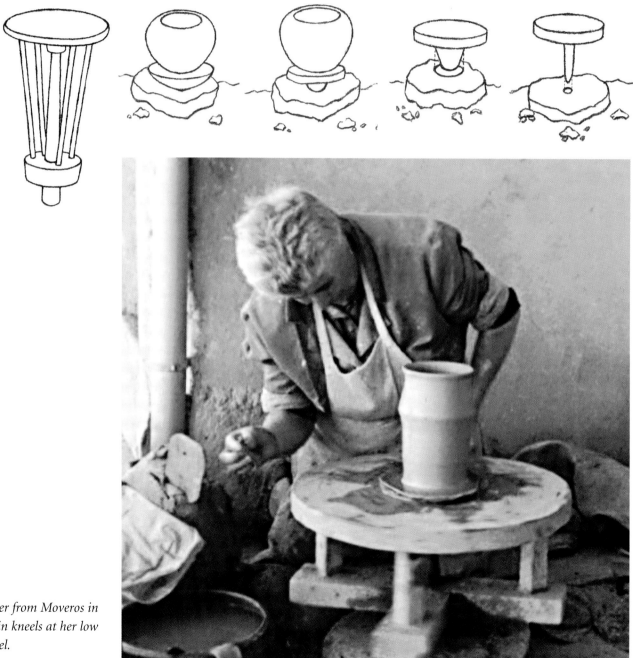

Potter from Moveros in Spain kneels at her low wheel.

Photo Richard Carlton

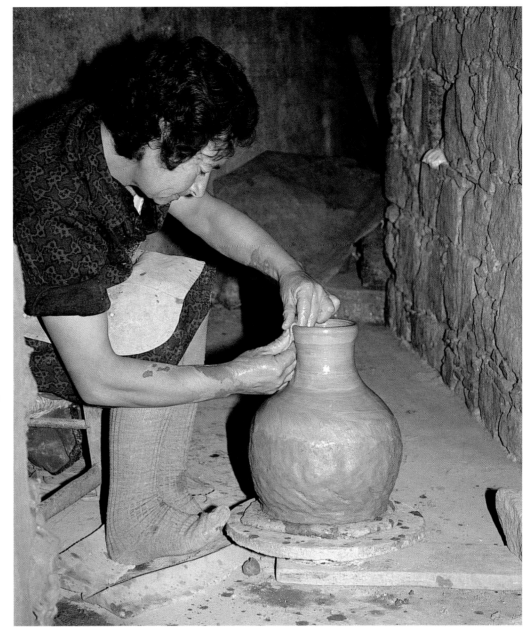

Paddle-and-Anvil

Clay forms are also made by beating out the form with a stone in a hollow in the ground (see Sudan) and, eventually, by thinning the walls using a wooden paddle against a clay or stone anvil held inside. The paddle-and-anvil system is widely used by women potters across Asia and can be a way of finishing a tubular pre-form made in a variety of ways including coiling, throwing or slab building. In India where there is a taboo against women working on the wheel, it will usually be extended to the paddle-and-anvil.

Moulds

Moulding is another commonly used system. The mould may be convex or concave and is usually of clay. A pancake of clay is draped over or pressed into the shape. The form may be beaten out and then when dry enough to hold the shape, finished off by coiling or beating. See the example from Yemen.

Two-part mould

The system where concave moulds are use used to make the two halves of an object – vessel or figurative form – is found particularly in South and Central America. It is not typical of women's production although women often help with the process in family workshops.

Yemeni potter of Rawdha near Sanaa making a base formed over a convex mould and the neck over a cylindrical stick, 1970s.
Photo Shelagh Weir

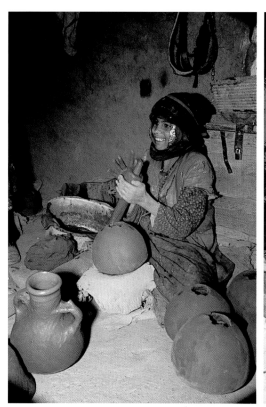
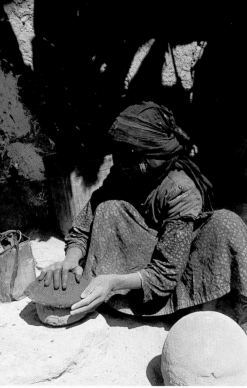

Inaq Rab'iah of Lombok, Indonesia shapes the form with a stone and a wooden paddle.
Photo Jean McKinnon

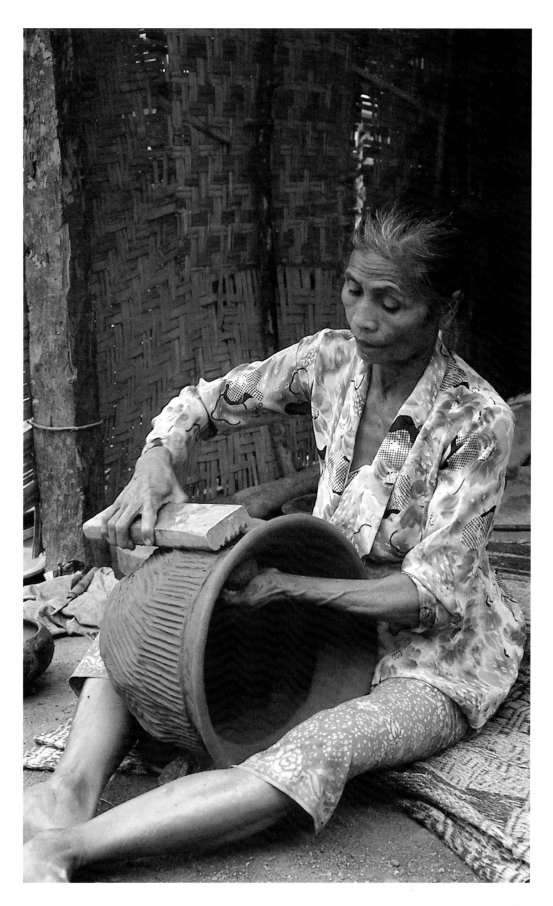

Decoration

Women's pottery is usually decorated before firing, either with paddle stamps, roulettes of twisted string, corn cobs or carved wood. Incised lines or patterns can be made with a sharp point. Pottery may be painted with coloured mineral paints from ground up rocks or liquid clays or with vegetable paints.

Left *Paddles for decoration New Guinea.*
Drawing Shao-Chi Huang

Right *Roullettes of knotted grass or carved wood used to make impressed bands of decoration, West Africa.*
Drawing Shao-Chi Huang

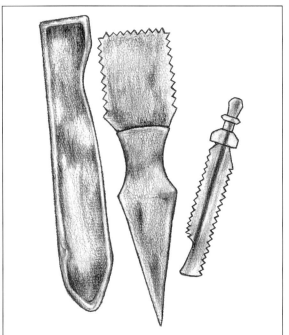

Painting materials and a pre-fired decorated triple plate, Kabylie, Algeria, 1982. The brush is made from goat's hair held together with a knob of dried clay.
Photo A. Vincentelli

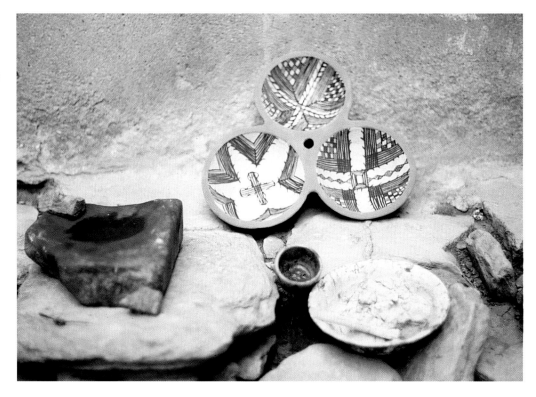

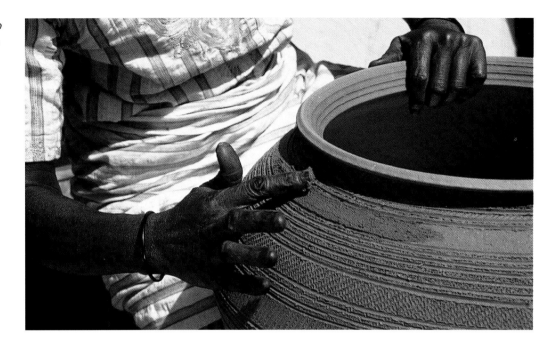

Asabe Magaji of Tatiko applies a coloured clay decoration, 1989.
Photo Alessandro Vincentelli

Burnishing

Burnishing at La Chamba in Colombia.
Photo Laurence Kruckman

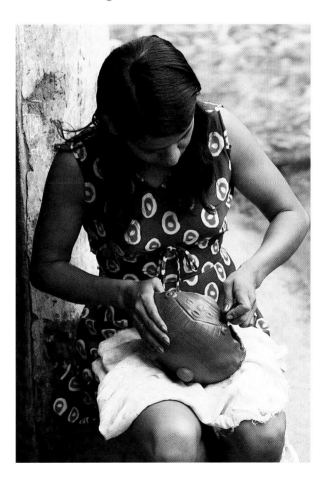

This is one of the most common finishes on women's pottery. The surface polishing seals the outside of the vessel and makes it smooth to touch. This is usually achieved with a hard river pebble and it is the burnishing stone that is the woman potter's most distinctive tool. Such stones are found in ancient burials but in modern times are frequently passed on from generation to generation.

Drying

Pottery has to be completely dried out to fire successfully. Depending on the climate, pottery will be dried out for a few days or a few weeks, usually in the shade rather than in the sun. In cooler climates such as Denmark the pottery is dried in an underground pit with a small fire over a few days. In other places (West Africa, South Africa) pots are preheated by putting some fired grass in the vessel just prior to firing.

Pots from Taliko in Nigeria being preheated with burning grass before bonfiring. Demonstration at Aberystwyth, 1989.
Photo Alessandro Vincentelli

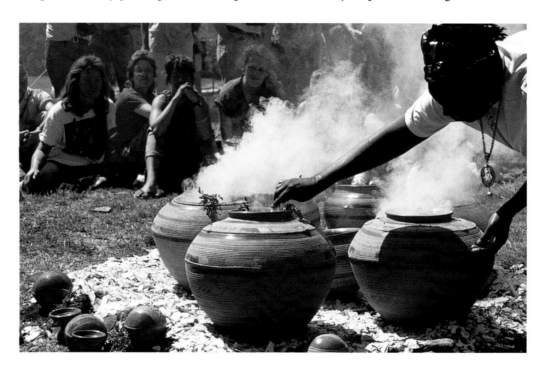

Gambian firing with palm fronds, 1992.
Photo Alessandro Vincentelli

Firing

The most typical form of firing for women potters is that of the open fire, sometimes in a slight hollow in the ground, at other times on the flat. The pots are usually laid on

a bed of fuel and then covered over with more fuel. Fuel may be added as necessary to keep the pots constantly covered. Whenever possible women potters use fuels that are easily and freely available. They rarely pay for fuel but if wood becomes scarce that is the most likely part of the whole process to require cash. The advantage of open firing is that the fuel is often a renewable material: grass, dung, palm fronds, aloe leaves or driftwood; other convenient materials can be peat, coal or even car tyres (for a Johannesburg firing). Open firing, unlike kiln-firing, rarely requires long hours. Bonfires usually take between 30 minutes to two hours.

Potters do occasionally fire special pots inside saggars or clay pots, used to protect the work from direct contact with the flames.

Black pottery

This is one of the most common forms of traditional pottery, where the pots are turned black by cutting out the oxygen at the end of the firing in various ways – for example, by smothering the fire with fine dung, or damp grass and then possibly pieces of metal sheeting (Pueblo pottery). Sometimes the pots are taken out of the fire and plunged into grass, sawdust or dung. Black pottery is to be found in many places in Africa, Pueblo pottery, Mexico, Colombia, Denmark and Central Europe and there are many examples from history and prehistory. Sometimes, as in the Zulu tradition, the black is achieved by smoking over an open flame. The black finish is a form of sealing a vessel, but is also a much-prized decorative surface, which eliminates the problem of fire clouds so common in open-fired pottery. Some potters try to avoid these but in other traditions the smudges or fire-clouds are appreciated as an integral part of the 'look' of the pottery.

Lamp bases, one with firing marks and the other smothered in grass at the end of the firing to turn it black, Endlovini Project, KwaZulu Natal, 2000.
Photo Adriano Vincentelli

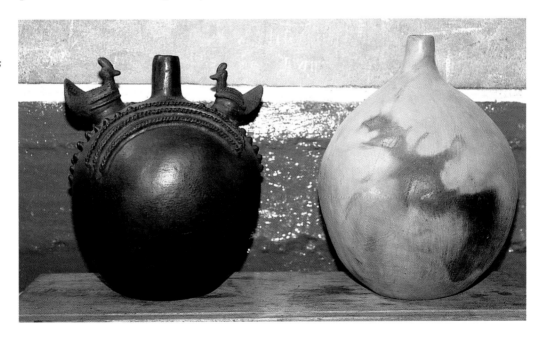

Glaze

As glazes are impossible to fire in an open-fire, once fired, they are not traditional in women's pottery. They are to be found more commonly where pottery is kiln-fired and usually where men and women are working together in family production (see Turkey or Mexico).

Other systems of sealing

There are, however, a number of other finishes used, often applied while the pots are still hot. They may be rubbed with certain kinds of leaves or dipped or splashed into a decoction of boiled bark (Vista Hermosa) or similar liquids, which stain or seal the surface. Pots may also be sealed in milk as in the Hebrides

Kilns

Kiln under construction at La Chamba, Colombia. The form will be covered with clay and fired at a low temperature a few times before it is used.
Photo Laurence Kruckman

In many places women potters now use kilns to fire their pottery. Again kiln-firers usually seem to work with male members of the family who help with this or, indeed, build the kilns in the first place. Kilns may take the form of an enclosed circular bee-hive shape, as at La Chamba, where the pottery is placed, albeit in saggars, directly into the burning fuel. More common, however, is the open-topped kiln with a grid of clay and a firebox beneath. Such kilns are found in the Mediterranean and in Mexico and South America.

Left *La Chamba, Colombia. Large vessels or saggars are used to shield the pots from the burning fuel during firing.*
Photo Laurence Kruckman

Right *Atzompa open-topped kiln with clay grid above the fire box. During firing the pots are covered over with broken sherds, pieces of metal or sometimes bark.*

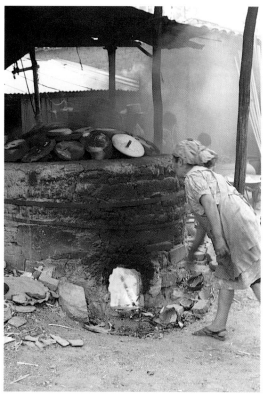

BIBLIOGRAPHY

Aiyappan, A., 1947, 'Handmade Pottery of the Urali Kurumbars of Wynad, South India' *Man* 54, 57–8

Arnold, Dean, 1985, *Ceramic Theory and Cultural Process,* Cambridge, Cambridge University Press

Babcock, Barbara A., 1995, 'Marketing Maria, the Tribal Artist in the Age of Mechanical Reproduction', in Bright,Brenda and Bakewell,Liza *Looking High and Low, Art and Cultural Identity*, Tucson, University of Arizona Press

Babcock, Barbara and Monthan, Guy & Doris, 1986, *The Pueblo Storyteller* Tucson, University of Arizona Press

Babcock, Barbara, 1987, 'Cochiti Figurative Ceramics' *American Indian Art* 12, 51–67

Babcock, Barbara, 1993, 'The Art of Helen Cordero', in *Imagery and Creativity,* Whitten, Dorothy S. and Whitten, Norman E. (eds) Tucson, University of Arizona Press

Bachofen, J.J. 1967 *Myth, Religion and Mother-Right,* London, Routledge and Kegan Paul

Baldwin, Cinda , 1993, *Great and Noble Jar, Traditional Stoneware of South Carolina,* Athens and London, University of Georgia Press

Balfet, Hélène, 1965, 'Ethnographic Observations in North Africa', in Matson, F. ed. *Ceramics and Man,* 161–177

Balfet, Hélène, 1981, 'Production and distribution of pottery in the Maghreb', in Howard, H. and Morris, E. (eds) *Production and Distribution, A Ceramic Viewpoint,* Oxford, BAR International Series

Bankes, George , 1980, *Moche Pottery of Peru,* London, British Museum

Bankes, George, 1989, *Peruvian Pottery,* Risborough, Shire Ethnography

Barbour, J. and Wandibba, S.(eds), 1989, *Kenyan Pots and Potters,* Nairobi, Oxford University Press

Barley, Nigel, 1994, *Smashing Pots: Feats of Clay in Africa,* London, British Museum Press

Barnett, W.K. and Hoopes, J.W., (eds), 1995, *The Emergence of Pottery: Innovation and Technology in Ancient Societies,* Washington D.C, Smithsonian Institution Press

Barstow, A., 1978, 'The Uses of Archaeology For Women's History: James Mellaart's Work on the Neolithic Goddess at Çatal Hüyük' *Feminist Studies* 4, 7–17

Batkin, Jonathan, 1987, *Pottery of the Pueblos of New Mexico 1700–1940,* Colorado Springs, Taylor Museum

Batkin, Jonathan, 1999, *Clay People, Pueblo Indian Figurative Traditions,* Santa Fe, Wheelwright Museum of the American Indian

Batkin, Jonathan, 1999, 'Tourism is Overrated: Pueblo Pottery and the Early Curio Trade, 1880–1910' *Unpacking Culture: Art and Commodity in Colonial and Postcolonial Worlds,* Phillips, Ruth & Steiner, Christopher (eds) Berkeley & Los Angeles, University of California Press

Bell, Brendan and Calder, Ian, 1998, *Ubumba: Aspects of Indigenous Ceramics in KwaZulu-Natal,* Pietermaritzburg, Natal Arts Trust

Bercht, Fatima, Brodsky, E., Farmer, J. and Taylor, D.(eds), 1997, *Taino – Pre-Columbian Art and Culture from the Caribbean,* New York, El Museo del Barrio, Monacelli Press

Berns, Marla, July 1990, 'Pots As People: Yungur Ancestral Portraits' *African Arts* 23, 50–60

Blandino, Betty, 1984, *Coiled Pottery, Traditional and Contemporary Ways,* London, A&C Black

Bodichon, Barbara, 1865, 'Kabyle Pottery' *Art Journal,* February 45–6

Bourdieu, Pierre, 1977, *Outline of a Theory of Practice,* Cambridge, Cambridge University Press

Briffault, R., 1927, *The Mothers, a Study of the Origins of Sentiments and Institutions,* London, Allen and Unwin

Brody, J.J. & Swentzell, R., 1996, *To Touch the Past: The Painted Pottery of the Mimbres People.* Minnesota, Weisman Art Museum.

Brody, J.J., 1990, *Beauty from the Earth, Pueblo Indian Pottery from the University Museum of Archaeology and Anthropology,* Philadelphia, University of Pennsylvania

Brody, J.J., Scott, C., Leblanc, S. Berlant, T., 1983, *Mimbres Pottery, Ancient Art of the American Southwest,* New York, Hudson Hills Press

Brown, Roxanna, 1977, *The Ceramics of South East Asia,* London, Oxford University Press

Brumfiel, E. 1991 'Weaving and Cooking, Women's Production in Aztec Mexico' *Engendering Archaeology,* Gero, Joan and Conkey, Margaret (eds), Oxford, Blackwell, 224–251

Brumfiel, E.M., 1996, 'Figurines and the Aztec State, Testing the Effectiveness of Ideological Domination' Wright, Rita P. (ed.), *Gender and Archaeology,* Philadelphia, University of Pennsylvania Press, 143–166

Brumfiel, Elizabeth 'Elite and Utilitarian Crafts in the Aztec State', in Brumfiel, Elizabeth and Earle, Timothy, 1987, *Specialization, Exchange and Complex Societies,* Cambridge, Cambridge University Press, 102–118

Bunzel, Ruth, 1972, *The Pueblo Potter: A Story of Creative Imagination in Primitive Art* (first published 1929), New York, Dover

Carlton, Richard, 1998, 'The Past and Future of Traditional Pottery-Making in Bosnia', *Studio Potter* December 27(1) 86–89

Carlton, Richard, 2002, 'Examining Social Boundaries through pottery Ethno-archaeology in the Western Balkans' Paper at the European Archaeology Association Conference, Thessaloniki, September, 2002 (unpublished)

Cheape, Hugh, 1988, 'Food and Liquid Containers in the Hebrides, A Window on the Iron Age', in Fenton, A.and Myrdal, J. *Food and Drink and Travelling Accessories – Essays in Honour of Gösta Berg,* Edinburgh, National Museums of Scotland, 6–27

Cheape, Hugh, 1993, 'Crogans and Barvas Ware, Handmade Pottery in the Hebrides' *Scottish Studies* 31, 109–127

Chiva, I and Ojalvo, D., 1959, 'La Poterie Corse a L'Amiante' *Arts et Traditions Populaire* 7, 203–227

Chui-mei, Ho, 1984, 'A brief survey of the pottery industry in villages in the south and north east of Thailand' in Picton ed., 259–284

Claassen, Cheryl and Joyce, Rosemary A. (eds), 1997, *Women in Prehistory: North America and Meso-America,* Philadelphia, University of Pennsylvania Press

Clark, John and Gosser, Dennis, 1995, 'Reinventing Mesoamerica's First Pottery' in Barnett and Hoopes (eds), 209–223

Classen, Cheryl, (ed.), 1994, *Women in Archaeology* Philadelphia, University of Pennsylvania Press

Clifford, James, 1988, 'On Collecting Art and Culture' in Clifford, James *The Predicament of Culture: Twentieth-Century Ethnography, Literature, and Art,* Cambridge, MA: Harvard University Press, 215–251

Cone, Cynthia, 1995, 'Crafting Selves: The Lives of Two Mayan Women' *Annals of Tourism Research* 22, 314–327

Cort, Louise Allison, 1979, *Shigaraki, Potter's Valley,* Tokyo and New York, Kodansha International

The Cosmos Encoiled: Indian Art of the Peruvian Amazon, 1984, Center for Inter-American Relations

Costin, Cathy & Wright, Rita, 1998, Craft and Social Identity, Archaeological Papers of the American Anthropological Association, No. 8

Crown, Patricia and Fish, Suzanne, 1996, 'Gender and Status in the Hohokam Pre-Classic to Classic Transition' *American Anthropologist,* December 98(4), 803–817

Crown, Patricia and Wills, W., 1995, 'The Origins of Southwestern Ceramic Containers; Women's time allocation and Economic Intensification' *Journal of Anthropological Research,* 15, 173–186

Dahn, Jo, 2003, 'PuebloPotteryDotCom' Interpreting Ceramics Issue 4, www.Interpretingceramics.com

Dankó, Imre, 1968, 'A magyarhertelendi noi fazekasság [The Hungarian Women Potters of Magyarhertelend] *Dunántúlii dolgozatok* 5, Pecs

Devulder, M., 1951, 'Peintures murales et pratiques magiques dans la tribu des Ouadhias', *Revue Africaine* 95, 63–102

Dillingham, Rick with Elliott, Melinda, 1992, *Acoma and Laguna Pottery* Santa Fe, School of American Research Press

Donmez and Brice, 1953, 'A Water Jar built without a wheel, in the Kurdish village of Dara' *Man* 131, 90

Donnan, Christopher, 1992, *Ceramics of Ancient Peru*, Los Angeles, Fowler Museum, University of California

Duncan, Ronald , 2000, *Crafts, Capitalism, and Women, the Potters of La Chamba, Colombia*, Gainsville, University Press of Florida

Duncan, Ronald, 1998, *The Ceramics of Ráquira, Colombia: Gender, Work, and Economic Change*, Gainsville, University of Florida

Ebanks, Roderick, 1984, 'Ma Lou and the Afro-Jamaican Pottery Tradition' *Jamaica Journal* Aug–Oct 17(3), 31–37

Eddy, Mike, 1989, *Crafts and Traditions of the Canary Islands*, Aylesbury, Shire

Edson, G., 1979, *Mexican Market Pottery* New York, Watson-Guptill Publications

Ellen, Roy and Glover, I.C., 1974, 'Central Moluccas, Indonesia: the Modern Situation and the Historical Implications' *Man* 9 (3) 353–379

Evans-Pritchard, E., 1970, 'Sexual Inversion among the Azande', *American Anthropologist*, 72, 1429–1435

Fagg, William and Picton, John, 1970, *The Potter's Art in Africa*, London, The British Museum

Fatunsin, Antonia, 1992, *Yoruba Pottery*, Lagos, National Commission for Museums and Monuments

Ferguson, Leland, 1991, 'Struggling with Pots in Colonial South Carolina' in *The Archaeology of Inequality*, McGuire, Randall and Paynter, Robert (eds) Oxford, Blackwell

Filipovic, Milenko, 1951, 'Primitive Ceramics made by women among the Balkan Peoples' *Serbian Academy of Sciences Monographs* Vol. CLXXXI Ethnographic Institute 2, 157–193

Foster, George, 1959, 'The Coyotepec Molde and Some Associated Problems of the Potter's' *Southwest Journal of Anthropology* 15, 53–63

Foster, George, 1960, 'Archaeological Implications of the Modern Pottery of Acatlan, Puebla, Mexico' *American Antiquity* 26(2), 205–214

Foster, George, 1965, 'The Sociology of Pottery: Questions and Hypotheses Arising From Contemporary Mexican Work' in Matson F. (ed.) *Ceramics and Man* 43–61

Franchet, L., 1911, *Ceramique Primitive, Introduction a L'Etude de la Technologie*, Paris, Geuthner

Frank, Barbara,1998, *Mande Potters and Leather Workers, Art and Heritage in West Africa*, Washington, Smithsonian Institution Press

Frisbie, Theodore R. 'The Influence of J.Walter Fewkes on Nampeyo: Fact or Fancy', in Schroeder, A.(ed), 1973, *The Changing Ways of Southwest Indians: A Historic Perspective*, Santa Fe, 231–234

Gartley, Richard, 1979, 'Afro-Cruzan Pottery, a new Style of Colonial Earthenware from St. Croix' *Journal of the Virgin Islands Archaeological Society* 8, 47–61

Gero, J. & Conkey, M., 1991 *Engendering Archaeology, Women and Prehistory*, Oxford, Blackwell

Gimbutas, Marija, 1989, *The Language of the Goddess*, New York, San Francisco, Harper

Glassie, Henry, 1993, *Turkish Traditional Art Today*, Bloomington and Indianapolis, Indiana University Press

Glassie, Henry, 1999, *The Potter's Art*, Bloomington and Indianapolis, Indiana University Press

Gosselain, Olivier, 1992, 'Technology and Style: Potters and Pottery among the Bafia of Cameroon', *Man* 27, 559–586

Grüner, Dorothee, 1973, *Die Berber-Keramik am beispiel, der Orte, Afir, Merkalla, Taher, Tiberguent und Roknia*, Wiesbaden, Franz Steiner

Guillen, A.C., 1998, 'Women, Rituals and Social Dynamics at Ancient Chalcatzingo', in Hays-Gilpin, Kelley and Whitley, David S. (eds) *Reader in Gender Archaeology*, London, Routledge

Güner, Günger, 1988, 'Anadolu'da Yasamakta Olan Ilkel Comlekcilik' University of Marmara, Istanbul

Güner, Günger, 1992, 'Primitive Potters in Anatolia', *Ceramics Art and Perception* 7 42–44

Guy, John, 1989, *Ceramic Traditions of South East Asia*, Oxford, Oxford University Press

Hammond, George P. and Rey, Agapito (eds),1966, *The Rediscovery of New Mexico, 1580–1594: The Explorations of Chamuscado, Espejo, Castaño deSosa, Morlete, and Leyva de Bonilla and Humaña*, Albuquerque, University of New Mexico Press

Hampe R. and Winter, A., 1965, *Bei Töpfern und Zieglern in Süditalien, Sizilien und Griechenland*, Mainz, Habelt Hayes

Haslová, Vera and Vajdis, Jaroslav, 1974, *Folk Art of Czechoslovakia*, London, Hamlyn

Heath, Barbara J., 1991, 'Pots of earth: Forms and Functions of Afro-Caribbean Ceramics in Florida' *Journal of Anthropology* 16, (Special Publication No.7: Caribbean Anthropology) 33–49

Hendry, Jean C., 1992, *A Pottery Producing Village in Southern Mexico in mid 1950s*, Nashville, Vanderbilt University

Herbert, Eugenia, 1993, *Iron, Gender and Power, Rituals of Transformation in African Societies*, Bloomington and Indianapolis, Indiana University Press

Higman, B.W., 1984, *Slave Populations of the British Caribbean 1807–1834*, Baltimore, John Hopkins University Press

Hodder, Ian (ed). 1996. *On the Surface: Çatal Hüyük 1993–95*, McDonald Institute Monographs: British Institute of Archaeology at Ankara.

Hodder, Ian, 1990, *The Domestication of Europe*, Oxford, Blackwell

Hodder, Ian, 1992, 'Burials, Houses, Women and Men', in Hodder, I., *Theory and Practice in Archaeology*, London, Routledge, 64–80

Holmes, W. H., 1889, 'Debasement of Pueblo Art', *American Anthropologist* 2(4), 320

Hoover, Deborah, Autumn 2000, 'Revealing the Mbusa as Art, Women Artists in Zambia', *African Arts* 40–53

Houlihan, P.,Collings, J.,Nestor, S., Batkin, J., 1987, *Harmony by Hand – Art of the Southwest Indians*, San Francisco, Chronicle Books

Interpreting Ceramics 3 http://www.uwic.ac.uk.htm (accessed 09/10/02)

Irving Rouse, 1992, *The Tainos: Rise and Fall of the People who greeted Columbus*. New Haven, Yale University Press

Jacobs, Julian, 1990, *The Nagas Hill People of North East India* London, Thames and Hudson

Jewitt, Llewellyn, 1883 reprinted 1985, *The Ceramic Art of Great Britain*, Poole New Orchard Editions, Dorset, England

Jules-Rosette, Bennetta, 1977, 'The Potters and the Painters: Art by and about Women', in Urban Africa' *Studies in the Anthropology of Visual Communication* 4(2),112–127

Kerchache, Jacques (ed) , 1994, *L'Art Taino*, Paris, Musee du Petit Palais

Köpke, Wulf, 1974, 'Frauentöpferei in Spanien' in *Baessler-Archiv*, Neue Folge, Band XXII, 335–439

Kramer, Barbara, 1996, *Nampeyo and Her Pottery*, Albuquerque, University of Mexico Press

Krause, Richard, 1985, *The Clay Sleeps: an Ethnoarchaeological Study of three African Potters*, Tuscaloosa, Alabama, University of Alabama Press

Kroun,E., 1984,'Methods of Pottery Manufacture among the Yami on Botel Tobago' in Picton, John (ed), 285–302

Kruckman, Laurence, 2001, *The Potters of La Chamba, Colombia*, Indiana, University of Pennsylvania, (exhibition catalogue)

La Duke, Betty, 1985, *Compañeras, Women Art and Social Change in Latin America*, San Francisco, City Light Books

Lange, C., 1959, *Cochiti, A New Mexico Pueblo, past and present*, Austin, University of Texas Press

Lathrap, Donald W., 1983, 'Recent Shipibo-Conibo ceramics and their implications for the archaeological interpretation', in Washburn, Dorothy (ed) *Structure and Cognition in Art*, Cambridge, Cambridge University Press, 25–39

Lathrap, Donald W., 1976, 'Shipibo Tourist Art' in Graburn (ed) *Ethnic and Tourist Art. Cultural Expressions from the Fourth World*, Berkeley, University of California Press, 197–207

Lawton, A.C., 1967, 'Bantu Pottery of Southern Africa', in *Annals of the South African Museum* 49,1, 1–440

Leblanc, Stephen A.,1983, *The Mimbres People, Ancient Pueblo Painters of the American Southwest*, London, Thames and Hudson

Lefferts, Leedom & Cort, Louise, 2002 'A Preliminary Cultural Geography of Contemporary Village-based earthenware production in mainland Southeast Asia', *Journal of the Siam Society* 88 (1&2), 204–211

Leith-Ross, Sylvia, 1970, *Nigerian Pottery*, Lagos, Ibadan University Press

Lévi-Strauss, Claude, 1988, *The Jealous Potter*, Chicago, University of Chicago Press

Litto, Gertrude, 1976, *South American Folk Pottery, traditional techniques from Peru, Ecuador, Bolivia, Venezuela, Chile, Colombia*, New York, Watson-Guptill

London, Gloria, 1989, 'On Fig Leaves, Itinerant Potters, and Pottery Production Locations in Cyprus', in *Crosscraft and Cross-cultural Interactions in Ceramics, Ceramics and Civilization, 4*, 65–80

Longacre, William 1999 'Standardization and Specialization: What's the Link?' in Skibo,J. and Feinman, G. (eds) *Pottery and People, a Dynamic Interaction*, Salt Lake City, University of Utah Press, 44–58

Lopez,C., Markesn, R., Winer,M., Lind,D., 2000, Ceramica de la fase XOO de Valle de Oaxaca, Centro INAH Oaxaca, 2000

Lorenz, Bente, 1989, *Traditional Zambian Pottery*, London, Ethnographica

Lynggaard, Finn,1972, *Jydepotter and Ildegrave*, Kobenhavn, KBH

Macfadyen,W.A., 1947, 'Bedyal Pottery: a Painted ware made in Iraqi Kurdistan' *Man* 43, 47–48

Man, E.H., 1894, 'Nicobar Pottery' *Journal of the Anthropological Institute* 23, 22–26

Marriott, Alice, 1948, *Maria, The Potter of San Ildefonso*, Norman, University of Oklahoma Press

Martelle, Holly, 1999, 'Redefining Craft Specialization: Women's Labor and Pottery Production - an Iroquoian Example' in From the Ground Up: Beyond Gender Theory in Archaeology, Oxford, BAR International Series 812:133-140

Mathewson, R. Duncan, March–June 1973, 'Archaeological Analysis of Material Culture as a Reflection of Sub–Cultural Differentiation in 18th Century Jamaica' *Jamaica Journal* 7(1–2), 25–29

Mathewson, R.Duncan, June 1972, 'Jamaican Ceramics , An Introduction to 18th century Folk Pottery in West African Tradition' *Jamaica Journal* 6(2),54–56

Matson, F.R. (ed.), 1965, *Ceramics and Man*, Chicago, Wenner Gren Foundation

May, Patricia and Tuckson, Margaret, 1982, *The Traditional Pottery of Papua New Guinea* Sydney, Bay Books

McDonald, Roderick, 1994, *The Economy and Material Culture of Slaves*, Baton Rouge and London, Louisiana State University Press

McEwan, Colin, Barreto, Cristiana, Neves, Edouardo, (eds) 2001, *Unknown Amazon*, London, British Museum Press

McKinnon, Jean, 1996, *Vessels of Life, Lombok Earthenware*, Bali, Saritaksu

Medley, Margaret, 1976, *The Chinese Potter*, Oxford, Phaidon.

Mellaart, J., 1965, *Earliest Civilizations in the Near East* London, Thames and Hudson

Mellaart, J., 1967, *Çatal Hüyük: A Neolithic Town in Anatolia*, London, McGraw-Hill

Mellaart, J., 1975, *The Neolithic of the Near East*, London, Charles Scribner's Sons

Mezzadri, Brigitte,1985, 'La Corse, Poterie Traditionnelle a l'Amiante' (no information)

Miller, Daniel, 1985, *Artefacts as Categories, A study of Ceramic Variability in Central India* Cambridge, Cambridge University Press

Miln, James, 1881, *Excavations at Carnac: Excavations at Carnac (Brittany)*, Edinburgh, D. Douglas

Mintz, Sidney and Hall, Douglas, 1960, 'The origins of the Jamaican Internal marketing System' *Yale University Publications in Anthropology*, 573–26

Mitchell, Arthur, 1880, *The Past in the Present, What is Civilization*, Edinburgh D. Douglas

Molinaro, Joe 'Fantastic Figures of Ocumicho' http://www.uky.edu/Artsource/Molinaro/ocomichu.html (accessed 29/03/03)

Molinaro, Joe *Jatun Molino*, film

Molinaro, Joe 'Jatun Molino – a Pottery Village in the Ecuadorian Amazon Basin'

http://www.uky.edu/Artsource/molinaro/molino.html (accessed 16/10/02)

Morrison, Jen., 1982, 'Folk Ceramics of Ocumichu' *Ceramic Review* 73, 26–27

Morrison, Jen., 1985, 'Women Potters Of Cocucho'

Ceramic Review 93, 35–37

Moszynski, K., 1929, *Kultura Ludowa Slowian,* Krakow

Murdock, George, 1973, 'Factors in the Division of Labour by Sex: a Cross-Cultural Analysis', *Ethnology* 12,2, 203–25

Myers, Thomas P., 2000, 'Looking Inward: the Floresence of Conibo/Shipibo Art during the Rubber Boom' Paper at the 50th International Congress of Americanists, Warsaw

Myers, Thomas, 1989, 'The Role of Pottery in the Rise of American Civilizations: the Ceramic Revolution', in Kolb C. (ed) Ceramic Ecology BAR International Series 1–28

Naranjo-Morse, Nora, 1992, *Mud Woman: Poems from the Clay,* University of Arizona Press

Nash, June, 1993, 'Maya Household production in the World market: the Potters of Amatengo del Valle, Chiapas, Mexico', J. (ed.) *Crafts in the World Market; the Impact of Global Exchange on Middle American Artisans* Nash, . New York, State University of New York Press

Niethammer, Carolyn, 1977, *Daughters of the Earth – The Lives and Legends of American Indian Women,* London and New York, Macmillan

Olwig, Karen Fog, 1990 'Cultural Identity and Material Culture: Afro-Caribbean Pottery', *Folk* 32, 5–52

Papousek, Dick, 1981, *The Peasants of Los Pueblos,* Assen, Van Gorcum

Papousek, Dick, 1984, 'Pots and People in Los Pueblos: The Social and Economic Organization of Pottery', *The Many Dimensions of Pottery,* Amsterdam, Universiteit van Amsterdam, 475–526

Payne, William, 1982 'Kilns and Ceramic Technology of Ancient Mesoamerica' Archaeological Ceramics, Washington D.C., Smithsonian Institute Press

Peacock, D.P.S., 1982, *Pottery of the Roman World, an Ethnoarchaeological Approach,* Harlow, Longman

Perryman, Jane, 2000, *Traditional Pottery of India,* London, A&C Black

Peterson, Susan, 1977, *The Living Tradition of Maria Martinez* Kodansha, Tokyo, New York and San Fransisco

Peterson, Susan, 1984, *Lucy Lewis: American Indian Potter* Tokyo, New York and San Fransisco, Kodansha International

Peterson, Susan, 1997, *Pottery by American Indian Women, The Legacy of Generations,* National Museum of Women in the Arts, New York, Abbeville Press

Picton, John (ed.), 1984, *Earthenware in Asia and Africa: a colloquy held 21–23 June 1982* London University of London, Percival David Foundation of Chinese Art

Pla, Josefina, 1994, *La Ceramica Popular de Paraguaya,* Asuncion, Centro de Documentacion e Investigaciones de Arte Indigena y Popular

Posey, Sarah, 1994, *Yemeni Pottery* London, British Museum Press

'Promotion and Production of Improved Cooking Stoves (Phase 1&2) GAM/85/XO1' http://www.undp.org/seed/unso/lesson/compendium/projects/gam85x01.htm (accessed 6/4/02)

Reents-Budet, Dorie, 1994, *Painting the Maya Universe: Royal Ceramics of the Classic Period,* Durham and London, Duke University Press

Reina, Ruben and Hill, Robert, 1978, *The Traditional Pottery of Guatemala,* Austin and London, University of Texas Press

Rice, P.M., 1991, 'Women and Prehistoric Pottery Production', Doreen (ed.) in *The Archaeology of Gender, Proceedings of the 22nd Annual Conference of the University of Calgary* Walde, . Calgary, University of Calgary

Rice, Prudence & Kingery, W.D. (eds) 1997, *The Prehistory and History of Ceramic Kilns,* The American Ceramic Society Vol. VII

Rice, Prudence and Sharer, Robert (eds), 1987, *Maya Ceramics: Papers from the 1985 Maya Ceramic Conference,* Oxford, BAR International Series 345(i)

Rice, Prudence, 1981, 'Evolution of Specialised Pottery Production : a Trial Model' *Current Anthropology* 22(3), 219–240

Rieth, Adolf,1960, *5000 Jahre Töpferscheibe* Konstanz Thorbecke Verlag

Rooney, Dawn F., 1987, *Folk Pottery of South East Asia* Oxford, Oxford University Press

Roosevelt, Anna, 1988, 'Interpreting certain Female Images in prehistoric Art', in Miller, V. E. (ed), *The Role of Gender in Precolumbian Art and Architecture,* Lanham, University Press of America

Roosevelt, Anna, 1991, *Moundbuilders of the Amazon, Geophysical Archaeology on Marajo Island, Brazil,* San Diego, Academic Press

Roosevelt, Anna, 1995 'Early Pottery in the Amazon: Twenty Years of Scholarly Obscurity' in Barnett & Hoopes (eds)115–131

Roscoe, Will, Spring 1988, 'We'wha and Klah – The American Indian Berdache as Artist and priest' *American Indian Quarterly* 12 (2),127–150

Rossi, Gail, 1987 'A 100-Year-Old Craft Endures', *Ceramics Monthly* December 42–46

Russell, P., 1998, 'The Paleolithic Mother-Goddess: Fact or Fiction?' in Hays-Gilpin, K. and Whitley, D. (eds), *Reader in Gender Archaeology* London and New York, Routledge, 261–67

Rye, O. and Evans, C., 1976, 'Traditional Pottery Technique of Pakistan' *Smithsonian Contributions to Anthropology* 21, Washington

Saraswati, Baidyanath,1978, *Pottery-Making Cultures and Indian Civilization* New Delhi, Shakti Malik

Sayer, Chloe, 1990, *Arts and Crafts of Mexico* London, Thames and Hudson

Schaedler, Karl-Ferdinand , 1997, *Earth and Ore, 2500 years of African Art in Terra-cotta and Metal*, Munich, Panterra

Schildkrout, E. and Keim, C., 1990, *African Reflections: Art from North Eastern Zaire*, Washington, American Museum of Natural History

Schofield, J.F., 1948, *Primitive Pottery an introduction to South African Ceramics, Prehistoric and Protohistoric*, Cape Town, The South African Archaeological Society

Scott, Gillian, 1998, *Ardmore, An African Discovery* Cape Town, Fernwood Press

Seeger, Mika, December1988, 'Pottery and Revolution in Nicaragua' *Studio Potter*, 17(1), 79–82

Shah,Haku, 1985, *Form and the Many Forms of Mother Clay* Exhibition catalogue, New Delhi

Simmonds, Doig, 1984, 'Pottery in Nigeria' in Picton, J. (ed.)1984, 54–92

Solheim , Wilhelm, 1952, 'Oceanian Pottery Manufacture' *Journal of East Asiatic Studies* (University of Manila) 1, 1–39

Spivey, Richard L., 1989, *Maria* Flagstaff, Northland Publishing

Steensberg, Axel, 1939, 'Primitive Black Pottery in Jutland' *Folkliv* 2–3, 113–146

Steensberg, Axel, 1940, 'Handmade Pottery, in Jutland' *Antiquity* 54, 148–153

Stössel, Arnulf, 1984, *Afrikanische Keramik Traditionelle Handwerkskunst südlich der sahara* München , Hinmer Verlag

Szabadfalvi, Jósef, 1986, *Hungarian Black Pottery*, Budapest, Corvina

Tate, C., 1999, 'Writing on the face of the moon – Women's products, archetypes, and power in ancient Maya civilization', in Sweely, T.L. (ed) *Manifesting Power – Gender and the Interpretation of Power in Archaeology*, London and New York, Routledge, 81–102

Teuteberg, Sabina 1996 'Towards a Revival of an Iban and Kelabit Pottery Tradition' unpublished paper at the Borneo Research Council Conference, Brunei

Thompson, Barbara, 1995, *Earthen Spirits: Ceramic Power Vessels of Lower Zaire*, University of Florida Master's Thesis, http://bailiwick.lib.uiowa.edu/african-ceramic-arts (accessed August 2000)

Thompson, R., 1969, 'Abatan: a Master Potter of the Egbado Yoruba', in Biebuyk, D. *Traditional and Creativity in Tribal Art* Berkley and Los Angeles, University of California Press,120–181

Thompson, Raymond,1974, *Modern Yucatan Maya Pottery Making*, Memoirs of the Society for American Archaeology No. 15, New York, Krauss Reprint

Tobert, Natalie, 1984, 'Potters of El-Fasher: one technique practised by two ethnic groups' in Picton ed. 1984, 219–237

Toulouse, Betty, 1977, *Pueblo Pottery of the New Mexico Indians*, Santa Fe, Museum of New Mexico Press

Trowell, Margaret and Wachsmann, K.P., 1953, *Tribal Arts of Uganda*, Oxford, Oxford University Press

Trowell, Margaret, 1960, *African Design*, London, Faber

Tschopik, H., 1950 'An Andean Ceramic Tradition', *American Antiquity* vol. 15:196–218

Tuckson, Margaret,1990, 'Sepik Pottery Research and its Relevance for Papua New Guinea', in Lutkehaus et al. (ed) *Sepik Heritage, Tradition and Change in Papua New Guinea*, Durham, Carolina Academic Press, 553–567

Van Camp, Gena R.,1979, *Kumeyaay Pottery – Paddle and Anvil Techniques of Southern California* Anthropological Papers, 15, Bellena Press

Van de Velde, P. and Van de Velde, H., 1939, 'The Black

Pottery of Coyotopec, Oaxaca, Mexico' *Southwest Museum Papers* 13, 1–43

Van der Leeuw, Sander (b), 1984, 'Manufacture, Trade and Use of Pottery on Negros, Philippines', in Picton, J. (ed.), 1984, 326–355

Van der Leeuw, Sander and Pritchard, Alison (eds), 1984, *The Many Dimensions of Pottery* Amsterdam, Universitat van Amsterdam

Van der Leeuw, Sander(a) ,1984, 'Dust to Dust: a transformational View of the Ceramic Cycle' in Van der Leeuw and Pritchard (eds), 1984, *The Many Dimensions of Pottery* 707–747

Vandiver, P.O.S., Klim B., Svoboda J., 1989, 'The Origins of Ceramic Technology at Dolni Vestonice, Czechoslovakia' *Science* 246, 1002–8

Vincentelli, M., 1989,'Reflections on a Kabyle Pot: Algerian Women and the Decorative Tradition' *Journal of Design History* 2 (2&3), 123–138

Vincentelli, Moira, 2000, *Women and Ceramics, Gendered Vessels*, Manchester, Manchester University Press

Vitelli, K., 1999, 'Looking Up at early ceramics in Greece', in Skibo, J. and Feinman, G. (eds) *Pottery and people, A Dynamic* Interaction, Salt Lake City, University of Utah Press, 184–198

Vlach, John, 1978, *The Afro-American Tradition in Decorative Arts*, Cleveland, Cleveland Museum of Art

Volavka, Zdenka, 1977, 'Voania Muba: Contributions to the History of Central African Pottery', *African Arts*, 10, (2) 59–66

Von Winning, H., 1969, *Pre-Columbian Art of Mexico and Central America*, London, Thames and Hudson

Wade, Edwin L., 1986, ' Straddling the Cultural Fence: The Conflict for Ethnic Artists within Pueblo Societies' in Wade, Edwin (ed) *The Arts of the North American Indian, Native Traditions in Evolution*, New York, Hudson Hills Press, 243–254

Wasserspring, Lois, 2000, *Oaxacan Ceramics, Traditional Folk Art by Oaxacan Women*, San Francisco, Chronicle Books

Weir, Shelagh, 1975, 'Some observations on pottery and weaving in the Yemen Arab Republic', *Proceedings of the Seminar for Arabian Studies*, 5, 65–76

Whitten, Dorothea and Whitten, Norman, 1993 'Creativity and Continuity; Communication and Clay' in Whitten and Whitten (eds) *Imagery and Creativity, Ethnoaesthetics and Art Worlds in the Americas*, Tucson & London, University of Arizona Press,

Whitten, Dorothea and Whitten, Norman, 1988, *From Myth to Creation*, Urbana & Chicago, University of Illinois Press

Wild, R.P., Jan 1934, 'Ashanti Baked Clay Heads from Graves' *Man* 34, 1–4

Willey, Gordo,n 1949, 'Ceramics' *Handbook of South American Indians*, Steward, J. ed.Vol.5:139–204

Williams, Walter L., 1986, *The Spirit and the Flesh: Sexual Diversity in American Indian Culture*, Boston, Beacon Press

Wilson, Samuel (ed.), 1997, T*he Indigenous People of the Caribbean*, Gainsville, University of Florida

Wright, Rita, 1991 'Women, Labour and Pottery Production in Prehistory' in *Engendering Archaeology, Women and Prehistory*, Oxford, Blackwell

Wyckoff, Lydia L., 1990, *Designs and Factions: Politics, Religion and Ceramics on the Hopi Third Mesa*, Albuquerque, University of New Mexico Press

Zhuhai,Cheng et al, 1986, 'Field Investigation of the Prehistoric Methods of Pottery Making in Yunnan' in *Scientific and Technological Insights on Ancient Chinese Pottery and Porcelain*, Beijing, China, Shanghai Institute of Ceramics, Science Press

INDEX

Numbers in italic refer to illustrations and captions